JACK EARL

Jack Earl

The Genesis and Triumphant Survival of an Underground Ohio Artist by Lee Nordness

Perimeter Press Limited Racine/Chicago

First Edition

Printed in the United States of America

The memory of Margaret Phillips pervaded the writing of this book.

Foreword

Occupying a unique place in the world of contemporary ceramics is Jack Earl, a solitary artist with a complex vision. Using his midwestern roots of rural life as a central inspiration, Earl creates ceramic figures and tableaux which reveal an essence and expression of daily life. To understand Earl's work one must understand a basic contradiction between his modest personality and simple life style and the vast range of intellectual and poetic works of art he has created. Earl's fertile imagination has led him to explore a unique union of visual and narrative qualities using the rich traditional heritage of porcelain figures in counterpoint to his subject matter of Middle America. One of Earl's most valued gifts is the ability to transform the common event into the moment of insight. His work captures the hopes and dreams as well as the sensitivities and wisdom of the common man. Few other artists have adopted clay's figurative tradition in such a personal and powerful way.

The written inscriptions and titles on Earl's sculptures reveal another dimension of the artist's creative vision. Straight forward and unassuming as their author, the narratives speak in a rambling rural tone and emanate from Earl's daily experiences. The hand-written lines of script, at times provocative and often humorous, weave personal tales of uncomplicated lives filled with universal wonderment. The poetic text reinforces the duality of complexity and simplicity evident in the visual elements which spring from the artist's life and sources.

In many ways Jack Earl demonstrates a special blend of qualities found in both contemporary and folk artists. While his works stand amid the finest of contemporary ceramic art, Earl maintains an isolation and almost puritanical concentration on his work to follow his own private path. His inspiration consistently reflects historical and personal sources. On a technical level, the artist has developed a masterful skill in modeling delicate clay reliefs with a painstaking control over their rich surfaces. The result is a compelling aesthetic union of the sophisticated and the natural as Earl invites the viewer to become a secret observer of his intimate, private world.

It has been an exciting experience to witness Jack's creative growth over the past two decades, from his early works in Toledo and later in Virginia to his maturation in his smalltown Ohio environment. Those who have followed his work are aware of its many subtle qualities and the pleasure that comes from lingering to absorb the detailed insights the artist has created.

The contents of this book on Jack Earl make an important contribution to the understanding of Jack's life and work, and place in perspective this truly unique American artist.

Paul Smith
Director, American Craft Museum
New York, New York

NOTE: To preserve local color of the Sciota marsh area of Ohio, irregularities in spelling and syntax found in stories, letters and notes written by Jack Earl, his family and his close friends remain intact. Original syntax is also duplicated from taped statements, but many probable unique spellings, alas, have been lost through the spoken word.

What am I doing?
Getting by.
How do I see myself?
Rather not say.

On an all but empty county highway, Jack drove us leisurely northward, away from Indian Lake where he, his wife Fairlie, and two of their three children live.

Fairlie
You should know that this is a special part of Ohio. Two reasons. The first's about the rivers: none of them are big here. That's because we're so near the Great Divide. It makes this the high area of the state —

Jack
The high point's about fifteen miles south from our house — and it's not very high.

Windows frame the same two fields mile after mile: horizon to road shoulder, interleafed rows of corn or bushy lanes of soybeans, leaves on both plants limp, motionless.

Fairlie
Well, it's high enough for rivers to start here. You see, in this area heads exist for four important rivers, long ones, and what's amazing is each one takes a different direction. I mean, each one of the four flows to a different corner of the state.

Jack contested this information, but Fairlie was able to cite the four waterways.

Fairlie
Maybe they don't all extend completely to a corner, but they're all sure headed in the right directions.

Low areas lay barren: early torrents uprooted seedlings, and farmers who replanted witnessed weeks of suffocating haze undo the effort. A county marker swept across the eye.

Fairlie
See that! Hardin County. Believe it or not, we are now driving over what everyone says, even in books, is the most incredible marsh in the United States. We live right on the edge of it, and Roy, my dad, has his farm right on it. The marsh is the second thing that's so interesting about this part of the state.

/

Ponderous ice from the last glacial invasion excavated a vast, ham-shaped depression, which the thaw deliberately transformed into a lake. Further warming germinated untended plant life: the water's surface was soon choked into a classic dense vegetative marsh. As late as mid-nineteenth century settlers avoided the crepitating, unsure footing of this primeval heirloom, but when arable land grew less accessible, the marsh's value was reassessed: here lay from two to ten feet of the accumulations of eons that supported a luxuriant growth. Why couldn't this trophic soil support luxuriant crops instead? However, decades elapsed before the paludal storehouse could be effectively drained, and some say it still hasn't been tamed. Along the way the black, grandular marsh soil was dubbed 'muck.'

Elk and deer considered the basin home; bear, porcupines, wild hogs with foot-long tusks, scavenging gray wolves and scavenging black wolves discouraged intruders; also uninviting were copperheads, racers and prairie rattlesnakes coiled in tall grasses and nesting in springs. Mud eels, gar pike, blunt-nosed minnows, yellow perch and both rock and black bass crowded pools and waterways.

The most visible residents were annual summer tenants — pigeons. Well over a million visited the marsh as soon as boughs budded, and lingered until leaves yellowed, each year roosting on the same weeping willows of a forty-acre island in the center of the morass. Daily the birds would lift in unison, establish a flight altitude, then arc into the dawn to raid off-marsh farms, stripping fields of from 4,000 to 5,000 bushels of grain in a single day. Finally in the 1870s farmers delivered a challenge: on moonless sorties oars were silently drawn through uncertain waters to the island, where shotguns rose from boats to blast the predators into hell. Even with ranks thinned, the pigeons returned on schedule. Or, until 1883, the languid summer when farm families stared in disbelief at pigeonless skies, when children remained awake as late as possible, and awoke as early as possible, ever alert for wingflaps. Praise the Lord: the pigeons had verily forsaken the marsh, and despite a summer of intense speculation and subsequent years of professional investigation, not a feather was discovered to indicate their new summer home.

Those who chanced to witness a million pigeons glide aloft as one form passed the image to children to pass to children.

Indians — Mingos, Roundheads, Shawnees, Ottawas, Wyadots, Miamis and Senecas, among other tribes, camped in the area — were the first to harvest food from the marsh, without ever having to enter it: each fall when the ten-foot grasses swayed paper-dry, hunters flung blazing torches into their midst. Deer, panthers (last one seen in 1850), turkeys,

wild cats, ducks, gray fox, lynx (last one seen in 1867), wild boars, porcupine bolted from flames and smoke; arrows and bullets brought them to the ground for winter larders.

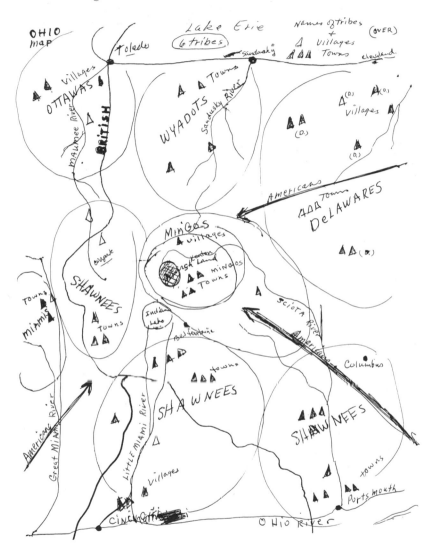

The eventual draining of the marsh was essentially accomplished by deepening beds of exiting waterways, some of which originated in the marsh, and some of which passed through, as the Sciota river, one of Fairlie's four rivers. Early homesteaders, staring in disbelief at the rich black muck straining through their fingers, reasoned that onion, celery and cabbage would fare well. All did, but big yellow and big white onions

flourished as if blessed by the swamp. Soon many a farmer would be granted the title of 'Onion King.' Many more would simply bestow the crown on themselves.

At the southern tip of the marsh a small peninsula extends into the muck, and though attached to land, came to be named 'Nigger Island.' In the early 1800s slave runners — usually anti-slavery sympathizers — worked below the Mason-Dixon line (which runs along the Ohio-Kentucky border to the south), mapping out escape routes for blacks to northern cities. Eventually these routes became known as the 'Underground Railroad,' and it is lore that this marsh 'island' was a major depot/hideout. A log cabin provided relative safety from bounty hunters or slave owners — who were allowed to continue pursuits over state lines — until further instructions arrived. Summer runaways were exposed to another peril: anyone leaving the cabin after sundown chanced enervating fevers and probable death from infestations of mosquitoes carrying swamp fever (malaria). The log cabin has long since disappeared.

Fairlie
Not only blacks came up here. Poor whites too. From Kentucky mostly, and because Kentucky people were from 'down in the hill,' they were called hillbillies. When I was a child my elders used to go down there and bring up families to work in the onion fields. The marsh was settled mostly by Swedish and German people, but soon it was mostly Kentuckian. We needed lots of labor. That's one reason there were so many kids.

Jack headed across the marsh, now laid out in farms and roads.

Jack
This spongey soil can still be unneighborly. A heavy rain and wow — it's oozing muck again. Smokers have to watch it in the summer. Any muck soil without vegetation dries up fast, then cracks open everywhere. One live butt down a crevice can do it.... This stuff burns! Then it smolders for weeks. Any crack, no matter how deep, will support fire if there's oxygen.

Only Richard's Grocery, more like a roadside 7-11, and a gas station — actually a roadside pump in front of the store — remain of 'Nigger Island.' Jack pulled up on a hard dirt road shoulder serving for parking. Inside several scattered, free-standing shelves exhibited mainly junk food, barely visible in a half-darkness. Outside again, a dusty pickup parked parallel to the front door, and a young couple slid from the cab seat and sauntered inside, letting the screendoor slam. Stretched out in the open back of the pickup were a boy and girl, each with silver

windmatted hair and sun dulled eyes. A young hunting hound sprawled between them, already asleep.

Fairlie
At least the place isn't called 'Nigger Island Store' anymore.

Stranger
Oh, it ain't been called that for some time.

The information came from a tall older man in bib overalls.

Stranger
See that cut in the side of the grass slope over there? Well, that's the end of the tunnel where them slaves come outta to hide on the island.

Fairlie
Where's the other end of the tunnel?

Stranger
I wouldn't know. Nobody believe me goes in there — fulla snakes and water. You know.

We returned to the car.

Fairlie
He's fulla something too. Some people don't think this spot was ever part of the Underground Railway anyway.

Jack paced to the car in long stiff Henry Fonda strides. But when stationary his composure unhinges. Often one foot is placed on top of the other, school boy fashion, or the toe-end of one shoe is hooked behind the heel-end of the other. Sometimes a hand rests on a hip, non-macho fashion. He also cups the elbow of one arm in the hand of the other arm, pressing the raised fingers over mouth and chin. Jack now supports a slouch with one arm across the top of the open car door, his eyes collecting images of the old man. Even while he positions himself behind the wheel, while he starts the motor he continues to watch the old man: washed and washed overalls, a serious mien tempered by playful eyes, hands turning limp at the loss of an encounter, and finally a hesitant, awkward move away.

Jack
He meant good. Just making life a little more exciting.

Fairlie
Did you ever hear about that tunnel before, Jack?

Jack
Nope. . . . Where to now?

Fairlie
You know you want to show off your home town.

Fairlie, a trim tanblonde, sat between us, her head twisting from right to left as she identified houses, trees, corners, fields known since childhood. Her animated monologue masked both her frequent wistfulness and Jack's taciturnity.

We moved westward, into Auglaize (pronounced 'Aw-glaze') county, named after the river which flows through it, another of Fairlie's quartet. As we approached Uniopolis, Jack related, as he does for newcomers, that a few years ago drivers had to be on the alert or they could pass right through town without noticing it.

Jack
Then in my teens they put up a stop light right at the main intersection. It's the town's first and last.Well, I guess even now if the light was green you could still drive right through and never know you'd been in Uniopolis.You know I used to tell everyone I was born here. Then one day my mom told me I wasn't.

Uniopolis (the township title, Union, mated to the Greek for city-state, polis) seems to extend no more than three or four blocks in any direction from the signal light and the unpretentious frame houses could have all materialized during the same afternoon, so similar is their style and depreciation. Always a yard of trimmed grass. Fences rare. Colors limited, other than gray and white. Trims will vary — conservatively. Houses sit conspicuously without numbers, but when streets are nameless, numbers can only be judged decorative.

Jack
No need for mailmen. Keeps taxes down. All the mail's right at the postoffice.

We cruised slowly up and down the graveled and occasionally macadamed streets.

Jack
You know about six months ago I asked my mother in which house exactly I was born, and that's when I found out I was born somewhere else. Sure makes you feel funny. But it wasn't far away, in a farm house. We didn't have a farm — only a farm house.

6

Recently his mother, Hazel Steele Earl, accompanied him on a drive to locate the house, but it was no longer where her memory placed it. His parents had been married three years before their first child, Robert, was born, and his mother had moved to her father's house — in Santa Fe, Ohio — for the delivery. Jack arrived three years later in their own house. Some two years later the family moved to Uniopolis where his sister, Marilyn, was born.

Jack
We actually lived in three houses in Uniopolis. I barely remember the first one. It was over on the other side of the railroad track — you know the track cuts the town in half. . . .

Retaining the chronology grew confusing with cognate houses and verging properties. Why would anyone bother moving in Uniopolis? At the third house his parents had occupied, a long-eared mutt stuck his head out of a doghouse on the front lawn and barked perfunctorily. No one inside made an appearance. On a neighbor's front lawn a yellow plastic duck was impaled on a rod, but such excesses were rare in Uniopolis.

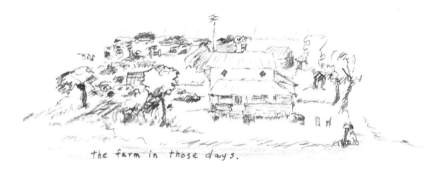

the farm in those days.

Times grew rough when Jack's father, Kermit Earl, joined the jobless during the depression. Finally the Superior Coach Corporation offered him work in Lima (53,000 in 1970; 47,000 in 1980), a city serving as a processing and marketing center for the area's farm products — from grain to beef. The factory produced school and highway buses, and Jack's father commuted the half hour to Lima for the rest of his life.

Jack
I had a good father-son relationship with him, but we weren't buddies the way it is in books.

Fairlie
He wanted Jack to go to college and learn something.

Jack
Dad worked hard for his living all his life. In fact, he died at the factory. Well, not right in the factory, but his cerebral hemorrhage occurred there. They rushed him to a Lima hospital. That's where he died. It was just a matter of hours. That was 1960, and he was 51. Oh yeah, the attack wasn't job related.

Later, during two summer vacations Jack worked at the same factory.

Jack
You know how when you step up into a bus there's a panel to the left — well, I installed them. And you had to place them real strategic. They're for any girls who might be sitting in that front row — it blocks under-skirt exposure! They're called modesty panels.

Subsequently the factory added hearses to the line, then changed its name, and a few years ago folded.

The two-storied brick school house where Jack studied through the eighth grade still stands, but now that a new school has been constructed elsewhere, it serves other purposes. A recent tenant was a farmers' grange. At one point, when a For Sale sign was posted, Jack dreamed of acquiring the property, attracted by commodious studio possibilities, as well as the calming ambiance of school memories. But how to rationalize the luxury of that much work space?

Jack
Of course areas could have been rented to stores or offices, but you know it wouldn't have had the same appeal.

As a school each of the floors was divided into two large classrooms, with two grades taught in each room simultaneously — by the same teacher. Jack claims it was not confusing.

Jack
That's how a little kid learns to concentrate.

A field stretches some fifty yards back from the school, now a bit overgrown, but previously well tended for sports.

Jack
Well, I didn't play many games. I was thin, even scrawny, and I was sure never the first choice for anyone's team.

Besides he had to earn spending money, so after school hours were usually spent behind lawn mowers. Later he replaced his brother at the choice job in town for a teenager: clerking in the sole grocery store. Customers entered no farther than the front counter, where food orders were presented and promptly rounded up by the grocery boy — Jack. Between customers, odd jobs abounded — unpacking boxes, sweeping, inventory.

Jack
I learned to make hamburger and cut meat. I was small so I couldn't handle a full beef, but I could handle a quarter. It was super service for the customer. I worked every day after school and all day every Saturday and Sunday, and I made 25 cents an hour and worked hard... but I don't think I did as good a job as my brother had.

The store still exists, but has changed hands and compromised its personal service to satisfy a new generation of wandering, label reading, package squeezing shoppers. There was homework, of course; and if that left free time he 'fooled around in the garage, building I don't remember what' in his father's modest metal and wood workshop.

*

When I was a child I had a friend named Larry who lived across the street and he had a sister and I had a sister and we all played together every day that summer. One day Larry turned his back to his house and opened his hand and showed me a five dollar bill. I was impressed but soon forgot the five dollar bill as we went on with our playing. The next week Larry opened his hand again and there was a ten dollar bill. Ten dollars was really a lot of money. I knew my Dad had to work in a factory all day to make ten dollars and I asked Larry where he got ten dollars. He said he'd helped his uncle work for a day, and he'd paid him ten dollars. I tried to imagine Larry helping his uncle and what they might have done and how rich his uncle would have to be to give Larry ten dollars for one day's work. I couldn't imagine that so I forgot it and I asked Mom if I could go to the store with Larry and he bought me an ice cream cone and he bought himself one and some candy. That was when everything was a nickel. We walked home slow enjoying ourselves and on the way home Larry gave me a dime. I knew I shouldn't have that dime so I buried it in a pothole in the pavement in front of our house. That night I heard serious talk about

9

Larry stealing money and I didn't say anything cause I had a dime of the stolen money. The next day was Saturday and I stayed away from Larry's house in the morning and didn't see any of the family out. That afternoon I kinda wandered over toward his house, like I didn't know anything and their house door opened and Larry and his sister and his mom and dad came out of the house. They were all dressed up. I said, 'Hi, Larry' like I didn't know he was in trouble and he looked at me and didn't say anything and his dad didn't even look at me and Larry's dad was usually real smiling and friendly and they just hurried to the car, got in and drove off, and they never went anywhere on Saturday afternoon, especially dressed up. I went on home and later heard my Mom and Dad say they had taken Larry to confession. I didn't know what that was but I knew it was serious and I was thinking I wouldn't go over to Larry's house for awhile but I'd wait until he came to my house and then I'd know his trouble was over and we could be natural. On the second day he came over and I looked at him to see if he'd changed and we were off talking and playing like always only neither of our sisters, Larry or myself ever mentioned Larry's trouble. I remembered the dime and went back to check on it. Street repairmen had filled the hole with asphalt! I often thought about that dime buried there under the road. I even dream about it now and then, even though the dream never has anything to do with Larry or Uniopolis.

*

Uniopolis has never had a high school, so that with grammar school graduation, busing commences to Wapakoneta (an Indian Chief, Wapa, linked to his daughter, Koneta), seven miles west, a town with a 1950 population of 5,771. False building facades lend a frontier air to the four or five blocks of the main commercial street and running parallel to it is the unclear Auglaise river, sections of which can be seen through alleys sloping down to the parking lot bordering the river's cemented banks. Business centers mainly around a cheese company and small manufacturing — machine knives, steel stampings, farm and garden tools. During Jack's four years of study a large brewery and a cigar factory thrived, but both businesses eventually failed, their once expansive and handsome brick buildings now crumbling unattended.

Jack
You know what Wapakoneta's really proud of — that it's Neil Armstrong's home town.

In honor of Armstrong's rocket flight, an Air and Space museum was erected, its futuristic white dome clearly visible on approaching town by Route 75, the north-south freeway. Gas station maps of the state celebrate the museum with red letters.

Jack's Wapakoneta High School hasn't changed, a stolid yellow brick building in a modest thirties residential area. Art courses were elective,

and Jack is not certain if he studied art during his first year or not, but it seems possible, as he was already into 'picture making.' Besides spending time in his father's workshop, he often sprawled around the house, drawing on any paper at hand.

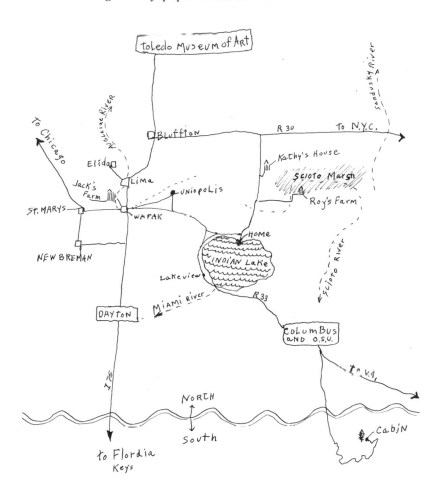

Jack
Not too much original work, you know, mainly copies of illustrations in adventure novels and comic books. For example, one of a wall with a Roman soldier stationed beside it. Not too much real art around to copy. Well, my family owned a painting. There was a hill and a wolf on this hill and it was dark and cold and steam came out of the wolf's nostrils and a moon was just coming out of the clouds, bringing light with it.

His selection for a major was Industrial Art.

Certainly formal art classes were attended by his junior year, as all free study time was consumed by art room projects. His family and school friends had always admired his drawings, and now Darvin Luginbuhl, the art instructor, was actually encouraging him. Today when Jack is asked why he turned to art, the answer seldom varies.

Jack
Well, it was the only thing that everyone said I could do well.

Luginbuhl introduced his students to a number of basic art techniques, mainly craft oriented, although nothing as sophisticated as ceramics. The class worked with linoleum blocks, papier mache, colored water media, and as soon as Luginbuhl located a student's interest, the student was assigned relevant projects to be completed at his own pace.

Luginbuhl
Jack's involvement was intense. Once when we were working on linoleum blocks, I mentioned printing from wood blocks, using the texture of the wood for background, or actually incorporating it in the design. That night Jack carved a woodblock. It was about a foot and a half long, two or three inches wide and he had cut out the words, IN GOD WE TRUST. The lettering was beautiful — old English or the like. Then we noticed — he had forgotten to reverse the image. All that work! My heart sank. But that was the kind of thing he would do on his own. I don't mean make mistakes — I mean take the involvement with his projects home.

Luginbuhl became a role model, this generous, easy going man who obviously gained self-fulfillment through teaching. Jack was also drawn to the freedom given art instructors, allowed to adapt class programs according to the talents and interests of each student. He established teaching art as his career goal.

Three churches had congregations in Uniopolis — two more than the number of grocery stores.

Jack
Our parents were not church goers, but they sent us kids to church. We walked cross Uniopolis, nickel in hand for the Sunday school collection, washed and pressed, in the sunshine. One of my oldest memories. I went with my brother before I was old enough to know the way. And before my sister was old enough to go along. In those days a nickel would buy food. We went to the Church of Christ.

At the beginning of Jack's senior year, the minister at the Church of Christ was replaced, and the new pastor, Roy Hanson, established residence in the parsonage across the street with his wife, Breneice, and four daughters — Victoria Frances, Karen Phyllis, Sandra Lee and the eldest, Fairlie Faye. During the following year Jack saw Fairlie often, both in Sunday bible class and at Wapakoneta High School, where, even though she was a year behind Jack, they attended the same art class under Luginbuhl. He still teases about that year, for as far as he could ascertain neither had any idea their lives would be spent together.

Jack
Oh, he tells that story over and over — just about every time we see him.

Fairlie
He's probably right, and we didn't go together then — but we were real aware of each other.

Jack was particularly drawn to her father, the first believably religious man he had ever encountered — gentle and direct, unpretentiously living minute by minute according to the values of Christ.

It was a happy year, climaxed by the commitment to teach art. Luginbuhl's encouragement and Pastor Roy Hanson's example of being yourself had made the decision easier, but his father was still to be sounded out.

Jack
Yes, dad used to brag about how well his son could draw, but I knew going to college and spending four years 'playing with art' would be another matter. . . . Well, I guess he didn't ever tell me not to — oh, he may have told me not to. He was — he spoke his mind, but by then I was old enough. You know I felt bad about not agreeing with him, but it was something that I couldn't really do anything about. It was just something all of me wanted to do. When I saw what Luginbuhl was doing, then I wanted to be a high school art teacher. Before that I wanted to work in a factory like my father did, but thank heavens he didn't want me to work in a factory — and you know what that's all about.

13

Sometime ago, about forty years now, I guess, there was a small child playing in the back yard. The child's Father stood in the doorway of the home and watched.

The little child didn't know that he loved his backyard, his toys, his brother who played with him or his Father who protected and sustained him. But his Father showed and taught him love.

The child is me. The father is God. Love is the Messiah. I live under this law and in the authority and protection of my Father where there is peace.

Football play in Genoa Ohio

Luginbuhl had been graduated from Bluffton College — some fifteen miles northwest of Lima on U.S. highway 75 to Toledo — where he had studied under Professor John Klassen, an artist born in Russia and educated in Western Europe. Jack couldn't imagine studying under someone who knew European culture first hand — and who was also a recognized artist. With Luginbuhl's recommendation, Jack was readily admitted.

*

A new minister arrived at the Church of Christ to replace Roy Hanson, who then accepted the ministry of a Church of Christ in a Lima suburb. Almost simultaneously with Jack's departure for Bluffton, Roy Hanson moved his family to a house he had bought near the new church in Lima.

Most Bluffton College graduates would instruct in small schools; therefore few teachers, if any, would ever know the luxury of teaching only a single subject. Usually mastery of two or three was required, and if teaching at the primary level, even art was mandatory. The President of the college decided — some years before Jack's arrival — that in lieu of placing an art professor on the faculty, a professional practicing artist would be sought. A forward insight: most elementary grade art classes employ 'teaching by doing,' hardly the province of an art historian.

John Klassen, a Russian sculptor recently immigrated to Canada, was strongly recommended for the position: born in the Ukraine (1888), early schooling in Basel, graduate work at the University of Berlin, further study in Munich, both at the Academy of Fine Arts and as an apprentice to a prominent sculptor. When he returned to Russia in 1914, his country was deeply committed to World War I. Throughout the devastation, Klassen, a pacifist, first drove a Red Cross truck, then worked in a hospital in Odessa on the Black Sea. With the fighting over he obtained a Professorship to teach art at a seminar in Choritza. The peace of mind anticipated in the academic world was shattered with the outburst of the revolution: daily new signs indicated he could no longer survive in the new Russia, no longer witness the suffering of brother against brother. Using every influence at hand, Klassen gained official emigration papers, not only for his family, but for a number of families equally unsympathetic to the Bolsheviks.

It seems improbable that the President of a small college in a small town in Ohio should learn so readily of a recently immigrated Russian sculptor whose reputation was unknown in both Canada and the United States. However, a thread existed: Bluffton is a Mennonite college, and Klassen was a Mennonite, as were the members of the group he led out of Russia; and so for that fact is Luginbuhl. Fear of religious persecution necessitated the flight to Canada, a repetition of a large 1872 Russia-Canada emigration when religious concessions granted by Catherine the Great were threateningly restricted. Klassen's son, John, now a Professor at Bluffton, wrote a background footnote concerning his father's flight.

Klassen (written account)
Choritza was the center of the original (1789) Mennonite settlements in the Ukraine. The Mennonite colonies became a battleground between the White and Red armies, and anarchists also ravaged the colonies. Eventually some 30,000 Mennonites migrated from Russia in the 1920s.

A number of Mennonite sects have found havens in America — such as the Amish, who cling to fundamentalist postures, whereas the Mennonites have reformed most rigid social interdictions. Bluffton's student body usually runs about eighteen percent Mennonite.

*

Klassen worked in stone and clay, and typical of much American sculpture in the thirties, his pieces were often didactic. A mimeographed tour guide of his sculpture on campus describes the subject matter: 'His work combines religious (Mennonite) themes with his first hand accounts of the Russian revolution, where he saw suffering, hardships and death.' Thirty-six works are listed, from an equestrian statue ('Russian Cossak') to small bronze reliefs. Typical titles from the brochure: 'Modern Crucifixion,' 'Feeding the Hungry,' 'A Modern Day Good Samaratan.'

Jack sensed immediately that his interest in Klassen lay not in the aesthetic statement, but in his prodigious knowledge of techniques and media. Eventually Klassen introduced Jack to clay: the attachment was spontaneous, penetrating.

In the early 1950s college courses in ceramics were rare. Their proliferation flourished in the sixties, but even then a caste system dominated most university art departments, with clay the untouchable. Paul Soldner, a respected contemporary ceramist who attended Bluffton a few years before Jack, had arrived thinking he was a painter, and left knowing — thanks to Klassen — he was a ceramist.

Soldner (letter excerpt)
Klassen was a kindly man — one who was supportive and humble. Of real importance was the fact that he had a studio in the class-room and worked with us all the time. In other words, he was a great role model of a working artist.

Few books were available on ceramics, and with almost no university instruction offered, those hungry for hands-on instruction traveled, seeking out studio artists under whom an apprenticeship could be negotiated. Soldner was typical, moving first to the University of Colorado to study under a Scottish ceramist visiting from the Edinborough College of Art, Katie Horsman. Her style derived from conservative English traditions, directions Soldner wished to master before considering more personal statements. Some time later rumors reached Colorado — almost all clay information passed by word of mouth or letters in those days — that fresh perspectives on clay were being explored in southern California. Soldner packed his bags. Peter Voulkos had reached Los Angeles only shortly before from Montana,

and in a matter of two years revolutionized the aesthetic approach to clay, both physically and spiritually, taking it from a functional limitation to a non-functional freedom. Enlightened art collectors today acknowledge that a hand-built functional container — as a tea pot — can qualify as sculpture; but in the fifties clay had to be taken to non-utilitarian forms before collectors would judge through a fine art scrim. Soldner's propitious arrival positioned him among the founding members of the movement Voulkos ignited. Soldner stated Klassen had been a 'great role model.' At the end of the same note he wrote: *But so was Voulkos!*

*

Jack's first art class was in pastels. A platform surrounded by easels and chairs was placed in the center of Klassen's studio, and when Jack arrived all seats were occupied except one.

Jack
I only had to look once to see I was the only male in the class. Klassen set up a still life on the platform, and the students recreated it in pastel. And that was the last real class I ever attended. I don't remember if he said anything to me or not, but I felt he didn't want me in that environment. So from then on I went into a workroom and completed projects he would set up especially for me. It wasn't sex bias. He was allowing me special treatment because I was an art education major — the only one out of the 250 students in the school.

Klassen's teaching approach was informal and personal, much like that of Luginbuhl's — but then Luginbuhl had studied with Klassen.

Jack
He didn't require me to learn anything except what I felt I needed. He led me through as many techniques as we could think of. No matter what I expressed interest in, he would stop everything to get me into it. Then I'd be left totally alone. Klassen never discussed theories of art, philosophies of art, anything like that. As a result I didn't think about art with a capital A. I just thought about making things, building things by hand. A picture today. A mosaic tomorrow. Then a pot. Then a sculpture. I was on my own, like a graduate student.

Klassen later introduced Jack to wheel throwing.

Jack
The wheel was so rudimentary — a washing machine motor and a

belt, and when you turned it on it went fast, and that's all there was to that, just fast, with no speed adjustment.

Jack never felt secure with it, although eventually he was able to throw a number of pots.

Klassen, a wizard with the washing machine wheel, held frequent demonstrations at churches and clubs, and Jack attended a number of the sessions.

Jack
Klassen related spiritual correspondences to each stage in the construction of a form: such as centering, forming a hole, raising the object. The decoration was usually related to plant or animal life, and his favorite subjects seemed to be wheat and rabbits. The pot growing, like, was as mysterious as wheat growing — right from the kernel to the stalk to the buds. The spout he said represented spreading the seed for new growth. . . . All very poetic. A deeply religious man. I'm real hazy now on a lot of his symbolism, but I know sometimes he was saying too that man and clay had a bond, and if you made clay beautiful you made man — you know, yourself — beautiful. Guess that should work the other way too, right?

Bluffton required each senior year student to select a high school where he would teach a class in his chosen major — under the observation and grading of the class' regular instructor. For two reasons Jack chose Luginbuhl's class: he would feel comfortable with Luginbuhl, and it would be logistically convenient. Luginbuhl had recently taken over the art class at Bluffton High School.

Luginbuhl
That was a long time ago, but I do remember that Jack was always awfully quiet. I often wondered how in the world he could ever become a teacher if he didn't say anything.

Jack
I talk when a student responds enough to want to know more — and wants the information enough to ask me. . . .

*

Jack
I was just lucky, so lucky to go to Bluffton. Imagine a small college like that with a man like Klassen. To see a real artist work. And he shared what he knew. At that point he probably had more clay

skills than most American art teachers. Sure, he was conservative, but students need basics. I wasn't ready to hear about the Voulkos thing yet. And when I was at Bluffton that was just happening in Los Angeles. But I didn't know anything about it. No one did in northwest Ohio — not for a long time. So Klassen was perfect. He seemed happy. Every free minute he was working in the studio. He didn't show his work too much — I mean in shows and exhibitions. Luginbuhl told me that Klassen made the 1940-41 Syracuse Everson Museum national show with a ceramic. The show traveled, and when it hit Ohio Luginbuhl and Soldner went with Klassen to the opening. That was a big night for Klassen. I don't know what happened to all the work he turned out. . . . I should find out.

Jack never saw Klassen socially. After school and weekends Klassen retired to his basement studio at home. When Jack tried to remember Klassen physically, he had to think a moment.

Jack
Yeah, he was short, built heavy, not particularly fat, and I believe he was bald, and he did have a heavy dark moustache, just straight across, thick, and no beard. . . . The only time I ever heard him raise his voice was once when he touched the kiln and it was hot and he yelled HEIS. Someone told me the word was either German or Russian for 'hot.' You know it was good to be introduced to clay at Bluffton, but when I think about it, we really didn't do too much

with it. There was only an electric kiln and it would have been unheard of to build our own big brick kiln outside on the grounds somewhere. Klassen did large sculptures — but not in ceramic. And he bought ready-mixed clay so I didn't get that experience of mushing around in the medium either. As I recall — and I could be wrong about this — he bought only one kind of clay, that red stuff. . . . Yeah, it was only an introduction, but a real important one because I got clay under my nails. Fairlie says they haven't been clean since. . . . I guess my gut feelings about Klassen as a person would be that he was a very gentle man, a quiet man, a friendly man, but still somehow a distant man — and never a chum.

One day out of every week I go visit my mother. Some weeks one of us is going to be gone for a few days so I can't go that week. When I get there we talk and I take her to the grocery store. Sometimes she wants to go to another store or I might do a little job around the house. We sit and talk and drink coffee.

I always sit in the rocker by the window and put my coffee mug on the dinning room table there. She sits almost facing me around the corner of the table. She drinks her coffee from a little fancy porcelain cup with flowers around it and she uses a matching saucer. I'm careful to set my mug on a magazene or a piece of paper so it don't leave a coffee ring on her table cloth.

We talk family.

*

In 1956 Jack was graduated with a Bachelor of Arts in Art Education. The Bluffton years had moved swiftly, so swiftly Jack finds it difficult to believe much of anything actually occurred.

Jack
I know I was busy every minute. I didn't do outside work during the school terms, but I had to have summer jobs to make winter expenses. The campus dorm I lived in didn't take I.O.U.s.

*

The Superior Coach Company took him on for the summer between his junior and senior years at high school. That started his nestegg. No work was available at Superior for the following year, but he located a rubber factory job, also in Lima.

Jack

My job was working with shoe soles. When they came out of a press that shaped them, they were real shiny. They were passed to me and I ran them through my machine. That put a texture on them. It was called 'buffing the sole.' They didn't make shoes. Just soles. I worked the third shift, you know the one they call graveyard. The place never closed down. Can you imagine producing soles twenty-four hours a day!

Between freshman and sophomore years at Bluffton Jack was unable to locate work, and finally settled for a gas station job in Uniopolis. That winter his father helped out. Jack was back at Superior Coach for his final Bluffton summer, but no modesty panels this time. He waited at the end of the production line to catch minor mishaps, such as a broken tail light.

Jack

Bluffton went so fast, I must have enjoyed it. Man, I had new roommates every year. The first was a relative, Earl Campbell. The second year I had my best friend from Uniopolis, Earl Bowersock. He was studying math education. The third year I roomed with a fellow I had known in Uniopolis, but we ended up not really respecting each other so I was lucky and found a real personality of a fellow who didn't have a roommate at that point either. That was John Rogers. He must have been about thirty-five. He was black, and did he ever have a good sense of humor, my kind. We really had fun. I painted a portrait of him right on the dorm wall. It's probably still there under layers of paint. He was from the east somewhere and on the G.I. bill. Gosh, I don't know what war he was in, but having been in one he couldn't have been a Mennonite. He went to Washington afterward and worked for the government as a career. Then I lost contact, but a few years ago he showed up at a homecoming football game. Yeah — Bluffton had a football team. They didn't win, but they sure played. Anyway, Rogers hadn't changed at all. . . . He died recently. I think I read about it in the college newspaper. I was too young and immature to notice much during the Bluffton years. For me it was a firm, safe place to grow a little older under people who didn't put up with much foolishness.

*

Flowers sewed on the collar of her dress and right on down the front to her waist. She was one of those girls you just know you could live in peace with and make happy but you don't have time right now. You got to get home and work on the car. There's always something wrong with that car.

During Jack's freshman year (1952-53) at Bluffton, Fairlie lived with her parents in Lima, and even though Lima was only fifteen miles south of Bluffton, neither Jack nor Fairlie established contact.

Fairlie (written account)
We were both real busy. Besides, when I lived for that year in Uniopolis we might have seen a lot of each other in high school and Sundays at church, but we really didn't ever have what you'd call a real date in those days.

My parents, my three sisters and I lived on the east side of town, on Pine Street. I had to walk only three blocks to my high school where I was a Senior. After school I would walk back home to change clothing for work. I then walked back down the same block to reach Equity, the carry-out grocery and dairy restaurant where I was a waitress, at least at the start. Later I was made an assistant manager. My hours were from four-thirty until ten-thirty every week evening and on Saturdays from one until five-thirty. Sundays were free.

Sunday mornings I would go with my family to Garfield Church of Christ where my father preached. On Saturday nights and Sunday afternoons and evenings I would spend a lot of time going to the movies. Sometimes I went twice on Sunday. There were five theatres in the center of Lima when I lived there. Now there's none. They're all in malls. In going to the movies often, I would even sometimes pay the way in for a sister or friend to have company. One evening my friends and my sister were with me when we went to the Sigma movie theatre. We were sitting up near the front and I happened to turn around and spotted Jack way in the back with some college friends. His brother was there too. When he saw me he started motioning a come-on with his finger — smiling all the while for me to go to the back and sit with him. Every time I'd look back that finger would move. Finally my friends double-dared me, so I took the dare and sat with him for the remainder of the movie. When the film was over Jack took me aside and made a date with me. That's how we met again — and started going together.

The dates were usually on weekends, with Jack's meeting her after work Saturday night. Sundays he would attend church with the Hanson family, and in the afternoon take Fairlie to a movie. In the midst of Fairlie's waitress/high school/Jack schedule, she was informed by Vera Griffith, her art instructor, that she was too talented a painter to ignore her potential. Required were the direction and refinement higher education

would provide, and when Fairlie confided that further study would be beyond reach without a scholarship, Miss Griffith personally accompanied Fairlie to the school she recommended, The John Herron Art Institute in Indianapolis, and arranged for a scholarship examination during the visit. Shortly before high school graduation a favorable reply arrived from the institute. Or semi-favorable: the grant offered half tuition, none of her school nor living expenses.

Fairlie
Well, heck, I had to try it.

Immediately following graduation from Lima High School, Fairlie switched from Equity, where the pay was meager, to The Big Huddle, a short order restaurant on the northwest side of Lima.

Fairlie (written account)
I made more money just by washing dishes — which is what I did — with hours from five in the afternoon until two in the morning. I sold my expensive bicycle and bought a motorbike. It was designed a lot like the moped. It was fancy and big enough to ride two people and had about the same speed. Before going to work, I spent most every day in the public swimming pool at the northeast end of Lima. I would swim right up until the time for work. Since I was off Sundays, Jack would often come to see me. Sometimes on Sunday I would ride my motorcycle to Uniopolis to see him. Well, by time.summer was over I had made enough money to pay for the other half of the tuition and some of my school supplies. That left nothing for living expenses, but I figured there would be part-time work in Indianapolis, and hopefully in a restaurant because one solid meal is usually included. . . . The nicest things about that summer were Jack and the swimming. By fall my complexion was the same color as my hair — a golden brown. You couldn't tell them apart. At least, even if I was broke, I would report to the John Herron Art Institute the picture of health.

Shortly after arriving in Indianapolis, Fairlie rented a bedroom in the house of a family with four young children. Kitchen and TV privileges were included, plus the use of the clothes washer — there was no dryer. Within a few days, Fairlie found employment to cover living expenses, but it required two jobs. For an hour and a half during the lunch rush she worked at the Colonial Tea Room where the generous tips were an improvement over the nickels and dimes of Lima. The free midday meal was generous too. Classes at the Art Institute were from eight-thirty until four each weekday, which meant an afternoon rush to reach her second job at the Delicatessen Restaurant and Grocery by four-thirty.

23

She was on duty week nights until eleven-thirty — sometimes midnight — as waitress, stockgirl and cashier; and was back again on Saturdays, waiting on tables from one until ten- or eleven-thirty.

Fairlie was enrolled in four classes: still life painting, commercial art design, life drawings, anatomy drawing.

Fairlie
Sundays I went to church with the family I stayed with. They were Lutherans and we had to go a long way to reach their church, but their service was very interesting. They wanted to get their children into a private school so they would have some good discipline. Also there were racial problems in the neighborhood. After church I had to rush back to the Colonial Tea Room to work for two hours to get my free midday meal, plus tips. I never got pay at the Tea Room — only lunch and tips, even during the week. Then I would go home to relax, catch up on studies and clean my room and etcetera. Sometimes on Sunday nights I would watch TV for awhile. There wasn't time to do much else. I never had a date in Indianapolis.

At the end of the school year Fairlie was exhausted, and further, knew that another year under similar work and study pressures would do her in.

Fairlie (written account)
I tried for a whole year's scholarship for the next year, but didn't receive the whole year. I received the half-year again. In my mind I felt if I were talented enough for a half-year, surely I was just as well entitled to a full year. Because they asked the reason that I sought a full year, I told them this same reason. Still they didn't increase the grant. It hurt, but I was almost too tired to care.

When spring term closed, Fairlie left The John Herron Art Institute for good.

*

Fairlie's parents offered a bedroom in their home in Lima at a nominal rent, and Fairlie found work at Kresge's as window trimmer. That summer Jack worked again in town at the Superior Coach Company, 'and Jack and I resumed our dating, only now you could call it heavy dating.' In the fall Jack started his Junior year at Bluffton, and spent most, if not all his free time in Lima, and by mid-winter Jack and Fairlie had admitted their love was deep enough for marriage. Jack was twenty-one, Fairlie a few months younger. Discussions were opened with their

parents: approval was unanimous. Since Jack would have no income until graduation, it seemed unrealistic to marry immediately. However, the Hansons suggested that if Jack and Fairlie really wished an earlier wedding, they could stay in their home during his final year at Bluffton. That winter their engagement was announced. Neither could afford an engagement ring, but Fairlie's grandmother gave her her own.

Fairlie
For the wedding rings, Jack and I went to the Sears and Roebuck catalog department store uptown and ordered matching gold bands. It cost seven dollars for the two.

Since the wedding would not be until summer, Jack stayed on at the Bluffton dorm for the completion of his junior year, spending as much time as allowable in Lima with Fairlie. Fairlie continued at Kresge's, trying to build a small bank account. Together they settled on a wedding date, August 5, and Jack placed the further details in Fairlie's trust. In May Mrs. Hanson stunned the family and the congregation by filing for divorce. Roy Hanson did not contest the action. In the settlement his wife was awarded the house, and after putting it up for sale, moved with her two youngest daughters to Kettersville, some fifty miles away, where her sister lived. The other daughter decided to remain in Lima, where she held a job at Memorial Hospital. The house didn't sell until August, allowing Fairlie and her father to occupy it until the wedding. However, Jack and Fairlie would now have no place to live after the marriage.

Roy Hanson announced his retirement from the ministry, feeling that 'a divorced man should not preach.'

Ray Hanson, Roy's twin, and his wife, Edna, owned a farm at Elida, a small town some six miles outside Lima. Fairlie asked if they could possibly put Jack and her up for the year following their marriage, that is, during his senior term, and Edna and Ray promptly offered them the spare upstairs bedroom. But shortly thereafter, Edna's growing weakness was diagnosed as terminal cancer. The seriousness of her deteriorating health had been kept a secret, not only from Fairlie and Jack, but even from Edna herself. The spare bedroom would now be required for a nurse.

Fairlie and Jack could not tackle the expense of buying a house, even renting one, and her father, who was without his sole asset in losing his house, and without income in leaving the ministry, was homeless and nearly fundless. The notion of a house trailer materialized, and Ray offered them parking space on his farm. Jack's father helped with a

loan, at no interest, which Fairlie and Jack were to repay during his first year of teaching. (The loan was repaid on schedule.) They purchased the mobile home in Lima, at a Happy Trailer Sales on the old Dixie highway across from the refinery. $1500. Ray provided parking space on his farm, and Roy was invited to share the trailer, with the understanding that Fairlie and Jack could use it alone, should they wish, for a possible honeymoon trip.

With the lives of so many people close to Fairlie suddenly in upheaval, she grew apprehensive about the marriage, at least its timing, and contacted Jack's father for advice. He assured her she had not initiated any of the complications and to proceed as planned. The invitations were then mailed — for the wedding in Lima at the Garfield Church of Christ, and for the reception at the Rousculp Church of Christ on the county highway between Lima and Uniopolis. Fairlie made arrangements almost single-handedly — including decorating both locations. Her father would give her away, and the preacher from Uniopolis who had replaced her father would perform the ceremony. A few days before the wedding, Fairlie's great uncle died, and through an oversight the funeral was scheduled for the wedding day. Neither date could be changed, but by juggling and rejuggling the hours, a schedule was finally realized which enabled the Hanson families first to bury their patriarch, then witness the wedding. It turned out to be the hottest day of the year, but the ceremony progressed without mishap, and the well-attended reception was remembered as lively. Fairlie's mother did not appear at either church, nor did her younger sisters.

The house trailer wasn't required for the honeymoon. Jack and Fairlie rented a small cottage at Chippewa State Park on Indian Lake, no more than half a mile from the house in which they live today.

Fairlie
It mostly rained. But who cared? It was lovely!

As planned, the housetrailer for Fairlie, Jack and Roy was hauled to Ray and Edna's farm, and parked just off the driveway behind the house. When the drainage hose, which Jack had buried during the summer, froze solid with the first cold month, Roy lost no time in locating a downstairs corner in the main house for himself. Jack commuted weekdays to Bluffton, and Fairlie returned to work. She had received an offer for more pay from Newbury's as their window trimmer, and two days before the wedding had served notice at Kresge's. At Thanksgiving Penney's approached her to trim their windows, again with a pay increment. She left Newbury's. Also around Thanksgiving

Edna became too incapacitated to leave her bedroom, and Fairlie helped as much as possible around the house, plus Christmas shopped for Edna. A few days before Christmas Edna died.

January was bleak. Roy was unemployed. Ray was undone by his wife's death. Fairlie was laid off from Penney's, leaving their sole income thirty-four dollars a week from her workman's compensation — and that would expire after ninety days. Then in February Grandfather Newman — the twins' father — died.

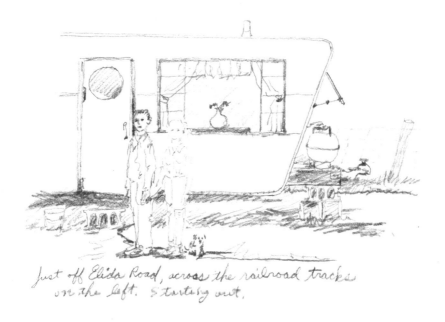

Just off Elida Road, across the railroad tracks on the left. Starting out.

Roy's dad, Newman, was always interested in politics. He could argue politics all afternoon. He was a republican. Most of the arguing was over presidents and senitors but he liked local politics too and worked for the state on the roads for awhile which was a job he got through political pull. One time he voted for and worked to get a guy he knew elected sherief. After this guy got to be sheriff he hired his son to be a depity which was normal.

About this time Roy used his farm truck to move a local family from one house to another and that of course is very much against a very important state law. The new sherieff's deputy son heard about this illegal act and confronted Roy at his mailbox. Approching from the west at 11:52 A.M. on June 22, 1952, driving his new deputy sheriff's car, wearing his new uniform and his new gun and having had a few drinks he told Roy he was going to arrest him and fine him $300 for movin that Dinsin family over to Nigger Island.

Roy was fittingly impressed and scared so he went and told his dad. His daddy, being political minded he knew just how to handel the situation. Him and Roy got in his car and drove over to the sheriffs house. Newman called the Sheriff out on the front porch and the sheriff standing on the porch Newman in the front yard, Roy in the car, the Shereff's son in the house, and with the neighbors listening, Numan gave the Sheriff a good loud cussin. The new Deputy sheriff never bothered Roy again.

*

Since their mother, Sarah, would now be alone, Roy moved immediately to the homestead on the marsh. Grandfather and Grandmother Hanson had deeded the property to their three sons. Allie, the third son, had already sold his portion, so what remained belonged equally to the twins. Ray then sold his small farm in Elida, and, with his two children, joined Roy and their mother on the marsh, once more in contact with the black soil, granular when loose, sponge-like when solid, and muck when wet.

Ray's move meant Jack and Fairlie's trailer must find a new driveway, and Jack's parents offered theirs in Uniopolis. In January Fairlie was visited with a body signal, and the doctor announced her pregnancy. From January until summer their only income had been the weekly thirty-four dollars, but fortunately, immediately upon graduation from Bluffton, Jack was hired again at the Superior Coach Company. Better news was forthcoming in the summer from New Bremen, a small town some fifty miles south of Lima. Jack was offered a faculty position at the New Bremen High School to teach two subjects: English and Art.

*

Jack had been worried about being drafted into the Korean War, but circumstances kept him just ahead of eligibility. First college students were exempt; then married men; and now with a child he should be out of reach.

*

Fairlie was due to give birth in a month, and to avoid her having to put a new house in order, they decided to stay with the trailer until her post-parturition vigor returned. A small park in downtown New Bremen allowed only one house trailer. They arrived at the right moment to obtain the space for the winter.

*

The privacy of their marriage would now commence, away from college and family, experiencing the challenge of a twoself-sufficiency. Fairlie as housewife and mother and lover.

2 P

Jack as school teacher and father and lover.

Jack
No, not as artist. It would never have entered my head to call myself an artist.

*

There was no way for Jack to have known, but James Melchert, a major ceramist (four years Jack's senior), was born and raised in a parsonage in New Bremen, where his father was a clergyman. After earning a degree at Princeton University, Melchert moved to the Berkeley area in California. Soon his original clay vision was realized and recognized. The forms, often body parts provocatively attached to unrelated inanimate shapes, appear forged by earth and fire itself. Dark grays and browns predominate, and surface textures suggest the fragment-like pieces have waited for centuries to be picked up — a meditative approach rare in ceramics then and now. Later Melchert switched to more conceptional work, and recently has moved to Italy to direct the American Academy in Rome.

Melchert (letter excerpt)
The circumstances of my childhood could have occurred in any number of Midwestern states. It didn't have to be Ohio. New Bremen was a village of about 1,800 people. There was lots of space, roads leading in and out, a railroad, and a length of the Miami-Érie canal system. There were lawns in all directions, an orchard, a playing field, and some tennis courts that didn't get much use. You spent a lot of time outdoors and there was such an expanse of it. Time and the world seemed to be on your side. It was a positive and secure world. Not a bad place for a beginning. . . . Nobody has ever asked me about it until now.

They came within only a few years of meeting: as Jack was commencing Bluffton, Jim was being graduated from Princeton. Melchert is a person one would have wanted Jack to meet, and eventually he might have shared an observation made of a major ceramist he came to know well: 'Voulkos is not one to avoid issues. This is the way you've got to be with yourself.'

*

Their child was due in October, and the nearby St Mary's hospital was Catholic. Fairlie, preferring a non-denominational environment, returned to Lima and stayed with her recently married sister, Sandy Rollins, until time to report to Memorial Hospital. On October 6 a son was born and named Steven, and following two weeks of recuperation at Jack's

parents in Uniopolis, Fairlie returned to the house trailer. Shortly after, Jack met an elderly couple who 'indicated a wish to sell their house' and the price was right — because it was rundown. Jack felt minimal patch work would allow them to move in before winter, and thus have warmer surroundings for Fairlie and the infant. Next summer major renovations could be undertaken. They sold the trailer for $1,000.

Jack

The house was two-storied, and square, with the downstairs equally divided into four rooms, each of them also square. And there was one light bulb hanging from the ceiling in each room, right in the middle of the ceiling. No water. Oh, there was one cold water spigot in the kitchen, but there was no toilet — that is, inside. Outside was one of the outside kind. Eventually of course I put a toilet inside. The first electric bill we got was for seventy-five cents! I spent two years working on that house, remodeling it from the bottom to the top. I mean first we raised the house — and we needed a lot of friends in for that — and put the first foundation it had ever had under it.

*

At New Bremen High School Jack felt he would be young enough to make friends with the students, and old enough to relate to the teachers. However, initially little opportunity existed to exercise relating. From the first day Jack was into overtime. He wasn't taking over an art department; he was effectuating the first for the school. Reports to prepare, budgets (small, alas) to balance, materials to order, class notes to outline, students to confront. But far better for an inexperienced teacher to design his own program than inherit an incompatible one.

Clay would be a basic ingredient, but for the present the budget would permit only a small electric kiln — no wheel. Harnessing student participation, Jack duplicated the Bluffton/Klassen contraption, again utilizing a washing machine belt and motor. Instead of a kick wheel, a foot-pumped treadle was installed. It worked.

The real headache — his second course. Actually Jack had selected English as his minor at Bluffton because he assumed it would be a pushover. His own language — could that be difficult? He scraped through the first grammar course with a D. Salvation arrived with the discovery that literature course credits would qualify toward an English minor.

Jack

I didn't know a verb from a noun. But I learned real quick about a

verb and a noun when I had to teach the subject. It took me a whole year to keep more than twenty-four hours ahead of those kids, but the second year I knew English and was okay. I taught creative writing too. I didn't mind it after the first year and I taught English for three years. After that I only had to teach art. I used to read a lot.

Friend
Did you ever read Dostoyevsky?

Jack
What did he write?

Friend
Novels.

Jack
. . . . In English?

*

Jack organized an art department that was a creative center for himself as well as the students, and soon felt secure with his educational instincts. He enjoyed sharing personal projects with students; and was aware that the attention devoted to their efforts helped lessen inhibitions toward self-expression. Luginbuhl, who had been appointed head of the art department at Bluffton College on Klassen's retirement, brought a class to New Bremen once a year, anxious to expose his art education majors to a high school art program actually engendering student creativity. Working with young people made Jack aware of the fragility of the creative impulse, how readily inventiveness dissipates when performance formulas are rubberstamped on the young. Jack is now aware that the New Bremen experience engendered his respect for the spontaneous over the intellectual — for anything over the intellectual.

In fraternizing with his best students in and out of school, Jack uncovered something childlike in his own lifestyle. In Fairlie's too. It might be best to protect this quality.

Jack's most successful art student was Rex Foyt, whose career Jack helped direct — obliquely of course. Foyt is now a recognized ceramic artist and valued teacher at the Toledo Museum School of Art.

Rex (letter excerpt)
I first met Jack Earl in my freshman year in high school in New Bremen in 1956. I was fourteen years old. So I've known Jack for over twenty-five years. He was the type of teacher who would take us (art students he liked) out of study hall to go outside and sketch,

buy candy bars, and drink pop. Sometimes we'd just drive around. Jack had a studio set up at his house, an old summer kitchen where a gang of us used to work (throw pots, paint and handbuild). We'd put flashlights on 22 rifles, sight them up, go to the town dump to shoot rats (at night). Jack would take his family and some of us guys to drive-ins. We'd purposely go to some lousy movie to laugh at the bad acting.

One of the things I remember most about those days is the teasing-hassling we'd do to each other. Jack would start laughing at you, and you were dead. The rest would follow suit. Jack would never sit with us in assemblies — we'd all end up laughing too hard at the speakers.

Jack often brought the boys home to play pinochle with him and his older brother, Robert, both of whom would dare any pair of students to take them on. Whatever closet frustrations or aggressions Jack might harbor received airings at the card table. A partner who jeopardized his chances of winning was verbally rubbed out. Foyt remembers the time Jack exploded at a bad decision of Robert's, and bounced his cards on the table so hard they flew all over the room. Pinochle and rook have continued to preoccupy Jack, and the kitchen tables in their various homes have known almost as many melds as meals. His deeper involvement with this sport is evident in his kitchen card games sculptures.

*

All of their children were born in New Bremen: following Steven, two girls — Kathy and Dianne. After the children, after the house alterations, after both art and English instruction grew routine, the pace slackened. They looked up and found five years had elapsed. An offer arrived to take over the art department in St Mary's, a town ten miles to the north, as large as Wapakoneta.

Jack
I really took the position because it offered more money, certainly not for the art scene. The art department was one room with some lockers along the back wall. No clay facilities. I didn't care. It would be easy.

*

When people get to be forlty years old they start talking about rain. That's the way it is where I live anywhere.

During the last two years at New Bremen Jack had resurrected interest to his own work: each new piece only matched the banality of the last. The more he pondered his clay involvement, the more apparent was his inadequacy. What did he know of the tradition of ceramics? of current styles? of the ambiance of working with a contemporary master? Most of all, how was it he had not been taught art talk vocabulary? A pressure swelled, forcing him off-balance, as if collapsing from an enervating fright. It was imperative he adopt a new stance — just for survival. Was he talented enough to survive as a craftsperson? Was he even capable of surviving as a high school instructor? The teaching challenge had all but extinguished, especially with the lack of exceptional students. How many exceptional students could be anticipated at New Bremen—or St Mary's—High School?

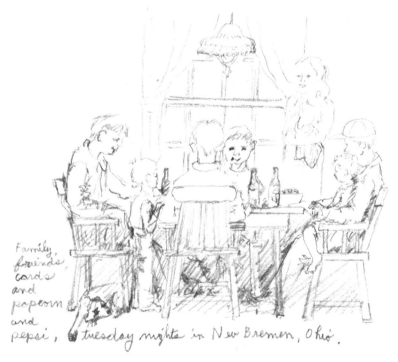

Family, friends, cards and popcorn and pepsi, tuesday nights in New Bremen, Ohio.

Jack
I had to get some more education. Instructing in a public educational system grows to be so boring, and really the major reason was that I never really quite knew what I was doing. I didn't even know what I was teaching. Just project after project. Was there any validity to it other than just making things? I assumed — I knew — that there was something besides just making things.

33

*There had to be some intelligence behind the art, but I didn't
understand the relationship. Maybe it was really tension. Not
Luginbuhl or even Klassen had ever really discussed art. Klassen's
sculptures didn't talk art either — it was brotherhood or hunger or,
you know, like tyranny. Even the school and city libraries didn't
have any serious art books, and definitely nothing on ceramics.
Not in New Bremen or St Mary's.*

Jack confessed to Fairlie he had no idea where further ceramic studies
— or even art education courses — could lead. Some time, nevertheless,
must be spent with professionals. How else assess his qualifications? They
decided to explore slowly. About the art thing. About the clay thing.
About the Jack thing.

Miami University, a liberal arts college in Oxford, Ohio, taught night
extension courses at a high school in Dayton (about an hour by car south
of New Bremen), and here Jack began, driving down after supper with
his brother and a cousin, Wendell, who were also taking courses for
graduate credit. Jack's first course was in painting — no ceramics offered.
The instructor 'was a media man,' encouraging the use of bird seed,
sand, the whole range of oddball textures fashionable during that period.
Jack's first assignment was this sort of experimentation, and when the
canvas was completed, the instructor said fine and asked him now to
move out on his own — 'Do whatever you want.' That was not what
Jack wished to hear.

Jack
*I drove down from New Bremen nights to get instruction — not
work at being self-taught. And never a word about art, the idea of
art. No, once more it was all doing, copying.*

The next semester Jack registered for an art education course, but again
gained no insight into this protean 'art thing': project after project was
assigned to construct objects, among which was an aztec sculpture.
Although Jack was unaware of qualities beyond craftsmanship in his
work, the teacher was impressed enough to recommend he apply for
a Masters Degree in Art Education.

Jack
You notice he didn't suggest I apply for a Master in Fine Arts. So I went to the Miami University campus in Oxford for the interview. A female Professor questioned me. 'Would you show your students pictures out of a magazine to motivate or stimulate them?' I said yes, and that was the wrong answer. Right afterward she said the interview was over. That meant no graduate education at Miami University.

Jack learned that ceramics courses were taught — supposedly by a teacher with a serious reputation — at the Dayton Museum, non-credit courses open to professional and amateur. Jack enrolled, and also invited two of his students — Foyt and John Schroyer — to join him. When an older class member at Dayton discovered who Foyt and Schroyer were, he asked disbelievingly, 'You mean you'd take a course side-by-side with the very same kids you're teaching?' As expected, Foyt, Schroyer and Jack broke into laughter. Dayton offered little satisfaction: the course was indeed designed for the potter who would ponder ceramics only when in class.

During the summer before starting at St Mary's, Jack made an appointment at Bowling Green State University for an admission interview to their graduate program in ceramics.

Jack
I took a portfolio up there, and as I recall some pottery too, and they just didn't like the work. Drawings, paintings, pottery. I remember now. It was during the period when everything was just splashes of color, brush marks. They wanted someone who had already started in that direction, rather than someone they would have to teach. I recall that I had done a portrait of Steven, and in the background I used an area to clean my brush and I covered it up later. They were very interested in that area, and I told them the truth about it. Anyway, they rejected me. I always wonder if I had said that spot was the real kind of painting I liked to do, would they have taken me in? No, sure not, because the person teaching ceramics there didn't like my clay pieces either.

The most professional ceramics department in Ohio was at the State University in Columbus. Gaining stature had been painful when physically placed in the basement and aesthetically ignored by the art department, but a strong teaching staff eventually achieved the quality to attract dedicated ceramists. Howard Kottler, for example, who would later stake a claim on funky-surreal turf.

Jack had avoided the challenge of Ohio State, but why not be turned down by every graduate school in the state? Once more that summer he traveled with pottery, paintings and drawings. The head of the ceramics department, Paul Bogatay, interviewed Jack, and while Jack wasn't turned away, neither was he offered a fully opened door.

Bogatay
You come down next summer if you want, see how it works out — on trial.

The drive back to New Bremen was interminable. On trial? His progress would be judged more severely than that of others. In fact, he wouldn't even be accepted as a peer by the others. It was a rerun of Fairlie's receiving half a scholarship.

Fairlie
Let's move along. I'm good at finances. We'll make it.

*

During the first two summers in New Bremen, Jack and his brother built two houses, including wiring and plumbing. Robert managed most of the financing ('He was single.') and they worked out a profit-sharing formula. Both houses sold, the first in Wapakoneta to Jack's parents one year before his father's death. The second, in New Bremen, to local people. Jack and Fairlie were able to save a healthy portion of their profits. During the final two summers in New Bremen Jack had hired out as a house painter. More into the savings account. When Jack took the St. Mary's position, they stayed on in New Bremen — only a twenty minute drive away — and avoided renting in St. Mary's.

It was finally decided that Jack would go to Columbus alone. His sister Marilyn had married her Bluffton College boyfriend, a black named Albert Dubenion — presently a scout for the Miami Dolphins — and they moved to Columbus, taking a house near the university. They now offered Jack a spare room; but could not provide for Fairlie and three children — three children of their own were underfoot. The Earl nestegg could have stretched to cover an apartment for them all in Columbus, but the expense could be meaningless if, at summer's end, Jack were not invited formally into the graduate program. Even if Jack were accepted, he would still have to wait until the following summer to matriculate. He could hardly gamble on his acceptance and serve notice immediately at the high school. If he weren't chosen after the summer at Columbus, then not only would there be no graduate program, there wouldn't even be a high school teaching position for the winter.

Fairlie thought more optimistically: if Jack did earn a master's degree, but couldn't pay his way as a ceramist upon graduation, he could teach again, this time qualifying for a college position with a more generous salary. Jack knew such openings to be scarce, and worse, that he would be competing with every recent M.F.A. graduate in the country, each hoping for a faculty position until a reputation as an artist was established.

*

When I'm on vacation, they call it, there is no shortage of time so I look for something of interest in the newspaper Roy always buys. It's a thick one 'The Miami Herald.' I read on that thing for five weeks until I come on to an artical about a man who fed bread crumbs to ducks. And he noticed that one of the ducks showed up one day with a homemade blow gun dart stickin out of it's head. And the artical went on about how he tried to catch the duck to take the dart out of it's head even though the duck didn't seem to know or care if it was in there. But this man worried about the dart rusting and making the duck sick or dead, and he was starting a 'Save the Duck' fund to save the duck and to educate the public on not shooting darts at ducks. And it gave his address where you could send your money. This all happened in Texas.

I quit the newspaper reading.

Then when I got home my wife bought a 'Toledo Blade' newspaper and I was waiting for Roy to wake up and was looking through it and there was an artical there about a lizard being found. A five foot lizart found in a pond, and the peple didn't know where it'd come from or what to do with it. This happened in Finland. The lizard. was froze.

*

At the start of summer, 1962, Jack drove southeast to Columbus, the largest city in the central part of the state, settled himself in at Marilyn's place, and the next day drove over to Ohio State University.

By Bluffton College standards the campus was endless, a maze of walks, lawns, steps, quadrangles and buildings with no unified architectural direction, made all the more staggering by the onrush of thousands of students when classes broke. The art department was housed in an old brick building, and Jack had been warned that the clay section would be located in the basement with an outdoor shed for the kilns.

Jack
All I had to do was work hard, and most, forget I was on trial.

Paul Bogatay greeted him warmly.

37

Bogatay had recently returned from a lengthy stay in Japan. Initially fascinated by Zen mystique, he was ultimately drawn to, and profoundly identified himself with the vigorous ceramics of Iga, one of the legendary five kilns (Shigaraki, Tamba, Iga, Echizen, Bizen) of medieval Japan. Jack reported that Bogatay was even able to work at Iga kilns.

Iga kilns trace their pottery back to the 5th Century, the nascence of Sue ware, when glazes were introduced from Korea. By the late 15th Century a number of feudal courts had introduced Iga ware into their tea ceremonies, and the rivalry between kilns for this honor indicates the weight carried by the ceremony.

During the Momoyama period (late 16th Century) the Iga kilns reached a height of expression, work as robustly sensitive as that of Voulkos today. An exemplary piece resides in the collection of Japanese art assembled by Mary and Jackson Burke, often designated the finest collection of Japanese art outside Japan: an eight-and-a-half-inch high water jar (mizusaki) [see Plate No. 3]: the wide mouthed, heavy coiled neck is bent slightly to the side; the body is flattened so that its height is only half the neck's; the surface is pierced with intentional slashings by potter's blades. Deep cracks in the base as well as the collapse of the forms resulted from unsophisticated kilns, mostly underground. Temperature control was a major problem, and firings of four hundred hours were not uncommon — some even as long as seventy days. Glaze trailings were accidental, as were the implosions of the forms, which is not to suggest that the collapsed form was not desired; its bending to the flame was integral to this expressionistic actualization of born-again fire and earth.

The champion of expressionistic tea ware was Furuta Oribe (1544-1615), tea master in the court of Tsutsui Sadat Sugu, Lord of Iga, a warrior-ruler who felt such an affinity with the strength of Iga that he ordered kilns constructed within his castle compound at Ueno. Oribe inspired many potters to work in the Iga aesthetic, but he had little control over royal tea ceremonies, the leading tea master of the Momoyama period being Sen no Rikyu (1520-1591) who leaned toward understated tea ceramics, actually preferring black ware.

Hideyoshi, the hero-warrior named Regent as well as Commander-in-Chief of Japanese forces, is credited with bringing order out of the disruptive wars between northern and southern courts. Sen no Rikyu was now in Hideyoshi's entourage and advised the Regent on all aesthetic matters. It is refreshing to read that on marches, Sen no Rikyu would select the proper locations, such as a pine grove along a shore, for the Regent's tea ceremony. Hideyoshi at one point brought captive

potters from Korea to install their new aboveground step-kiln in Japan, designed to stretch up an incline, permitting greater visual and temperature controls, particularly important for glazes. Oribe again lent influence to assure a vigorous surface decoration. In 1591 Sen no Rikyu fell into disfavor with Hideyoshi, who ordered him to commit seppuku (ritual suicide). The rupture was political, not, alas, lodged in tea ceremony intrigue, but Hideyoshi never forgave himself for the act of temper which led to his tea master's death. Oribe was named master of the tea ceremony, and court after court adopted the dynamic Iga forms, so ideally attuned to the ritualistic pleasure of leaders who had fought for their stations.

In the early 1960s involvements with Japanese clay traditions appeared in ceramic classes seemingly overnight and definitely from coast to coast, and after Hamada — the master of country pottery designated a National Treasure by the Japanese government — made his tour of demonstration lectures across America, the rapport was intense. Foundations were flooded with requests for study grants to apprentice with Japanese craftsmen. On his visit Hamada mentioned that friends often asked why he seldom signed his pieces, particularly since dealers could ascribe inferior bowls to his name after his death. Hamada was intrigued by another possibility: someone's ascribing to him a bowl much more handsome than he could ever have created. When asked why he worked only with functional forms, he replied that even a bad bowl could be drunk from, but a bad painting must be disposed of.

*

The post World War II craft movement was still young, and clay had only in the past ten years been taken into universities. The movement was also — at least initially — anti-establishment, anti-mass production, anti the anonymously made object — whether it be shoe or champagne glass — and certainly anti the hype used to promote and sell objects. Craftsmen of the forties and fifties had managed to maintain low profiles, but their objects were soon to be pulled into the marketplace whirlpool, as must just about anything that can be sold. Weavers, glass blowers, ceramists, metalsmiths, now working in remote byways, would witness their privacy erode as important private collectors rapped on their doors, soon to be followed by the tapping of museum directors; and more, helplessly find themselves, as the bandwagon gained momentum, transformed into living legends or stars or even superstars. The sixties represented the turning point, which only made more appealing the unpretentious vitality of the Japanese country potter, a quality the pioneer American craftspersons were struggling to sustain.

39

Jack Earl walked into the oriental scene cold. But before long he was forming tea bowls, and shortly after drinking tea from them. All the grad students drank tea, warmed by small unendingly glowing hot plates.

Jack

You had to sort of stare into a corner when you drank. And meditate. I usually meditated on whether I was really meditating.

Jack struck up a friendship with a black clayworker, Robert Stull, also from Ohio.

Jack

Stull could really meditate. I used to envy him. . . . A few years later I told someone that the whole tea scene was really out of hand, you know, a little like superficial, but this fellow said no — that's what university's all about, a place where you're supposed to experience all kinds of life styles without having to make a commitment.

Jack was stimulated by Bogatay's intense dedication to Oriental aesthetics, but other areas awaited exploration as well. The point was not pressed, however: Jack feared he was being judged at every turn. When Bogatay brought in books on Japanese clay styles from his own library, Jack was quick to read them from cover to cover. Jack also researched books on the subject in the main campus library.

Jack

I never went anywhere that summer except to the art building and the library and my sister's house. Well, that is except for weekends. Almost every — yes, I think every weekend, I drove back to New Bremen to be with Fairlie and the kids.

Jack's version of the Iga/Hamada adventure was to copy forms, 'with a little reworking,' from Bogatay's books. One day Bogatay passed by and said, 'You know you can do whatever you want, create your own forms.' For some time Jack had longed to do just that. Now he wished he had started earlier — before Bogatay turned it into a challenge.
[Plates 1, 2]

Jack

I took a painting course and a throwing course, then later a hand-building course. I got the painting assignment and had a painting the next day. The teacher laughed at it and told me to paint it over. The next day I had another one for him. He said paint it over. The same thing the next day. The painting got thick. Finally I got what he wanted, and after that I was able to satisfy him easily.

I worked at the wheel during the throwing course, and also into the night each night. I believe Eugene Friley taught that course and I got to hear what he had to say also. I'm sure Bogatay and Friley said the same thing over and over but Bogatay was the man I heard. He was the one who saw and commented on the change in my work and took an interest in me. Paul Bogatay was a tall, lean man with dark straight hair. He wore glasses that set peculiarly on his noise. He was always well dressed, but loosely. He always spoke carefully and calmly, moving his hands as he talked like he was making something.

I worked on a container that was off-center and had a tear in it — and Bogatay came by. My fingers kind of stuck in the clay. He made some compliment, a little statement about it, not just one or two words. He really liked what I was trying. From that minute on I felt I was going to be in the grad program.

In the beginning I was just another art teacher taking summer courses. As I got to know the teachers I made my intentions known. Toward the end of the summer Bogatay told me I could now make application for graduate school and that he was sure I would be accepted. The best surprise was when he said the trial summer could count for graduate credit. Of course this had to go through the formality of a committee — and it did slip through.

Before summer waned Jack received official notice of his acceptance into the graduate program.

Just before leaving Columbus, Ray, Roy's twin, unexpectedly appeared at Jack's studio with his son, Glenn, a freshman at Bliss Business School. Father and son stood just inside the door, eyes roving from table to table holding Jack's summer production — Japanese tea bowls, Japanese tea pots, Japanese plates, Japanese saki cups. Jack waited...and waited.... Having seen a number of Jack's earlier functional pieces hardly qualified Ray as an expert, but he felt compelled to voice an important observation.

'But Jack, you ain't Chinese.'

When Jack returned to New Bremen bearing the news of his acceptance, Fairlie lost no time in designing a budget projection for the next two years.

One matter was settled at the outset: the family would accompany Jack to Columbus. The next summer, plus the following winter and spring terms, would pass before Jack could build enough credits for a master's degree, far too many months for them to remain a weekend family. Since Jack was contracted to teach a last term at St. Mary's, Fairlie would have ample time to visit Columbus and locate an apartment. Their savings were still intact, but the considerable expenses of Jack's tuition and class supplies precluded any extravagances. However, some unexpected news arrived to bolster the budget. Professor Littlefield, from whom Jack had taken a course on glaze calculations, wrote to inquire if the Earls might be interested in housesitting during the summer. Besides assuming responsibility for normal house maintenance, they would be expected to babysit for a Siamese cat and keep a five acre lawn mown. Fairlie felt she could manage both, particularly when it saved their having to rent an apartment until fall.

While the family's endorsement of Jack's continuing his education was unanimous, trepidation remained over the situation the day after he was handed the master's degree. It seemed prudent to ask the Principal of St. Mary's if a substitute teacher could be taken on for the winter-spring he would be at Columbus. That would allow Jack to return — if necessary — to his old classroom until a college faculty position opened. The Principal promptly replied that the possession of a master's degree would certainly numb his stimulation for teaching at a 'high school level.

Jack taught his final year of high school, and at the close of spring term the family moved to Columbus.

*

Fairlie
The summer at Professor Littlefield's was okay, no major setbacks, except that the cat was a real idiot, and even though there was a power mower with the deal, I have never seen grass grow so fast. I just about lived on the mower. Have you ever seen a five acre lawn? When he returned and looked over the house and yard, he did not express any great pleasure.

During the summer Fairlie also located a three story duplex plus basement for their term in town.

Fairlie
I did have to have a realtor help with this, though. Then my cousin was going to college — that's Glenn. We gave him the third floor for ten dollars a week. That was half our rent. I don't know how the five of us made it through the winter. I began to budget week by week. Then Dianne had to have two operations — double hernia, one side and then the other. But we still made it. And without borrowing a cent from anybody!

*

During the trial summer, Jack remembers that except for a young couple and Howard Kottler, he was the only grad student.

Jack
Maybe Kottler was working for a doctorate. I know there was one couple there working for doctorates. I guess Kottler, in fact, was there for years, or so I was told. He was something else. I think I had heard of his reputation, and I knew he was far superior to me. Real intelligent. Anyway, I was always careful around him, and maybe that's why he got to like me — because I was so careful. Fairlie just approached him in her usual open way and they got along great. She used to help him when he was constructing his big pieces. She'd hold up slabs so he could fit them together. Oh, he had a real caustic wit, the kind of humor you didn't want to laugh at but couldn't help yourself. I guess that kind of humor is funny until he applies it to you — but far as I know we stayed buddies, and once he came to visit me when I was teaching upstate.

Kottler eventually joined the art faculty at the University of Washington in Seattle, where he and the two nationally recognized ceramist sculptors also on the faculty — Patti Warashina and Robert Sperry — formed a brilliant catalysis for younger artists. The Northwest Craft Center, guided by the enthusiasm of Ruth Nomura, provided exposure for a new generation of artists, followed by the opening of several smaller galleries to provide additional support.

*

During Jack's first summer as a formal grad student, no more than three or four others were working for M.F.A.'s, which meant each had as much attention from the professors as needed — or wanted. A new fine arts building had been inaugurated during the winter and now most of the art departments had relocated in the new space — but not ceramics. Some staff members considered their being left behind a putdown, but

43

it did leave the department with commodious work areas. More spacious kilns were installed: for the first time Jack could fire objects three feet long. But everyone was still doing tea cups. Jack trod the accepted path, borrowing and reembellishing Oriental forms, even though this secure direction offered shallow personal esteem.

During the year three established ceramists were booked for lecture/demonstrations. First was Harvey Littleton, a ceramist now internationally recognized for his glass sculpture; but then he was still dedicated to clay. Littleton presented a serious class in basic pottery maneuvers, but for Jack it was a throwback to Klassen — superb technique mated to traditional design.

Jack
Of course Littleton found deep inspiration when he moved to glass. Guess that was his real medium all along.

Next was Toshiko Takaezu, a neisei born and educated in Hawaii, and for many years an instructor in clay at the Cleveland Institute of Art. Formal oriental values provide a foundation for her sensuous lyricism, revealed both in undulated shapes and glaze scrims. The former draw hands to the surface, the latter bring eyes to fresh color soundings. Jack admired Takaezu's work, but it was not his approach.

The final demonstration was from Peter Voulkos, the doyen of the clay breakthrough, the young man from Montana who traveled to Los Angeles, and was turned insideout on encountering abstract expressionist paintings; and who then turned the conventions of contemporary ceramics insideout by reshaping functional forms into nonfunctional states, at last allowing the art world to recognize them as the sculptures they always had been; even farther reaching, the transformation led to the acceptance of clay — even clay formed by the hands of artist-craftspersons — as a medium for contemporary art.

Jack
Boy, he's a guy just like his work. Real gusto. Maybe passion. All those gouged holes in his surfaces. I also heard he plays poker for folding money. I play pinochle for match sticks.

44 This massive, handsome, large-featured artist hides his quiet pool behind

a puffed and chewed cigar, and has been known to precede lectures with a calming stimulant or two. When at Ohio State the fever of his contribution was at its height, and if ever the ceramic world recognized a superstar, it was Voulkos. Neither the lectures nor demonstrations ever prompted his occasional stage uneasiness: it was the superstar hype — that he didn't know how to handle.

Stories of Voulkos' aesthetic and technical break-throughs, as well as of his macho personal antics, peppered campus name-dropping sessions. Finally Jack could actually lay hands on Voulkos sculptures: they held more power and invention than he had ever touched.

Also during that year a selection of clay pieces from the Everson Museum of Art's annual ceramics exhibition was shown in a small art department gallery, which included another incredible Voulkos sculpture. Due to the three visiting artists and the Everson show, Jack in one year was made strikingly aware of how many dynamic artists were active in his medium — and every one far more advanced than he.

Jack
Like Kottler. The guy was really sophisticated. And could he talk.
I listened hard but I didn't understand very much. I'm not even
certain if I knew what Kottler's sculptures were about. But everyone
said they 'worked.' 'It works' was the big expression — well, I guess
the only expression — used during those two years to show
approval for a piece of sculpture. Oh yes, you could also say,
'It's strong.'

Jack returned to his studio, where more and more of Voulkos' ideas and techniques converged with the oriental forms.

Jack
I made kind of slab sculptures, layers and slabs to get depth. I
worked like this right up until the end of the spring term. With low-
fire glazes and grinders to take off some of the surface. I'd mix a
lot of stuff with the clay that would burn out and leave holes and
all that. Mostly wallhanging things, not standing work. I signed
them too, with a kind of scratch. I had a few of them in my
graduate show, but I don't think any exist anymore.

One day toward the completion of the term repeated knockings sounded on the outer wall of Jack's studio, followed by the appearance of Professor Littlefield with a friend Jack knew to be a conservative potter. They asked to examine Jack's recent work. The two men circled the room, carefully judging each wall sculpture, and lingered before one with a red spot.

45

Jack
A red glaze never fails to excite potters. They're always trying to get red. Finally this visiting artist put his finger right on the red — and he found out that it was paint. No, they didn't like that at all. And no, I didn't mention Voulkos.

Voulkos represented such a force that any ceramist still in a formative stage had to react headon. Surveying student work in the early sixties, it appeared every ceramic sculpture in the future would be a Voulkos variation. Voulkos didn't mind, and unlike Hamada, he made certain to scratch his name into each work.

*

During the following school year Jack and Robert Stull shared a studio. Stull, born about forty miles to the south of Springfield, moved to Columbus with his parents when he was in his teens.

Stull (letter excerpt)
I attended Ohio State University because I could not afford to attend another school — thus it was the only choice really considered.

Jack's work has an honesty, integrity and strength which reflects his personality. He is a master artist, master technician and master human being. We met in the summer of '61 in a ceramic class at Ohio State University. I liked him immediately. No pretense with Jack, a few words, those shared-of meaning. One of our instructors was a ceramic art historian, Carleton Atherton, who did not work in clay or teach firing. He was however a delightful man. And so we learned from one another and became studio partners the ensuing year in graduate study. This seemed natural to us. In retrospect it was rather revolutionary. Jack worked harder than anyone I had known in art. He literally filled the studio each day with what he threw on the wheel. He also placed work on carts in the hall outside the studio. He was ideal to share a space with. We experienced not one cross word or uptight moment. I believed then and still believe that Jack was a living form of Zen, his hours and days were haiku of the natural and not the unreal.

We shared books which contained work or thoughts that seemed to make sense. One book shared was 'Zen in the Art of Archery' by Eugene Herrigel. Jack was patient and sharing with people who worked hard, and had little time for people who did not. He had and still has what I term the Jack Earl smile. It is unique: open, quizzical, warm and again unpretentious.

Jack is a person whom I love and respect without limit.

After being graduated from Ohio State, Robert Stull taught at the University of Michigan. Later he returned to Columbus, joining the faculty at Ohio State University. In 1975 he was appointed Chairman of the Art Department, and in 1979 named Associate Dean of the College of the Arts.

*

Graduate students must, for final faculty judgment, assemble an exhibition representing their best work.

Jack
My show naturally bent toward the Oriental, just pottery, real coarse ragged Japanese kind of pottery. A bit like Klassen, a bit like Iga. All stoneware. Earthy colors. Some Japanese brush work. The latest pieces were in the Voulkos mold, slabs and holes and sharp edges, more like sculpture.

In June Jack was awarded his Master of Fine Arts degree.

Fairlie
His dad would really have been proud.

But a degree did not automatically provide Jack with an audience for his sculpture. Why should anyone wish to acquire a second generation Voulkos or Hamada from Jack Earl, particularly when second generation Voulkoses and Hamadas by other grad students were available in university ceramics departments from coast to coast?

*

Luginbuhl asked Jack if he would assemble a selection from his graduate show for an exhibition in Bluffton. Jack was flattered and agreed. Sometime later Luginbuhl related Klassen's visit to the gallery. After touring the exhibition, Klassen returned to the group of Voulkos influenced works, studying them for a long time, and with apparent interest. Finally he ran a hand over one. A sharp edge cut his finger.

Luginbuhl
That didn't impress Klassen.

*

In the spring prior to graduation, Fairlie and Jack were invited by the Luginbuhls to an informal reception honoring Paul Soldner, who would be in Bluffton visiting his parents. Jack had never met an Ohio ceramist

47

with a national reputation. Another ceramist, Norman Schulman, who had met Soldner several years previously on a ship bound for Europe, was also there, and when Jack heard Schulman taught ceramics at the Toledo Museum School, he was more anxious to speak with him than with Soldner. Graduate school would be over in a few months, and no prospects for employment had surfaced. Perhaps Schulman had a lead. At one point Jack entered the kitchen in search of ice and found Schulman pulling a tray from the refrigerator. Jack introduced himself, and soon launched into the difficulty of financial survival — especially with a family — in the creative end of clay. Schulman sighed, and asked how anyone could decide to stay with clay on a full-time basis. Jack didn't know how to answer, so he went right to the point and inquired if Schulman knew of an available faculty position — anywhere. Schulman laughed, as actually one — in art education — had recently opened, a course designed at the museum school exclusively for Toledo University students: the university lacked an art department. Jack had dreamed of teaching straight ceramics — not education courses — but waiting for the ideal faculty position was tantamount to begging for another factory graveyard shift.

Eventually Jack did speak briefly with Soldner.

Jack
He was all right, but he wasn't from Ohio anymore. He had all that California jazz.

Schulman was questioned by letter about the kitchen encounter.

Schulman (letter excerpt)
Well, he was laid back, calm, a studying look trying to figure out people. He listened with his eyes as well as his ears. Plus, he looked like my closest friend, a painter, Fred Kline. We had grown up together, same age. There was something about Jack that rang true.

After receiving documentation and recommendations on Jack's scholastic and teaching records, Schulman wrote a strong endorsement for him to the head of the Toledo Museum School, and during the final two weeks at Ohio State, word arrived confirming the appointment.

*

The teaching post alleviated Jack's prime concern — providing for a family of five; and shelved his second concern — insecurity over entering the market place as an artist. During the brief time spent at Ohio State his work had matured more than during the seven years of teaching

at primary schools, but Jack had yet to discover if there were 'a unique Jack Earl statement,' and if there were, if he possessed adequate technical knowledge to express it. The ideal route would be total immersion in the creative gesture, dreams of clay, fantasies in clay, hands in clay, day after day until fingers, palms, knuckles, nerve ends automatically manifested whatever, if anything, needed to be expressed. However, it would be unconscionable to ask his family to make out for itself while he searched for his elusive full self. For the present he could be thankful for an income, even if modest, from a position allowing contact with other artists, with an art library, with research materials, and perhaps most valuable of all, with a collection of actual art objects.

*

Jack's faculty placement relaxed the entire family, and Fairlie and Jack accepted the invitation from Roy and his mother, now in her eighties, to spend the summer at the farm.

Jack
Of course Roy hoped I would help with farm chores and what he calls minor house repairs.

Roy lives on one of those narrow, no lines down the middle country roads but he says he would like to live in a house way back off the road so the cars wouldn't kill his dogs and then he'd have a eight-foot high chain-link fence all the way around his property so he could have all kind of animals like deer and rabbits and he'd stock it with pheasants and he could go huntin anytime you wanted to and all the farmers should set junk cars along their fence rows for the rabbits to live under.

That summer basks in unfocused memories, except for one interruption: Roy approached Jack to build a bathroom inside the house so that at least his mother ('and Fairlie's grandmother') would not have ('in her late years') to use an outhouse. The location? After several days' discussion, Roy proposed the front porch, as that entry was seldom used. The driveway, stretching along the left side of the house, turned right to the back kitchen steps. 'Most everybody comes in that way just natural,' Roy pointed out. Grandma Sara acquiesced.

Jack acceded.

*

Jack
Want the history of the bathroom I spent all summer building? A few years later on — after his mother died — the drain under the wash basin began to leak. Roy never fixed that. It rotted the floor. From then on nothing was ever fixed in the bathroom. The toilet quit working. Wouldn't flush. You took water from the kitchen sink and poured it into the john when you used it. And since the outhouse was torn out, you were stuck always having to do the water pouring thing. Now the entire water system is pretty much gone because Roy left water in the pipes one winter when he went away. They froze, and with the thaw, burst. There's a storage tank for water pressure in the kitchen, and when he couldn't get the bucket under the spigot to drain it — because there wasn't enough room — he cut a hole in the floor. When the drain in the sink got plugged up, he took the drain out. Now the water plunges right from the sink, down through a hole and into a five gallon bucket — all without the benefit of a single pipe. That's how Roy solved those problems. That's the way Roy operates.

*

While Jack was building the bathroom, Fairlie, the advance scout, visited Toledo, found a house for the family, and signed a two-year lease. The downstairs contained a living room, sitting room, dining room and kitchen, all small, except for the kitchen. Upstairs: two good-sized bedrooms and a small one, plus a fairly large room for storage. A front porch stretched the width of the house; in back sat a commodious two-story ex-barn, now a garage. The yard was small. From the street an alley ran along one edge of the property, and another traversed the back of the lot. The densely populated residential area was just one block off Central, a busy street which led directly to Collingwood, which dead-ended at the Toledo Museum School, about a mile in all. The family was pleased with Fairlie's selection.

The atmosphere at school was congenial, and classes not difficult: the education majors from the University of Toledo would eventually be teaching in elementary schools — the same setup as at Bluffton.

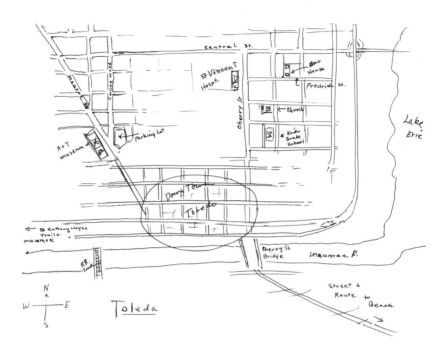

Jack

Well, I taught them fundamentally to present the art materials to the students and discuss what could be done with them for long enough to get the class interested. Like they could tell the students that it was possible to draw a picture of them helping their mother. Then break that down to specifics — I mean like let each one talk about how they help their mothers. Then give them the materials and let them go to work. And basically for the teachers to keep their noses out. The only thing I suggested further was that if the students became stuck, then suggestions could be offered.

A major disappointment was discovering that only faculty members teaching hands-on art were given studios, and naturally Schulman had access to the one studio for clay. Idle time was plentiful: no matter how many or few hours faculty members taught a day, museum rules stated they must remain in the building from nine until five. The off-duty faculty drank coffee and conversed. The painting teacher, Jim Barbee, was particularly loquacious.

Jack
*He related everything to painting. I don't know if I learned anything
from him, but I learned that painters can sure talk. He painted
women. Maybe only women. And when we talked about art there
was always lots of emphasis on sex. He was a serious artist — and
he could sure put down the dilettante. Everything he said was real
down to earth, whereas Schulman was a romantic. Al Melis was
also there, the jewelry instructor. He just made things all the time,
jewelry and sculpture. There were just enough people for me to
handle. In the long run, between the guys who taught there and the
library and the museum collection itself, I guess that's where I
began to get a little feeling of what art might possibly be about.*

Since teaching consumed only three hours of the day, Jack had sufficient
time to explore perspectives offered by artists, authors and objects, and
while not much time was spent in the museum library, he did sift
regularly through current art publications, as usual eschewing the
written word, trusting his suspicion of intellectualized art talk, especially
from non-artists. The slick color reproductions signaled well enough
the art world 'images of the month.' It was the mid-sixties, the height
of the erotic wave rolling in from the west coast.

Jack
*I didn't really pass judgment on what I was seeing. And about
erotic stuff, well, I'd never thought of doing anything like that. But I
do remember thinking that maybe — some day — I would try it.*

*

The highlight of the first year was a lecture-demonstration by Rudy
Autio, a coeval buddy of Voulkos from Montana. If Voulkos represents
the extrovert driven to escape the woolly hills of Missoula in search
of growth stimuli, Autio was the introvert, geared to develop at a more
careful pace from catalysts less frenetic than abstract expressionism.

Although Autio's recognition came later, it is now as secure as that of
his hometown buddy. Jack took one look at Autio and liked him; and
he liked his work too, mostly non-functional container forms built with
asymmetrically placed slabs. Often the shapes suggested bulky headless
sculpture busts, pied with bright acrylic paints on faceted surfaces. One,
a slab-built shape with an open vessel-like top, was titled 'Sheriff' due
to a large five-pointed star painted on one of the slabs. Another with
a painted flag was labeled 'Mailbox.' Jack bought 'Sheriff,' his first art
acquisition. This was not to be his statement, but he recognized it as
stimulating and important.

During the spring Schulman received an offer to teach at the Rhode Island School of Design. Again Jack requested Schulman to submit a recommendation, this time to fill the position Schulman was vacating. Again Schulman accommodated, and again Jack was awarded the post. By then Jack and Schulman and their families had become close friends, and Schulman well understood that Jack would soon wither teaching teachers-to-be who had no gut involvement with clay. And wither too without a studio.

The school was closed during the summer. Jack had not worked with clay for a year. 'My hands itched.' With no kiln, he turned to ready-made forms. From a factory in Findlay, a nearby town, he hauled home a trailer load of six inch by six inch green tiles, and spent most of the summer working with them: first the surfaces, not yet dry, were carved as deeply as possible. Some tears and slashes of course. Then acrylics applied boldly, influenced by both Autio and the Hans Hoffman 'push and pull' theory of color juxtapositioning, a technique he had recently found illustrated in an art magazine. Finally the tiles were affixed to one another in asymmetrial designs.

Jack
I was able to work fast, which I was taught at Ohio State. Speed was part of the Zen mystique. Later someone told me that Zen speed applied only to functional ware, never to sculpture. I didn't know.

*

When Jack returned to the Toledo Museum School in the fall, he found himself not only the sole ceramics instructor, but also the sole potter in the department. With no clay authority on hand, challenges would have to be solved on his own initiative, a more circuitous route, but a healthier one for Jack as craftsperson and Jack as artist.

The search for a style recommenced. If he sheltered a statement, should it not surface naturally and itself indicate a style? And would not the style then dictate the medium for its realization?

While dissatisfied with the summer experiments with green tiles, Jack was not finished with a non-figurative approach. For some time a box form had been on his mind — five faces (Jack discounted the bottom) facing five directions. Each would be surfaced with a variation of a similar concept. Finally the project was abandoned: too contrived, not a natural posture for Jack. Back to Autio's approach, now introducing more natural forms. One slab sculpture was built into a rooster — but it didn't work. None of the pieces in this direction worked: his subject matter proved incompatible with Autio's building forms.

*

Jack is not certain where he first encountered (in a show? an art magazine?) the elegant jugs of Brother Bruno (who later left his order, reverting to Bruno Laverdiere, and is now a major abstract sculptor, and into his second marriage), but soon Jack was coiling his own versions. The distinguishing marks of Bruno's forms were usually expanded chestlike bodies, thin waist bases and tapering neck tops. Plus enormous handles, often suggesting a female torso with arms akimbo. Or sometimes the handles were curled upward, as if a maiden with fingertips on her shoulders. Jack built handsome replicas, but was unable to personalize Bruno's definitive statement.

The jugs were abandoned, but not the ladies. Round slick columns — some as tall as six feet — appeared, the lower parts unadorned, the uppers painted, usually to suggest a face. The medium was stoneware, and after firing, the surface was covered with an englobe, a form of

white clay which readily takes staining. Jack coated each column with a single color — brown, blue, black, yellow or a shade near red. The faces were then overpainted in acrylics. With time the columns were converted into more recognizable torsos.

Jack

I was making armless females without brassieres. The breasts were kind of idealistic, but more naturalistic than the face and rest of the body. Several of the torsos were life-sized.

After several months the columns metamorphosed into realistic playboy figures, and Jack spent the entire next summer modeling stoneware tributes — so intended or not — to mass media sensuality, all nudes, all mostly life-sized or just under. [Plate 4]

Jack

I didn't know what I was doing — I mean technically, working that large in stoneware. I lost them all in the fire.

Defeated? Not at all. Jack then attempted larger-than-life playboy models, designed so that the clay could be cut into sections and thereby safely fired piece by piece. Students and faculty would not soon forget his final playboy statements — several eight-foot long lounging centerfold bare beauties, which when not being modeled, lay on table tops shrouded in clear plastic to retain moisture. The coverings blurred the figures just enough to turn them all the more exotic — or erotic. Fairlie remembers that he made breasts, too — lots of them, usually generously proportioned, some honed toward a Brancusi purity

Fairlie

Oh yes, outsized armpit sculptures too.

Jack

Well, you know I was still unconsciously — or maybe helplessly — following people, and that was the time when there was a lot of art world concentration on sex. Ceramic pieces were full of it, especially from the west coast. I hadn't seen any, only reproductions. And there was Barbee, right on the faculty, painting only women, his conversation seldom veering from women.

Charles Gunther, the member of the administrative staff who had given the final approval for Jack's replacing Schulman, questioned Jack about reactions, in and out of school, to his large breasty nudes, and 'Jack just shrugged his shoulders and said his mother liked them.'

The centerfold nudes were never fired.

Jack decided to expose some sculpture at the Ann Arbor (Michigan) street fair, a well-attended outdoor show where many younger potters in the area exhibited. A number of works remaining from his graduate show were chosen — the functional stoneware pieces steeped in diluted Zen, plus the Jack-made Voulkos/Autio sculptures.

Jack
I didn't take any of the sexy things. Maybe some of those first heads — well, I don't remember for sure.

Every display table sagged under dark brown stoneware pieces with the 'made in country Japan' imprint. You could hardly tell which artist had created which object, and Jack didn't sell enough to pay for the gas or motel.

Jack
Somehow or other the fact that I didn't sell that stuff made an impression on me.

Then and there Jack turned his back on stoneware.

*

Jack and the family also abandoned Toledo. After two years city life proved too precarious, especially for the children.

Jack
Weird people walking in the alleys, locked doors, drawn blinds, guns under beds, Fairlie walking the kids to school three blocks away, worried until they got home safe.

Plus the small rooms were really too small. After some scouting, led by Fairlie, the town of Genoa (pronounced with a hard accented NOH on the second syllable), some fifteen miles to the south-east, was selected. Jack guessed at the population — 700. Fairlie again found the house, with some help from realtors, and then asked Jack to okay it. They decided to buy.

Jack
Beyond the suburb zone: bank, grocery store, bar, restaurant, dime store, volunteer fire department, grade school right next to our house, junior high two blocks away and the high school new, built out in the country north of town. It had a built-in back porch where the hot water heater, washer and dryer were placed, a junk room off that, a kitchen with a window that looked out on the school's playground and an eating and working area next with two windows surrounding the table. The living room was large and

open. It was a good room for parties. We had many over the years, mostly art school and museum people. Our bedroom and Steve's was off this room and the girls' room was upstairs. It was an older home that had been remodeled. We enjoyed living there. We had an opened grassed lot next to the house, opposite the school yard. The neighborhood kids played there. I played touch football with them. Fairlie made friends with the women in the neighborhood and I became acquainted with the families through her.

Standing at the back of the lot was a two-car garage, clumsily transformed from a small house by previous owners. Jack set up a studio in what had been the kitchen, kept the car in the livingroom and stored junk in the bedroom. The roof sprang leaks regularly.

*

During their first year in Genoa Jack had worked overtime with the stoneware females, and now so many columns lay in passageways that movement was seriously hampered. At that moment the Toledo Museum of Art offered him a one-man show, an honor normally given to faculty members. It didn't take him long to decide not to show the erotic art.

In fact he rationalized that the whole involvement had been an unconsciously driven exercise to cleanse his system of further need for such subject matter. Not nudes — but erotic nudes. One weekend, as if it were destined, he carried the females, one heavy column at a time, out of the house and out of the studio and stacked them along the side of the garage.

Jack
Suddenly they were cordwood.

With the children at school and Jack's teaching during the week, Fairlie began her own project, one that had interested her for a number of years — synchronizing colored lights to organ sounds.

Fairlie (written account)
When I was a window trimmer in Lima I became interested in lighting because of the set-ups required for displays. Because of not having much money when Jack and I first married, we couldn't afford many luxury items; so I learned to fix our few electrical appliances when they broke down. Jack's dad gave us an old TV, our first, and I was always taking out the tubes to go up to the drug store in town and check them myself on a tube tester. This led to more complicated repairs. Then I got several hobby kits and parts at a Radio Shack. I knew how great light and sound were together, and this unit would be a real addition to our home decorating. I made my workshop in the middle of the front room, cleaning up each day after a few hours of work. I found a portable organ keyboard in a garage sale. I tore up an old TV, radio and record player console and took those ingredients for my own music

*center. I had to buy the color kit for lighting, the special speakers
for the Lesley effect, which would be spread over the organ so the
lights would spread according to the sounds produced. I also
bought a pre-amp and mike mixer and a few other things to build
in to make it a one-man operation music center. I had a place for
hookup of instruments and microphones so you could really have
a variety of things working at one time. I loved black light and
psychedelic color and installed that around the room, and anything
else you could do to cause excitement. But no obscenity was
involved with the color slide projection which was thrown on the
walls from a slide projector. I loved mirrors and illusional effects.
We used the light-sound-music organ a lot for parties. It was over
nine feet long; the side cabinets were about two and a half feet tall;
and the center cabinet with the organ about three feet high. There
were three hinged sections so it could be moved into a circling
effect, or folded in a triangle for storage.*

*

After the outdoor fair Jack initiated a search for another medium, and
in so doing found himself involved in a new technique as well. The
medium was plaster, and the technique carving. In subject matter and
scale the new pieces represented a complete antithesis to the large
stoneware works of the previous two years. Jack now recreated small
realistic (except for their blinding whiteness) scenes of observed
everyday situations: a girl leaning against a car door, upset over an
incident between her and the man at the wheel — neither looked at
the other, a man stretched out on a lounge chair placed, not on his front
lawn, but on the cement walk from the front porch to the sidewalk.
Jack liked the feel of these small carvings, but plaster held two inherent
drawbacks. The first was its fragility. Any less than delicate handling,
whether by hand or tool, resulted in a crack or break. The second was
the difficulty of working in fine detail. For example, it was impossible
to shape tiny blades of grass for the front lawn of the man in the lounge
chair. The plaster sculptures invariably ended up chunky.

Jack
*Also, I couldn't work with plaster — or store plaster pieces — in my
garage studio. The roof leaked and plaster gets mad and dissolves
when it gets wet.*

The date for Jack's Toledo Museum show arrived, and he mounted five
or six of the new plaster tableaux, with a few of his small non-erotic
stoneware sculptures as fill ins. No noticeable splash was created, but
faculty and students were particularly taken with the genre scenes.

Almost afraid to admit it, Jack sensed the genre scenes were nearly in vibration with an inner motion, and this only intensified the anxiety over locating a medium that would not technically inhibit the statement. What white material was tensile enough to support minute carving? Experimentations with low-fire white clay began. Fine modeling was indeed possible, but unfortunately the kiln transformed the white body into dishwater yellow.

Whenever the use of porcelain was suggested, Jack recalled its reputation as the most difficult of the clay bodies, particularly on the wheel. Because it had to be worked quite watery, the experience was likened to transforming a jellyfish into a bowl. Nevertheless, his burgeoning genre scenes would be ideally stated with the qualities of porcelain: a gleaming nearly transparent white, a strength almost metallic, a tactile body sympathetic to carving of remarkable precision. When Jack would sit down to think about it, he realized there was no point in sitting down to think about it: if he were serious about working with scenes, the challenge of porcelain had to be faced. Where to turn for help? Evidently the museum library contained a section on porcelain. Also, the museum collection held fine examples of Oriental and European porcelains.

Jack repaired first to the library.

*

Porcelain is a mixture of pure white clay or paste, usually called kaolin or China clay; and China stone, a kind of granite, mainly orthoclase feldspar. The kaolin provides elasticity, plus retention of the form when in the fire; and the feldspar provides translucence.

During the latter part of the 16th Century (the date varies in differing accounts, as does just about every other specific regarding the eventual production of porcelain clay in Europe) the first porcelain objects arrived in Europe from China. Connoisseurs required but one glance to certify the preciousness of this charismatic clay. Hands were raised and porcelains elevated to status symbols. Meanwhile, mired in secrecy and intrigue, pottery firms throughout the continent smashed and ground valuable porcelain objects to extract their formulas. In Florence a group sponsored by no less than Francesco de' Medici reasoned that the compound must involve a marriage of white clay and glass. While the effort managed to produce a pleasing look-alike, collectors turned their heads — away. Not until early in the nineteenth century was the medium broken into its proper components. However, the group of French chemists responsible would not have been able to claim this

accomplishment without the fortuitous assistance of a Jesuit priest on missionary duty in China. During a guided tour of a mountainous region, this Priest realized he was being shown the source of the elusive clay that had the whole of Europe in its thrall. He immediately sent samples to a friend in Paris, who in turn entrusted them to chemists for what would be the first analysis of the clay in its unfired condition. The French missionary's source was near a hill named Kau-Ling (High Ridge), and kaolin is a French corruption of Kau-Ling.

With the formula uncovered, the illustrious history of European porcelains formally commenced.

By this time a number of pottery centers had, through more than a century of experimentation, approximated Chinese porcelain; in fact many of the variations are now recognized as important additions to the history of ceramics. But at that time all were labeled faux.

Jack Earl spent many hours over reference works in the Toledo Museum of Art library reviewing past achievements in his newly chosen medium. The Chinese accomplishments were staggering, but he related more to European statements. Color plate after color plate of tureens, candelabra, sweetmeat stands, armorial mugs, drug-vases, inkstands, teapots, coffeepots, pomade jars, jugs, cups and plates, plates, plates. And sculptures: lovers, bald grinning Buddhas, birds, harlequins, enchanted cottages, wild animals, Michelangelo replicas, portraits, ships, boudoirs. Jack browsed through the museum collection often, speculating on techniques utilized for the porcelain sculptures. Most were certainly hand-built; and the vases and jugs — all the containers — probably pressed into molds. The sculptural detail possible — grass blades, curls, cat hairs — was impressive. Yes, this was his medium, and here were the artists of the past on whose works he would build.

Jack's interest was not limited to artists involved with ceramics, as in reviewing the porcelain collection he gained respect for a number of European sculptors working during the same period in other media, such as Benvenuto Cellini. The ceramist whose work consistently disarmed him was Bernard Palissy. These artists stand at different ends of the expressive spectrum, Cellini audaciously spectacular, Palissy painterly provincial. Cellini, of course, is familiar to those who have ventured no farther into sculpture than Art Appreciation I. But Palissy's following is limited mainly to ceramic scholars and serious collectors.

Jack

Maybe I was attracted. . . well, maybe I sensed something rural about him. I don't know much. . . anything about his private life. Oh, yeah, I'm sure he's European. Sometimes the way he mixes colors is like those old paintings in general stores around here that sell for two dollars. They're the ones I buy. He must have been kind of himself.

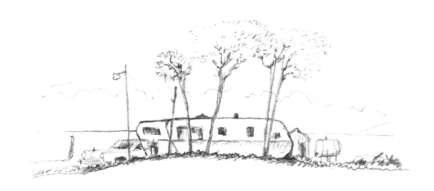

Palissy was born in France in the early part of the sixteenth century, and apprenticed at an early age to a glass painter. Later, to gain more worldly experience, he traveled as a general workman, and it is thought he reached the lowlands and Italy. Finally he returned to settle in his birthplace, Saintes, his future uncertain. Then one day he was shown a white cup, which scholars feel was unmistakably of porcelain. Even though Palissy knew little about pottery, he decided then and there that it would be his destiny, and 'like a man who gropes in the dark' he applied all his resources toward the discovery of the clay constituents which could duplicate those of the cup. With little trouble, almost as if his hands already knew what to do, he learned the rudiments of peasant pottery. But his clay would not produce porcelain, no matter what the additives. According to his autobiography he labored sixteen years without coming within reach of the magic luminosity. His obsession brought him and his family close to financial ruin a number of times, and he claims he was once forced to burn not only his furniture, but the very floor boards of the house to maintain a constant kiln temperature.

Palissy never produced porcelain, but then neither did many others with far more experience in ceramic chemistry. However, the future would

be kind — for awhile. From his position of poverty he was discovered by a visiting official, who recommended him to influential friends in Paris. Soon he was under the aegis of royalty and appointed 'inventor of rustic pottery to the King and the Queen-mother.' His studio/factory was established near the Louvre, and he lived and worked in peace for twenty-five years, an especial favorite of Catherine de' Medici. Then in a political uprising of 1588 he was thrown into the Bastille, and at 80 years of age condemned to death. He died in his dungeon before the sentence could be enacted.

Pottery authorities note that Palissy's clay never matured beyond country pottery quality — and certainly did not approach porcelain — but his surface painting was remarkable, especially background marbling effects. No one is yet credited with surpassing their elusive softness. He failed his goal, but his passion earned him a secure position in the history of ceramics, well illustrated by the placement of his works in major museums, particularly at the Louvre in Paris and the Victoria and Albert in London, where collections of his ceramics can be seen, not merely one or two examples.

*

Palissy's search for porcelain represented in microcosm the continent-wide search. Fortunes were lost by many established firms, and the new potteries formed on the hope of creating porcelain met with bankruptcy when their clientele would not settle for less exact formulas. Porcelain reached America during colonial times, and speculators lost fortunes here as well trying to duplicate the 'wonder clay.' Kaolin and white clay were found in a number of places, including Kentucky and Tennessee. Nevertheless no one ever matched the Chinese source until the French announced the formula. Later two locations in Ohio gained their reputations through porcelain, as well as other ceramic ware. The first was in Liverpool, where after 1831 a thin porcelain body was produced, based on an Irish variation, Belleck. The second historically important manufacturer of earthenware objects in Ohio was the Rookwood Pottery of Cincinnati, an outgrowth of a local potters group under the influence of William Morris, the British champion of craft work who, in retaliation against the industrial revolution, aimed to replace as many mass produced objects in the home as was practical. The accent was on one-of-a-kind objects or objects in reasonable editions. And all created by hand. The movement — both in England and America — finally collapsed, but did establish an important precedent for the artist-craftsperson movement in the United States following World War II.

Jack remembers visiting a large Ohio pottery with Luginbuhl's high 63

school art class, but now neither can remember its name or even its location; and Jack certainly was not aware of the extensive achievement in clay that had taken place in Ohio.

*

The main thrust of Jack's researching porcelain had been to locate a medium which would fire white and be strong enough to support minute sculpturing details, essential qualities for the genre scenes. But now he procrastinated returning to them. The major historical statements in porcelain actually lay in the elegant container forms — bowls, vases, cups — and he wanted to work with these classical shapes, effect a transformation, not by altering in any way the ineffable container forms, but by replacing the surface painting and three-dimensional ornamentations, which he often found downright silly.

Jack

I related with all my heart to the forms, but seldom with what was done in decorating them. I mean there were exceptions, of course. . . .

How would his embellishments look on these containers, most of which seemed to emanate from an ideal world of proportions, beyond his ever creating? For that, an artist would have had to live in a world where ideal shapes were everyday — rooms, gardens, cities, then books, art, philosophies — traditions Jack had hardly encountered in Ohio. But was there not a legitimate tradition for borrowing basic shapes from the past, then introducing information from a new age for their surfaces? The idea soon became an obsession.

The students in Jack's ceramic classes were predominately amateur potters, and predominately well beyond the normal student age. Jack readily admitted a number of them had attained technical knowledge more advanced than his own. Having dabbled at potting for years, these amateurs had experimented with most clay media — some even with porcelain. And when Jack announced the warping of white clay in firing his genre scenes, a woman in the class immediately suggested a tried porcelain formula: kaolin, ball clay from Kentucky and Tennessee, plus feldspar and flint. The ball clay was a dusty brown, but turned white on firing. The flint was white. The formula required an extremely high firing, cone 9 or 10.

From reference books Jack selected two containers, one a graceful, tall jar with a round cover, the other a vase. Each had been initially created by a European master, but obviously under the influence of earlier Chinese masters. Because Jack did not possess the technique to handthrow porcelain, he laboriously constructed his forms by coiling, a process in which the artist first forms a long worm of clay — its diameter depending on the thickness desired for the vessel being built — and winds it around and around on top of itself to construct a shape. These containers would be thin, so he used a thin coil; and the thinner the coil the more chance of the form's sagging into formlessness. Therefore he advanced slowly. After coiling a wall up several inches, he stopped. Then, while pressing the coils on both sides with his hands, he gently turned the wheel until the coil wall between his hands had become a smooth wall. Again he wound a few more inches of coil onto the finished wall, and repeated the smoothing process. This inching upward was continued until the desired shape and height were attained. Next he modeled handles, not ordinary loop handles, but sculptural shapes one could grasp for lifting — two faces, a girl's on one side, a dog's on the other. Along the shoulders of the bowl lines were traced in a graceful crossing pattern, with minute bas-relief daisies at several points where lines intersected. Modeled flowers were placed on the cover as finger grips. The undulating shape of this covered jar was a taxing challenge to recreate with coiling, particularly as a first exercise in porcelain.

The Everson Museum of Art in Syracuse was the first institution to acquire American ceramics with an eye toward establishing a collection extending from colonial to contemporary. Its semi-annual juried ceramics exhibition — from which works were acquired for the permanent collection — offered the most prestigious exposure available for potters, whether recognized or still aspiring, and entries arrived from across the country. Jack had avoided entering major juried exhibitions, knowing his statement was not strong enough. Now, anxious to test his confidence in this new direction, he decided to submit porcelains to a national jury — and why not try the most challenging? He wrote for application forms. Contributing to his tentative self-confidence was surprise recognition received for two years in a row at craft fairs in Louisville, Kentucky. Paul Smith, Director of the American Craft Museum

in New York, had been selected to choose the prize winners, and Jack's scenes — then still in white clay or plaster — were given a major award for two years in a row. It made the trips worthwhile, even if none of the hundreds of buyers who passed his table was interested enough to buy one of the sculptures.

When the Everson Museum application papers arrived, Jack was stunned to read that the deadline for submission was immediate. Far too anxious to wait two years for the next jury, Jack chose an intrepid move: the two porcelains to be submitted would be the first two porcelains he would ever create. That is, if both emerged from the kiln in mint condition, two would be sent. If only one was acceptable, only one would be sent; if neither survived the firing — a reasonable possibility — Jack would be forced to renege on the application. The entry deadline tolerated no time for refiring duplicates. In fact, timing was so tight, he had already constructed padded shipping boxes.

Jack earnestly wanted the freshness of celadon for his porcelains, but had no knowledge of how to incorporate the color into the clay. Again a class member raised a hand, this time with a mock celadon: the green shade could be produced by placing .50 percent of iron oxide into the glaze instead of the clay. [Plate 6]

The vessels emerged from the fire exactly as Jack had envisioned, and were carefully laid to rest on the yielding foam of his hand-constructed crate. Acceptance/rejection notification would be mailed by the Everson Museum within a month following the jurying. The exhibition itself would open November 24, 1968 and continue through January 5, 1969.

Some five weeks later, as scheduled, word arrived from the museum. Both of Jack's sculptures were accepted for the exhibition. Later another letter: the 'Covered Jar' had won the Award of Distinction. A further communication: one of the porcelains would be acquired by the museum for the permanent collection. The final communication: an invitation for the opening in Syracuse. Fairlie's budget, however, had not anticipated the expense of a roundtrip flight, the only form of transportation guaranteeing his honoring the tight Toledo teaching schedule. Jack and Fairlie spent the night of the opening in Genoa.

Later a letter arrived from Bill Farrell, then teaching ceramics at the School of The Art Institute of Chicago, informing him that he had been on the jury and had reacted with joy on first seeing Jack's entries.

Jack

I've never met him, but I'm real grateful not only for him voting for me for the award, but for taking the time to write me. Chicago's not that far away, but you know I don't travel much out of the county, and when it comes to letter writing — well, everybody really knows about that too.

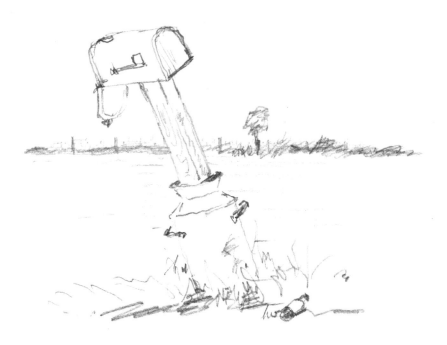

The boy who harvested Roy's corn one year tells this story. He says as he was driving the cornsheller he soon realized by having to follow the rows of corn that instead of the usual way of planting rows, strait rows, back and forth across the field, Roy had planted the field in circles or rather a spiral with the rows getting smaller and smaller toward the center of the field. When the boy finally got the field harvested to the center, he discovered a tractor sitting there in the center of the field.

When Roy had finished planting the field in circles he just drove the tractor over the planted rows to the house but later when he cultivated the partly grown corn around and around to the center of the field he couldn't drive the tractor over the corn to get the tractor out and he didn't want to back it all the way back out of the spiral so he just turned off the motor and let it set in the field.

When the boy drove the cornsheller into the barnyard, Roy was there and the boy told Roy he'd found a tractor in the middle of the corn field. Roy said he'd been wondering where that tractor was, that it'd come up missing some time back. 67

A review in 'Craft Horizons' magazine (recently rechristened 'American Crafts') described Jack Earl's award winning container as 'a beautiful celadon porcelain covered jar with unusual, delicately molded handles on both jar and lid.' The article opened with, 'The 25th Ceramic National exhibition at the Everson Museum of Art almost defied verbalization. It must be seen to be believed. The material is clay, the prospectus demands it, the catalog proclaims it, but where have all the potters gone?' The second paragraph begins, 'There is sculpture aplenty.'

The review is by Jean Delius, a respected teacher/jeweler in close rapport with the national artist-craftspersons movement. Jean was a close friend of, and advisor to Aileen Osborne Webb, the wealthy patron and potter who created the American Craft Council, a nationwide organization dedicated to addressing the needs and publicizing the merits of the nascent American craft movement. The Craft Council generated the American Craft Museum and the 'American Crafts' magazine. The sound influence on the contemporary craft movement by Jean Delius, one of Mrs. Webb's most reliable and confidential liaisons between artists and the Council, cannot be overestimated.

Jean was well aware that artist-craftspersons were plumbing approaches other than functional. After all, the post-war craft media rejuvenation was not comprised of young people apprenticed to a workshop of a single master, but young people sent to universities to examine aesthetic principles in the classrooms of many masters. This environment offered introductions to sophisticated art forms, plus the encouragement to extend the expressive limits of traditional craft media. Most soon considered themselves artists — whether creating functional or nonfunctional objects; most worked in the privacy of studios, not in factories or design shops; and most restricted their production to unique pieces, or at most pieces in small editions.

This year, 1969, is discussed as the year non-functional works outnumbered functional works in national survey ceramic exhibitions. Jean Delius knew the evidence of this direction would soon surface — but not this soon — and thus expressed her surprise in print. However, for the time being she kept off the record the portent of this 'sculpture aplenty': soon the art world, ready or not, would have to contend with contemporary statements in clay. In 1968 only a handful of museums exhibited contemporary objects in craft media, and many 'fine artists' contributed to the snobbery by refusing to show in exhibitions — particularly in art galleries — with artists-craftspersons. Critics, especially those in metropolitan areas, refused to recognize the movement's existence, and when New York critics were informed that prime movers

in clay sculpture originated, at that point, mainly from the west coast, they dashed to pull the covers over their typewriters.

Jean Delius and Paul Smith were both from Rochester, and Jean not only introduced him to craft media during his school years, but served as mentor during the early years of his career in New York. Paul rose to the top rapidly: following a short Manhattan apprenticeship, Mrs. Webb named him Director of the American Craft Museum.

*

When asked recently about his giving Jack the Merit Award at the craft fair in Louisville, Paul admitted he did not remember the specific work, except that it was a small whiteware scene.

Smith
It's confusing since I have seen so much of his work since. During those years I juried show after show. Many different exceptional artists would surface. In those days competitions were really the only means for even the best artists to have their work shown, and particularly in regional situations. Jack was something else. I remember feeling that actually very few people — if anyone — really understood what he was up to, and later I didn't even feel they grasped him at the Toledo Museum school — except as a teacher. There he was in Ohio, figuring it all out by himself. In other words, I think he was actually an underground artist.

*

At long last Jack experienced an honest relationship with his work: porcelain containers surviving in library books — and occasionally in museum vitrines — were one after another replicated with exquisite craftsmanship, then resurfaced with personal iconography. The forms were classic, but they did not lead him into mock seriousness. Just the opposite: their beauty inspired a light heartedness, as pure as the borrowed forms themselves. The erotic expressions attempted earlier — oversized phallic forms topped with female heads, enormous breast shapes, larger-than-life PLAYBOY centerfold figures — disappeared when Jack found Boucher at the museum. The French painter's nudes were promptly scaled to embellishment proportions: small porcelain-pure girls, nude and nubile, now hung from jar lids, balanced on the end of banana handles, cavorted through liands of spring flowers on vase bases. With a growing confidence he entered other shows: a Patrons Award was won at the Columbus Gallery of Fine Arts [Plate 5], and an award plus purchase at the Toledo Area Artists Exhibit.

In 1963 I gained the support of the Johnson Wax Company to acquire, tour nationally and then internationally, and finally donate to museums a collection — titled ART:USA:NOW — of major contemporary American paintings. 'The New York Times' put this business endorsement of fine art on the front page, and 'Time Magazine' responded with eight pages of color reproductions. The Johnson Company's corporate identity with contemporary art was a first, and launched the American 'business-in-the-arts' movement. The 103 paintings now form the nucleus of the contemporary American painting collection at the National Gallery of American Art in Washington, D.C., a gift of the Johnson Company.

Five years later — in 1968 — I felt deeply committed to the artist/craftsperson, disturbed that the fully matured craft movement had received little public or art community endorsement. Searching for an avenue to establish recognition for the artist/craftsperson, I turned again to Johnson Wax, and once more the company responded enthusiastically.

It soon became evident that selecting artists would be a nightmare: with few, if any, galleries exhibiting work in craft media, traveling by plane and bus and car from studio to studio would be inevitable. The launching of this movement was initially anti-establishment; therefore a high proportion of the artists located their studios in the backways of the nation, as far from cities as was practical. The project loomed too mammoth for one person, and arrangements were made with the Johnson Company for Paul Smith to assist. Eventually Paul and I traveled 40,000 miles, acquiring over 300 examples in all craft media from more than 250 artists. The collection, called OBJECTS:USA, was also toured internationally, and eventually given to the permanent collections of a number of American museums.

*

Toledo was on Paul and my itinerary, as it was imperative to visit the studio of Dominick Labino, who with Harvey Littleton, is credited with the revival in the early 1960s of blown art glass in the United States. Paul then remembered giving an award at a crafts fair in Louisville to a promising ceramist who taught at the Toledo Museum School.

Paul
In fact, I think I gave it to him two years in a row. Country scenes in clay or maybe even plaster. He should be checked out.

The visit could not have been more opportune for Jack, now in the full swing of his initial porcelain statement. If we had arrived six months earlier, he would probably have been penciled in our notes as 'still

promising.' The visit was short, but long enough to recognize work with a freshness not derived from any American contemporary clay master we knew. On hand were a number of qualifying sculptures, but Jack requested a specific decision be delayed: several new pieces were started which should be more successful. We agreed, but assigned a deadline. On schedule a carton barrel arrived in New York. Two of the three porcelains enclosed were smashed. Fortunately the one intact was an excellent example.

"Figure With Bananas": a lifesize bunch of bananas lies on its side, disguising a box constructed within. For chocolates? Potpourri? Grocery store coupons? Not important. One of the top bananas extends beyond the others, and straddling this airborne extremity is a young nude girl thoughtfully gazing into new distances. [Plate 7]

All in white porcelain.

*

OBJECTS: USA opened in the fall of 1969 at the National Museum of American Art in Washington, D.C., a lavish formal evening, attended by government and museum officials, art educators, collectors, critics and artists/craftspersons. The museum staff prayed for the safety of the objects in the crush of the astonished but appreciative crowd. Missing were Fairlie and Jack: again, budget limitations and a tight teaching schedule kept them home. But Jack's "Figure With Bananas" was there — on a pedestal keeping company with the finest artist/craftspersons in the nation, including Harvey Littleton, Toshiko Takaezu, Rudy Autio and Pete Voulkos, precursors of the movement whose workshops he had attended only four years previously.

*

I remember this girl and she liked to deam about liven in a castel and had pictures of castels hanging around and she'd talk about how pretty they were when the sun was settin and how she'd like to climb to the top of the tower and look out over the country and how much she'd like to live in one and she'd say "Wouldn't you like to live in one too" and I'd look a the big flowers printed on the linoleum floor and say "Yes."

*

The American Craft Museum, a four story building then abutting the Museum of Modern Art on West 53rd Street, maintained a policy of not sponsoring one-man exhibitions of contemporary artists in its main gallery: the Board felt, at least for the time being, that the public would

be better serviced through group thematic shows providing overviews on the entire movement. Later, however, a small area on the top floor was opened for one-person exhibitions, hardly space for a retrospective, but room enough to delineate an artist's current statement. Soon after our visit to Toledo, Paul offered Jack a show in 1971 in the upper gallery, which allowed Jack two years to prepare for the first New York exposure of his porcelains.

Almost simultaneously Jack was contacted by the John Michael Kohler Art Center in Sheboygan, Wisconsin, roughly an hour's drive north of Milwaukee, a town with a nearly contiguous neighbor, Kohler, the source of millions of tubs, basins, urinals and other plumbingware found in American homes. Jack had never heard of Sheboygan, its small art center, nor of The Kohler Company, but was complimented by the attention of any serious art organization. When the assistant director, Ruth Kohler, a large woman noted for her perpetual joviality, telephoned to ask if he would prepare work for a 1972 one-man exhibition, Jack responded with an immediate yes. Like Paul, Ruth can no longer remember at which craft fair she first encountered Jack's work, but she never forgot it. Ruth is also sister to the Chairman of the Board of the home-owned Kohler company, but did not at that time mention it.

The eponymous John Michael Kohler was Ruth's grandfather, an Austrian emigrant who advanced from salesman to the founder, in 1873, of the Kohler Company. The art center bears his name only because the building was once his home.

Ruth
He was into the arts, though. He produced an opera house for
Sheboygan, and commissioned stained glass windows for his home
— they're still here.

Even though Ruth is a Kohler, the art center is not an extension of the company. Instead it is supported, according to Ruth, by some 121 corporations in the area, the Kohler Company's providing only four percent of the operating funds. For a house the space is commodious; for an art center it is modest, actually inadequate considering its full

program of concerts, theatre, cultural explorations for children, plus art exhibitions. Ruth's major interest lay in contemporary art, and particularly in craft media art, and more specifically in clay art, due to her immersion in the familial involvement with commercial porcelain.

Basically, of course, Ruth invited Jack to show at the art center because of a rapport with his statement, but other motives were present. First, the company's centennial was approaching, and she hoped to interest her brother in sponsoring a national survey of contemporary American ceramics, distinguished enough to tour. Secondly, she wished to interest her brother in an 'artist-in-industry' program for the Kohler Company. To elicit her brother's interest in the survey, she must introduce him to the mature work being turned out by artists in the medium, and of all the clay artists she could think of, Jack seemed the most qualified for her intrigue. The medium was porcelain; the technique impeccable; the statement easily absorbed by an audience uninitiated into the art-craft movement. Ruth had never met Jack, but she didn't want to bother with letters — artists are notorious for agonizing delays in replying. She picked up the telephone, called the Toledo Museum School, spoke with Jack and received his commitment. To lessen the likelihood of breakage, Ruth drove to Toledo herself to pick up the sculpture. Besides, it would be nice to meet him.

After Ruth and Jack had loaded the cartons of porcelains onto the truck, they sat down to talk. Ruth mentioned her relationship with the Kohler Company, and Jack expressed his respect for factories, their efficiency, knowhow, no nonsense, no bull sessions, no intellectualizing — everything channeled toward the best job possible. Ruth then confided her 'artist-in-industry' dream. They were together no more than a quarter of an hour: it was a long drive back and she hoped to make it before dark.

Of course Jack was unable to attend the opening.

*

Herbert V. Kohler, Ruth's brother, enjoyed Jack's one-man show, and with this favorable reception from the man who was both President and Chairman of the Board, Ruth broached the possibility of a national exhibition of ceramics as a company centennial project. It was too early to mention the art-in-industry concept: one involvement at a time. Her brother consented to consider the idea: Ruth drew up a prospectus, and during each meeting with him and the board, enthusiasm mounted. At last the company issued a formal endorsement. Ruth titled the show 'The Plastic Earth.'

Ruth

Eighty-eight artists were included with a total of about 350 pieces. Needless to say, it occupied every corner of the art center. It was exciting as there hadn't been a large survey of only ceramics in a long time. About thirty-five of the artists arrived for the opening — oh, not Jack. And since these artists paid their own way to Wisconsin, I thought something special should be arranged for them. What about a tour of the factory! Herb okayed it. And after the artists had seen the inside of Kohler, we had a picnic lunch — oh no, my brother wasn't there for the lunch. I wanted to learn if the artists were really interested, so during this picnic everyone brainstormed the idea of artists' studying Kohler's commercial methodology. The interest was spontaneous. They had already been awed by the technical possibilities not available to studio artists. Well, it was good to have that confirmed, and then I would just have to sit on the idea until the right time popped up for another Kohler adventure in the art world.

There is no indication that Paul Smith knew of the Kohler Art Center's plans for an Earl exhibition, but Paul managed to arrive in Toledo well ahead of Ruth to make his selections. Paul of course wanted Jack's New York debut to be well received, and toward that end strove for an impression of consistency; all porcelain, all containers, all with lighthearted, witty embellishments.

Away from New York for the opening, I was unable to see the exhibition until a month later. The upper gallery had been painted completely white, including the sculpture stands. Besides spotlights, shadowless available light poured in from the floor-to-ceiling north windows, and in this space devoid of distraction, the white porcelain containers dazzled, each as chaste as the first porcelain container ever formed: elegant coffeepots, vases, jars predominated: the remaining works were porcelain boxes to be displayed with lids askew enough to reveal the contents: a miniature bathroom, a fish, a dog, a finger. Jack used one box cover for a sculpture: a large unexploded bomb dented an area of grass deeply enough to remain erect. The surface flourishes of flower garlands and nudes and birds and leaves and bananas and strawberries and more leaves and napkins and puppies enlivened both the forms and viewers. Seventeen works.

I had arrived at the museum door when it opened, early enough to be alone in the top floor gallery for half an hour. On the way downstairs I glanced into a small mezzanine gallery, and remained transfixed by a life-sized sculpture of a large dog of a certain age, as blase as the most jaded of the jet set, seated with hind paws in pink dancing slippers, eyelids half-closed, a red bow for a collar, a red panting tongue, a tail bent under his haunch to protrude suggestively between his legs in front, a ruff of wirey rufescent hair down his spine. Unmistakably porcelain, a dazzling achievement in conception, modeling and scale. [Plates 9, 10]

A museum guard whom I knew stopped at the doorway to ask if I had noticed the plaque on the wall. 'It's the title — all of that's the title!' Its presence was as unexpected as the dog's: a flat porcelain plaque, almost egg-shaped, perhaps almond-shaped. Tiny porcelain clam shells traced the outer edge, not unlike a necklace. Eggs and clams and almonds — containers of secrets. With further reflection the shape became the ruralization of a vesica piscis — a mandorla, an aureole masquerading in drugstore iconography. The message on the plaque was written in gold — good grief, it was in Jack Earl's hand. Was Jack sophisticated enough to employ these numinous forms? At any rate, with these plaques, the alert viewer should recognize this dog as far more than a camp object.

"Dogs are nice and make wonderful companions I have been told, and most people get dogs when they are young and cute and so much fun to play with, not thinking about how long a dog can live. You got to train them when they are young too, of course a kid can't train a dog right. I wouldn't take a grown dog who had had a previous owner, cause you never can tell what you are getting, even though some of them look real good and will lay still for you. You can't change a used dog's bad habits either and they stink, dogs all smell the same. The best dog has a greedy streak and will howl and drool and paw until they get what they want and I like old dogs best because they just lay around and don't bother you so much anymore."

Clams, eggs, almonds, visica piscis/aureole certify this title to be Jack Earl scripture. Paul had rightly not collocated the dog with the other sculpture: the frolicsome statements upstairs were from an earlier turn of the road.

Guard
I like the long titles upstairs too, but this is the best.

Lee
Upstairs?

Guard
They're all together, typed on white paper and posted on the wall.

To the top floor again. Most of these porcelains too had narrative titles, not as extensive as "Dogs are nice," but all cast in a similar good humored rusticity. An example, this for a coffee pot with a girl kneeling on a horizontal spout, arms resting on the lid, looking at a dog on the other side balancing on the lip below the lid.

"My girl is a nice girl, she's not too pretty but she is real nice. We went swimming off by ourselves one time and she fell down and hurt her leg. I should have known then, but it was too late and I guess she could have done better." [Plate 11]

A hexagonal covered vase with a dog and girl at the base:

"Me and my dog used to go on walks and we would walk the railroad track for about a half mile and then cut through the woods over to Wendell Fraiser's dad's farm and then come back past the pond and I'd throw rocks in it for a while and then go home. Now I got me this girl and we don't go so far."

Following several visits to the museum, I unravelled, for my satisfaction, the personal declaration — if not credo — Jack fired into this redoubtable dog, the final sculpture completed for the New York exhibition.

The surface announcement: with the uninhibited tour-de-force of the dog, Jack first proclaims — almost trumpets — his technical assurance, and second, acknowledges himself as fine artist. The technical self-confidence evolved through his adoption of porcelain, permitting him to build shapes and design surfaces matching his visions; the artistic self-assurance solidified through the approval of his conceptual ability by peers, starting with the Everson jury and ending with Smith's inviting him for a New York museum exhibition.

The deeper — inside the clam/egg/almond — kernel disclosure: no more hitchhiking on bandwagons of stylish movements. From this point his work would be oriented only toward personal experience — which means life in Ohio, precisely as the gilded narrative title for the dog exemplifies. The vesica piscis, consciously utilized or not, signifies the anagoge of the decision, uniting him with the muck-world goodness of heart and deed and spirit, his own swamp of creativity. Finally, selecting a dog for his metaphor — and particularly this dog — is assurance Jack's credenda will not preclude humor.

*

I telephoned Jack, inviting him to join my gallery roster; he accepted. I acquired the dog for my collection (later given to the American Craft Museum), and acquired all of the containers still unsold for the gallery collection.

Jack
I remember when Paul came to pick out the show from what I had on hand in Toledo. Sudden like he asked why I was doing this kind of work. I just couldn't find an answer to the question. Then he went on to say that some people were making things just to be different, you know be noticed and get recognition. Well, what I did and what I knew then was how to take something and make it different by making it like me. It wasn't copying. I was being honest, or I sure think I was anyway. I really think that if you are doing something different to be different — I don't think it's going to amount to anything. There's not going to be any depth in that. I really thought about what he said after he had left — and you don't have to print this. I don't think fast but I think things over. I thought he should have been able to recognize if it was something done to be different or if it did really have body, you know, depth. . . . When I think about it now, I guess he did know my sculptures weren't hoaxy or he wouldn't have given me the show. . . . Oh, you can print this if you want.

Paul Smith's next major exhibition in the large downstairs galleries would be 'Clay Works,' a national survey of recent ceramic directions, which would also include Howard Kottler and Patti Warashina. Paul wanted Jack represented, but not with a work already exposed in his one-man exhibition. He telephoned Toledo. Jack was away, but an associate, Karl Cohn, took the call and informed Paul of 'three incredible penguins,' Jack's latest sculptures. Paul requested all three for the show. When Jack learned of Cohn's commitment, he was upset, not because Paul shouldn't have his best work, but because it meant driving once more to New York for the delivery.

The penguins were a highlight of the exhibition. Jack explained that the concept had been germinating for several years, but it wasn't until he thought of doing three instead of one that it jelled — a trio of fraternizing individualists. Jack first fashioned a mold of a paunchy penguin, flippers down at his sides (the identical attitude to be used later for portraits of marsh farmers), with an expression of discomfort, as if being looked at by a stranger. Three porcelain castings were taken, and Jack then personalized the form, surface and color of each. One penguin's back became a landscape painting of Ohio; a pair of large

white angel wings were hung from another; the third carried a woven basket of spring posies — Ohio, the church, the beautiful life! Brilliant china painting on the map and posies contrasted dramatically with the black and white of the birds, and represented his first use of this paint usually considered exclusive property of hobby artists. [Plate 13]

The trio appeared to be alto-egos of "Dogs are nice," the weary dog representing Jack's struggle to gain acceptance as an artist; the penguins celebrating the resilience gained.

Jack later mentioned that a mold of the dog had been made as well. Four were cast, and each given an individually altered surface.

Jack
I ended up basically with a two-piece mold. But there were three smaller molds to pick up the belly and the inside of the front legs. And lots and lots of modeling after I got the basic shape of the dog out of my hit-or-miss molds. It's a miracle that dog ever saw the light. But I was determined. I coddled and coaxed those plaster molds. Maybe someone was guiding my hands. I won't try a mold like that again without more expert instruction from a pro. Maybe I can find a course somewhere.

*

Jack and Fairlie, joined by a couple on the staff of the Toledo Museum school, had driven to New York to deliver the works for the American Craft Museum one-man show.

Jack (letter excerpt)
The first time Fairlie and I went to NYC was with Karl Cohn and his wife, Donna. Delivering the work for the craft museum show. We stayed at some friends of their's apartment. Lots of locks on the door and an iron bar to prop against it. Wood work that had lost its shape with the many coats of paint. Radios and lights left on to fool the robbers. Voices shouting behind closed doors. I don't blame them. We raced from gallery to museum to landmark. We did NYC in three days, I think. Fairlie and I never did that again. We just go and wait, take a walk, look for something to buy the kids. We might take a drive down to the end and up into Harlem. No more galleries, no more museums, no more landmarks. Praise God. But they were fun. I just don't feel like I belong there.

Because of the teaching schedule, the Earls and their friends were obliged to return to Toledo before the opening of Jack's first New York exhibition.

During the end of the sixties Jack created a large wall relief, a major work which was not exposed either in Toledo, the Kohler Arts Center or at either of the American Craft Museum shows. The work is dated twice, once 1969, and in another location, 1970.

Jack
Usually works that I completed in 1970, I also put 1969 on. 1969 is a much more interesting number — visually. I hated to see that year pass.

The large white bas-relief porcelain portrays a woman's standing at an open window. At the left heavy draperies tumble to and over the stone sill, much as her dressing gown spills off her left shoulder, revealing a full breast. Her left hand absently holds the collar of a lamb-like dog, whose head hangs over the sill. Her right hand is raised chin high, the index and middle fingers joined just above the thumb, as if composing a Buddha mudra. Reverently she observes the gesture. Behind the woman we do not see, as expected, a room interior; instead, with artistic time/space license, Jack reveals a house trailer sitting in an outdoor yard area. The sumptuous white surface undulates from form to

gleaming form, all reverberating with joyous rhythms of Della Robbia; and more, evoking one of the most respected images in the catalog of Christian iconography, the Virgin mother. Jack has bent space, tradition and spirituality into a jubilantly focused recreation of 'a fifteenth century Italian painting and I can't remember the painter's name.' The woman, of course, is Fairlie, even though called Marsha in the title, and the house trailer their first home. The breast suggests her being with child, but Jack claims that was not intended. The title below, however, confirms a pregnancy. [Plate 8]

Jack burned the handwritten title into the surface of both side panels of a broad frame he fashioned from rough wooden planks.

Title (left panel)
"I met Marsha in a bowling alley over in Belle Center about two years ago. I don't remember how we really first met but anyhow she showed me a few pointers about bowling and we had a couple beers. She asked if I wanted to take her home and I ask her where she lived because I didn't have much gas and I didn't have a dollar left to buy any. She said she lived over on 51 and I thought I ought to have enough for that so I said okay. She set real close to me all the way and she put her hand inside my shirt, that felt real good and I kept thinking about whether I'd have enough gas to make the trip and then I had to pick up the guy I'd gone bowling with in the first place and take him home."

Title (right panel)
"I got her home and she asked if I wanted to sit in the car for awhile and I said I'd like to but I had to get back before the bowling alley closed and pick up Tim and take him home. She took her hand out, gave me a pretty long kiss, thanked me alot and went in the house. After I saw her at the allies a couple more times and we started dating and after a couple months I figured we ought to get married and we live in a house trailer now and I still got my same job. She is going to have a baby in three months and after we get the trailer paid off we are going to use it for a down payment on a nice house until then we store the stuff we don't have room for in her dad's barn."

Signed: Jack Eugene Earl

If "Dogs are nice" celebrates the epiphany of 'Jack come into the art world,' "I met Marsha" celebrates the epiphany of 'Fairlie and Jack come into love.'

In the late seventies the Studio A gallery in Chicago mounted two exhibitions for Jack, and the Director, Alice Westphal, asked me to write a few lines for the invitation to one of them. I entitled it, "I once knew a man with two first names." If I had known then that Jack had a middle name, and that it was Eugene, my title could have been more lively: "I once knew a man with three first names."

Later, Westphal decided to concentrate solely on abstract ceramics, and dropped Jack, among others, from the roster.

Kenroy Wireman's favorite chair was an old overstuffed chair with the backing tore off and when ever Kenroy was in his chair his dog would crawl in the hole in the back of the chair and lay there under the chair. You couldn't see the dog. Roy said when he went to visit Kenroy and didn't know about the dog, he said when ever Kenroy talked the dog kept quiet but the dog would growl all the time Roy was talking.

*

Jack Earl's new sculpture in the new medium attracted sudden, serious attention, and by 1972 his career was launched with the most respectable of credits: both museum exhibitions and acquisitions. The satisfaction of this recognition was tempered by a nagging agitation,

which Jack eventually centered on the museum school itself. Specific grievances were readily identified: minimal compensation, minimal (or perhaps zero) advancement opportunity, minimal studio facilities; none of these, however, could match the growing enervation resulting from seven years of teaching non-professionals. Jack had noted other faculty members, after serving four or five years, exhibit a similar disenchantment, the major putdown identifying the school as an involvement in smalltime instruction: only universities provided vital environments. During his stay, Jack had watched a painter, a print maker and a potter transfer to other posts, and now Jack admitted he too sought a new climate.

Jack
It just seemed time to plain leave. I was restless, frustrated and couldn't sort it out. So change. Maybe even to outside Ohio.

His only out-of-state travels were the quick trips to New York, and until that moment, living outside Ohio could never have been considered.

On a spring afternoon in 1972 the first serious possibility for a shift arrived with a telephone call from Richard Butts, head of the Craft Department at the Virginia Commonwealth University in Richmond: would Jack be interested in joining the department and teach ceramics? The appointment would include an Assistant Professorship and a salary well exceeding his present one. Jack acknowledged interest, but told Butts a discussion with his family must precede the decision. At home everyone admitted to some form of listlessness with Genoa. Jack then accepted Butt's offer to inspect the craft department and meet the faculty. Fairlie flew down too, but the university only paid his fare.

The VCU craft department was large: besides clay, courses were available in glass, weaving, jewelry, wood and metal working. The faculty impressed him, first, by immediately making him feel welcome, and second, by its obvious pride in being artists-craftspersons.

Jack
They were all younger than me — I always forget that I started my graduate work ten years later than everyone else — and they wanted the best craft department in the U.S.A.

The one serious shortcoming lay in the clay section where equipment was inadequate and outmoded; even the kilns were small. The department head offered assurances that upgrading was already on the way. Jack gathered the necessary letters of recommendation, and after normal institutional delays, notification of the appointment arrived. Teaching would start in the fall.

Sometimes Jack explains switching to Virginia in more off-handed versions.

Jack
I left Toledo because it was the style. I didn't know any better. I thought a university job would be the thing to grab.... Well, it was a lot more money and we needed it with the kids growing up.... It got me out of the state.

*

In early summer the Earls located a realty agent to place their house on the market. The family, plus Roy, then drove to the land they had recently bought in southeast corner of the state through a newspaper ad, an ideal retreat for weathering the hot weeks: walking by the stream, even with no fish to catch; hiking, even if restricted pretty much to the property; playing cards, even though every deck had bent corners; doing nothing, Roy's favorite pastime; repairing the house, not Roy's favorite pastime. The family together, sharing apprehensions and expectations over living for the first time outside Ohio. In August the realtor telephoned: 'a sure buyer' was at hand. The family hastened north to sign final papers.

Shortly thereafter Fairlie and Jack drove, with expenses paid by VCU, to Virginia in search of yet another home. The sale of the Genoa property provided sufficient funds to purchase a house in Virginia, that is, if prices weren't out of line. Hardly partial to cities, and particularly to cities 'in foreign states,' they requested suburban rentals or sales. Realtors escorted them in all directions for several days, and when it seemed no house surrounding Richmond was unoccupied, a diehard agent informed them of a new listing in Chesterfield, a section to the south. The house represented just about everything the Earls didn't want, and they couldn't believe even undiluted desperation could lead them to signing, but it did. However, a lingering presence of mind insisted on, and was able to obtain, a six months 'trial lease.' Once settled into Chesterfield they would renew the search.

9 3

Moving date was the end of summer. Jack painstakingly transferred the stack of corded pre-porcelain erotic stonewares beside the garage to the property edge for the city trash truck. Plaster nudes and breasts from the garage studio soon swelled the pickup pile.

Jack
I really wondered if they'd take them. Or maybe just call the police — or the newspapers. But they were you know real indifferent. And those pieces weighed a ton apiece. It was a one-at-a-time job. But they did it. Man, a lotta work. I really felt sorry for them.

Stoneware breasts, armpits, nude torsos sailed into the air and crashed into trash.

Jack
You know — it felt good to have them hauled out of my life. But when I think about it, they did help future faculty members. Or so we were told sometime after. Fairlie says it was kind of my legacy. See, the reason all of us faculty spent so much time talking to each other was that on the days we taught we had to stay there a full day even if we only had one class. The bullsessions finally started to — well, bore me, so I'd go to work, especially when I inherited Schulman's studio. Well, for several years I filled the place with all those big sexy stonewares. Besides the ones made there, I brought lots of others from home for firing. Pretty soon the administration didn't know what to do. They were beside themselves. All those classes of college students and adult amateurs — you know, nonprofessionals, some real conservative, couldn't keep their eyes off my pieces. Some were even starting to do erotic work! And then that lifesize playgirl centerfold did it. That lay there exposed for months because I wasn't sure how to fire it, and by that time I was losing interest in the whole nude scene. They couldn't censor me without a statewide faculty strike. When I left they found a real good solution everyone liked — especially the faculty. From then on, faculty was required to be in the building only when teaching. That meant: 'Do your oddball stuff at home.'

*

Jack and Fairlie and Steven and Kathy and Dianne, plus Robert, Jack's brother, and his wife and three of their children formed a caravan and forsook Genoa before dawn: a large new U Haul truck, with trailer attached, was driven by Jack; followed by a volkswagen van, driven by Fairlie; followed by a station wagon driven by Robert, Jack's brother, who came along to help because Jack had helped him move a couple

of times. When they reached the freeway south, Jack accelerated, but the truck would not exceed 35 miles an hour.

Jack
You know, it became real obvious real soon that someone — like the rental company! — had adjusted something — like the governor — to limit the speed.

The caravan was pulled off the road for a hasty conference. One and all decided not to return to the rental concern: a confrontation would only magnify the ordeal and risk a lengthy delay. Like Sunday sightseers, they ambled south. At one point Jack took a wrong turn, and while half aware of it, was too tired to admit it. Eventually Robert got him turned around. Twenty-one hours later, with stops only for food, they entered Richmond.

Jack
Everyone was wore out when we got there. Fairlie was the only one with enough energy to go to the landlord and get the key.

Their new home didn't charm the rest of the family either, and on the day Fairlie discovered the entire house infested with cockroaches, real estate agents were again alerted.

Jack
But the properties we could afford — $13,000 maximum as down payment — were just generally dumps. Or something just not us. I remember talking to one realtor who was giving us a peek at a choice place just right for us that hadn't been listed yet. It was a big mansion. White — with pillars, like the real south, and it was down a pretty lane. They wanted $60,000 and I kept saying we couldn't afford that and he kept saying oh yes oh yes we could. And maybe we could have managed, but this mansion began to frighten me. We didn't want to live in a mansion. We didn't even have clothes for a mansion.

Finally the Earls inquired about properties beyond the suburbs. One agent, remembering Jack had mentioned fishing, suggested a river site to the southeast, 'not too far off.'

Jack
And we got in his car and started driving and it just seemed like we drove for a long, long time before we got there. And, I think it was even after dark, wasn't it? When we got there?

Fairlie
It was just dusk.

Jack
Yeah, I remember now because the sun was setting across that river. It was pretty nice. Cape Cod design house, I think. Two story. Brick. Fireplaces at each end of the house. Porch off the living room. Loplolly pines like telephone poles in the yard. We went through the house and it was real nice. It was $47,000.

Fairlie
That was beginning to sound reasonable to us!

Jack
It was more than I ever expected to pay for any house. And it was so far — it seemed so long — but that river. And with the sun setting. Fish were flopping. There was a white sand beach. Oh yeah — the view was to a bend in the river so it looked twice as wide. Well, it didn't make any difference how far the drive was. We knew we wanted it. So we bought it. We didn't even make an offer or bargain. No, we just gave her what she wanted.

*

The property covered a little less than an acre of land. A dirt lane wide enough for a car, wound from the road through a grove of tall pines to a sandy rise of ground on which the house rested. A garage abutted the left wall. The back of the house, facing the river, was considered the front, and some twenty feet of lawn led from the door to a steep bluff rising roughly thirty feet above the water. The river was tidal and usually silty, but with no cities nor factories upwater, it was unpolluted.

The Earls established a good rapport with the owner, 'a real tough old lady,' who kept a forty-five under a napkin in the upstairs bathroom so she could shoot down at strangers on the property. To alert the countryside about the gun, she would target practice now and then in the yard. She told Jack and Fairlie about a boatload of men who had dropped anchor right at the bend of the river. The drinking was all right, but the yelling was driving her crazy. Finally she shot at them. To her consternation, they shot back.

Just prior to the Earls' arrival an antique dealer from Richmond had appeared to purchase her furniture, which evidently included several rare early American pieces. After spending hours flyspecking every object on the property, he offered her $450. She threw him out. But she liked Jack and Fairlie and the kids, and since they had met her price for the house and since she was tired of 'shyster dealers,' she offered them the antiques for the $450. They accepted. It was the finest furniture they had ever owned. It was the finest house they had ever lived in

too. Relatives and friends in Ohio agreed — including Rex Foyt and his family — and visited often. Roy, who will travel to any water supporting fish, made frequent appearances.

Daisy would wait on the pier for Roy and Steve to come in from fishin on the Chickahoming river in VA.

Jack's teaching schedule was relatively light — beginning and advanced and graduate level ceramics courses — and helpfully concentrated into three days a week. But until the new equipment for the craft department was installed, Jack found it impossible to work at the university.

Jack
No space. The ceramic area a dump. Most equipment hand made. Kilns inadequate. Too many students.

As an interim solution, a wheel and work table were set up in the Charles City garage. During the winter moving quilts were hung from the low ceiling: four padded walls defined his studio. Lacking kilns, he was forced to drive — slowly — the fragile shelf-dried sculptures to the campus for firing. Jack's initial one-man exhibition with the Lee Nordness Galleries comprised only work previously exposed: porcelain containers from the American Craft Museum show and "Dogs are nice," actually an ideal group to introduce Jack Earl to the gallery collectors; and it was questionable whether he could have produced a body of work as

consistent in quality when caught in the midst of the switch to Virginia.

Three-fourths of the works for his second Nordness show were modeled between the quilts, and the balance in a studio Jack later built halfway down the bluff. A platform floor was anchored against the embankment, with pillars rising from the river beach to support the floating end. The working area was placed snugly against the bluff. Lots of glass for light. A deck was positioned on the river side for the view. Jack also constructed stairs from the lawn to the beach, with a break at the studio.

When Jack had completed the sculptures for the show, he and Fairlie drove them to New York, but as usual returned before the opening. The garage pieces were perforce small due to the sizes of both studio and kilns, a situation particularly frustrating to Jack because he now felt the urge to increase scale. The studio space would accommodate working larger, but where was the larger kiln? The promised university upgrading was still only promised.

Jack had abandoned borrowed classic container forms, as "Dogs are nice" presaged, and returned to the genre tableaux that had initially led him to porcelain. The earlier plaster narrative sculptures — objective, deadpan replications, with or without humor, of everyday Small Town, Ohio activities — now adventurously opened for conjecture the subjective fantasies of neighbors.

A typical work: in an art museum a somewhat self-consciously nude girl stands stiffly, arms hanging down at the sides, hands pressed against her thighs. Behind her hangs a landscape painting faintly resembling one in Cezanne's Mont Sainte-Victoire series.

"Me and my girl used to go to the museum on Sunday, while we were still dressed up and she had me take her picture for her brother in the army."

Whose fantasy undressed the girl? The photographer, whose unseen presence we only learn of through the title? Since the snapshot was intended for the girl's brother, it would not likely be, we hope, her fantasy. It appears that the photographer must assume the role of Wishful Thinker. Jack used only one wall — that behind the girl — to create the museum gallery space, and it is only partial. Both ends are broken off as if wrenched from someone's psyche: slats holding the plaster (memories of Jack and his brother's housebuilding?) protrude; studs are visible. The gallery at once becomes a theatrical set, further accentuating the irrationality of unclad girl/photographer/museum. The scale is intimate (6¼" x 7¼" x 4"), as it is with all but one of the works in this series.

In a slightly smaller sculpture — a living room is defined only by a floor and the wall facing the street — a nude woman holds the front door open wide enough to glance into the front yard. Again we are given a structural detail torn from the house: floor board support beams are exposed; one end of the single wall is broken off in the middle of a cabinet, revealing shelves of dinnerware; an overstuffed chair is sliced in half. The only color in the work, except for the rich cream of the porcelain body, lies on the street side of the wall, where a richly hued landscape covers the entire front of the house, including the door. [Plates 24, 25]

"Where I used to live in Genoa Ohio, people lived in houses. They lived in them mostly at night. During the day they would come out and do things. When it got dark they would go in and turn on the lights and after a little while they would turn them off. Nobody knows what people living in their houses is."

As to why the nude looks out of the front door, perhaps she wants someone to notice her. Or is it the wishful conjecture of the 'I' in the title?

Porcelain allowed crisp details — the slats and miniature dinnerware — without the heaviness encountered with plaster. For a finishing touch, a reflective transparent glaze was applied to suggest a distance from reality appropriate for these uncomplicated realizations of complicated psychological states.

Also included in the exhibition were sculptures exploring a vein Jack first worked at Ohio State with his studio-mate, Stull: Jack labels this direction a Zen 'interior/exterior' vision. A group of porcelains appear to be solid, but are actually constructed of two perfectly fitting parts, which, when separated, usually disclose china paintings on each of the inner surfaces. Hiding inside sculptures of rocks, coffee cups, houses are drawings of dogs, landscapes, sunsets. Perhaps the most intriguing was a form shaped like a pound box of candy, porcelain white sides and a peaceful landscape in muted colors on the top. Closer observation reveals a thin line around the sides of the box: its construction also is of two fitted halves. The top is lifted, unveiling a white anaglyph: a young woman lies on a bed, a sheet pulled up to just below her breasts. Her head is propped on a pillow, hair fanned to the sides, and her body turned slightly to one side, with knees bent. On the inside of the top half the reclining figure is carved in negative. Normally in this series, painted surfaces lie buried inside. Here the color is outside; inside a woman (intriguing enough to qualify as succubus) waits in white silence. [Plate 27]

The title for one work — a white farmhouse with china paintings on its two inner surfaces — provides a down-to-marsh rationale for this series.

"I was setting along the river, watching it flap when this guy came along with a big knife and he was chopping things into [sic] and I said what are you doing that for and he said to see whats inside."

Jack
There is a relationship of nature to all things. Take apart a landscape and find a bowl, and take apart a bowl and find a landscape. It's really not all clear to me. Just the idea of chopping things in two — this is difficult to verbalize — not a kind of act — but to find out what's inside and the same thing is in all of them.

"Duck on waves: a duck can stir you, all floating and pretty setting there making you think but as soon as you get to know him you find out he don't want nothing." [Plate 19]

The largest work in the show floats a life-sized white porcelain duck on a long platform of white porcelain waves. Hollow modular boxes, each roughly 4 inches high by 12 inches square, form a six foot long base, whose top surface is undulated. An erect open book is also floating, from which the duck is reading. This time, a gentle debt seems due Surrealism. "Duck on waves" was invited to the International Exhibition of Ceramics, shown in London at the Victoria and Albert Museum.

Jack complemented the exhibition with several miniature white porcelains. A female nude stands on a chair (9″ high): 'May I use your chair she asked. Sure I said and then she stood on it.' A mutt (2″ high) with a rag over his head: 'Come out of there I holler but he just set there.' [Plate 15]

Jack
Sometimes it's more serious than the humor it first seems like. Things that surprise us we often find funny, and they aren't always meant to be.

The strength of the exhibition centered in the fantasy genre scenes, trenchant insights of small town privacies, most pulsing with sensuality. Jack actually never abandoned eroticism when the stoneware playgirls were abandoned and he changed clay mediums. First the Boucher nudes appeared to decorate (circumspectly) the earliest porcelains; soon sexual statements grew more forthright: girls straddling branches and bananas — how far can subtlety lapse? Bare breasts adorned pots, and one small

round jar lid was modeled with a vagina-inspired flower. A faculty friend suggested that teaching college girls can energize the libido of the most conservative male.

The sexuality of the genre scenes is far more sophisticated: bluntness evaporates as (healthy) erotic inhibitions are expressed as a way of life, not as decorations. It would appear the fantasies are those of the artist, not of the figures in the scenes, and it is our loss that Jack was unable to particularize more universal daydreams at the time — as he never returned to them. In fact, these works closed the chapter on eroticism.

His intention for this exhibition had been to exhaust a single subject, but bureacratic vibrations at VCU soon proved too disruptive to sustain the required concentration.

One further note on the sensuality: in the initial American Craft Museum exhibition a small porcelain depicted a girl's sitting on a grassy mound, not under the shade of a tree, but under the shade of an enormous bomb whose head had dented the ground enough to remain erect. When I questioned Jack about the obvious sexual references of a seated nude with legs spread apart and a bomb, he answered that this was one work which 'for sure' was not erotic: the sculpture expressed the explosive, frightening shock of puberty. Indeed, the intention of the work was not erotic, but only the purest of heart would read into it Jack's mainspring without a clue from a title.

*

Although Jack and Fairlie did not remain in New York for the opening of the Nordness Gallery exhibition, they did linger for a pre-opening dinner party in their honor. Some time after a bread and butter note arrived.

Jack (letter excerpt)
So this is what the people in N.Y.C. are like. No disappointment. On the edge, no slow up. I was glad to find out later there was some Ohio in you when you went to sleep while I was talking. The thing I remember most about that dinner party was the tall wine glasses, the oriental young man who did the cooking and the fat Princess who always had somebody next to her, letting her accent roll off her lower lip. She seemed taller than me but she wasn't. You never seem to have any dull people hanging around, everybody full of gogo. As far as I can tell Fairlie and I are the dullest you are able to put up with. I'm glad we made it over the line.

On a subsequent trip to New York, the Earls were accompanied by Sandy and Ted Rollins, Fairlie's sister and husband. To liven up dinner, a Spanish restaurant famous for its floorshow was chosen. Margaret Phillips was my date.

It was summer and Ted arrived in New York in shirtsleeves, and furthermore, with shoulders too broad for my coats. Then I remembered an Admiral's jacket bought in a second-hand store long ago for a party. The fit was perfect, and we were given a ringside table, for the Admiral, of course.

Jack (letter excerpt)

I remember the night you took that wonderful actress, Ted and Sandy and Fairlie and me to that wild forigen night club. When I heard your girlfriend, Maggie, had been the star of a Tennessee Williams play and had been in two movies, well, that was the first famous New York actress we've ever met. Fairlie said she has the most beautiful voice she's ever heard. I agree. Remember when the waiter asked if we wanted anything to drink and I said coffee. You touched my shoulder and said, "no, No. After that you took over the ordering for us. And then the dancing girls came on. Skin, pearls and feathers everywhere. Whisling and kicking, head dresses so tall they had to bend down to get on stage. Pearls falling and rolling around on the stage. Somebody could get hurt. The girls was all happy to be working, at least they never stopped smiling. And then that chubby pragent lady came on and sang a vicious love song. She was a hard worker. The food came and you had to tell us to eat as a group of young men acrobats started jumping, springing, bouncing and flying all over the stage. We saw them later on TV and were proud to tell our friends we'd seen them in person. I remember you looking at the bill with the waiter's flash light it took a while. It was serious business. You were still smiling when you paid. And then off to the most popular ice cream parlor in town for coffee and desert. It was crouded, its crouded everywhere in New York. Everybody in there was talking, eating ice cream and drinking imported water from France. Imported water from France? That made me look and wonder. We ordered. Fairlie ordered a $4.50 sunday. She was getting into the swing of things. You were finished first. You sure can eat fast. You paid the bill again. You taught me how to intertain but I haven't used that knowledge much. That taxie ride. Roy never had an old junk car or truck that rode as bad as the taxies in NYC. I made some comment about maybe slowing down, we weren't in any hurry and you and the cab driver gave me a lecture on the art of taxie riding

*and taxie driving in N.Y.C. All that racing honking bouncing
thumping and dents and scrapes is just the way its supposed to be
cause thats the way it is.*

*

In 1973, a year after Jack's arrival in Virginia, the editor of an art
magazine published by the Virginia Museum of Art invited me to write
an article on Jack's work. Not yet certain where Jack was headed, I
tempered my appraisal with flippancy, much as Jack tempered his
porcelains with levity.

"Down Home With Jack Earl"
*Initial exposure to the porcelain sculptures of Jack Earl evokes a
visual mix of reactions, and this mix can lead to an exhilarating
mind-bending in blending apparently incompatible aspects of
the work.*

*For example: the obvious technical excellence expended on subjects
which at first glance often appear too prosaic; the serenity of a
basic container form contrasted with lavish, even excessive surface
embellishments; sophistication of a sculptural concept contrasted
with the undeniable provincialism of its title; iconography that is
personal, local and emotional contrasted with compositions of
intellectual, non-expressionistic classicism. Worse, through it all
runs a thread of seeming mockery begging a cautious judgment:
dare the viewer become too enthusiastic? This may be a put-on.*

*These conflicts may eventually disappear from the work of Jack
Earl. But they do not represent affectations, and will only be
resolved when prompted from within the artist. It is even possible
that Jack Earl will remain a universal hometown sophisticate in the
tradition of Will Rogers, even Mark Twain. The 'experience' of Earl
could be labeled 'The Twentieth Century Immanuel Kant Scene.'
Or 'Malraux's Museum Without Walls Leaves Imprint on
Midwest Artist.'*

*Why Immanuel Kant? Because Kant refined his pan-influencing
philosophy without reportedly ever traveling more than a hundred
miles from his birthplace. Earl's style was developed without his
ever leaving Ohio. Why Malraux? Because Earl's sophisticated
container forms, typical of his work up to two years ago, all came
from sources found in the 'museum without walls,' library volumes
documenting respected clay art from all corners of the earth.
(Actually, Earl did have access to one museum with walls, the
Toledo Museum of Art.)*

Earl today does not fit into any school of ceramics — or sculpture in any medium. He is a loner, a most refreshing quality in view of the mass-stamped artists being graduated from so many university production lines.

He has favorite subjects which he chooses because they fit what he feels, such as dogs. 'I could never feel a cat.' His definitive statement: 'My stuff is very human. I get as much human in it as I can. I suppose there are other subconscious comments. And these scenes — they're not necessarily things that happened to me, but they could have happened to me.'

The subject content is his own; it is personal, anecdotal, generic, all Jack Earl, vibrated into a reality that is the reality of the artist, not that of an abstract concept or an honorable tradition. Only forms, Earl claims, have influenced him, and when one is appealing, he unabashedly adopts/adapts it for his own, not unlike Shakespeare's lifting plot after plot for his dramas. There have been pieces by contemporary ceramists he has liked, but no artist's full body of work or aesthetic has, he avers, influenced him in any way.

At the county fair I paid a quarter to see the world's biggest bull. It was big. It was layin down and it was still tall. If it didn't have a cow's head you wouldn't have known what it was it was so big. They got the world's biggest alligator there too but I'm saving that until tomorrow.

The dense thicket of loplolly pines, whose trunks are bare for some thirty feet before needled branches spread, nearly shielded the road from the house; and you could, depending on where you stood, see a neighbor's house to one side. The Earls were soon friendly with this next door couple, Martha and Jim Hunsucker. Later they met a new couple who moved in farther down the road, Grady and Shannon Byington. Grady and Shannon enjoyed fishing as much as the Earls, and they often boated together. In the fall Jack cut fireplace wood with Grady, while Fairlie visited with Shannon. Then there were the card games, into the night.

Jack
Grady went to wrestling matches all the time. He liked wrestling so much that during card games — can you believe it! — we had to pause when a fight came on TV.

Faculty bullsessions were as much a way of life in Virginia as they had been in Toledo, except more disconcerting. Whether the subject was art or the teaching of art, discussions were almost always on conceptional planes, opening opportunities for the flexing of intellectual muscle — or maybe 'flexing of intellectual flab.' Jack's Ohio State Zen lessons would defensively pulse back: the emphasis on direct perception of truth or reality, the discouragement of too much intellectualizing for fear of blocking cognizance. Faculty raps drove him to reading art magazines instead of merely looking at reproductions, and occasionally a passage was indentified which had been lifted by one of the faculty without acknowledging credit.

Jack
But it wouldn't matter how many magazines I'd read, I just didn't know how — or even want to learn to speak the language. Also, I felt no need to learn it.

Conversational putdowns from some of his associates were gentle but not unfelt. In the beginning these discussions consumed his attention during the daily drives home. All those years of yearning to delve into art meanings with someone, and now these professionals operated on levels so artificial he was unable, unwilling to participate. Jack could apprehend what was being said, but could not — or would not — comprehend it.

Unlike the university routine, river life rippled ahead peacefully. Jack worked in the studio, in the yard, on the house. Fairlie patiently reassembled her color organ along one wall of the recreation room. Spatial proportions were ideal, and the family decided it fit better in Charles City than it had in Genoa.

*

Teaching continued. When Butts left, Kent Ipson, a glassblower from Michigan, was appointed head of the craft department. He came across as cool, easy-going, and he promoted Jack from Assistant to Associate Professor. Jack's strongest faculty bond was with a clay instructor, Tom Kerrigan, now teaching in Arizona.

Kerrigan (letter excerpt)
Jack and I taught together for three years in Virginia. In fact, we shared the same office, so I usually was the first person to see new works he would bring in to school for firing. For me, this was one of the more pleasurable facets of teaching there. I always found Jack's work to have an unlabored freshness, and a quiet, subtle sense of humor.... I sensed that Jack felt very deeply his ties to Ohio, and that a lot of his work reflects 'life-in-small-town-Ohio' attitudes and sensibilities. Jack is very much a family man — his wife and children were foremost concerns of his. He was strongly committed to Christian morals and was concerned that his children be brought up in the Christian tradition.

Part of our ritual in Richmond was a get-together every Wednesday night with Jack and Fairlie, and occasionally one or two other faculty members. We would congregate at our home for drinks, then go out to eat. These were jovial evenings that I will always cherish. Jack's wit would often blossom during these relaxed Wednesday evenings.

Jack
I had a special rapport with Kerrigan. We taught together. He was sensible, a good dedicated teacher and made nice stuff.

*

One of Jack's students during his early days at VCU — 1973 and 1974 — was Annie Rhodes Lee, who now lives in New York.

Annie Rhodes Lee
At that time the atmosphere was still in a complete hangover from the sixties. For the south Virginia Commonwealth University was

considered a radical university, and it was different, the only 'inner city' University in the south. It was urban, right in the downtown area they call 'The Fan.' There wasn't any campus as is expected of most colleges. University buildings were scattered in a certain downtown area, separated by office buildings, apartment houses and so forth. Campus buildings blended right in with the city. Also, at that time that area was invaded by a large transient population that would come and go to study at the Free University, an institution also in that area. That may be why there was such a sixties feeling around. Rock groups would be playing in the middle of streets while you were going to class. The instructors fell right into this atmosphere. Their uniform was levis, long hair and beards. VCU not long before had been the Richmond Professional Institute, which was completely an art school, but now that it was a state school, the art department still dominated completely.

But the mood was still sixties. In drawing class we had sensitivity sessions where you become aware of the objects you were going to have to draw, and people were dealing with abstract expressionism and deep feelings. I remember being completely overwhelmed, having come from a small town, to be told to sit in the dark and feel objects for two hours so I would draw better. The kids went crazy there, some stripping nude, then covering their bodies with paint, and then rolling on canvases. You were allowed to try anything you wanted. I know this freedom came from the immediate neighborhood environment. There was so much going on outside in The Fan. Oh, The Fan is just a name for that area, and I guess it is fan-shaped. Monument Avenue, which has beautiful old homes, runs right through the city, and from there all streets start fanning out. That's right where the university is. Now it's been developed into a quite nice area, but then it was low income apartments and houses that students and residents could rent. There was also a mix with low income black and white regular city people throughout the entire area.

When I walked into ceramics class, there stood Jack Earl wearing slacks — and real well pressed slacks. To make him stand out more, he had real short cropped hair. He was never messy, which amazed me — to be a ceramics teacher and stay so neat. He didn't look like an art teacher, and yet he was one of the best teachers I had there. You were always a buddy with all the other teachers — there was little differentiation between students and teachers. Jack was inaccessible on the buddy level, but accessible on the good instructor level. At the same time he was very boyish in his humor

and manner — and I mean that as a compliment. In my first ceramics class they gave you awful clay and expected you to learn to do coils and the other basics. Awful. One day in Jack's office I saw some of the figurines he was making, and I asked how he could use clay to make such a beautiful little head, a tiny little head, one inch, and yet it looked like it was saying something. He got some of his clay, porcelain, gave me a hunk and kept one for himself. Then he just started shaping it. From that moment I don't think I have ever changed my way of approaching how to get a porcelain head to work — the time to let it sit up, the time to carve, the time to mold. I wasn't a ceramics major, but I kept up my studies in the medium.

I recall the various art department parties, like craft parties, and I can remember Jack coming by with his wife and saying hello, but not staying all hours in the night as some would and getting all involved and drinking barrels of beer. I remember speaking to Jack once about VCU, and he said his son wouldn't go there. I thought that was interesting and realized if my parents had known more about the school, they might not have wanted me there. But it was a good experience as far as having to volley all kinds of wild ideas back and forth. I don't do ceramics now. I do mainly woodwork. I use old frames and build carvings around them, and then build plaster reliefs inside. It's narrative work, like Jack; also like Jack, it expresses what I have known about my little town, only mine's in South Carolina.

During Jack's tenure at Virginia Commonwealth University, I was invited by the Richmond Museum of Art to jury their annual craft exhibition, and I stayed on for a few days with the Earls to enjoy Charles City's undiluted ruralism. The most vivid memory is of the daughters, Kathy, the elder, and Dianne, both still in their teens. Recall is fresh because I photographed them, a hazy day, lawn and flowers between the house and river bank saturated with early spring color. The camera viewfinder framed closeups of faces both beautiful and haunted: dark soft hair, peaches and cream skin, brown eyes. Each was insecure about her head angle, and eventually each assumed the identical slightly turned and bent head, with large eyes almost peeking into the lens. A tension signaled a state between fascination and mistrust. Then finally pressure eased in submission to the lens. A moment of Wuthering Heights on the Chickahominy.

Although the area was named Charles City, no city existed. It turned out to be the name of the county. The nearest — three miles away — commercial activity was at the Holcroft crossroad: grocery store, gas pump, church, parsonage and two other houses. The church was Baptist: the Earls became Baptists. The three children had gone for some four months to Chester public school while still in Richmond; now, after the move, to Charles City County public schools.

Jack
Ninety-nine percent black. You will have to ask them about that experience, and it was an experience. Very few white families sent their kids to public school there.

Throughout the Richmond district, older frame houses, whether built by farmers or gentry, were in demand. The Earl's recently constructed brick house was not of this vintage, being more of a cozy brick misplacement from a planned suburb. Jack usually refers to it as either Colonial or Cape Cod, but it wasn't much of either. Perhaps due to their having lived in so many older houses, poorly conceived and carelessly kept-up, they were delighted to wrap up in relatively maintenance-free brick.

*

Jack
I remember the relaxed peaceful visit we had with you when you visited us in Virginia. And the party the museum people in Richmond invited you to and we went along. The long dresses, high ceilings and carved stone fireplace. Fairlie and I never got back in that house after you left. . . . I didn't know OBJECTS:USA was so important. I learned later.

*

Except for the two shows for the Lee Nordness Galleries, Jack felt he hadn't turned out much important work, at least not major pieces, while in Virginia. He did make dogs, small dogs, 'nearly a hundred of them,' an exercise in ingenuity, as he worked from four or five basic dog body molds. Each casting was altered by the addition of a unique head, tail and legs. But always an unchanged torso. Few people noticed. Among these packs was a 'mad dog' series — dogs provoking, dogs provoked. Thomas Armstrong, Director of the Whitney Museum of American Art in New York, and his wife acquired a number of the dogs for their personal collection during a visit to Jack's university studio. Jack has later been invited to participate in two major Whitney Museum exhibitions.

Jack still considered his first priority the mastering of his medium. How was he to achieve more sophisticated porcelain techniques without a porcelain guru? Perhaps industrial training could be investigated. A number of porcelain factories were scattered around Ohio, and even though most specialize in dinnerware, worthwhile experience could certainly be picked up through hands-on learning, the method to which Jack best responded. A letter arrived, requesting me to write several Ohio pottery factories about a possible artist-in-residency. When I telephoned for more details, Jack as well mentioned the Kohler Company in Wisconsin, and described his first meeting with Ruth Kohler in Toledo. Most relevant was her dream of initiating a continuing art-in-industry program at the Kohler Company.

I suggested Kohler as a more challenging location than a dinnerware factory. Not only was Kohler probably the largest producer of commercial porcelain ware, mostly plumbing, in the United States, but it was known for its quality and continuous technical updating. Jack agreed, and I wrote the company. An answer from their public relations department was prompt: my letter was being turned over to Ruth Kohler, now director of the art center. I mailed Jack a photocopy of the correspondence, and suggested that, since he had met her, she would probably appreciate his contacting her directly.

Jack knew Ruth liked his work. She had after all arranged a one-man show of his early porcelains, and later acquired a piece from the exhibition for her own collection. Her brother evidently thought his show fine, too. As a favor for Ruth, Jack had designed a number of announcements for his show — postcard shaped clay slabs with the invitation scratched into the surface — which she sent to local critics and press representatives.

Jack
I realized I had just hit forty. Imagine, forty and I still hadn't mastered my medium. Why was it so difficult to get help?

Finally he telephoned Ruth, and told her he had been thinking about that factory — and would really like to come work there. Ruth remembers laughing at his forthrightness, and recognizing simultaneously the fortuity of the call. Her dedication to involve Kohler with contemporary ceramists was as strong as ever, but she had been forced to procrastinate: as the arts center attracted wider attention, obligations to its schedule consumed more energy. Jack was right, there should be an artist-in-residency program — and wouldn't Jack be ideal to initiate it? His national reputation as an artist-ceramist was secure; more crucial, his personality would be compatible with a factory ethos

— no self-indulgent antics, no effete nonsense, no superiority vibrations. The Kohler artisans were accepted masters in their field: they must not under any circumstance feel slighted by the introduction of an artist into an environment rightly theirs. Ruth thanked Jack for the idea, and promised a residency project would be presented to Kohler as soon as she and her staff could get it on paper; further, Jack would be recommended as the artist to launch the program.

Jack
What kind of compensation would there be?

Ruth
Well, there usually isn't any with a residency — oh, of course lodging and food and materials.

Jack
Would you or the company mind if I tried to get a small National Endowment of the Arts grant to help out — in case I want to buy special industrial tools or so forth? And for transportation?

Ruth
Of course not.

Jack
When I think about it, there could be times when it might be too much to be there all alone — you know, with no one to talk to in sort of art language. What about another ceramist with me? With two we could feel more independent, even if only in lifting heavy things. We wouldn't have to bother the employees. And I'd try to get someone who also had worked in a factory.

Ruth
I'll put it in the prospectus.

Jack
You know, there might be times when I'll need a buddy to let off steam.

Sometime later Ruth telephoned that the Kohler Board of Directors had been responsive to the idea, and chances were warm for its adoption. Jack then applied for his grant and began thinking about a co-worker.

*

As if the answer had already been determined, Tom Ladusa popped into mind. They had met when participating in a ceramics workshop in Baton Rouge, and Jack had thought him 'quite a personality,' long on humor, industrious, even-tempered.

Jack
He was as inventive as he was intense. Intelligent — not an intellectual, no academic hangups. And he had mentioned having worked at American Motors, at Jack Case and some foundry.

LaDusa was teaching ceramics at Southwestern Louisiana State University, located in Lafayette, and inviting an artist from the boondocks was appealing, not only because Jack was pure backwood marsh himself, but also because boondocks fellows were mostly overlooked when unusual opportunities materialized. He telephoned Tom LaDusa. The young man's enthusiastic response was assurance that the right selection had been made.

Jack
I asked Tom to go to Kohler with me because his wife told me he worked hard and he said, 'Yeh, I work hard.' We, Fairlie and I, met them at a workshop in Louisiana. I liked Tom. He told some jokes I'd never heard before. I sure didn't want to take on Kohler by myself. Ruth asked me about this weakness in myself, but I'd been teaching at VCU so it was easy to come up with some intelligent-sounding, face-saving philosophical reasons for having another artist along. I knew we'd have a time. I asked my boy Steve to go too, more companionship, and to show Steve the inside of a factory and to go get us cokes. He was just seventeen then. Ruth okayed all this. If I'd been thinking real good I'd taken my dog, Daisey Mae, along too. Then it would have been perfect.

Tom
Jack and I met, I believe, in March of 1974 in Baton Rouge, Louisiana. He was selected to do a workshop at Louisiana State College in the ceramic shop there. I heard about it, so I drove over to see what he was about and what he was up to. The first thing they had asked Jack to do was show his slides. There was this large room, enormous room, cold and just a lot of concrete and it

was obvious he wasn't really at home there at all. I would think he was quite nervous. He was showing his slides and they were delightful. I was excited, but you could not hear what he was saying. He had this real real soft soft voice. You might pick up a word here and there. People were beginning to complain. Somebody suggested to give him a mike. When they were trying to push the mike toward him, he more or less backed away — like it was some kind of weapon. Finally, reluctantly, I think, as I recall, he did take the mike, but spoke so very softly that we could barely hear him even through the mike.

Later on there was a party for Jack and that was during the evening, and I showed up to see him. It was strange that Jack and his wife, Fairlie, were sitting all by themselves off in a corner, again in a very large room. There wasn't anyone going over, talking to him. It just was like nothing was happening in that room. It wasn't a party at all, and I walked over and introduced myself, and we talked. Like all ceramic type people I had my slides with me, and we started to look at them and he was responding and liked what I was about. Later on we we went out and ate something.

The workshop went on the next day and Jack was demonstrating how to cast objects in plaster, and you could see that there was a whole lot of enthusiasm in this man, lots of energy, and he would bob around and answer questions, trying to get everyone squared away. He seemed very involved in his teaching method. Later someone asked him to demonstrate actually building an object like the way he built them, and he had everyone gather around him. He sat down at a potter's wheel and used the bat as the form to build on. Then he pulled out a real real small coil and circled that coil around and took a little more clay and rolled out another real small coil. Then he attached that coil to the one he had just put down. And this went on for at least half an hour. Everyone was just standing around and watching him do this, and that's the way he works on his own pieces, I guess. I've still never seen him build one of his forms, and I think it was Cynthia Bringle or someone who said why don't you just throw that form on the potter's wheel and be done with it, and his reply was, 'No one can throw or build walls this thin.'

The thing that strikes me now is that while Jack was in that ceramics studio he was in control, and there was confidence. Nothing there disturbed or distracted him. You could hear him easily in that room. He would give advice and criticism and so that was his power-place. The people were all there to get information

he knew full well about, so he was very confident and worked well in the studio, whereas he doesn't do as well showing slides or talking about what people should do. When I showed Jack my slides, the things I was doing then were real large rubber latex forms, great big butterfly-looking things and space creatures, organic and funky — that was like ten years ago. The scale was so different from what he was doing. I kind of analyze it that I like people's work that is far removed from the way I think.

It wasn't too long after the workshop that Jack telephoned and asked me if I wanted to join him at Kohler in Wisconsin to work in the factory sort of like an artist-in-residence. He explained a little about it, and I said yes before he got into the third sentence. I knew it was going to be right, going to be something exciting because I knew how much he was involved in this material I was involved in. Plans were made and I sent slides to Ruth Kohler, and they asked me to come. Jack and I met in Wisconsin, just outside Sturtsman. My parents were living there then, and we stopped to visit. Jack had his son, Steve, with him and he would stay the month and help us in the factory. I feel he had Steve there for other reasons too. It's very important that Jack has a part of his family with him at all times. I have talked about Jack's involvement in porcelain and all that, but probably the most important aspect of this man's life is his family. What goes down there is more important than what would go down in the studio. It's like he has a good grip on what is his job and what is his family and he knows where the important element belongs. We visited with my parents, and he was very relaxed and my parents enjoyed him a lot and I think Jack enjoyed them. Of course we were still in the midwest and I think he fares well in the midwest. The same kind of people, I guess, are in Ohio as are in Wisconsin, and everything went off just perfectly. It was nice.

*

Fairlie suggested that since the residency would be 'heavy duty,' both Jack and Tom would get a lot more out of the month without families — except for Steven. Tom's wife agreed. Jack, Tom and Steven were provided with rooms at the American Club, a facility built for single — usually blue collar — employees in 1918. A few rooms usually remained open for transients.

The Kohler Company lies four miles due west of Sheboygan, on the other side of the I-9 freeway, in a small town eponymously named Kohler. (1984 population is 1,623.) Manicured lawns prevail; shade trees

abound, and the ride from Sheboygan on Highway 28 — usually called the Lower Road — is at times like moving through a park, especially when the Sheboygan river meanders along the highway. During Jack's stay, the company fronted on a street with a wide strip of lawn and trees down the center, but recently the company expanded, annexing half the street plus the center parkway for company property. The street name was then changed from High Street to, curiously enough, Highland Drive.

Jack
A careful town, neat, no old cars sittin' around. Residents are more permanent than the average.

The Kohler company entry drive cuts through a vined brick wall. First stop is the sentry gate for security clearance. Ahead, to the right, to the left, are massive buildings of stained yellow brick, their air institutional and anonymous in the manner of austere factory structures in Europe's older industrial cities. Designations are explicit: Cast Iron Foundry, Brass Foundry, Enameling, Packaging, Generator Plant, Office Building, Small Motors, Warehouse. Pavement stretches from building wall to building wall, and the trio was driven through these broad shadowed passageways to what was to become their building, Pottery. They entered a vast high-ceilinged space vibrating with movement and sound and heat, a work environment as distant as possible from an artist's studio.

*

Jack
In our first tour of what was to be our working building, we went past a place where there were yellow sculpture stands all lined up neatly in a row. I didn't pay much attention to it, but then I said, 'My God, Tom, I bet that's where we're going to work!' He looked back and said, 'Oh no — like a fish in a glass bowl.' But it turned out to be the best place because it was the most public. We could get the best response and pick up on the total energy of the place, and not just one area. It was a big space, high ceilings and there were ropes around it to mark our place.

Tom
When we walked through on the first tour I was a little uneasy looking at all those fine pieces of ceramics and all this wonderful color. A-1 quality everywhere — any blemish whatsoever and the piece was discarded. That high level of achievement was almost scary to me.

Jack

When we first got there we were invited to the President of the company and Chairman of the Board's home for a party. There was Ruth's brother, Herb, Ruth, the main men of the company and the main men in the pottery, all with their wives, plus Clayton — he's the one who would work with us — and his lovely wife. Fairlie was with me then, and Tom's wife, Dickie, was there too.

Everything went just fine for awhile, everybody standing around, eating little things and drinking a little, the way it's supposed to be and then Tom and I decided we wanted to play some softball so we got the equipment from Herb's boy, David. Tom, Steve, David and myself went out to the big circle in front of the house and went at it. Somebody came out to watch, somebody else came out and pretty soon we had a game going. Somehow or other it got competitive, and Herb went to first base and wasn't going to let Tom make it past. He was going to tackle him. Tom figured that out so he just ran to third. Herb took off across the circle chasing him. And it stayed rough until the women figured out what had happened to the party inside and came out and broke our game up. We stayed some after the company men had left. Herb liked Tom. When I first met Herb I asked him how he was doing. That was a dumb question. Anybody could see he was getting by pretty good. He didn't answer me. Tom tried to talk him into producing a toilet for children, maybe shaped like a worm or animal or something. Tom was full of ideas and big plans. We didn't know that the place moved even slower than a university.

Clayton Hill, an experienced caster with Kohler for thirty-two years, was designated official liaison for the residency project. Only a few days were required to build a professional and personal rapport between artisan and artist.

Jack and Tom were provided with standard Kohler ware, any form each wished — wash basin, cast iron bath tub, urinal, mortician's sink, on and on — with no limitations on quantity. Nor on quality: each piece would be in prime condition — no cull, as flawed pieces were designated.

Jack and Tom were trained to create sculptures from scratch in the usual studio procedure. At Kohler they would encounter no soft clay: preformed plumbing shapes were the starting point, all raw — that is, direct from molds, leather-hard, still unfired. These unblemished functional objects were to be transformed into art objects. The shapes could not be squeezed back into mounds of pliable clay, then reshaped. The forms must be dealt with 1) as a whole, or 2) by physical dissection into solid parts, or 3) by joining with special epoxy glues to other plumbing ware,

or 4) by any combination of these possibilities. Glazes in eight to ten bathroom colors were available for surface decoration; commodious kilns were ready for firing.

Tom

The plant was a good place to work. There was nothing formal and we were able to act out our personalities. And have fun. We could enjoy ourselves and yell and scream and roll on the floor and spit. And the workers would join in and hoot and holler and we got some kind of jungle sound going back and forth. Noise — but there was communication in it. . . . The thing I really want to emphasize is the situation that the factory set up for us pace-wise. It was incredible that noises were fine — and that they functioned. We moved along with the factory, along with these guys. If you took a break you felt sort of like a criminal, like you were breaking the law and that you were falling way behind. And that's the kind of thing I think exists at Kohler between the workers. We were going to work hard at any rate, but it helped to have that kind of thing existing already. Quick pace, big strides. Clayton kept us from going bananas. The men Kohler has in charge are the right ones. Really pros. The men respond to them. [Plates 16-19, 21-23]

Jack and Tom and Steven's daily routine:
6:30 A.M.: breakfast at the American Club coffee shop.
7:00 A.M.: arrive at work area. Clayton awaits their order of the new ware they wish to work on during the afternoon. Jack and Tom wheel the work they have glazed late the night before to the kiln loaders for firing.
Return to the work area to complete transformations of the ware Clayton brought the previous afternoon.
Noon: lunch, usually at factory cafeteria.
1 P.M.: wheel the pieces finished before lunch to the drier. The balance of the afternoon is spent working on the new ware Clayton has had delivered.
6 P.M.: dinner.
10 P.M.: return to working area. When the glazers finish their shift — around ten — Jack and Tom spray-paint the 'art objects' that were dried that afternoon.

Midnight: return to motel.

Tom

We only had a month. We wanted to take advantage of it. I think that was my personality. I know it's Jack's too. He's the kind of person who's going to milk a situation for all it's worth, get out of it everything that is possible. We ended up working on five or six pieces at a time. You know you aren't going to do the same thing on every piece so an intuitive thing has to take over, and you just attack it, making marks, adding or subtracting or whatever — all quickly. What happened was that we needed ideas and we needed to find visual material to look at to try to induce another shape or form or line or composition. Jack's suggestion was that we go to town, into Sheboygan, and we ended up at a bookstand. There's Jack, buying up comic books, coloring books, Vogue and Bazaar and all these different magazines. You know how you put them on a table and just start turning pages and what you're seeing is images and forms and your mind is possibly grabbing hold of an idea. You're putting it together that rapidly, and then you would turn to the piece you're working on and gesturally make the image-idea happen, with a tool, brush anything that seemed right. Again all very very quickly. We produced an enormous amount of work.

Jack

I had been used to shaping, modeling clay. At Kohler everything was pre-shaped, right from a mold, and it was up to us to do something with this ware. It is really not like clay, but like a soft no-grain balsawood. It was very strong when pieces of it were fastened together. Before I went to Kohler, I'd heard the clay would be different, harder. That was one of the points of applying for the National Endowment grant — oh, they gave me $3,000 — so I could buy tools that had never, as far as I knew, been used by artists on porcelain. The most important turned out to be the 1/4th inch variable speed electric drill, with all the different attachments, being able to drill any kind of hole — even being able to shape with it. The power saw was not quite as effective — it was unwieldly. You could do the same thing with a knife. The only difference was that a power saw was a lot quicker. With a knife it might take three minutes to cut a shape. With the saw — ten seconds. You could get a good straight line with a saw too. . . .
It was hot in the factory, 90-100 all the time. Poor lighting, tow motors going by during the first shift. Second shift was quieter, more private. Hot, noisy and of course dirty, working with clay. I remember the feeling of my skin in my dirty clothes.

I like to put a lot of craftsmanship into my work — right from the

unformed clay. With the Kohler ware the craftsmanship was already there. To personalize something that is already shaped is pretty difficult. It took me awhile to get into it. Tom was able to get right into it. The first piece he made was put aside for the show they gave us at the arts center when our residency was over. The first piece I made was thrown away before it even got to the drier. Probably most of the first week's work was thrown away.

Tom

Before we got to Kohler Jack said something about 'we should try to make fifty pieces each.' I thought — impossible. I thought we would use brushes for glazes. That's how studio oriented, how prehistoric my mind was. But when we got there and wheeled the stuff down to the spray booths — it doesn't take any time whatsoever to spray up ten to fifteen pieces. So the problem was no problem whatsoever. I really enjoyed it. The floor itself was a tremendous experience — like a spray gun Jackson Pollock.

Jack

I remember Tom with the first piece he was going to glaze. He put it on the stand, picked up the hose and zap — the pressure of the glaze shooting out knocked his piece right off the stand. This was equipment we weren't used to. . . . Kiln space, which is so hard to get in university ceramic studios! We used as much space every day as a graduate student is allowed in a semester.

Tom

University ceramists will have to get into mold construction. The men who make these plaster molds are masters. Their molds are sculpture, functional sculpture. Jack and my idea would be to bring these men to the university for workshops. When they had left the student would have a bank of professional, usable knowledge — certainly more than is gained by having a few of these fruity artists in who show us a few of their slides, tell some stories and then wander off and get drunk. I've already had Exxon people come in to my classes and give welding demonstrations — and it's worked out really well.

Jack

In the beginning the workers, the crews at the driers and sprayers would look at us more than speak to us. Later we heard, 'Whatcha gonna do with that stuff?' I said we were going to sell it. They understood that. Others asked us if Kohler was going to pay us, or if we were getting time and a half.

109

Tom

Once I was pushing a cart with glazes to a spray booth and passed three workers. I overheard one make a comment about 'weird artists.' Another responded with, 'Oh yeah! They work like hell!' Actually during the last week we never left earlier than 3 A.M.

Jack

Things soon changed. Men would come to us saying they were now seeing the pieces they worked with as more than just functional shapes. They were developing different kinds of visual attitudes. Some men wanted us to select the objects they specifically worked with to see how we would transform them. Several brought ceramic objects and asked us to personalize them so they'd have a souvenir of our visit. Our art became personal to the workers because of their involvement with the forms we were working on. Soon kiln loaders and casters and grinders were making suggestions. For example, they came to our aid immediately when we were making floor tiles, showing us how to assure they would fire flat. I know a lot of them didn't want us to leave. . . . I don't see how a man could compete with the factory as a teacher. Not only the technical knowledge, but also the pace, the life, the energy. I don't feel that the sculpture is the most important thing I got out of this experience. That was sort of a by-product. The important thing was the whole experience, something bigger and more important than making a sculpture. The effect the workers had on us was not minimal, and they certainly gave us a lot more than we could give them.

Tom

My teaching method has always been to preach the value of being prolific, make many things, make mistakes to learn from them. This has been reinforced by working in the factory. My students are now going to know that clay is not a hobby shop, not therapy — it is a serious business. Just ask the Kohler workers. The kids will have to work their butts off. That's the only way they can come to understand the material. I will introduce them to the pace of the factory, plus the intuitive way of working fast.

Jack

The whole deal wouldn't have made it without Clayton, solid, steady, stilling influence, and he knew his job with us and didn't take nothing from nobody, that included everybody. He protected us. He enjoyed us. It was a vacation for him. He even got in overtime working for us. He respected us — don't know why, except we didn't cuss. . . . Several people have mentioned that the

factory be involved with the actual education of the graduate student. Tom suggested simply getting a job in a factory. I think that would be restrictive in that you learn only one area. You do learn to work; you learn the pace. It seems to me it would be much better if you could get a feeling for the whole pottery undertaking. Some kind of factory problem — the student would receive college credit for it, and it would simply be part of his education on the graduate level.

Tom

At night we found ourselves driving to Sheboygan. We found a family restaurant there, and it seemed like it was bound to happen that way because here was a place that you walked in and it was like table settings for a family deal and the waitress brings out the mashed potatoes and the chicken and we were able to sit around and it was like a real homey thing, not like eating at McDonalds or Burger Ship or anything like that. It was not a living room, but was as close as you could get. Jack, I think, had something like this in mind. I know we looked around for a little while as to where we would eat and when we found that place — that was it. We may have deviated once or twice. Someone would say why don't you try this or that place, but I think our place was where we had our best and most relaxed meals. We forgot the factory, a refreshing change of pace — while we ate, while we were driving over there and while we drove back. We spent as much as eighteen hours of working time in the factory and just rested or slept enough so that we weren't walking zombies, which did happen perhaps at the very end when we were really putting in a lot of time and getting very tired. Maintaining this kind of energy was the one thing that won us over at Kohler. We walked in there to face an experiment and all the workers — and no telling what would happen. We didn't want to interfere with anyone, alter or change anything. We respected what they were doing, their total professionalism. They were helpful to us. We needed them. They got to the point where they knew that — and then they turned around and wanted to help.

During four weeks Jack and Tom created over 120 sculptures — plus a collaboration on a 83¼" x 107½" floor, constructed of foot square tiles. The designs were painted and sprayed in overlapping color fields. 117

Jack
I liked it. Now I don't know if it still looks good. It was supposed to be thrown away. If not, it should still be in that basement junk room at the arts center.

The news media were alerted, and produced what Jack labeled 'art in a toilet factory' feature articles. Television crews also appeared for news spots. At the first encounter Jack and Tom played it for laughs. The thirty second scene on the screen convinced them to be serious for the next television coverage, and that one they liked. The public did not expect artists, they quickly learned, to be clowns; the public was much more interested in responsible creativity. No sooner was the session over than a craving began for a second reaction to Kohler, and they requested an additional one or two weeks during their Christmas-New Year holidays. Kohler granted permission.

*

Back in their classrooms Jack and Tom attempted to introduce the Kohler attitudes toward clay. Tom felt his students responded to this more pragmatic approach. Jack, however, felt stymied in his attempts by a department not excessively receptive to factory guide lines, particularly when the current accent for craft media was toward studio/fine art disciplines. Jack introduced as much of the Kohler experience as possible without launching a crusade.

*

The return to Kohler during the holidays was a homecoming: handshakes, arm wavings, yells immediately renewing the summer's rapport. Jack and Tom assumed the work pace at once. Tom wrestled mostly with color, an aspect of ceramics he had not really solved.

Jack wanted to perfect two skills only touched on during the summer residency: drawing with the air drill and mold making. Mastering the latter, he discovered, would require far more than two weeks, so he concentrated on the drill, primarily as a drawing tool, blasting the blade along porcelain plaques to embed freehand lines. Glazes were applied as paints, brushed or rubbed on, and he was able to create both abstract and realistic scenes. Memorable was a colorful landscape drawn on the wall of a toilet water tank.

Jack
I met and grew to know and like many workers there, visited their homes, met their families. We were highly honored.

When the two weeks were up, Jack returned to Virginia determined to negotiate still another Kohler stay: while he could fashion molds, they were hopelessly crude compared to those constructed by Clayton Hill.

Even though Jack's classes at VCU were confined to three days a week; and even though he was granted an Associate Professorship with a pay increment, he felt less and less loyalty toward the department. The staff was constantly shifting, and consistently those he cared for most were the most anxious to leave. Jack found it difficult to identify specifically the cause of his alienation, but he made it a point to assiduously avoid bullsessions, especially the heated discussions over teaching theories, most of which Jack could only describe as incredulous.

Once more an escape: Kohler had approved his working at the factory for four months. He couldn't believe they would give him all that time; nor could he believe the university would allow him the necessary leave of absence.

Jack
Maybe some people could breathe easier with me out of the department for awhile.

The mold-making residency would start in September, 1976. Meanwhile, he hoped to take fuller advantage of this opportunity by constructing beforehand, in his self-taught technique, molds for sculptures in scales that had been difficult, if not impossible, to fire in the university kilns. The molds would be carted to Wisconsin for Clayton's evaluation.

Most of Jack's sculptures in Virginia had been from 2 to 6 inches high. Now they would reach 24 inches high. No more the delicate detailing of grass blades: now the scale was appropriate for life-sized portrait heads, roofless house interiors, card players. Modeling strokes were broader. In all he created molds for six major pieces, each to be cast in editions of up to nine. Multiples would allow him to participate in a number of exhibitions simultaneously.

During Jack's first period at Kohler, I closed my gallery in New York to concentrate on individual, institutional and corporate consultations. With no exhibition space, I could no longer sponsor one-man shows; therefore, difficult as it was to relinquish artists whom we had launched — such as Jack — contracts were broken: a continuity of exposure through one-man exhibitions is vital to an artist's growth.

Theo Portnoy, a collector and champion of art in craft media, opened a gallery on one of Manhattan's gallery rows, 57th Street. She had admired Jack's sculptures in exhibitions at the American Craft Museum and The Nordness Gallery, and hearing of my decision to deal privately, contacted Jack. A trial arrangement was eventually reached by telephone, and soon after made permanent.

Secure with a new gallery and challenged by the opportunity of returning to Kohler, Jack plunged into studio work, readying molds for the series of multiples. If these works turned out as well as hoped, they would comprise his first one-man exhibition with Theo. Involvement at the university was now limited to teaching his classes 'as well as possible': the rest was disenchantment. On the drives back to Charles City and the studio nestled against the bluff, many hours were spent staring at the car hood, wondering if the estrangement with the ceramics department could be resolved. No solution was ever forthcoming, and perhaps it was time to recognize it never would be: his value system and the university's modus operandi were irreconcilable.

*

Lee
What kind of lies were you told?

Jack
Well, one example was while I was there they were going to move the department to a better building where you would have better facilities, twice the space. Of course that never happened.

Lee
Was that an out-and-out falsehood or was there a change from a higher level at the last minute?

Jack
It's somehow or other higher up where it begins as a thought and then somewhere or other it gets changed into fact, and by time it gets down to the teacher — well, you know you live around these kind of things. They become a reality to you — and then they don't happen. Now let me give you one illustration of what they would do: on a Wednesday they had to know by Friday where we wanted the light sockets in the new space. They wanted them all marked on the plan of this building.

Lee
They aren't going to make floor plans for a building just to keep the faculty busy. Perhaps funds faded at the last minute.

Jack
Well, like you say, you know, it wasn't necessarily a lie, but — yes, it was a lie to me because when someone tells you a thing is going to happen, and it doesn't. . . and no reason is given.

Lee
You're describing the reality of any bureaucratic world.

Jack
That's right — which to me is lying. . . .

Lee
But knowing it was merely talk didn't help, did it?

Jack
I learned how to handle it, but it still gave me headaches. If you like to talk and talk and talk and talk, a university department can be worth while. If you want to think about it ten hours a day and give it your life. I didn't and don't have that kind of energy. On the surface I was lied to by students, teachers, department heads and deans. It hurt my pride.

*

Due to the length of the Kohler residency — four months — Fairlie and Dianne, the youngest daughter, would accompany Jack. Dianne could enroll in high school in Kohler for the length of their stay; the other children would be in colleges, Steven starting his second year, Kathy her first. After packing and repacking his fragile plaster molds — six months of work — Jack drove north ahead of the others, giving himself lead time in Kohler to establish a work schedule.

Fairlie (written account)
Jack went on ahead to Kohler just before the kids were to start their separate schools. I drove the V. Wagon carrying a load of school equipment and luggage for each college kid plus things for the apartment in Kohler for Jack and me and Dianne. The V. Wagon was made over to a U Haul. We built luggage racks on top of the van to have external room for carrying. The inside was as full as the outside. I took up the toaster and etc., towels, you know, name it, because I didn't want to buy anything unless necessary. We were filled to the top, just enough room for three kids and me. The V.W. is supposed to carry 7 people comfortably. The Byingtons helped me load the top the night before. As we left home we first went to Bluefield, left Steve off with his school things, which did leave a little dent in the weight. Then we came to Ohio. Steve's

school started two days before Kathy's would. When it was Kathy's turn for college, I took her over to Bluffton, got her signed up for her first year. It took all day. The next day Dianne and I went on to Kohler. And in a couple of days she went to high school there. It worked out that the school started just after we arrived. After they were in their schools, I shaped the apartment up for living quarters. A couple of weeks later I started working for Ruth Kohler at the art center in Sheboygan. I could choose my own hours. I worked about 35 hours a week and got off when I pleased. I was only an assistant.

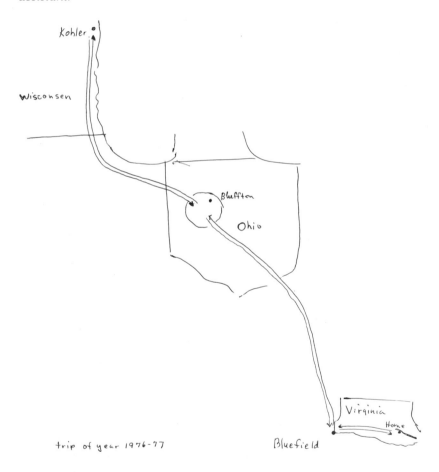

Kohler

Wisconsen

Bluffton

Ohio

Virginia

Home

trip of year 1976-77

Bluefield

During the last Kohler stay Jack learned molds exist to be reworked and reworked, and then refined and refined and refined. No artist will believe another artist's account of a perfect first casting. Jack had appeared at Kohler with a single mold for "Ohio Dog" — a neck and

head and four legs and a tail in one mold. With good reason, it didn't function. With Clayton's help, it was reworked into several sectional molds.

Jack

We discussed mold making, but most of my time was spent casting. I really learned to correct the mold design through casting and firing techniques.

Clayton was a real solid man. Understood slip and molds. Fairlie and I socialized with him and his lovely wife. No exaggeration! They were easy to be with. I long for Clayton's fellowship. We talked.

*

Jack

When I was at Kohler for four months, an arrangement was worked out for me to create a mural for the Pottery building (our building) lunch room. Do you recall Tom LaDusa having big ideas? This was one of them. He wanted to cover the complex with art. Now I was there alone, and doing a big mural where all the workers met to eat. Okay — and enough. I got my idea, made a drawing and gave it to Ruth. I used the general profile shape of the building, constructing it with two-foot by two-foot tiles, each representing through a drawing a separate area of the Pottery. I rested the whole building on a pile of cull. At the top I put Herb Kohler riding on a horse — and he kept horses and rode them — like a statue on a court house. He didn't like the idea too well, Ruth told me, but his family talked him into it.

His wife gave me a couple horse magazines and a picture of Herb so I'd get things right. I took photographs of the various areas and processes, and I photographed men doing things, and started in. One of the tiles was of the lunchroom itself with the mural in it and the workers waving at me like I was photographing it. It was a big job. It took a lot of time and was a lot of work. By time I got to the top of the factory where the horse was I'd got pretty good at making areas look right and people look like themselves. Herb came down to the pottery to look at the mural, but really he came down to look at that tile of him at the top. And when he saw it he stepped back — and groaned. There he was on the horse — unmistakably him, even smoking his pipe. He was embarrassed and wanted out. 'Give me a choice,' he said. I was tired. I was finished. I couldn't come up with another idea. The mural went up. None of

the workers ever commented negatively on the equestrian at the top. He gained respect. But the mural never got respect from the company itself because of him on the horse. The men appreciated it, and felt the company had given them a gift. The management felt I had shown too much cull. They hate cull. Actually cull is not really in the basement, but to them cull is money down the shoot, and cull does go down a shute from the second floor into a dump truck on the ground floor, and then is hauled to the bottom land of a river where the cull truck dumps the cull over the edge of the cull hill it has made. It's pretty out there, the sun reflecting off all those broken, different Kohler-colored toilets and stuff. I soon found out working there that cull is more than lost 'number ones.' There ain't much science in that pottery. It's try and try and try and try again. Their perfection never came from science but from cull, one hundred years of cull. They learn by mistakes. That's a lot of cull. That's why I put the factory on cull. [Plate 20]

*

Jack's first show (1977) at the Theo Portnoy Gallery comprised the final two groups of sculptures completed in Virginia: a satiric dog series, and the multiples prepared at Charles City and cast at Kohler. Six multiples, each in an edition of nine: fifty-four sculptures, varying from twelve to eighteen inches in height.

Another reason Jack had turned to multiples was the fear that gallery income would not yet maintain their budget, especially with three children in colleges. Ceramic sales were steadily growing, but prices were not major league — at that point hovering under a five hundred dollar top, and until prices appreciated, Jack reasoned more work must be available for sale. Multiples were surely a more rational direction than forcing fifty-four unique pieces in the same time period. Even if such a production level could be met, quality would have had to suffer.

*

The six molds created in Virginia sing of Ohio, and should there be any doubt, four of the titles contain the state's name — "Ohio Boy," "Ohio Dresser," "Ohio House," "Ohio Dog." The sculptures snap with the crispness of uncomplicated surfaces — multiples normally preclude intricate detailing — and please with apple pie vibrations. Actually every work in all six editions was individualized. For example, each of the nine "Ohio Dogs" (a life-sized replica of Daisy Mae, surely the world's most sculpted mutt) was glazed with a different palette in a different pattern, the first in the black and white spots natural to Daisy Mae, the others in fauve pigments — green, purple, orange — with arbitrary designs — swirls, diamonds, circles.

Each "Ohio Boy" — the bust of a teen-ager, face blank with Ohio innocence — was detailed differently: on some the caps changed — one billed, one with a bite taken out of it; on some the jackets varied — one a herringbone, one with a boutonniere. [Plate 33]

Jack

"Ohio Boy" felt like nineteen to me. I vaguely used Steve as a model until Kathy said it was beginning to look like him. Then I stopped. Don't know why. I had some strange art ideas then.

Often the individual pieces within an edition not only varied in sculptural details, but in titles as well. For example, three of the "Ohio Boy" titles: "Now look what you've done to my new hat." "Ohio boy in herringbone." "Mom got me the coat for Christmas, I picked out the hat." The dog and the Ohio boy were glazed in varying colors, but the other four multiples remained in shiny white Kohler vitreous porcelain.

Jack

Porcelain as I understand it must be vitreous to be porcelain. The clay at Kohler has to be very hard because of government standards. No water could soak through. Kohler's clay was not white but tan when fired. Tan comes from impure ball clay. White comes from the glaze.

"Ohio Dresser" [Plate 16]
The first of the all-white porcelains, a typically stolid unadorned four-drawer dresser, with the top drawer slightly ajar. The edition varied by placing different objects on the top of each — such as lamp, envelope, wallet, 1930s radio, book. On the cover of the book is scratched 'The Book,' which for Jack always indicates the holy bible.

"Saturday Night" [Plate 31]
The first of his cardgame sculptures consists of only a kitchen table and two intense card players — no walls or floor. The table and two card players (on chairs) were cast separately so that they could be positioned as the owner wished.

"Bouquet"
A bouquet, grasped at the base by a hand cut off at the wrist, stands on its stems; flower varieties and their arrangements vary in each casting. Theo Portnoy feels she has seen a similar bouquet in a print by Picasso.

"Ohio House"
A replica of one of the houses Jack called home during his childhood in Uniopolis. The roof lifts off, transforming the sculpture into a container, perhaps a soup tureen.

In Jack's last exhibition at the Lee Nordness Galleries were a number of miniature whitewear dogs in ludicrous situations. For the balance of this first Portnoy show, Jack reworked these studies into major dog statements. Probably they should be labeled canine sculptures — dog evokes too mundane an image for the elegance and wit now aimed at the art world. All in white glazed porcelain, none higher than nine inches. A canine-man — some breed between a poodle and a wolfhound — portrays Van Gogh, a paw raised to cover his missing ear. Another is a sculptor, passionately modeling a lifesize head of the west coast Funk ceramist, Robert Arneson. Arneson sticks out a long tongue at the dog-artist, who waves an even longer tongue back. (Arneson has created countless ceramic self-portraits, and a protruding tongue has been de rigueur.) Jack also modeled a curvaceous nude female canine descending a staircase, and even though the staircase is not spiral, the Duchamp reference is explicit. A spoof on the sentimentality of nineteenth century European presentation piece porcelains is the technical masterpiece of the group: under a bower an elegant male canine proposes to his lady canine. The smaller lady sits with all four paws on a bench; the larger male places one knee on it, extending his forepaws toward her. Drooping tongues confirm the emotional intensity of the tryst. The bower, an intricate porcelain fretwork of branches thick with sexually suggestive flower and leaf forms, bends around the couple, cocooning them in privacy. At each side, providing both divine approval and protection for the lovers, is a winged canine putto. [Plates 29, 30]

Also in the exhibition were two Kohler bathroom wash basins, each glazed with richly colored amorphous shapes.

Jack
Fairlie, Dianne and Daisy Mae stayed with me during that four-month mold making session at Kohler. Steve and Kathy were at colleges. Dianne went to school and Daisy Mae stayed in the apartment and slept for four months. What a dog. We all had a good time. The night of the farewell party at the art center, it turned cold, twenty below, and snowing and windy. A bad night.

My V.W. bus wouldn't start so we all piled out, my family, Roy, Ray, Ruth. All pushed until we froze up and got back in. I looked back at Roy. He was all huddled up and shaking, shaking all over. We had to laugh. He still remembers that night. He says that is the coldest he's ever been. A couple of young boys stopped and jumped the batteries and got us started. The next day the weather was just as bad and we drove out of that country. What a drive, slow, cold and dangerous. We were all glad to see Ohio.

Fairlie (written account)
When Christmas was approaching, about December 22 or 23, we packed up from Kohler in the V.W. and Jack's car. Plus there was my dad, Roy, and his twin, Ray. They came up to see us just a few days before we left. It was below zero a couple of days before we drove to Ohio. We got to Ohio just before the blizzard hit Wisconsin. We had Dianne with us, of course, and Steven and Kathy joined us. All together with our family and with Jack's mother and my father and relatives for Christmas in Ohio. Then we left Ohio just before the blizzard hit it, and for New Year's 1977 we would be back in Virginia. The kids had about two more weeks before they had to be back in school.

In Virginia they drove through the loplolly poles to a postcard house nestled in snow and pines. Settling in was easy, a family assembled for the commencement of another year. After a few days the fuel ran low, then out. They had forgotten the tank had been almost empty before leaving for Kohler. And it was Friday: no one would make a delivery over the weekend. They remembered the good supply of dry logs Jack had chopped during the fall. The fireplace glow and the pungent sap added to the holiday coziness. On Saturday night Jack and Fairlie visited the Byington's for a card game, and Kathy and Dianne decided to spend the night with girlfriends living farther up their road. Steven stayed home.

Even though logs had been crackling in the two fireplaces all day, Steven's downstairs bedroom remained chilly. He spent most of the evening in the recreation room, lying in front of the fire, watching television. Around ten a smell of smoke distracted him. With no smoke visible, Steven assumed the snow-dampened logs were to blame. The smell persisted, but a tour of the downstairs indicated nothing amiss. Odd, the smell was always strongest in the recreation room; yet there was absolutely no smoke, not even a smoldering log. Nevertheless the smoke odor was real. The garage, built against the house and actually sharing the fireplace wall, could be entered from the kitchen. Steven pulled open the kitchen door, then pushed open the screen door. The garage interior flickered in orange light, reflections of flames rising up the rear of the fireplace wall to the left. The source: a stack of Fairlie's early oil paintings leaning against the base of the brick fireplace. The red hot logs had been burning red hot for too many days, and finally the bricks heated enough to ignite the paper and cardboard wrappings around the paintings. Next the pigments, canvas and frames ignited. Draft from a wide-open garage door hastened combustion. Flames now neared the rafters.

Steven dashed back into the house and telephoned the Volunteer Fire Department. Then he returned to the garage and yanked a garden hose from a shelf opposite the fireplace. The faucet was just outside the garage door, but the hose proved too stiff to straighten, and the nozzle too frozen to mesh threads with the spigot's. Abandoning the hose, he ran back through the garage: part of the roof was now burning. Flames were at the edge of the screen door too. When he pulled on the handle, the screen loosened and fell, the hot wire singeing his hair before he could brush it aside. Inside was worse: a noxious throat-burning smoke filled the rooms. Reacting to fire drill instructions heard or read long before, he dropped to his knees and crawled to the door facing the road. Daisy Mae! With one call the dog materialized and followed him outside. Flames now soared from the garage roof. Grabbing Daisy Mae in his arms, he ran through the dark woods to the Hunsuckers' house.

The neighbors were hesitant to phone Jack and Fairlie at the Byingtons' for fear they go into shock. Instead they drove down and picked them up. The Byingtons returned with them — hoping they could be of help. The house was now half consumed, but still no firemen. Roaring flames flashed heat colors against the snow and tinted high needle clusters on the pines, as if Fairlie's light organ were in a last performance. Fairlie, unable to endure more, walked to the Hunsuckers' house. At last the Volunteer crew arrived: five or six men, two small trucks, one with a water tank. Hosing began immediately, but the tank was emptied in

a few minutes. By time the truck returned with a refill, all was over except last rites: walls were knocked down to avoid their crumbling on someone later. Left were two blackened fireplace towers at either end of the remains.

Dianne and Kathy heard fire trucks passing and came out onto the porch of their friends' house. An orange haze lay against the cold night sky in the direction of their place. When there was no response to a phone call home, the mother of their friends offered to drive the girls back. From the road in front of their property the pines were black silhouettes against a flaming eruption. They dashed from the car to run pell mell down the winding road. Could their parents be trapped inside? Now they began yelling 'Mom! Dad! Steven!' Fairlie, at the Hunsuckers, heard their cries, and terrified they might enter the burning house before they could be stopped, stumbled through the trees toward the flames, screaming their names over and over. Shannon Byington tried to keep up with her, and in the confusion stepped into a hole and broke her foot. The girls heard their mother's calls before reaching the fire.

Kathy (letter excerpt)
The firemen went to the gas station and filled their tanks from an outside faucet, but they needed gas too. The man who owned the station didn't want to get out of bed to turn on the pump. It took forever, about thirty to forty-five minutes elapsed by the time they got back with another tank full. When a house is burning, every minute is crucial. I know that man that didn't want to get out of bed. Every time I think about him, it upsets me greatly. I can still see that whole night flash before my eyes, I can still see the flames coming out of mom and dad's window. How wonderful it was suddenly to hear mom's voice.

Everything they owned, except a few porcelain sculptures in the bluffside studio, was consumed: family papers and photographs, the light and sound organ, antique furniture, motorcycle, clothes, color slide history of Jack's work, the Autio ceramic. Every documentary thread to their existence was cinder. The next day Fairlie remembered that her engagement ring, which she had stopped wearing shortly before, had gone as well, the one from her maternal grandmother, Minnie Hunsicker Zieger, when she gave each of her five grandchildren a ring. Fairlie's had been special because it was the engagement ring from her grandmother's first marriage, which was to Fairlie's grandfather. But wouldn't a diamond require more heat than that from a house fire to disintegrate? Calculating the approximate location of where the ring would have been in the house, she began systematically poking and sifting through the debris. Patience. 'It was the loveliest of the five: a

lacy silver band with a nice sized diamond.' Jack and Fairlie had used it for their engagement ring. And then — there it lay. In disbelief Fairlie turned the ring over and over in her palm. The silverlaced band was now jet: the modest diamond gleamed even brighter.

Ring or no ring, the Earls accepted the disaster as a warning straight from God.

Shortly thereafter they withdrew to dwell in safety in Ohio.

HOME BURNS DOWN
EARLS OKAY

Ceramist Jack Earl and his family found themselves homeless as the year began—on January 5 a fire burned their Charles City, VA, house down to the ground, sparing nothing. Fortunately, Jack, his wife Fairlie, and their children Steven, Kathy, and Diane were not caught in the fire; his nearby studio escaped the flames as well. "We were just stunned at first," Jack said, "but everyone's just fine now." The Earls are living in a house trailer until they decide on their future plans. Asked if he was in need of anything, Jack replied, "No, the people at Mt. Pleasant Baptist Church have been really helpful, giving us money and clothing." After a moment's pause he added, "I *did* lose all my slides though. It would be nice if people who had any sent me copies." Write to: R.R. 1, Box 11713, Charles City, VA 23030.

('Craft Horizons,' April, 1977)

Jack

We always said grace at the meal when the family was home, and the night that our house burnt, I sat at the table and I always said grace, or usually. And I couldn't think — you know, I always thank the Lord for different things and for the food — and I couldn't think of anything to thank the Lord for. And then I just said thank you for the food because there it set.

Lee

And do you think that's why the house burned down?

Jack

Well, I think that is a part of it. . . . Lee, HE STRUCK THE HOUSE. Answer you can or not, as you choose. Live under His protection or He can lift that protection anytime He wants and then you are on

124

*your own. Anyone as ungrateful as I — and I represent my family
— needs a lesson. . . . The Lord has a hand on my life and I was
made to crawl back to Ohio to live and do what He wants. That's
Good News.*

Fairlie (written account)
*The insurance gave us a thousand dollars to get clothes for all of
us. So we went shopping, buying clothes — and luggage bags for
the kids going to college. We decided since we were moving back to
Ohio we just as well let Dianne stay in New Bremen with the
Rollins (my sister Sandy and her husband) the rest of her soph-
omore year in high school. Jack and I sent Kathy and Dianne
by train from Petersburg to Dayton. Ted and Sandy picked them
up. Later we took Steve to Petersburg to catch a train to Bluefield
U. for his college. Jack and I stayed in a rented trailer near where
we lived on the Chickahominy river. It was all furnished. We stayed
there until Jack finished the semester at V.C.U. Ray and Roy came
two or three weeks before we moved back to Ohio. He brought his
R.V. and his boat and trailer down. We fished and played music
and made a recording of a party which is very memorable. Daddy
made up a song about leaving the Chickahominy River and the
fishing and etc. and going home. Saying goodbye to the good times.
When we got ready to leave, there was just enough things to fill the
R.V. and the boat trailer and V.W. and we had bought a new car
(Bonneville). We used it once that spring for a trip, to drive back to
Ohio for Easter.*

"The Old Chickahominy River" *by Roy Hanson*
(as copied by hand by Fairlie Earl)

I'll never forget the Old Chickihominy
Its the prettist home I ever did see
I sit in a chair, in-front of that home
And watch that beautiful river flow by me
She flows so gently as the waters stood still,
And I'll never forget that music of that big
Whipper Will, as I sit by that shore and listen
* to the waters roll.*
As I sit and listen, I will never forget the
* Old Chickahominy Shore.*
While looking across the waters at that
big boat that lays close by.
She layed there for a couple of years and I'll
* never forget her till I die.*
I've fished from that big boat and got a big fish
* and it about took me.*
I'll never forget that Old Chickihominy that never
* got me.*
I'll never forget that day that we left her beautiful shore.
The fish on the other banks have gone,
And I look on the other side, and I see the children
Playin awaitin for me, awaitin for me.
And Oh, the catfish in the Chickahominy, well
* you see, some weigh 3 lb, some 5 lb, some*
* even 10, and that's enough for me.*
I'll sit there all day, and watch the ripples of the
* sea, catch them old Catfish and take them*
* home with me.*
How many in that boat, I don't know, from day to day,
* some comes, some goes, some stays.*
But tonight I'll take one more look over the river
* that looks like a sea.*
And I'll say goodbye to that old Chickahominy
* that old Chickahominy.*

As long as I have known Roy, he has sung and played the guitar and so did a lot of his family and friends and somebody might stop by the farm and he'd hand them the guitar and they'd whip off a tune like 'Wild Wood Rose.' They could play the guitar. But Roy wouldn't sing real songs but he'd just kind a play and sing making up and changing songs as he went. He'd make up songs about the kids when they was around, silly, funny songs, and they always liked that. And he had a particular way of playing the guitar, kind a blues, jass, and hill-billy missed and messed around together and he had a good voice. He could sing but he didn't sing in church. In church he'd just kind a hum and mumble along and sometimes he'd still be huming when everbody else had stopped singing. At home Roy had a tape recording machine in his kitchen and he knew we liked his music and so one day he gave us a tape recording of his music.

I was listening to his tape one day and on the tape he was singing about 'Why didn't you take my posies?' and 'I wish you'd take my roses' and on and on like that and in the background there was a cricket churring. Knowing Roy and his house it was kinda natural for a cricket to be singing in the background of Roy's music. It sounded quiet and peaceful and thats how things were with Roy too.

Roy was singing and playing and the cricket was too when I heard on the tape Roy's nephue, Glen, call 'Roy.' I knew Glen's voice, and then I heard the screen door slam shut. Glen had come in the house.

Roy and the cricket didn't stop singing and Glen called a little louder 'Roy' and he began to tell Roy what he wanted and Roy was still singing.

I couldn't understand what Glen was saying.

Roy stopped his music and said 'yeh' and then there was a click as Roy turned off the tape recorder. A couple minutes of silence.

Then there was music again. This time Roy was singing about the Lord creating the earth and the devil was out to get you and how Jesus was your only chance. The cricket was still singing and playing too.

Fairlie (written account)
We used the LAKEVIEW SHOPPERS GUIDE to locate a new home that spring when we came to Ohio at Easter. That's how we found our present place on Indian Lake. It wouldn't be until June 4 — that was in 1977 — that the house would be vacant, but it was all furnished with towels on the rack and sheets on the bed, ready to move in. All we had was a new stereo, toaster and blender and clothes we had bought, and things people had given us in Virginia. Many people gave us different things. Nice things, too.

Of course we didn't buy from a realtor here at the lake. We saw a House for Sale sign on the mail box as we were driving around the lake and stopped to ask about this home. It was not exactly cheap, but it was furnished and the boat came with the house. Double lot on water front. So Dianne finished school — junior and senior years — in Lake View, Ohio. Kathy and Steve finished up the college years in Bluffton together. Jack worked on his art only. New life. And me, I became a housewife and etc. once again.

*

Jack
The kids worked before college, during college and in the summers between terms, and got state grants, federal grants and federal loans. I helped when it was necessary. They paid most.

*

Perhaps to reaffirm a hold on muck resonances, Jack turned to Ohio genre scenes for the second Portnoy exhibition. The sophisticated and often surreal veneers prevalent in his Virginia sculptures are now replaced with redolences of rustic buckeye humor, expressed with the leanness and purity of a three-dimensional sumi drawing. A transparent glaze over the light beige clay is color enough for these master drawings mounted on flat platform/stages. Less is again more: a paucity of strong, suggestive forms is able to ignite a complete environment.

"A rock on a fence post gives you something to look at
as you pass by." [Plate 32]
From the stage one post rises with three evenly spaced horizontal board fragments. A farmer stands nearby, his outstretched hands gripping a rock he is about to balance on the post. A post, a suggested fence, a rock, a man. No grass, trees, road — and no dog. The indicative weight carried by so few forms endows them with ritualistic force.

"A boy and a girl was talking to each other in the living room. His dog was sleepin under the coffee table. The boy and girl started to kiss each other. The dog got up and walked out."
A sofa, a coffee table, a dog under the table, a standing couple, embracing. The dog has risen, his back pushing up the table so that its legs are an inch or two off the floor.

"One of the most interesting things to people is a man
behind a bush."
On a round stage a lawn bush trimmed to a point at the top. A man

wearing a farmer's cap presses his waist and hands into the foliage. A small dog waits beside him.

"You can take a bath, change you'r underware and your socks, put on your newest cloths to go see your girl and the first thing her dog comes around sniffing you out."
A young man stands with one foot on a step. One hand is raised to knock on an unseen door. The other holds a bouquet. Behind him a dog sniffs his pantleg.

"When you'r toe's hurt and you can't work that day watchin cars go by is what you do in downtown Lakeview, Ohio."
A middle-aged man wearing a farmer's cap, open shirt, work pants and work shoes sits on a free standing porch step. His hands rest on his knees as he stares dead ahead.

Other titles suggest the imagery:
"A successful man is relaxed but not so relaxed he gets his pants wrinkled."

"Darn dogs fighting on my bed, I might as well be married."

"You can tell from across the street if a guys been to college. You can tell by how he walks and by the way he hold himself. You can tell if you want to go over there."

Theo labeled the exhibition, 'Vignettes in Clay.'

The humor is not far from the one-liner variety associated with drugstore souvenir pottery, and appropriately so, as muck humor is not noted for its refinement. It is even likely that the marsh is a major repository for this genre of humor. Jack maintains his distance from the usual commercial sentimentality of Hallmark cards and gift shop figurines through the purity of the whitewear, the strength of the compositions, and most profoundly through his respect and empathy for the cast of characters. Bill and the others are Jack's folk.

Another sculptural direction in this second Portnoy show: five provocative porcelain images with wood-splitting referents, experiences recycled through Jack's Surreal/Zen perspective.

"The Hand" [Plate 34]
A self-standing section of a branch with the circumference of an arm. Part way up the base the bark disappears, and carving revealing the clear wood interior commences: a forearm, a wrist and finally a hand. The index finger is extended upward, and above the knuckle is transformed back into a forked branch. The three smaller fingers are

bent into the palm, and resting on them are two miniature tools — a mallet and a carving blade. The branch has carved itself a hand, and then is becoming a branch again. Surreal — the stuff of dreams? Or Zen — who is the artist, the man or the medium? Or both?

"Campfire"

A large tree stump with bark peeled away toward the top is leveled to a mesa, on which kindling and split wood are stacked — and ignited. Flames dance without consuming the stump.

The daedal modeling and skillful color application in these five ceremonial sculptures represent Jack at a technical zenith, matched conceptually by his transformation of chores into koans.

My first visit with the Earls in Ohio was in 1979. Jack and Fairlie met me shortly before noon at the Dayton airport, some two hours south of Indian Lake. We loaded into their secondhand Plymouth — called a Duster — while Jack explained that the six cylinders were not placed vertically but at a 45 degree angle. Straight or slanted, the six cylinders swept us north smoothly, over long stretches on two freeways through mostly uninhabited countryside. Jack usually initiates little conversation, but Fairlie always has something to relate. The day before they had driven to Elma, Michigan where she and Jack visited a man promoting gasahol stills. It was the height of the gasoline shortage, and few city car drivers, Fairlie explained, knew how crucial fuel was to farming. Reapers and binders consume astonishing quantities, and when the moment of harvest arrives — the annual delicate balance between the state of the weather and the stage of the crop — the delay caused by an additional gas ration request could be disastrous. Most farmers excavated underground storage tanks to hoard fuel for the harvest's day of truth. Fairlie was convinced she could construct a still for their family, which if successful could be enlarged to supply fuel for the nearby farm of the Springers, Jack and Idalou. Idalou is Jack Earl's cousin. Costs for the equipment were minimal, and the fuel could germinate from almost anything organic — Fairlie would use corn and sugar. A bonus: gasahol pollution emission was all but nil.

What Jack did relate during the ride was their joy at being once again in Ohio, and particularly in the part of Ohio where they knew every road, tree, house.

Jack
What I felt in Virginia, when I passed a car on a road, I don't know anything about the guy in the car. When I pass a house I don't know anything about the people in it. Here you know almost everyone. Even if you don't know them — you have a feeling about them and who they are. Even if you never saw them before you feel right about them. And the houses. You know about what's in the house and what kind of people they are. And how they live. You have a feeling about it. You're right about it. If the license plate on the car says Ohio, then you understand him. That's what I mean.

Fairlie
They call our area the hollow. This area makes you feel safe — because of the people.

Jack
I know that the guy next door leads an entirely different life than I do, and I am not interested in the kind of life he leads. I don't want to know about it, but I know that he gets up at 8:30 in the morning and goes to work and works hard, works hard to keep things going. I can walk up and talk to him like a friend — I understand him.

Lee
Has either of you ever read Winesburg, Ohio? It's an American classic.

Jack
Who wrote it?

Lee
Sherwood Anderson, a Ohioan. He recreated the people in Winesberg, a fictitious Ohioan town, and Anderson wrote that a lady from a town in Ohio said she would never feel clean again. In a New England town a group of librarians burned the book.

Jack
Well, maybe I'll read it sometime.

Fairlie
In our family we always had big reunions, and I had my children for a reason — to have them around me, not going away. They are

near the marrying age now, and we wanted them back here.

Lee
So they would marry Ohioans?

Fairlie
Why not. . . . The family is part of you. When you're a family, you even adopt people. My grandmother adopted several children.

 *

We approached Indian Lake from the south, a large lake, some five miles long, and, Jack explained, artificial, formed by closing off one of the small draining rivers. Several tiny islands dot the tan-silted surface, each with a few trees and usually a single house. The original lake was crystal deep, but damming flooded high ground, which loosened enough silt to cloud the water permanently. Still, fish are plentiful. We followed Island View Road along the shore, passing sturdy year-round residences, as well as rundown summer trailer camps and cabins, their yards cluttered with the possessions which turn Jack on — scrap lumber piles, beaten up row boats, a corroded kitchen stove.

For years the lake was famed for an amusement park at Russell Point, the town at the south end, but now it sleeps in ruin: a weathered roller coaster with support planks swinging loose; a rusted, tilting ferris wheel; a whip overtaken by crawler weeds; rows of empty booths, some boarded up, some vandalized; rows of larger buildings with faded signs indicating tunnels of love, tunnels of horror, tunnels of fun. Spanning the remaining narrow draining river — the Miami, one of Fairlie's four — is a broad wooden planked bridge, raked at an almost insurmountable angle to allow passsage for high-masted sailboats. Moored to a high bulwark on the opposite bank a cavernous wooden ship sits motionless, its side planks weather-sheened. Jack explained that the vessel was born only a shell for restaurants and dancing areas.

 *

Jack and Fairlie live at the tip of a peninsula on the north end of the lake, and on the way we stopped at a small town bordering the water, Lakeview, for lunch at Pickering's. Dim interior, cozy grandma's house decor, souvenir plates on shallow wall shelves, abundance of plastic decorative objects, including flowers. We served ourselves from a generous salad bar, then ordered a large platter of chicken. It arrived accompanied by a house specialty, broasted potatoes: potatoes cut into wedges, then half boiled and finally deep fried. A row of stiff puddings

132

at the salad bar comprised dessert. Complaints about food, decor, service, in fact about anything evaporate on inspecting the check: $2.95 each.

Alcoholic beverages had not been offered, and the Earls warned that even though the county was not dry, few places served hard drinks. Liquor stores were available one right in Lake View — if I wanted to pick up a bottle.

*

The road abandoned the shoreline to circle the lake on higher ground. Soon a turn south led us directly down onto their Avondale Park peninsula. First a 'Private' sign; later a 'Restricted' sign. The road ended in a loop, and at its southernmost tip stood Jack and Fairlie's house, comfortably situated on a double lot. The turnoff led to the kitchen door, where we parked. Rushing up to greet us with tailwaggings and quick sniffs was Daisy Mae, managing to resemble the white almost wirehaired terrier with black spots from so many sculptures.

Fairlie
She's nine years old.

Downstairs a kitchen, living room with fireplace, master bedroom and bath. Upstairs three small bedrooms. A porch. Attached to the right side of the house was the garage, now a storage area with the carport permanently closed. A handsome boathouse. A wide splendid view down the length of the lake. A lawn shaded by several tall oaks and sycamores.

*

After unpacking, I asked about the studio. Jack led me back into the kitchen, then through a door leading directly into the garage: piles of unsorted tools, clothes, car parts, a large freezer, an outsized refrigerator, both functioning. Beyond the freezer, on the left, once-clear plastic sheets were draped from the ceiling, partitioning an area — no larger than eight feet wide by 4 feet deep — that backed on the kitchen wall. A shelf/table working space extended the full width.

Jack
Yes, that's it. That's where everything is done.

Lee
It's like that first studio you had in Virginia — the blanket room. Now it's a plastic studio.

133

Jack
Right.

Lee
But where do you stretch out the clay? Where's the kiln? Where —

Jack
I don't work like that anymore. . . . It'll be easier to show you. You have to see my other place. I'll get Fairlie. It's just a few minutes away.

Back into the Duster and out onto the highway, backtracking the arrival route for a quarter of a mile, then a turn off once more toward the lake. Hiawatha Street.

Jack
This is Chippewa Park. You know, mainly little houses to rent or trailer parking space.

Fairlie
We had our honeymoon in one of these bungalows.

Streets were banked with summer cottages — most beyond better days — and patched up house trailers. An occasional lawn. We turned right on Eagle Street and passed the New Frontier grocery. A pomeranian waited out front. Another turn and through the intersection of Blue Jacket and Big Bear Streets.

Jack
On that corner you can sometimes see a crosseyed dog.

Tire swings sag from trees; ceramic ducks bake on lawns.

Jack
People hang plastic owls to scare off coons.

Suddenly lot after lot of blue wildflowers. Neither knows their name. The street deadends into the last road of the park. Facing us is a single building, Chippewa Trophy and Ceramics Shop, doublelot frontage, one story, suspiciously pre-fab, fastidiously maintained, its broad siding freshly stained a dark brown.

Jack
This place and the grocery store are the only two places you can buy anything in Chippewa Park.

We park on the gravel placed between the road and the building. Two wide windows display trophies and ceramics, the latter in stages from green to glazed. A cowboy and a Spanish lady seemed to be covered in suede.

Jack
That's a new surface. You just paint it on or dip it on and it's instant suede.

Inside a counter stands left rear. To the right tall shelved stacks are jammed with greenware, unfired molded objects waiting for inspired china paint decoration from amateurs — and then a kiln to end it all.

Jack
Oh, they fire right here. There's a kiln in the back section. Hobby ceramists can also buy clay here.

I turned into the stacks, certain Jack will next tell me he now works in hobby clay and has the young man behind the counter fire his works in an electric kiln.

Greenware to the right, to the left: cement gray molds of planters with deer intaglios, booted Turks with puffy onionshaped hats kneeling in prayer, Santa Claus boots with holly, planters in the shapes of big frogs and snails, camels, biblical wise men, horses rearing at each other, bird houses, ducks, bears, little girls in pigtails, little boys and little girls holding cats, baby angels kissing, boy scouts at attention, witches on brooms, on pumpkins, on candlesticks, shrouds, lions, poodles, King Arthur's castles, chess sets of medieval figures, lounging nude women with crotches concealed and breasts revealed, cups, tall chalices, small animals, hearts with roses, girls with milk pails, spreadwinged eagles on rocks, foxes, owls, raccoons, Snow Whites with their dwarfs, Don Quixotes with their Panchos, candelabra of crossed swords, takeoffs on Rodin's 'The Kiss,' — the male's hand planted noticeably on the girl's bare behind — colonial churches, giraffes, lamps — one with Christ in it — Christmas trees, clock frames, Plymouth rocks, hippopotamuses, hyacinth vases, Chinese vases, bud vases, Grecian vases, ginger jars, fruit bowls, Wilson canteens, Victorian houses.

Jack appeared.

Jack
Howard Kottler once used that Victorian House mold. Yes, Howard Kottler. It was a funny piece called "The Old Bag Next Door is Nuts." As I remember he had a house like this, and then next to it was a ceramic bag full of nuts the same size as the real house with 135

a stoop leading into the bag. Or else he had nuts coming out of the house next door like it was a bag of nuts. You get the drift. . . . Come see the kiln in the back.

Two rooms were at the rear, and Jack was heading for the one to the left. Over the other door was 'Trophy Room,' and I darted into a maze of tiered stands, shelves supporting rows of trophies, most on bases of light blue plexiglass. A figure or object at top served to label the category of the trophy, such as a baseball, horse, tennis racket, automobile, rabbit. Rabbit? Allen Morris, the owner's son, explained that all over the country rabbit fairs were proliferating 'like rabbits.' He also explained that trophies made a much more lucrative business for them than hobby ceramics. Parts for the trophies were manufactured from coast to coast, assembled in their shop, and then marketed to every state. The shop drifted into ceramics only because his father had once modeled clay rabbits for the crests of the trophies, each unique. Now the rabbits are stamped out of some shiny metal. Local hobbyists, hearing of his working in ceramics, asked if clay could be ordered for their own use, and soon a business grew — but a small business, not to be compared with the trophy activity. On the following Sunday Allen Morris would attend a trophy trade show in Michigan, and in a few months another in Syracuse. The flagrant banality of the trophies (and of almost every other trophy in the world) was even more depressing than the mock sentimentality of the greenware (and of almost every other piece of commercial greenware in the world).

I joined Jack in the other back room, where he pointed to a white, decagon object about the size of a washing machine. Its label read Skutt Electric Kiln.

Jack
The oven can accommodate an object oh thirty inches high. And the diameter's about two feet.

Lee
You fire here?

Jack
No, I bring my piece in still green and they fire it. Then I take it home and glaze it. They fire it again. Then I take it home and china paint it. They fire it again. Three firings.

Lee
And is the body porcelain?

Jack
Nope. I use a clay I buy from the hobby shop here.

Lee
Yes?

Jack
The clay they use here to cast the figurines. Only, I don't cast it. I dry it out.

Lee
It's liquid then, a slip?

Jack
Yes.

Lee
Do you know of any serious artists who use a slip clay for modeling?

Jack
I don't know of anyone who uses the slip the way I use it.

Lee
It's good clay, though, not some half-clay, half-I-don't-know-what they push onto hobbyists?

Jack
Oh no, it's quality. It has to be or they couldn't cast these figurines. It just wouldn't work in the molds. They have to use good clay. In fact the company tried to change the formula and so many people had trouble with it that they went back to the original recipe. It's called G.H.S.

Lee
Good Hobby Stuff?

Jack
Hey — that's close. Great Hobby Slip.

Lee
Now, how do you reduce the liquidity of slip so that it can be worked?

Jack
I pour it out on a plaster slab. The plaster absorbs the water. I just wait. When enough has been absorbed and evaporated, when it has a thick mudlike consistency, that's it.

Lee
It sounds like white muck.

Jack

It works fine. It holds well. It builds well. It has a lot of strength. It sticks to itself good. It's a real nice clay body to work with.

Lee

From then on you use the same building techniques you did with porcelain?

Jack

Right. You know everything I make is first built with coils of clay. Then I model that. Well, modeling and every other technique I can think of to get the effect I need.

Lee

You use the glazes from here?

Jack

Yes, the transparent glaze. Then the china paint — you know they have that in every color here. And you know I like china paint because it comes out of the kiln the same color it was when you put it on the sculpture. With those other glazes you never know what can happen in that heat.

On the way to the front door, we passed another greenware shelf: shot glasses, liberty bells, mallard ducks, baking soda bears, bunnies with banjos, greyhounds, Atlantic poodles, Fidos, Fred the frogs, kitchen plaques with fruits and vegetables, Byrons, Mary Melodys, Juliets, Renees and Candaces, two of those cute babies also found cast in soap in drugstores. . . .

While Jack and Fairlie finished morning chores, I waited at the edge of the cement bulwark protecting the rounded lake point of their property. The tan water lay flat in early heat, and Turkey Foot Point, the peninsula to the left, was washed in haze. Jack's abandoning porcelain for Great Hobby Slip still disquieted me, and I had carried the frustrations into sleep. Now I was troubled that I could have allowed his working with GHS to unsettle me. For years in lectures and articles I had faulted the fine art establishment for its media snobbery, its insistence that objects in craft media must be confined to a purgatory below fine art. What difference could a choice of clay body hold in the evaluation of an aesthetically successful object? Jack joined me, and I shamefully admitted my media bigotry.

Jack

Well, you know how it happened, don't you? When I got back to Ohio I went into color. I think a major reason I didn't use color before was that I was in love with the look of porcelain just as it was. But then I began feeling things in color, and if the sculpture is painted all over, who knows if it's porcelain underneath? Now if you remember I had had trouble at Toledo finding a clay that would let me work in detail, and that's how I went to porcelain. Well, I didn't know what kind of clay to use now back in Ohio, and I asked at the craft shop what they used in their molds to cast the greenware. A slip, they said. And then flashing back was Kohler. All they used there was slip too, liquid slip poured into molds. It was good clay, and maybe this hobby slip was okay too. How to thicken it? I didn't dare add anything, so by trial and error I worked out the process of evaporation plus absorption in the plaster slab. And the clay I got — well, it's great, holds up in the kiln, takes glazes and paint real good.

Lee

Have you told Portnoy you're not working in porcelain?

Jack

No, but I haven't called it porcelain anymore either.

Lee

Tell her. I'm sure she thinks it is, and she may be innocently telling collectors it is. She won't mind. Just don't tell her right away it's called Great Hobby Slip.

Jack and Fairlie had spoken often of Roy Hanson, her father, and his stabilizing role in their family structure. His past was only faintly limned: trained as a preacher, eventually serving as Pastor for several churches for short periods; owner of a farm — and had a twin. One day Jack and Fairlie announced we would drive to Roy's farm, the Hanson homestead.

Fairlie

He's away now. But maybe he'll return before you leave. At least you can see the farm.

Fairlie's great grandfather on her father's side settled near the marsh as early as 1831; and later ancestors on her mother's side staked out

muck land. In 1876 Charles Oscar Hanson arrived from Sweden, and after marrying into the family, acquired desirable property on the southern section of the marsh. Before long he qualified as one more Onion King. His son, Newman Hanson, married Sarah Bailey, who eventually became Fairlie's grandparents on her father's side. Newman Hanson raised onions successfully, as had his father, and before his death built a frame house with a lawn stretching from the porch to the county road — already named Hanson Road.

Minnie Hunsicker Williams (Fairlie's mother's mother) outlived five husbands, collecting five engagement and five wedding rings. The former were distributed to her five granddaughters, and the one given Fairlie was used for her engagement to Jack, and later survived the Charles City fire.

The death of Newman Hanson (Roy's father) was contemporaneous with the death of Ray's wife, and the twins then returned to the homestead, Ray only long enough to sell his share to Roy. Roy remains master of the property.

<p style="text-align:center">*</p>

Everynight in the summer Bill sits on his front porch and watches the sunset over the silowet of his neighbor's house trailer. He remembers when there was a woods there, then a field and now the house trailer. He listens to the neighbors dog barkin at a shadow.

It's getting pretty dark now. A car goes by with it's lights on. Bill don't recognize the car. It wont be long until the meskitoes will be out and he will have to go in the house. His mind goes over gettin up, walking to the screen door, it slammin after him. How hot the house will be. Turnin on the radio in the kitchen. Settin in the overstuffed chair and lookin through the newspaper again for awhile before going to bed. But he'll stay outside here as long as he can watchin the sun go down.

<p style="text-align:center">*</p>

Jack
It's not far now. We're on Hanson Road. . . . There it is On the left.

Back some fifty feet from the road stood a two-storied white A-frame house of modest proportions, four rooms downstairs, two up. The lawn had long disappeared under heavy weeds and wild brush. What suggested fruit trees leaned in unpruned states, unruly branches poking radially and asymmetrically, some into the ground, some onto the porch. Dirty windows. Siding paint badly weathered. The entry drive lay to the left, a rutted road that stopped when on a line with the rear of the

house. Nearby a couple of trucks rested fender-high in brambles. A small shed, perhaps once a summer kitchen, stood to the rear. We walked to the kitchen entrance. The step was crumbling, the screen door torn, the door without lock. The kitchen: no floor covering, soiled walls, paper or T.V. aluminum plates on the table, floor, drainboard, stove, everywhere, each holding a portion of a dried, unfinished meal. Furnishings comprised a refrigerator, sink, enormous coal stove, large wing-backed chair and floor lamp with a ribboned shade.

Jack
This is the way Roy likes it. He lives here in the kitchen. Sleeps in the chair usually.

They exposed only one other room, the parlor, and the first impression was of an Ohio road company version of the spider-webbed room in "Great Expectations." Through the dim light of drawn window shades loomed handsome (perhaps) pieces of furniture, matte with dust, as were the portrait photographs on the far wall.

Fairlie and Jack led me farther back on the property. Sprouting from black granular soil were soybeans in rows trailing out of sight to the right and left.

Jack
Roy doesn't farm anymore. He rents it out. It's all rented by Bob Shaw, you know, the husband of our oldest daughter, Kathy. When Roy's dad had it, there were sixty-five acres. Now Roy has forty.

Lee
Roy must have a good income from this land.

Jack
He gets three thousand a year rent; and then there's his Social Security, but that doesn't amount to much. He didn't pay in practically anything.

*

When I asked Jack and Fairlie for a location at which they might like to be photographed, the reply was immediate: 'At our church.' The next morning, even though a weekday, Jack and Fairlie were in their Sunday-to-church clothes with bibles in hand. We made right angle following right angle through a number of straight and narrow country roads, ending up in an area called Flat Branch, which they said was not far from Roy's house. The small gleaming white frame church with steeple rested some twenty feet back from the pavement. Near the road shoulder a painted sign indicated the denomination: Church of Christ.

It appeared that the small church yard had been cut out of someone's farm property: high stalks of corn waved against the fences on three sides. The church was locked, so Jack and Fairlie posed on the entry porch.

PLAT BRANCH
CHURCH of CHRIST

In 1979 another gallery show from Jack with works representing several directions; since Ohio genre scenes predominated, Theo labeled the exhibition "Scenes from Ohio." Compositions relied heavily on a gift shop ceramic cliche — a map, in this case a map of Ohio serving as an inch-high platform, for most of the scenes, with titles scratched around the curbs. A farmer named Bill was everywhere, and if not literally represented, part of his farm was, usually a backyard containing similar props: a tire (often used as a planter), a trash can, a black and white chicken, a dog, a clothes line with pants and towel and shirt, an abandoned icebox with tools on top. Steps to the back porch may be

shown, but never the house to which they are attached. The sumi economy of objects in Jack's last show has evaporated: now we hardly know where to rest attention. Not only are the scenes weighted with specifics, but with larger areas encompassed, the details become miniatures. Scenes or vignettes, a one liner joke — or jolt — is relentlessly pursued. They become, however, much more vigorous — and entertaining — when considered upgradings of drug store ceramic souvenirs. Again they are technically flawless, and no one but Jack's clay supplier could vouch if he used porcelain or hobby clay. Lengthy studio sessions certainly figured in the preparation of this exhibition: forty-five sculptures were included, some two-thirds Ohio scenes.

"Ohio is a Pile of Dirt"
Plowed dirt covers the surface of the map platform; and on two sides plank forms are wedged against the edges to hold the dirt in place; a shovel lies on the surface.

"Mt Ohio"
A massive mountain rises from the map; at its crest is a two-silo Ohio farm compound.

"Rich Man"
The map surface is now a cemetery plot where an elderly Bill moves a metal detector back and forth before a gravestone on which 'Rich Man' is engraved.

"Ohio Chair"
One of the most delightful works (only five inches high) in the Ohio series, reminiscent of the strength through sparsity of the last show. A kitchen chair with a five spindled back; green paint streaked, scratched and all but worn away; the ubiquitous farmer's cap hanging from the top crossbar; and a dog — this one yellow/brown — stretched out on the floor beneath the seat. No platform stage required for this sculpture.

On returning home from Virginia, Jack's first two exhibitions had been devoted almost entirely to local genre subjects; 'Ohio Scenes' was the second of these, and there would be one more, devoted to Bill. Two therapeutic purposes were served by continuing with the narrative local subjects: by working close to the soil he reacclimatized himself to his native magnetism; he also came to terms once and for all with local sculpture, which in muck country is the gift store ceramic. Jack has lifted this archetypal totem — with not a grain of condescension — to an aesthetic level able to evoke favorable responses far from the Onion King farms, even from museums.

Three works not in the Vignette series:

"America the Beautiful"
A mantle of fresh snow, sparkling in moonlight. At one end of the snow field a miniature house — windows warmly lighted, chimney smoking. This romantic nightscape lies, as if poured from a bowl of frosting, on a thick amalgamation of trampled trash, not unlike an enormous mattress of junk.

"Bill Meets Art at the Museum" [Plate 42]
In what is evidently a Museum of Natural History, Bill stands in wonderment before a headless prehistoric colossus, twice his size. The giant's build, stance and clothes exactly match Bill's.

"Doggone" [Plate 36]
A male figure, definitely not Bill. For one thing he is neatly dressed in slacks and sport jacket plus necktie; and for another he has a dog-head — with German shepherd definitely in the mix. The Dog-Gentleman raises his hand to his forehead in exasperation: the dog he is walking has managed to wind his leash several times around both of the Dog-Gentleman's legs. This sculpture is a giant — over two feet tall — among the Ohio scenes, reaffirming Jack's ability to model in large as well as intimate scales.

"Running Man I, II, III"
Three small works, each involving a prone log, a tire, a dog and lastly a man who is indicated only by his bottom half — pants and shoes. The half-man runs, the tire rolls (evidently by self propulsion) and the dog races, all along the top of the log — in different orders on each of the three pieces, and always with no seeming relationship to the other. The enjoyment of these pieces — whose images endure — spreads through a range of wonderment.

Normally two or three weeks before each exhibition Jack ships one representative work to New York which Theo then has photographed for the show announcement. Jack and Fairlie arrive later — normally only two or three days before the opening — with the balance of the sculptures packed into every corner of the car. The ceramic which arrived through the mail for the 1979 'Ohio Scene' show was called "Lighthead." Theo was excited, both by its scale — 20 inches high — and its subject: a standing man with a school teacher slump, crisp shirt, neat tie and baggy suit holds an open book waist high. His long skinny neck narrows as it rises above his collar, then bends abruptly forward. In place of a head is a lamp whose metal shade is directed to illuminate the book. Theo had the piece photographed and rushed to the printer.

When Jack and Fairlie arrived and unloaded a show of primarily Ohio maps, Theo realized "Lighthead" was a stylistic stranger.

Theo
Jack — why did you send this piece for the announcement? What does it have to do with these Ohio scenes?

Jack
I forgot about the invitation. I just, you know, wanted you to see where I'm going now.

Jack's 1980 exhibition, 'The Men,' with figures "Lighthead" had anticipated, was the most integrated show Jack had yet prepared for Portnoy. For each figure a symbol, identifying his profession or activity, replaced a part of his anatomy. Conceptual ingenuity outweighed humor, and the varied explorations of a single subject resulted in a consistency of style and content. No odds and ends in other directions were included — no matter how appealing they might be.

"Building Superintendent"
All to be seen of the man are his shoes and a small portion of his trousers. Rising from mid-thighs is a tall elegant metropolitan building.

"New York New York"
A souvenir pillow with 'New York, New York' stitched on it replaces a man's head.

"Celery Man" [Plate 43]
A bulging celadon-hued head of celery rises from a man's waist, replacing his upper body.

"Springtime in Ohio" [Plate 37]
Again no head or torso. Under a man's hat is a window frame with a bird cage resting on the sill; under the sill are the man's pants and shoes.

"Traveling Man"
A dapper salesman wears a white shirt, necktie, nifty vest and pants, as well as yellow shoes, but lacks a head: topping his neck is a stack of four different styles of hats.

No need to search for profundity: these works are to be admired for craftsmanship and alacrity of wit; even elegance, as evidenced in "Celery Man." As Jack explains below, they began and ended as exercises in proportion.

Jack
I had for a long time wanted to make some figures with different kinds of heads — well, for several years.

Lee
You had always used pretty much the same head before?

Jack
*Yeah. Bill's. It's a personality or character that you just know. But
I've always wanted to do these figures with different kinds of heads.
One time, or one day I was looking through a* National Geographic
Magazine *and there was a photograph of a young man and the
wind was blowing through his suit and so it was all puffed out, had
big legs, big body, but his head was real little and he was wearing
glasses and so it gave me the idea for the heads because I then
realized that the heads didn't have to be the same size as a normal
head. Well, before always when I thought of a figure, you think of
the figure and the head matching. What I thought, like if before I
would think of making a man with a birdhouse for a head, the
birdhouse would have to be the same size as the head or else it
would look weird. Like the man with a carrot for a head, the
carrot would have to be the same size as the man's head, but that
photograph showed me that —*

Lee
Artistic license existed.

Jack
*Right. I could make his head any size I wanted to and it would all
go together.*

For the past few years Jack had concentrated on genre sculptures
centered around a middle-aged man whom he called Bill — Bill with
sagging pants and visored, or billed, workman's cap. I asked to meet Bill.

Jack
*I don't think I could ever put my finger on a Bill. Now, what would
you like to see?*

Lee
Then Roy, Fairlie's father — if he's returned.

Jack
Yup. That's easy.

Back into the Duster. Just beyond Chippewa Park we turned into Indian
Lake State Park, also at lake edge, and reached a treed area where
campers huddled in the shade.

Jack
There's a waiting list for space here in the summer. And no one can camp for more than two weeks.

Fairlie mentioned that her sister, Vicky, with her four children, had been vacationing in the park, and that this was the final day of their two weeks. Therefore Roy would be on hand with his truck to pull out the camping trailer.

Fairlie
The trailer really belongs to us, but everyone in the family's welcome to use it.

The parking lot was on the fringe of the pine clump, and as we walked to Vicky's trailer location, Jack rushed ahead. Confronting Fairlie and my arrival were Jack and a man I assumed to be Fairlie's father, Roy, motionlessly facing each other, so near the bills of their workman's caps almost touched: an Ohio tableau vivant. Everyone except the two posers was watching me, and at last Vicky's children burst into laughter. Then everyone was laughing. The visored caps finally led me to the joke. Bill was Roy's nom-de-hobby clay.

Roy/Bill has fair skin, grayblonde hair, a slight build, a graceful slump and a mischievous smile sometimes accompanied by a peekaboo glance. His conversation seems restricted to a single soft volume — has he ever yelled? — and phrased in a confidentiality begging the listener to lean closer. A lack of motor control for his right hand became noticeable when he repeatedly pressed it against his pantleg to still the fingers. When he caught my looking at his hand, he moved to my side.

Roy
It may be the beginning of Parkinson's disease. . . . But I have pills to help.

*

Off in the Duster again with Jack, this time westward, through Wapakoneta, through Buckland, a small town where Jack has his automotive work done, and finally just outside Buckland to the Springer farm. A large haybarn to the left, a grain storage barn to the rear, and cow barn and pig shed to the right form a U-shaped compound. Although the property contains two farm houses, Jack and Idalou live in Buckland. Jack stepped out of the car and yelled for Springer. His son appeared, and after instructing us that his father was in a back wheat field, disappeared.

Jack swung the car around, drove out the main gate, and by deftly following county roads, eventually reached the one fronting on the right stretch of wheat. An attempt to drive up the dirt entry road along the wooded edge of the field was soon stalled by deep ruts. Springer, at the other end of the field, saw the car and headed his tractor toward us. The grain had been harvested, and now the tractor pulled a bailer: hay was scooped up, matted into a circular bail about six feet in diameter, bound with wire, dropped in the field. His cows would eat well this winter.

Springer is a husky, handsome man, his voice resonant, his speech measured by forethought. The greetings of the two Jacks was warm evidence of a close friendship. We returned in Jack's car to the compound, where Springer led us on a tour. At the storage barn we were told that corn and wheat are first dried by a propane gas unit (which costs $25,000 and can demoisturize about 200 bushels an hour), then lifted by a grain auger — 'just like the flanged rod that pulls meat along in a meat grinder' — into silos. The bailer costs about $8,000. His two tractors require about 60 gallons of gas a day, and the combine about 40.

Springer
We don't sell much of the corn. Most is used to fatten up the hogs and cows.

Then we drove to another field where the corn, with stalks taller than any of us, was near the moment for picking. Springer explained that initially corn grew with only one ear, right at the top; and every year now several stalks would revert to that early form. Bordering the area, mingled with weeds, was that blue flower, which Springer immediately identified as wild chickory. I spotted Queen Anne's lace too, but Springer said that in Ohio it was wild carrot. He also located foxtail, rag weed, milk weed, jimson.

We walked across the road to the pasture. Huddled near the feed trough was a small herd of dark cattle, and standing nearby an enormous dirty white bull.

Springer
Oh, he weights about 1,800 to 2,000 pounds. It's a French breed, Charlet.

Nearby stood a rack of salt, masked with a curtain of strings designed to brush flies off the cow's face as she approaches the salt for a lick.

Springer
Certain fly bites cause pinkeye, a serious matter for cattle....
Recently my bull was used to breed a cow and he slipped off. Fell
right on his back, and I was afraid it might turn him off the habit.
But it didn't. Still, I kept him up in the barn for about two months,
and then one morning he broke out of his pen and there he was
walking down the road. He had decided to come down here. You
take a ton of beef and if he decides to go through that fence,
nothing could stop him. He's pretty gentle, but I can't trust him.
You don't trust any bull. They can be playful and the next minute
have you down, pounding you to death — and he may consider it
just having fun.

We drove into Buckland for lunch at Carolyn's Cafe, directly across the street from Sprague's Garage, Jack's automotive shop, and next door to the only other business in town, a hardware store.

Jack
This place is famous for Carolyn's fried baloney sandwiches and
homemade blueberry pie.

Dim lighting. A long counter down the length of one side, with the kitchen behind. Farmers, in groups of three or four, occupied most of the tables, and their conversations appeared light, with the usual ribbing of waitresses. As a new face in town, I drew courteous attention. A bottle of beer rested on a nearby table, and I waved to one of the waitresses behind the counter. As she approached I asked Springer if he would join me.

Springer
I don't drink, but thanks.

It was my first drink in Ohio.

In 1980, shortly after Jack segued silently from porcelain to hobby clay, Theo Portnoy received word from Lloyd Herman, Director of the Renwick Gallery at the National Collection of American Art in

Washington, D.C., that his museum would be interested in a Jack Earl porcelain sculpture for the permanent collection.

Theo

Jack had only recently told me about his medium switch, and since Lloyd accented how accomplished Jack was in the handling of porcelain, and how few people worked in the medium, I couldn't bring myself to say a word about hobby clay. Paramount was the importance of having him represented in this national collection. After all, the Renwick is part of The National Collection of Fine Arts which is part of the Smithsonian Institution. Of course there was no way I would deceive Lloyd about the medium of a work — and he certainly would know the full characteristics of porcelain — so I phoned Jack to see if he would make one more porcelain. He hemmed and hawed and said yes. I then phoned Lloyd that Jack did not have any work on hand of museum quality — which was true — and he would like to create a new porcelain sculpture for him. I also said that Jack offered to send sketches for his approval. Lloyd was delighted — and all went well. Phew.

The eventual sculpture — "The Man From His Youth" — describes a man in work clothes and a visored cap, slightly crouching at the base of a large tree to peer into a knothole. The opposite side, hollowed away, contains the detailed idealistic landscape panorama seen by the farmer inside the trunk: mountains, trees, a cozy house and a rushing river which cascades right out of the tree trunk onto the round sculpture base. Again Jack substantiates his rich lode of fresh imagery, simultaneously totally realistic and totally unrealistic, which we readily and helplessly accept as believable. Where better to view the cloudless days of childhood than through a knothole? [Plate 46]

Lloyd was pleased with the porcelain, and immediately placed it in a U.S. museum tour of ceramic sculptures. Later it was toured extensively abroad in an official government-sponsored exhibition of art from the United States.

One evening, almost eight but still light, Jack, Fairlie and I piled into the front of their beatenup red pickup truck — with Steven in the open back — and started for Bluffton to visit Darvin Luginbuhl. On the way Jack abruptly pulled up at the side of the road, squarely in the center of railroad tracks.

Jack

You may not know it, but these tracks are real special. They took all the short rails out and put down ones that are each a quarter of a mile long. Now that makes a smooth ride. They go all the way from Ada to Lima, maybe farther.

The wide tree lined main street of Bluffton held a more prosperous look than Uniopolis, the bungalows more substantial, some with Greek revival details. On the other side of town we turned onto a country road, and soon Jack pointed to Luginbuhl Road.

Jack

It was named after Darvin's father.

The Luginbuhl ranch house was not far off, sitting cozily by itself. Jack spotted Darvin on a small power mower.

Jack

He's trying to finish the lawn before twilight goes.

Jack waved and parked in the driveway. Darvin soon joined us, and later his wife, Evelyn, emerged from the house. We stood on the lawn, talking.

Darvin

I don't remember Jack too much in high school, except that he was awful quiet and I often wondered how in the world he could ever make a teacher if he didn't say anything, but I guess he talks when he has to. . . . And when he started teaching in New Bremen I would take my students, those prospective teachers, to observe him. He had a good active program, and the kids were interested. You know, Rex Foyt came out of one of Jack's classes.

Lee

You're a sculptor yourself, aren't you?

Darvin

I've been a lifelong friend of Paul Soldner. He grew up in high school here, and I always kept in touch with what he was doing. Ceramics was always in the back of my mind. I think he influenced me a lot. And then I started going to Ohio State in Columbus for summer courses — for seven summers. Of course, Klassen here at Bluffton had a sound program, and I think that's where Jack probably got some initial spark. But I didn't get serious until around 1958 when I started teaching at college and had more time. My first outside influence was Autio and I went to a workshop in

Toledo, and I thought, oh, I can't stand anymore of this stuff. I hated what he was doing. You know, he was making these slabs and just kind of sticking them together. But the longer I stayed on in the afternoon, the more it started catching me and the first thing you know I was trying to do it.

Lee
Did you follow how Jack was progressing?

Darvin
Well, when he was in this area. The thing that always kind of got me about Jack was that, you know, when he went to Ohio State he was doing great highfire stoneware, making some great stuff, real organic. Then I went to see him in Toledo one time and he was making white stuff, mostly in plaster and I thought, what in the world are you doing? And I hated it. Then a little later he finally got into white porcelain. Again, it was not what I thought he ought to be doing. Then later on he was going into china painting.

Lee
It seemed compatible with the medium.

Darvin
One time he was giving a demonstration over at Ohio Northern — we had, how many people did we have, five artists, or six or something like that — and all he did was sit at a table and make bananas. He had a little mold and he'd sit there making bananas all day long — that was so funny. But I think I learned to admire his work, especially his ability to work in detail and to work patiently, slowly. I can't work that way. His coils will be about as big as fish worms or smaller. I just couldn't, you know, quite work that way. I've always admired his patience, that sort of thing. Another thing that I always have trouble with — I always try to read things into his work. Then he always says, well, if you want to think that way, you go ahead and think that way. Many times, as a matter of fact, I give him ideas, try to, but he doesn't just pick up an idea. You know, you think, well, if he's working that way why not give him an idea? But he doesn't really pick up the ideas that you put out. There's always the kind of a — a what? — a gap there or a chasm, or that kind of thing.

Evelyn
I always thought that your work was a lot more serious than you ever wanted anybody to, well, that you ever wanted to admit to anybody. I think there's a very deeply serious part of Jack that he

won't discuss or that he avoids discussing with people. I don't know. I just suspect it.

Darvin
Yes, but as far as using words, he can use words when it comes time to putting a title on something — but sometimes the title kind of leaves you hanging too. I always thought, also, that his life, his daily life, his life with his father-in-law and family members is reflected in his work.

Lee
That seems evident. I met Roy for the first time on this trip.

Darvin
It's just him standing there, when you see some of the figures. What's he called. Oh yeah — Bill. I think even of Jack's fruit and vegetables and so forth came as a result of his father-in-law being a kind of a huckster or whatever. I don't think Jack's work on sex ever was — he kind of dropped that. . . . The other thing that kind of startled me — he was a good potter, good on the wheel, but he left that altogether. And when you have all the training and all the experience with kilns, then you start having someone do your firing. I mean it seems like he could at least do his own firing, or want to do his own firing.

Lee
You know where he does his firing?

Darvin
Yeah, a hobby shop, and then to go from porcelain down to lower temperature and china painting. I guess I just have a block on china painting. It used to be the little ladies who did this, and it was just something we left behind. But I think that, there again, I'm sure you would have arguments about picking it up again and why he should want to do it.

Lee
In the art world we mustn't hold any block against any medium. It's a maxim to be believed, and, believe me, there can be times when we have to remind ourselves of it.

Darvin
The other thing that startled me — he has a calendar hanging there and supposedly takes ideas directly from this calendar and its gosh awful pictorial stuff. . . . But Jack is one of the outstanding alumni of the college here, and so is Soldner. Of course Soldner got really

153

turned on with Voulkos. . . . I think that maybe one of the reasons that these fellows, like Jack and Soldner and Foyt, developed this way still goes back to Klassen as being a kind of open permissive person. Maybe he should have been more strict!

Mosquitoes were rising from the lawn, bushes, flower beds, and Evelyn suggested we step inside. An inviting interior: preponderance of natural textures, rich fibers, stone fireplace, stuffed bookshelves, small art objects crowding walls and ledges. Sliding glass doors opened a vista onto fields. When asked, Luginbuhl showed us a few of his ceramics: jars, pots, other functional ware. While Darvin had obviously rejected the vivid end of Autio's color range, Autio's strong compositional slabs still held the best of Darvin's work together. Later Jack told me Luginbuhl had taken, during summer terms, a Master in Art Education at the University of Montana in Missoula, which included a number of classes under Autio.

*

Jack
I don't respect intelligence. Intelligent people often do the most ridiculously stupid things, ruin their careers and their normal lives. Old ladies, just ordinary nice old ladies, can live like that. Crazy. Well respected people live like that. Crazy. You know I think intelligence has become a kind of worship. If you don't have intelligence, you're not capable, something is wrong with you. Now, you go out in a community and talk to people who are like fifty years old, and when that person was in the eighth grade it was perfectly obvious, you know, that you could line them up and say this one is the most intelligent. You could actually line them up in the actual order of their intelligence. But when they are fifty or sixty you can't put that same lineup together. The importance of intelligence has disappeared. That criterion is no longer important because most people that are intelligent are not intelligent about their lives. . . . That's one of the problems with universities. Well, not only universities, but just generally, it's the way people at universities act to other people. The intelligence of that person is the most important thing. I don't know whether it's always been that way or not. It's your major concern, the major interest is how intelligent you feel other people think you are. I think it's ninety-nine percent of an argument with people who are close to each other. That's one of the reasons I don't like theories. The kind of theories I am talking about come from your mind, and if you have a theory and it has come out of your head, well, then that theory is an expression of your intelligence and when you put that theory

down it means that you are this intelligent and then the people who examine it, you know, look at what you have done. They examine it to see how intelligent they are compared to you. . . . One of the problems with a university is that it's not a real thing. Living with your family is a real thing. That's what it's about. The university becomes so important, too important. . . . Okay, you say universities are important. They are, but not for me. . . . Oh sure, they are important for students, but not for teachers. . . . Bluffton, when I went there it was small with just a few teachers and 250 students. Now there are probably 600 students. When I was working over there and going home for the weekends, teachers were sitting around the table, I think it was the English department, talking so much junk, same talk as at the university. Unbelievable. They've gone out and learned that junk at universities and then they bring it back there to block that school up. I'd forgotten all about how teachers are so concerned in trying to outsmart students to make them think They were trying to figure out how to help some students read better, almost the whole class, including my daughter. They felt that poor readers got that way because they didn't crawl enough as babies, so at the start of the class the poor readers should all crawl around the floor on all fours. For about fifteen minutes!

*

David Freed, a painter and print maker, taught with Jack at both Toledo and Virginia Commonwealth.

David (telephone conversation excerpt)
I never knew him to be a bit intellectual. He could not discuss literature or music, in fact, any concept. Nor could he teach it, which disturbed some students. It's not easy to know Jack. He's hardly what one would label an out-going fellow. Then Jack lived way out in Charles City so we didn't see too much of him socially. But I like Jack. He's just different from most people and one should not presume he is sizing up matters the way the rest of us are.

*

Thompson (letter excerpt)
I am pleased to respond to your letter of inquiry regarding Jack Earl.

During the period of 1972-77 when I had the pleasure of knowing and working with Jack, I considered him to be a very fine, well- / 55

respected teacher. He was a continuous source of inspiration and influence on students. As an artist (during the seventies), Jack was making important statements in porcelain and establishing himself as a significant figure in contemporary sculpture. His personal vision was anecdotal, poetical and metaphorical. Jack as a person was 'very special,' a warm, caring individual with a delightful sense of humor.

Nancy K. Thompson
Chairperson, Department of Crafts
Virginia Commonwealth University

*

Jack
That letter from Nancy Thompson. Just put it beside any other statements about me you might receive, and you'll immediately get the picture, the feeling of what I've been trying to say VCU is all about.

*

Tom Ladusa
I used to be asked a lot about why Jack got out of teaching. Well, we talked in a way that students needed to have more energy and more interests and produce more and not worry so much about products that were going to be quality immediately. Nobody wanted to pay the dues. Everyone wanted instant success, and I don't know, there is a lot of energy put forth in teaching. I gave a workshop at Virginia Commonwealth and while doing it, I was stimulated by Jack's real concern toward those students, what they were doing, what they were making. He was generally interested in each and every one of them, and was trying to intercede by saying the right thing or directing them in the right direction for their pattern. It looked as if he was actually enjoying it. And when we would leave Virginia Commonwealth and make the forty minute or more drive to his house, the man was exhausted. He put a day in, because when he went to teach it was a profound and very tiring effort. And I think probably in time all his effort, all his concern, going home tired, just wasn't worth it. You know when you are dealing with graduate students, the way they do at V.C.U., it's getting them prepared, getting their work to a high level, and then sending them out, hoping they will find a job and make a connection. You also have to go into the critique session — and just
looking at a non-satisfactory student situation, and having to come

down on the person, telling the guy his work is nowhere, that maybe he'll have to put in another year — Jack wasn't able to handle those sorts of things. I know that I was involved in critiquing some of the grads' work when I was there, and all the way back that night after those critiques I knew and felt and saw Jack was upset having to deal with individuals in that fashion. It wasn't his thing. He had too much empathy to do it. I believe that's one of the reasons, probably a major factor as to why he stepped out. He saved that energy, saved all that tension, put it off somewhere, and concentrated on what he liked to do. He was able to be close to his family, protected if you will. I think Jack is the kind of person who thinks about all those kinds of things: where should I be? where would it be best for my family? for my work? He analyzes all of it. If he finds a solution, he's going to take it and make it that way. I think that is probably why he is so very successful is what he does. It's in a sense really simplistic. It's just deciding to do it and getting it done.

*

Shortly following 'The Men' exhibition at Portnoy's, Jack produced one of his finest sculptures, the culmination of the theme wherein an object is substituted for a body part. A 27-inch high figure — the largest work to date — resembles Roy in stance, but is a younger muck farmer: muddied work shoes, unpressed work pants, unironed work shirt, snugly fitted billed cap; and as usual, a self-conscious slump with slack mid-area, arms dropping straight down at the sides. Is he possibly posing for a photograph? The figure would not differ from any of the marshland Ohioans Jack has put into clay were it not for one detail: the forefinger of his left hand is a crisp, firm carrot, almost twice as long as his adjacent normal fingers. As with most of Jack's seminal works, the title is expansive. [Plates 47, 48]

"I knew a boy who had a carrot for a finger. I guess he was born with it 'cause he had it when I met him in high school when we was boys. It was just a carrot stickin' out where a finger ought to have been. When I first noticed it I looked out of the corner of my eye at it a few times and got used to it and didn't pay it any attention. Nobody else did either, they were all used to it. Sometimes some younger kid would holler 'carrot finger' at him from a distance but he didn't pay any attention to them kids. When he got older and went to church, a wedding, or a funeral, he would keep his carrot finger in a pocket so he wouldn't distract

from the service. He got married to a local girl here, a real nice girl but not as pretty a one as he could have got, I suppose, if he hadn't had a carrot finger. They had three kids and they all came out normal.

"Anyhow, one time he was walkin' in the woods. It was in December, one of those special days in December when the sun is real warm, and little white fluffy clouds was passin' shadows over you once in a while. He had plenty of cloths on since it was December. It was nice and warm and he layed down in the tall grass on the side of a hill and was watchin' the clouds drift by and listenin' to the bees buzz. You know how nice it is to hear bees on a real warm winter day. Well he was layin' there and he went to sleep but what he didn't know was that there was a lot of rabbits in that woods. When he woke up, his finger, the carrot one, was gone. He told me he thought it might grow back out, but it didn't."

The conceit of indicating a tourist by replacing his head with a souvenir pillow has matured to the introduction of a mutational element the artist makes us accept as within and rationale of nature, and whose metaphorical vibrations are boundless.

The sculpture, in a Wisconsin collection, was recently shown at The Wustum Museum of Fine Arts in Racine in an exhibition culled from local art collections. Kevin Lynch, the art critic for "The Milwaukee Journal," singled out "Carrot Finger" from works by Ad Reinhardt, Claes Oldenburg, Jim Dine, Marc Chagall, Josef Albers, among other art celebrities, for comment.

Lynch
Step in and you'll find a superb collection, brimming with masters, modern and classic. . . and such delightful and telling surprises as the corn-pone surreality of Jack Earl's sculpture, "Carrot Finger."

A noted ceramic sculptor from Ohio, Earl has fashioned a superbly detailed caricature of an open-faced farmer who is still strong but shows traces of middle-aged slouch and paunch — and a big orange carrot for a forefinger. The single Surreal twist is so simply and effectively executed that it carries many implications: besides the variation on the green thumb, a vegetable brain, this carrot [is] at once his livelihood, his curse and phallic weapon. He's an eternal tempter of gluttonous pigs and what not else.

The power of "Carrot Finger" lies not only in the virtuoso modeling, but equally in the masterfully honed story/title, which at once graces the metaphor with human dimensions, as well as vouchsafing its dignity.

In June of the following year, 1981, the Theo Portnoy Gallery mounted its annual Earl exhibition. Another show with consistency, but how could it miss when all the works concerned Bill? Theo called the group 'This Is Bill.'

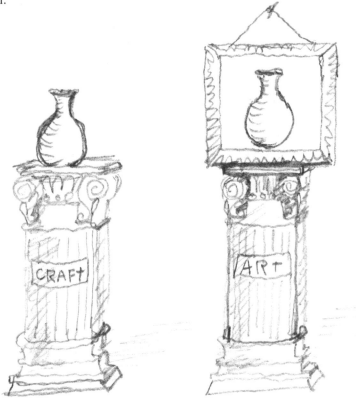

A typical ceramics depicts four Bills on a low platform, each dressed in identical pants and shirts and billed caps, except for slight color variations.

Scratched around the sides of the platform base is the full title: "This is Bill thinkin! This is Bill talkin! This is Bill tryin to rest. This is Bill workin!" [Plates 49, 50] Postures change only to the extent of a tilt of the head or a shift of weight on a foot. Only "Bill Working" carries an object — a hammer.

Despite the fine modeling and the emotional appeal, none offers the impact of "Carrot Finger," which Theo included in this exhibition because it had only been seen by a few people: it had arrived between exhibitions and sold immediately. The Bill statements remain situation portraits of an amusing, likeable, even endearing person, probing only

gently, not examining Roy/Bill much deeper than what is open to any viewer's eye. Jack has captured perfectly Bill's unruffable nonchalance, leaving for further works the ticking inside this unusual fellow.

The largest work in the show, "That's Bill — That's Bill Smokin!" [Plate 52], is double the height of "Carrot Finger." Smoke billows upward, concealing half of Bill's face in a cloud larger than the head itself. Again a tour-de-force of modeling, but the rather unpleasant (to non-smokers) subject matter places it in a special category well known among art dealers: sculpture for a museum, not a private collector.

"Bill Talking to his Dog"
We see Bill's kitchen, in glorious disarray, detailed on a platform. Only one wall, with a closed screendoor, suffices, a backdrop for his torn, soiled and overstuffed chair/bed and the ribboned lamp shade behind it. Turn the small dos-a-dos* sculpture around. The reverse of the wall is painted with a romantic landscape: a tall silhouetted tree stands at each outer edge, framing the view of a lake extending to the feet of distant hazy mountains. What this landscape — stylistically allied to early twentieth century midwest art — has to do with Bill/Roy is uncertain. Perhaps its peace matches the like feeling Roy enjoys at day's end, standing by his chair, ready to switch off the lamp and settle into overstuffed sleep. But first, of course, he must get his mutt out of the seat.

*To minimize repetitive descriptions of sculptural constructions created by Earl, names have been assigned to three which Jack will regularly adopt for use:

1) Interior/Exterior: works with an exposed interior as well as exterior; and the subjects of each are seemingly unrelated — such as a landscape inside a tree.

2) Front/Back: works with a front and back (each side visible only by walking to the other side of the sculpture, or by turning the sculpture around), the subjects of each related — such as an interior of a house on one side, and its exterior on the other side.

3) Dos-a-dos (pronounced doze-ah-dough, French for back-to-back, a term commonly use for a book binding format wherein two writings — as essays or poems or novels — are bound so that one starts from the front cover, the other from the rear; if, however, you are square dancing you remember the same French back-to-back is pronounced dozey-dough): similar to Front/Back, except that the subjects of the two sides are seemingly unrelated — such as a house interior on one side, a seascape on the other.

In 1982, an "Arts Magazine" critic, Geraldine Wojno Kiefer, visited a large exhibition of Jack's work at the Akron (Ohio) Museum, almost a retrospective of the Ohio genre scenes, with Bill sculptures very much in evidence.

Kiefer

Jack Earl's ceramic sculptures have been described as humorous, pleasurable, insightful, enigmatic, and Surrealist. All of which goes to say that his critics have circumscribed the very directness of his point and the pointedness of his direction. Earl presents simple people doing ordinary things, namely the stuff of life of mainstream Middle America. It is not life transformed, certainly not life made over into art, but living as an ongoing, not-so-alert process, which of course is fraught with pitfalls and dangers. In essence, Jack Earl's Bills are thinking, conversing beings. They are, however, private people, who tell their innermost thoughts only to their intimate familiars, particularly their dogs. Earl's dogs are actually more lifelike than his people. . . . Although Earl's exquisitely crafted figures in this exhibition are self-contained in the sense of not alluding to an environment (save for "Mount Ohio"), they are not self-referential, 'performance' pieces like their forebears, the figurines perfected in the Meissen factory by Kandler and others in the eighteenth century and the romanticized Art Deco mantel pieces produced by the Cowan Pottery workshop in Ohio in the 1920s and early 1930s. . . . Earl specifically intends no rural American stereotype, but he does intend a receptive, rather than an aggressive, lifestyle. Passivity for Earl is far from pessimistic determinism. It is the attitude which generates the creative spark.

In another article covering the Akron Museum exhibition, the writer included an interesting quote from Jack.

Kiefer

In describing the art of today that Earl likes, he might be describing his own vignettes in clay: '. . . I like things that when you look at them you know they were made by people, living somewhere in some kind of environment and having personal thoughts, personal lives, families maybe friends.'

Another "Arts Magazine" critic, Helen Thomas, visited a Theo Portnoy exhibition of Jack's rural scenes.

Thomas

It is impossible to look at this work without feeling allied to mainstream America.

Roy and I rode in the back seat while Fairlie and Karen Boyd, the Chicago art dealer, sat in front with Jack. We moved slowly through snow-heavy landscapes on the way to Uniopolis to take further photographs.

Roy
Jack mentioned you wanted to interview me.

I handed him the tape recorder.

Lee
Relate anything you'd like.

Roy
You know after your previous visit my doctor has prescribed a new medicine, almost completely controls my problem, you know my muscle movement.

An inordinately long reflection followed. Finally he resumed, maintaining his mode of confidentiality even into the recorder.

Roy
Well, when I first got married I decided to write a play about school days. You know, a spoof on school, lots of short scenes. So I got with my wife and we decided to work it out and have this show. So we got everyone in town interested, even the teachers and merchants. I said we should go down to the library and get all the literature we could, pro and con. It seemed it would cost a lot of money and some said we should quit, but I said no we can't quit now. We gotta put this play on. So we had use of the McGuffy school auditorium, and had it all ready to go and we were going to give the money to charity so it would all be donations. I'd never written a play like that before, but I knew when I took it over something had to happen for good. But we finally had the play and it was very successful but I said I would never try with another play again. It takes a lot of work and time and effort and perserverance and I mean you have to be moved. . . .

The snow transformed windows into flat fleeting snowscapes where barren and iced tree limbs suddenly exposed the modesty of farm houses.

Roy
After I gave up being in school plays I decided to go into the record business. Of course if I had stayed in it like I should have I'd a made a lot of records that would be very important. But anyhow I still got a box and a half of records I've made. And I keep them at

home, and of course these I do not sing on myself. I give them to others to sing. My twin wrote songs too. I sort of thought, well, I'd study them over when I got a little older. Yes, I had my own play and own music and of course we did this all — like, we'd all come to Jack's house and sit down and sing. And we took a boy out of college to play the fiddle and he could play like a regular musician. Of course he gave us a lot of help. For recording we used a guitar and a fiddle. Mostly guitar. I sang then. I had two I wrote — one, "Indian Girl," and the other, "The Bee Song." The bee one was just about bees on the farm, just a nature song. I also wrote, "Stay On The Farm, Boys" and "Why Didn't You Take My Roses." I always carry my own equipment. I have a hi-fi recorder. Tape. But now I don't plan to be a musician or a singer, but as a boy our family always did this when we would get together. Some were good players. Some good singers. And we'd spend the evenings out in the yard singing. We tried to sing only original songs as much as we could, something that's never been out on the market. Of course that's not too hard to do. . . .

"The Honey Moon Blues" *by Ray Hanson*

I'm out of money honey, please don't spend another penny more.
We've sailed and crossed the blue seas, and landed on a distant
 shore.
Call your mother, honey, we need more money. I fear the
 honeymoon is over.
We spent all of our money, and now honey, we are broke to the
 core.
So now we're out of money, honey, please don't spend another
 penny more.

Roy:

Yes, I was born on the Hanson Road. It dead ends off on Belle Center and Marsh Pike. It's three miles and a half south — or southeast of McGuffey. It's where I live now. My parents were born in Hardin County — on my mother's side they were Baileys. They homesteaded a farm also, I guess. On my dad's side they were Hansons, and my dad's dad was from Sweden and he was a builder, what they call a road builder, and a farmer also. He did real well. But his son, my father, he loved to raise onions. Of course his dad owned the land and they had oh about seventy acres. Of course he was an Onion King. That's all he raised.

On some fields winds had lifted off more recent snowfalls, unmasking winter wheat sprouts, vibrant green blades almost blinding in the gray sameness.

Roy

This year our crops went on for ninety days with no water, no rain. I'm in what they call the disaster area and we're having a meeting next on the fifteenth of December to see what happened in our county and other counties and I'm going to be there. You can't expect any farm to make profit with such conditions, but even if a farmer had only a poor crop, he could break even, but not this year. I think the government will give us corn grass this year and we will probably raise corn. Soy beans are pretty hearty and make about fifty bushels to the acre, but this year they only made nineteen. And that figure is considered disaster area. . . .

Fence posts, roofs, corn cribs, sheds, mailboxes lost their angularity as snow smoothly rounded all corners.

Roy

The first fire I had was a barn and I had a lot of burlap stored there. We use burlap, hang it across the fields near the ground to keep the muck and the onions from being blown away. My two daughters and my brother's son were playing in the barn and decided to light some firecrackers. They went to the woman in the kitchen who was running the house, and got matches. And playing around they set fire to the burlap and the boy said I'm going for help and the girls said no, we're goin with you. And if they hadn't gone with him they'd probably got burned up, but then they made a miraculous escape. We had over a hundred people working at this time. Each one was doing all he could do to get the equipment away from the barn. And the cars away from the barn. And that was difficult because here were eight cars on the farm. We even got my truck out safely. . . .

164

The sky turned heavy, tarnished, low. Suddenly in the distance a lone evergreen on a rise of ground to the right of a house, trunk tilting and sweeping low branches down a drifted slope of unfocused snow. House, barn, field relinquished to the gray scrim, but not this indelible tree, positioned by a meditation-driven stroke of sumi.

Roy
We had another fire too later on in the year. Another big storage shed and it held potatoes and onions. We stored them all winter. And Jack had a lot of pottery stored in there. And so we got some of it out. No, Jack wasn't there. The insurance company estimated the fire very large, but we didn't get all the money. So then we thought we'd reinvest it in another building. Then my neighbors got their yard on fire and it swept right through the fields, right up to my last big shed. That one caught fire underground too. It burned for months and months. I can smell muck burning for a mile away. Jack's art was in there too and it really burned up. But he just keeps on making more and more anyhow. That was a bad fire. We lost five cars, five trucks, five tractors and all the potato equipment and I had a thousand bales of straw, six thousand onion crates. It made a big fire because of the tires on the equipment and then we had piles and piles of tires in there — hundreds. The smoke was heavy. They called the fire department but they couldn't come. It was so windy and this other place was on fire. McGuffy is where the fire department is. We had three fires, all accidental of course, and then I didn't rebuild. Then I decided I would do a little trucking, moving produce for other farmers. I drove as high as 50,000 bushels of potatoes for other farmers. But I never did much from then on. Most of my time was being around the home and helping mother and the family that I had. . . .

Roy's voice trailed away and silenced as his head turned to the window, the landscape claiming him. In front Fairlie was enthusiastically informing Karen, just as she had instructed me on my first visit, that this was the highest area in Ohio, and more, that four rivers originated here, each flowing to a different corner of the state. Did Fairlie know about the river which flowed from Eden to irrigate Paradise? And that from Paradise the river divided into four to nourish the major areas of the old world? They are even designated on medieval world maps.

Roy stirred.

Roy
I love to hunt and so I had four dogs, three beagles and one airdale. They were good dogs. The neighbors gave me some to take

care of for them. We kept these dogs alive on the farm and then we'd hunt with them down the river. They really got a lot of rabbits up. Of course when I had my farm I had an old dog and she had six pups. I think there were four left, but they couldn't get out of the fire and they just burnt. Dogs are nice things to have. Of course my mother had a dog and it had pups and she kept them for many years. A chihuahua. Beautiful dog. He was an outside fellow and he was tough. But he was called a woman's dog because my mother was the only one who could handle him. So with him I had five dogs that I kept in the house. At one time I had the four pups plus the four big dogs, but the house got so high I decided I had to cut down on the dogs a little bit. Someone stole all of them but one, and he was a lovely dog, the one I had left and he protected me very much. I'd take him fishin and he'd see to it that no one bothered around with me. Now I have one dog. It isn't really mine. It belongs to my grand daughter. She got it and she can't keep it so she wanted it to live on the farm so I said okay. But he's a lovely dog and he has the nature of Jack's dogs, like the one who got run over, Daisy Mae. But I kept my dogs on farm produce. They ate soy beans and corn and I'd mix some other food in and have it ground up all together. So it wasn't expensive to keep my dogs. They were all fast. Some hunted for rabbits, some for pheasants. On the farm it was often flooded and the coons would come in to hunt and we'd get them. Then when the floods went down the coons went back in the woods in the swamp. We never went after them there. I have ate coon as a kid. My mother cooked a coon. She also cooked a muskrat. My dad said he would never eat a possum, so we never caught them. As a boy my dad had watched possums, the way they lived and acted and he didn't like it. But the coons were a very clean animal. The groundhog tastes the same about like a coon. Both not bad, a little fatty. . . .

Wapakoneta was slush from one end to the other, and we stopped at a corner cafe called 'D's Dinner Bell.' Jack detained me for a minute at the car.

Jack
Now you should understand his description of dogs spans a twenty year period, broken up by many dog births, deaths, stray arrivals, wandering and stolen dogs.

Lee
What did his father have against possums?

Jack
Well, as I understand it, he didn't like that they sometimes live inside large dead animals.

Fairlie
We weren't able to sell the Charles City land for some six months. We went back only once — to get the lawn furniture. That had been on the sunporch and the firemen pulled it out.

Lee
When was it that you informed Virginia Commonwealth University that you were leaving?

Jack
They wanted me to stay, but —

Lee
You mean after you said you wanted to go? Was it before the fire or after?

(An agitated discussion at this point between Jack and Fairlie which ended up as mumbling on the tape.)

Lee
You mean you had the house for sale before the fire?

Fairlie
Before we went to Kohler that last time, we already had a realtor look at the house and put it on the market. When I left I had the house cleaned spotless so that it could be shown off. When we came back, we hadn't even put everything away before the fire.

Jack
I had asked to go really about a year earlier.

Lee
A year! You mean the December before?

Jack
Well, near that. The major reason I wanted to leave, the reason I told them I was going to leave was because I didn't want my children to grow up and get married in Virginia.

Lee
It had nothing to do with the university?

Jack
The children were the major reason. I knew I wasn't going to spend my life in Virginia, and didn't want my kids to be in Virginia and that's why we sent Kathy back to Ohio to Bluffton College. . . . When I went down to Virginia I decided I was going to stay five years.

Fairlie
He didn't tell me this, but that's okay.

Jack
I surely must have. Anyway, I knew I didn't want to spend my life in Virginia when I was down there. You knew that didn't you?

Fairlie
I didn't know that.

Jack
You thought we might live the rest of our lives in Virginia?

Fairlie
A longer period of time, yes.

Jack
We stayed longer than I had intended to. That was the major reason I left.

Lee
Were there any slightly less than major reasons?

Jack
The other reason we discussed.

Lee
Yes, the university. Was there any particular kind of last straw?

Jack

I simply lost faith in that university system. It was just an absolute endless rigamarol and there wasn't going to be any progress in the ceramic department. And after I told them I was goin to leave, we went up to Kohler for the last four month stay. Let me give you an example. The Dean called me over to his office and talked me into taking money from the university while I was in Kohler. I didn't want to do it. It just wasn't honest for me to take money. He wanted to keep his hooks in me. And he said well you can work it this way: we'll get a substitute and you can pay the substitute. I must have spent an hour with him and finally I agreed. I said all right all right, and I went home and that day or the next day he called me and said that conversation we had never existed. He didn't say cancel it or anything like that — he just said it never existed.

Lee

That's the dean of the art department, right? Not the craft department?

Jack

Right. . . . To sum up, our craft department couldn't make up its mind what it wanted to be. Big — little. Great — mediocre. National — local. White — black. Clean — dirty. Move — stay. New — old. Etc. It sure got on my nerves. I don't like change.

Country western songs filled the livingroom while I waited for breakfast; then a voice broke through to announce that federal subsidies for small farms would be slashed. A New York luncheon party with the late Armand Erpf — financial wizard, advisor to Presidents and serious art collector — suddenly surfaced. He was discussing the fate of the small business, which if not providing some unique service or product, would have little chance of surviving the balance of the century. Increases in population breed increases in technology which in turn breed increases in efficiency, all to meet increases in demand. Small farms — with efficiency already at a maximum — were on the dropout list. /69

The farm's demise would not harm Roy, but what of Kathy and Bob Shaw, now farming Roy's property? The Shaws also planted the land surrounding the tall frame farmhouse they remodeled: soybeans wave at windows from all four sides. How would they survive? He was young, ambitious, a serious worker. And Jack and Idalou Springer. Could they outlast two summers of draughts? But surely even marsh farmers had already heard of these odds against the small grower, or had governmental subsidies blinded the entire farm belt?

When the small business discussion had finished, Armand saluted the producer whose output was probably the world's most precious — and smallest. 'Yes, he will survive. The fine artist will survive.'

The annual farm rent from Roy's grandson-in-law was exhausted, but it was far too early in the year to borrow against next year's income. Roy turned to his unplanted fields; before him lay possibilities for profits as large as those from tended fields. The secret crop — junk, and even though Roy no longer possessed the muscle to breakdown heavy metal, Jack did. Before long Roy found an opportunity to enlighten — offhandedly — his son-in-law on the profits sleeping in scrap metal, and of course Jack's joining him in the venture would automatically entitle him to half the payoff. Roy didn't detail the status of his bank account, but Jack judged the balance to be nearing a darning egg. What else could entice Roy into a physically heavy-duty project?

Jack
I really didn't expect to make any money. It was money for Roy.
Fifty dollars is money to him. He wanted me to help cut up this
stuff. It was one of his ways to make money without working. By
that I mean without having a regular eight to five job. He gets
some friends and they go out and look around the countryside, find
old cars, and haul them back to his place, cut them up. Sometimes
they would just take the weight out of the car and leave the body
— the shell wasn't worth anything. Soon his place was mostly
junk yard.

Over the past ten years or so junk had been accumulating on Roy's property: charred cars, abandoned cars, truck bodies, rusted farm equipment, remains of a large butane tank that exploded in one of the fires — everyone had assumed it was empty. Some vehicles remained from the various barn and shed fires, some had been towed in from roadsides or fields.

I don't suppose you will ever get a chance to work a day with Roy cause he don't do too much of that anymore but if you do I better tell you what to expect. He might say how he'd like for you to help him junk out a car. That is cutting up a car with a cutting torch and hauling it into the junk yard. And then he will say, 'It won't take long.' You might ask 'How long is long Roy?' and he will say 'Oh you should be back home by noon ' And you will say 'All right, I'll be out to the farm tomorrow morning,' and he will say 'Oh I don't mean tomorrow. I got this or that to do tomorrow. I was thinkin maybe someday next week.' But you will find that next week's time gets filled up with something else and the next week you set a day and drive out to the farm but Roy desides it is too windy to work that day so you have a cup of coffee and set around for about an hour and go back home and drive back out to the farm the next day. He is up and got the fire built and you and him will have a cup of coffee and you'll spent about 45 minutes injoying listenin to him talk. But then you get up, put on your gloves and ask Roy where the torch is and he looks behind the coal stove, in the bedroom, in the kitchen cabinet and finds it by standing on the arm of an easy chair. The torch was laying on top of the refridgerator. Now he starts getting dressed. It is about forty degrees out and is supposed to go to sixty that day. Roy puts on two more pair of pants, another shirt and a sweater all from Goodwill, 25 cents each. Then he puts on his shoes, the kind you can walk though water with. They cost $38. Then his coat and cap and then the gloves. You have been holding the cutting torch all this time and you could have had another cup of coffee. And then you walk outside. The sun feels good on your back and you feel good and so does Roy and you ask him which car he wants to cut up. 'That green Chevie back there' he says. 'We'll have to start the tractor to turn the car over on its side,' he says. That is how you cut up a car, you turn it over and then cut the frame out from under it, the motor. The tractor is driven over and the car turned over. Meanwhile he decides we should cut up the Ford car too. Now the tractor is shut off and it is very quite. The next step is to take the gas tanks off the cars so they can be burnt. The torch is hooked up to the tanks and Roy will give you a one minute lesson on how to use a cutting torch and you are on your way. The straps are easily cut, the tanks fall off and you and Roy drag them a way from the cars. Roy wonders about how much gas is in the tank. The next step will be to fill the cars with anything that will burn. Mostly old paper and cardboard boxes, sticks and old sacks. You light the paper when Roy says and soon there is a great fire. Flames roaring. Windows poping, paints burning off and great clouds of rolling black smoke. It is pretty exciting. There is nothing to do now but watch and feel the heat of the fire and Roy goes to the house. Cars burn hot but not very long. In about fifteen minutes the fire will be about out and here comes Roy with a bucket of water just in case, and he says 'We might as well go into Kenton and get a good dinner while the cars are coolin down. It's about dinner time anyway.' Don't worry about money. Roy always buys. I won't tell you about eating dinner in the restaurant with Roy cause that is a whole nother story. It is about twenty minutes drive into Kenton and by time you eat and get back it'll be a little after one and time to go down to actually cutting up the cars. Roy will tell you where and what to cut and watch and talk you through the first car and when there are a few pieces laying

around he will back his one and-a-half-ton Ford truck up to where you are working and throw the small pieces on and help you load the heavy stuff but he can't do much cause he's got a sore muscle and he complains about it, not about it hurting, but about stopping him from lifting and helping like he'd like to. In a short time you will have the rear end, the front wheels and the frame cut loose from the car and will be beating on the motor with a broken handeled sledge hammer. The motor will be worth more if the different metals are separated. With the warming of the day, the heat of the torch and now the exercise of the sledge hammer you are down to your tee shirt but Roy hasn't even taken his coat off. By the time the motor is broken up and you have thrown on the truck what you can you will be ready for a break so you go to the hoiuse. Roy is already there saying he needed a rest and you agree and he will warn you not to work too hard and hurt yourself and want to fix you a cup of coffee. You and Roy will talk. After some time you get up and go back out and Roy follows. You and him load the heavy stuff you've cut up on the truck and then take the torch and tanks over to the Ford and you start cutting on that. After a few cuts the torch stoppes working and you call Roy over and he explains that you are out of oxigen and he will have to go into Kenton and get some. You load the empty tank into the trunk of his old car and he asks you if you want to go along and if you stay he promises to hurry right back and won't be gone long. You deside to stay and you spend time exploring around the junk and buildings of the farm, looking out across the flat black march land and willow rows of the country there, lay on the roof of an old car watching the clouds, go in the house and make another cup of coffee and leaf through an old Ohio Farm Journal magazine. In a little while you will hear Roy's old car coming and you get up and go out to meet him. When he gets out of the car he will be holding what is left of a Dairy Queen milk shake in one hand and with the other he will offer you a grape drink called Grape Slurrpy. You gratefully thank him and are wishing you hadn't had that cup of coffee. You and he stand around having our drinks and then back to work. After the Ford is cut up Roy desides to load the body of the Chevie on to the trailer but it is no easy task but it is finally lifted, pushed and pried into the position Roy wants on the trailer. By now it is getting late and starting to cool off some. In a short time the sun will be setting, but you deside to load what you have cut off the Ford on the truck. After this is finished Roy goes to get rope to tie the Chevie body on the trailer. Roy has his own method of tieing. Generally he uses great lengths of rope to tie the body on, using many giant knots which only Roy will be able to untie. The sun is gone now, and Roy says he'll take the load to the junk yard tomorrow, first thing, and he begins to speculate on how much it will weigh and how much he will get for the load. You two will lean agains the truck talking for awile and then it's time to go and you get in your car. Just before you drive out of the barn yard, he comes to your window and says 'I'll see you in the morning. You know, just a few more cars to do. Then I'll take the whole load in to sell it.' When you look back Roy is a dark siloete walking toward the house. You are tired but you feel good. You are dirty. Black oil smoke, dirty skin and cloths. You've burned two holes in the shirt your mother gave you for Christmas

and ruined your twenty dollar rubber soles work shoes stepping on hot pieces of metal and lost a glove, but you can't count those in a day working with Roy.

Lee
What do you think about your work? You are satisfied that it's art?

Jack
I think of myself as being an artist/potter more than a plain potter. I mean I'm not a functional potter. But I am in the family of potters, not sculptors, I think.

Lee
People pay more for non-functional clay work.

Jack
I know. The idea of opposing pottery and sculpture still exists, and people have the idea that straight pottery, functional pottery isn't worth the money that sculpture is. That's one of the reasons that right now I'd have to think real hard about showing with pottery. But actually I don't count my stuff any better than a good pot, and it doesn't make any sense that my stuff should be priced one way and a pot, just as good, be priced a lot less, and the two not be sitting beside each other. I've got a lot of respect for some potters. I wouldn't mind showing with them. It just doesn't make financial

173

sense right now. But you know, I like the pots of Robert Turner,
and in 1976 I saw a show and his best stuff was selling for about
eighty or ninety dollars in a gallery. That's crazy.... But I still
don't know what art is. I don't talk art. I don't talk philosophy.
When I grew up the people I talked to never talked philosophy.
They talked about the price of stuff. Just people living and working.

For some time after the sledge hammer and acetylene torch had been put down, Jack was haunted — 'or maybe it plain turned me on' — by junk, not by cutting it up, but by the plain junk itself. For years he had seen, 'but sort of blindly,' junk thrown onto road shoulders, junk piled in front yards, junk cached in woods and forsaken, completely different from what lay on Roy's property, of course: his was technically not junk since it held the distinction of being collected. Jack began tours of junk accumulations, heaps with iron beds, metal drums, tomato cans, shampoo bottles, horseshoes, doors, doll baby carriages, seed catalogs, bath tubs, detritus from which life styles could be reconstructed. Later Jack was packing along a sketch pad, then a camera as well.

"There was a man who worked at Copelands and he lived at 513 W. St. and then he got a job at the Stove Factory and now he lives at 1680 Lincolnshire Dr. and then he bought a new Oldsmobile and his kids are grown now. One lives in Texas. One says he'll be down Sat. So the man's wife cooked a bunch of chicken for everybody, but they didn't come. Now the man has to eat chicken all week." [Plates 40, 41]

Vibrations from the sculpture extend beyond its title. A battered lidless metal garbage can, approximately two feet high, is stuffed with kitchen trash, particularly chicken necks, heads and feet. When the viewer walks around the work, he discovers the rear hollowed out, but not to expose more trash. A cycloramic space contains an impressively modeled woodland scene: it is night, and from the greenery, summer. The needle covered ground slants upward, placing the site on a hillside. At the center a man, squatting beside a camp fire in front of his puptent, holds a frying pan over the flame to cook his trout. Gigantic trees loom behind; in the foreground, a stream churns white water — nature unspoiled and generous, a typical theme of late nineteenth century American landscape painting: a forestral/cathedral stillness, a spirited brook, a comforting fire, a bountiful sizzling trout — nature, wildlife and man wrapped in protective night.

Jack avers his sculptures do not involve messages, an acceptable claim as long as it refers to literal genre works. However, when reality is dislodged (when a garbage can is gouged out to make room for a landscape) the artist is impressing a statement, even if unconsciously. In this sculpture we encounter a reality/fantasy juxtapositioning. Or perhaps a juxtapositioning of two realities, one past (inner and ideal), one present (outer and real). Would Jack not be saying: the ideal world hasn't perished; we've only buried it.

On first encountering this particular sculpture at the Theo Portnoy Gallery, I stood fixed by the woodland scene. At last its imagery reshaped itself into a flat surface: this 'trashcanarama' was a three dimensional reproduction of the dollar-fifty 8″ x 10″ painting reproduction Jack had acquired after we lunched in Lakeview on my first day in Indian Lake country.

A young artist, Glenn Doell, who had assisted Theo in mounting the Earl exhibition, appeared at the gallery again before the show was taken down, waving a reproduction of the 'trashcanarama' before Theo.

Doell
Can you believe it? I was in a small antiques shop on City Island just off the Bronx when I spotted this.

He then described a situation similar to mine, except that I had been standing in front of the sculpture, and he in front of the reproduction, but it was the identical reach for a referent, made all the more difficult when it was in a different dimension.

Lee
Doell only paid a dollar for the reproduction he found in the Bronx. The one you bought in Lakeview was a buck and a half.

Jack
Well, supply and demand. Guess they don't know the value of great art in New York... By the way, I made another garbage can, same idea, only the top was just filled with tons of kitchen junk. Again the side was cut out for a landscape scene. I couldn't think of a title, so Theo named it. I am not into — I'm just not interested in political or ecological or any kind of statement like that. So when it got to the gallery, Theo called it "America the Beautiful." I guess that made it political and ecological.... I like titles. If the title comes swift, you know, that's good. I don't like to put a title on it if I can't think of anything to call it. Theo says buyers like titles, so when there's something I can't think of a title for, it's okay if she wants to do it.

John Klassen, the son of Jack's art professor at Bluffton, is now an established potter as well as Director of the Massillon (Ohio) Museum. In 1981 he interviewed Jack for "Ceramics Monthly" magazine.

John
You seem to be almost a recluse. Do you feel isolated here? Do you feel you need contact with other artists?

Jack
No, at one time I thought it was neat. It's like teaching — there's an excitement to talking about your work, talking about other people's work, and seeing other people's things. But I don't miss it. Looking back over the years at what I've done, I don't see where it had any effect on my work. When I was making things, my ideas were subject to myself and not to what was going on. The other stuff was exciting, but time consuming. Now, the usual comment I get on my work is that somebody likes it. I like to know that people like it. It is then telling me I haven't made a mistake. My work is directed toward selling on the art market. If people don't like it, then it doesn't sell. As far as I'm concerned, there is no reason to make anything that doesn't sell, because I don't have any need to express myself. I've got other things to do. . . . I make things that I like and things that the people I know like. It's hard to talk about art, the fine arts generally. I'm not interested in it.

John
You really don't have much of a studio here.

Jack
I just took a space with a bench and started to work. Then when winter came I hung walls around it and I've never had it better.

John
Why is it better?

Jack
Because it's simpler. I buy my clay. I have it fired. I don't have to load the kilns. All I have to do is take it to the place about a mile away, and come back. I don't do anything, just simply make the stuff and decorate it. And it's cheap.

*

In 1978 Jack and Fairlie began what turned into annual five to six week winter trips south, sojourns in winter warmth, for the first two years along the Texas coastline, since 1980 the Florida coastline. Expenses are kept within reason by traveling in the twenty-two foot camper trailer

with stopovers in state parks. Roy often travels along; sometimes Idalou and Jack Springer bring their car. Now that the children are adults, they too join the family for a week or two. The itinerary remains flexible: if enough fish can't be caught for dinner every night, they move on. Gulf water and east coast Florida water are considered too cold for swimming, but on particularly hot days the family has been known to wade knee-deep.

Jack (note from Florida)
The days are clicking off. Breakfast, fishin, sunin, walkin in the short salt water, playin rook in the evenings. Fairlie gets up at daylight and we go to bed with the pelicans.

*

One of the earlier trips south took them through Louisiana: Tom Ladusa had arranged a workshop for Jack at the University of Southwest Louisiana.

Tom
We have a fund here at the University for bringing in visiting artists, and it was my turn to bring in someone, so I chose Jack. We made contact. He was on his way south — you know how he comes to fish — so he would stop and show slides and demonstrate using china paint. I was excited. I hadn't seen him since Kohler. I was at the university in the ceramic shop, and that's where they pulled in, and Jack walks in and Fairlie walks in and Steve walks in and Grandpa walks in. It looked like the whole family was on tour. We did our hugs and everything. We live in a small town outside Lafayette called New Iberia, and there's a large house and it has a very very large yard and the family was in one of these carpulled trailer-type things. They pulled it right up into the driveway. They were insisting on the fact that they were gong to stay in this camper and not come in the house and sleep. One thing, they did not want to impose.

There was a story I'll jump into right now. I had an old Chevy. I forgot what year it was. It was one of the old kind, the kind Jack looked at and he liked right away. Like the kind you find in every farm yard in Ohio or Wisconsin. I told them I had a whole lot of trouble with the starter motor and here I have Jack Earl in to do a workshop and everyone is excited and waiting to see him and he says let's get on that starter motor. I think he wanted to do that more than anything else. He would have rather done that than talk or show slides or paint china paint. We're under the car. He had some tools from somewhere, like a prepared midwesterner and he *177*

pulled that starter motor out and we put it in the car and ran around town until we found another one and he put the new starter motor in that car and we had the Chevy running and it had been sitting there for a month. Jack Earl comes in and fixes my Chevy. It was a lot of fun. It was raining. We put a carpet down so he wouldn't get all wet, but he did get all wet and all muddy and he was under that car. Just like everything else, the jack didn't work right so we had to use blocks and brick it up. He did it like this is all right, this is what I like to do, what we should do: we should get this car running.

One evening we had a whole lot of fun. We had just finished eating and were sitting down to listen to the 'William Tell Overture' — we have an old Victrola, the kind you wind up, and old records for it. Then Jack asked how would you like to play a game? This is something that we are not used to do as a family and I said okay. What kind of game? He said, well, it's a war game. I said well that sounds all right, so Steve goes out to the trailer and gets the game and down goes the board and everybody divies out the things that they get initially, and all of a sudden we're playing a war game and you have to capture countries and I thought the game might run maybe half an hour or something, but three hours later we're sitting still playing. It's late and we're all tired and they go back in the trailer and I go in the bedroom and Judy says I can't believe it. I can't believe that you could play a game for three hours and we lay there for a long time talking about it and laughing about the whole experience and how much fun it was and how much they enjoyed it and the conversation that went on, always ribbing Roy. You know, Roy's losing and all of a sudden Steve is losing and Steve is getting extremely upset because he's losing. One thing I noticed: they sure wanted to win and they played to win.

When Jack was doing the workshop I talked with Roy. He's one rare kind of character. Roy was saying he didn't know exactly what Jack was doing or he didn't really have any insight as to what it was all about, but the main thing was that Jack was really happy and worked all the time and he made money doing it and so that was all that was necessary. He could climb trees or do anything else as long as you were happy and that he made a living. I believe that Roy does exactly what he wants to do. He wants to fish now and then. He wants to have a meal on the table. He wants a tight family relationship. Those are the paramount things in life.

Only fourteen works arrived in New York for Jack's 1982 gallery show. Four were major sculptures.

"Midway Diner" [Plate 54]
Four cement walls with a large oval section cut out of the flat roof to offer a bird's eye view of the diner interior. As with Jack's early houses where sections of walls were missing and studs bared, here the ceiling joists are exposed. No detail of a typical diner is missing: booths, counter with stools, waist high wall separating dining and food preparation areas, kitchen with stoves, sinks, shelves, a refrigerator and hot plates for coffee pots, checkerboard linoleum floor throughout, pale blue formica on the counter, red curtains at the windows, awnings on the outside, not to mention detailing of accouterments, every coffee cup, salt cellar, menu, pot, frying pan, napkin holder, ashtray, ad infinitum. A front entrance stoop is delineated, as is a service entrance at rear. On an outer wall near the entrance, in fading paint illuminated by an unseen spotlight, is lettered:

MIDWAY
RESTAURANT

HOME COOKING and SOUP COFFEE

Outer walls are gray; inside colors tend toward the wornout. It is late: the sole customer stands at the cash register paying the sole employee on duty, a waitress. He wears a red billed farmer's cap and she wears a little white cap.

The "Midway Diner" offers no more than itself, a universal haven most have haunted, particularly at a late hour, hungry for scrambled eggs, for unwinding with friends, for coffee to maintain safe driving. Through the years Jack had modeled a number of diner studies, and finally a definitive statement was resolved. Like "Carrot Finger," this solitary "Midway Diner" represents the culmination of a theme.

"His Girl (Miss Sears 1968)," "Mr Sam Doke," "Miss Sears 1979" (life-sized) [Plate 56]
The "Miss Sears" girls have golden blonde hair, open collared dresses or blouses, open smiles. The 1968 girl's smile is slightly twisted, indicating a friskiness also suggested by plucked eyebrows. The 1979 girl's smile is less spontaneous, and her mein confirms an ability to endure frailties of friend and foe with inconspicuous suffering. They are readily known: the 1968 girl has waited on your table somewhere, and from there would have been tapped by a talent scout — she even resembles, particularly in the smile, a fine movie actress of the fifties, Jan Sterling. The 1979 girl dated the captain of the football team but married the class president. Everyone knows her, and some consider

stepping aside. But unfairly, as her ambition and reserve are directed to what will preserve a healthful life and a strong future for her family.

Jack encountered the faces in Sears catalogs.

Jack
The years are pretty close, but maybe not exactly right. I tore out the pages but they don't have the years printed on them. We had lots of Sears catalogs at one point.

The likenesses have been altered in Jack's hands, but the sources remain recognizable. In the sixties Sears selected models identifiable with middle America, but by the late seventies the types were more national — without, of course, the extremes of California bathing queens or New York supper club swingers. Jack lifted these two girls into three-dimensionality and impressed them with the strength of everyday familiarity.

"Mr Sam Doke" stands higher than the girls only because more of his chest is included. He wears a black suit and vest, white shirt with straight upturned collar, an unusual brown fedora, and a spunky bow tie with vertical mustard and red stripes. The face is exceptionally long, ears enormous, eyes large and brown under thick eyebrows, and mouth held in a faint smile — again, for a photographer. The ludicrous reaction one anticipates at first glance is not forthcoming: disproportionate facial elements are readily noticeable, but an innate goodness in this plain countenance renders any mismatching of features irrelevant. A canonization of the yokel?

Jack
He was copied from an old junk store photo found in Lima. His last name came from Bobby Smocks' (a nephew of Fairlie's) talking about a family in Sidney, Ohio. The name just seemed right so I used it.

The more time spent with Sam Doke, the more the viewer is conscious of this man's integrity. Jack is at last delineating his 'Ohio values' without resorting to humor or near caricature. Thus far characterizations seem to deepen with increases in scale.

"Man and His Hole Bowl" [Plate 58]
The final major work in the 1982 Portnoy group was initially created for a theme show on containers. Again it illustrates how some subjects are energized by an increase in scale. Would this work have an equal effect if the bowl's diameter were six inches instead of its sixteen? Surely not. Could a number of the small genre works in Jack's earlier exhibitions benefit from enlargements? Their mini-scales and sassy titles

often discouraged searching for more than humor and good craftsmanship.

"Man and His Hole Bowl" has captured a moment when a form evokes an irrational fascination. A man digs a hole, which then holds him in its thrall. We look inside too, but nothing lies at the bottom except more dirt. Nevertheless we understand, having ourselves been summoned and held in suspension by some usually unspectacular object — a door, pier, stone, button, wave — a brief return to a tabula rasa.

One time Roy desided to go into business with his brother who owned some land up in Michigan that had a peat swamp on it and Roy and him was going to sell peat moss for lawns. Roy was supposed to buy a crane which would be paid for out of the sale of the peat. He borrowed the money from a lone company here in Ohio and bought an old crane and hauled it to Mighigan and put it to work. Everything went good except for the crane beaking down every once in a while but then some kind of problem came up and the pardnership was broken up. Roy left the business and the crane and came back to Ohio and of course he still had the crane to pay for. Roy farmed a little and peddeled a little and so he didnt have much money and he fell back on his crane payments and the loan company started sending him letters reminding him he was late. Roy would send them all the money he could but they of course wanted all. Roy kept falling farther and farther behind and the loan Co's. letters kept talking meaner and meaner and coming more and more often and Roy would send them what he could and letters explaining his money problem and that he wasn't trying to cheat them out of the money that he wanted to pay the debt but that he wasn't making enough money. One day he got a telephone call. "Is this Roy L. Hanson? This is So and So Loan Co. This debt has got to be paid now. You will loose your credit rating. We are going to repossess the crane. Where is the crane?" Roy answered, "It's up in Mishigan laying on its side in a swamp." 'Well, Mr. Hanson, we understand your situation, and if you continue paying in good faith as you have been we will be satisfied," and that's what Roy did. 181

Lee
You came from agriculture into the ministry?

Roy
*Well, I went and studied at the Cincinnati Bible Seminary. You
know, when everyone moved into the marsh area, the place on
Hanson Road and on down, they were quite religious people. They
left the old country — mostly Germany and Sweden — and came
over here. Of course there were no churches at that time. So my
grandmother and grandfather they sort of made their home a
church, that is to say, a place for services. You know, they had a
brick house, not far from our farm house. They had a big family,
you know, seven to eight children. And of course the neighbors
came for the services. On Sunday when I went to church, I went to
my grandmother's house. Few people had transportation to go too
far, so churches were localized in homes. Of course later on they
did build churches.*

Lee
*For the services in the homes, were they of any certain
denomination, like Church of Christ or Methodist or —*

Roy
*Just a church. There were four or five preachers who would travel
around. When they'd come, they'd stay right with us. Then when
granddad died — you know people didn't live too long then — I
went to church with grandmother at one that had been built at
Jumbo. It was a Mount Zion church.*

Lee
Did you have a scholarship grant to study in Cincinnati?

Roy
*Well, no, but the community, I guess, paid some of the cost. I know
I went to summer school a lot. I think I was thirty — let's see in
1938. Take that from 1912. Yeah, that's 26.*

Fairlie
*No, that would be before the war, and I know it was after Pearl
Harbor.*

Roy
*Maybe so, but I was preaching after in my home area in three
different places. Flat Branch Church of Christ. I had a church in the
west end of Foraker, and one in the east end. I was very active in
building the church at first. I wasn't doing so much preaching as
building, helping the minister build a larger congregation. I bought*

*a school bus, and hauled materials and children that way. Of
course I also preached while in Cincinnati. Yes, the Fourth Street
Church of Christ.*

Lee
Was the Bible College connected with the Church of Christ?

Roy
*They say they're nondenominational, but they're more what they
call the Independent Church of Christ. That was a big college. I
think it had five hundred students. So I gave up my studies and
came back to Ohio and lived close to Ridgeway. Then I was
preaching in — what was the name?*

Fairlie
Middleberg, right near Marysville.

Roy
*Then I moved to Uniopolis for one year. I came for a trial and they
accepted me at the Church of Christ. Then I went on to Lima at the
Garfield Chapel Church. I don't remember how many years that
was.*

Fairlie
Several years.

Roy
*Then I had another little church out of Miller City. It's called — was
it Prairie Chapel? No.*

Fairlie
I don't know. I just know it's near Defiance.

*Roy studied to be a preacher and he was a preacher for awhile and has always
been real careful about going to church. One time Reverant White, the preacher
where we was going to church came to visit us and Roy was there. In the
conversation we mentioned to Reverant White that Roy had been a minister.
We all talked and had a nice visit and when Reverant White got ready to leave
we all stood up and he set the rules and said that he'd say a prayer and when
he'd finished Roy should follow and say one too. I didnt think too much about
that until he was well into his prayer. He had thanked the Lord for everything
I could think of and then went on to ask the Lord to help and bless everything
I could think of. He was an old preacher and had been praying all his life. He
said his whole prayer without a pause or hesitation. It was a long prayer. Then
it was Roy's turn.*

I didn't know what Roy was going to pray about cause I couldn't see where Reverant White had left any room for Roy at all. I felt myself in Roy's place and I felt weak and little like a little boy.

Roy started his turn. I remember he started by thanking the Lord for Reverant White and all work Reverant White had done for the Lord and for our church and he went on thanking the Lord and asking the Lord's help and blessing on just as important stuff as Reverant White had and never repeated one thing that Reverant White had mentioned and his prayer was just a few seconds longer.

The next Sunday Reverant White introduced Roy to the church and ask him to lead the church in prayer.

Lee
And how did you get back to farming?

Roy
All right! All right! (laughter)

Jack
Now you're getting to what he likes. Back on the farm.

Roy
When I was living in Lima my father passed away. Of course he and mother lived on the farm on Hanson Road. And at the same time my brother's wife died and I had to help take care of his seven year old girl and nine year old boy. So I took them out to the farm.

Lee
And then your twin married four more times?

Roy
Well. . . . Well, that was his first wife that died. One of his good wives. . . . He has a good wife now. Well, we have a lot of little funny jokes we talk about —

Jack
And these wives are one of them. (laughter)

Roy
My mother was quite old and before too long she died too. So I decided I would take care of the farm, and still keep up the church work whenever anyone asked me to. So that I stayed on the farm from then on — I'd say practically all my life. And we are right on the south part of the marsh.

Lee

*I just finished reading a book which claims the marsh covered
16,000 acres.*

Roy

*That's larger than I thought it was. It's probably one of the largest
marshes there is. We used to raise 70 acres of onions every year.
And I was very excellent in knowing how to keep the mud from
blowing. I worked a lot with onions so it's given me an extended
knowledge. We'd get 60 to 70 thousand crates a year. The muck of
course was deeper then, but our farm muck they say is the best
there is. We do mix forty percent clay — it's drift clay, you know —
with muck, because most of the muck has left. Even the greenhouse
does that. After my father passed away we stopped with onions for
the big main crop. Course I still put some out, but we had a labor
problem. You know, the government asked you not to work kids,
children, small people, so we had to give up. Onions take lots of
people, sorting, cleaning and all. Now everything is corn or soy
beans. Soy beans can grow on even bad soil. Course I rent out
the farm now.*

Lee

*Haven't I heard that you would buy produce in Cincinnati and
distribute it to markets and restaurants?*

Roy

*Oh, I was only fourteen when I started trucking for my father. My
twin and I, we'd haul produce into the little cities and we just kept
venturing out and getting in the big cities. I was independent.
Sometimes I put out twenty acres of potatoes, fifty acres of onions
— whatever we figured would be best to make money for the
following year. I sold produce in practically all the big cities in
Ohio. And we would buy, sometimes would buy a field off of some
farmer and sell it. And we were called shippers and buyers. And so
that was about it. When I come back on the farm after my dad
died, I started in putting trucks back on the road to sell produce. I
had about two or three trucks — so I know I was pretty busy. I
sold to stores and restaurants and cut out the wholesale house, but
sometimes we'd sell to it too.*

Fairlie

*You can go in any restaurant for miles away from here, and they
will know dad. He even sold food to liquor bars! The summer after
Jack and I came back from Virginia, we would go with Daddy in
his new Ford truck, go all over Ohio to restaurants, bars, grocery*

stores and so forth and sell produce and fruits. We bought it all
from the Cincinnati produce houses.

Roy

*But I wanted to operate out of my own community, so I could still
work in my churches. I call myself a personal evangelist. And I
help the preachers. But I stay home most now, or visit relatives.*

Jack

When it's time to eat. (laughter)

Lee

*I imagine the house is quite different now from what it was. You
seem to have boarded up some of the rooms.*

Roy

I'm in the process of remodeling. (laughter)

Jack

Yes, you've done a lot of remodeling.

Fairlie

First, he torn it all down. (laughter)

Jack

*Notice he didn't say he was remodeling — he said he was in the
process of remodeling. (laughter)*

Roy

*Well today I'm sort of retired, you might say. They try to get me
back in to work again.*

Jack

*Actually he has remodeled: he put in some very expensive paneling
up on the walls, but you know it's a ten foot ceiling and the
paneling only goes up eight foot. Then he's carpeted the kitchen,
and it's a real nice carpet — red. But it came in irregular sizes, so
it's just laid out over the floor. It's real nice and comfortable, real
soft to walk on.*

Roy

*Sometimes I get active. Now, Jack said he was going up to Kohler
one of those summers, and I said well, I'll go with you. I take the
truck and work with produce, sell it on the way, and then do a
little fishing on the side. And they probably won't forget me around
Kohler because I had about one hundred watermelons on the truck
and gave a lot of them to the art center and Kohler workers there.
I'd sit up late at night and talk to a lot of them. College kids. Then*

I would bring some of Jack's art work back to the farm and store them in my buildings, things he couldn't get in his car. So I took my truck and did a lot of trucking with him. And we had a lot of fun doing it. And if he wants to go anywhere today, he just asks me to go, and I say yes, and we go.

During the second visit to the Earls, I was loaned Dianne's car, a Chevy Vega, for a tour of the marsh area at my own pace, particularly the two towns lying on the marsh — McGuffey and Alger, once centers for the once Onion Kings. The main highway between Lima and Kenton bypasses them by a mile — their time has passed. Moving south from Lima, the turnoff for Alger appears first, a two-lane road sloping gently to the west, pressed on both sides by ubiquitous soybean fields. All morning dark amorphous clouds slipped into one another, releasing a rain-mist to refresh the almost parched plants, the first rain in weeks, and if it remained gentle the crops could survive. Soon lining the road were modest kempt ranch houses whose backyards were horizon-deep soybean fields. The rain let up. The town, except for one or two new buildings, registered neglect. Main Street is three blocks long. Next to Howard's Pool Room stands a large abandoned building whose sides and facade are completely faced with large tiles colored a burnt sienna. Almost a barn form: high straight sides, then a gambrel roof with a flat top. An almost completely faded name stretches across the top front: C V O Y L E R. I asked several passers-by about the building's former function, as well as the name. No one knew. Most pleaded to being new in town. In fact, girls and men in their late twenties — barefoot or occasionally sandaled, wearing levis and unironed shirts — were the only residents in sight, lending an art colony air. An unpainted cinderblock barber shop next to C V O Y L E R bore a sign in the window composed with stationery shop block letters:

SORRY
CLOSED
GABBY

The letters were all blue except for a red 'y' in 'sorry.' Why didn't the 'y' in 'Gabby' end up with the red 'y'? The other side of the street was dominated by a small supermarket, where the occasional 'art colony' residents emerged with newspapers. Actually, except for the farms — and they are mostly machine operated now — little in Alger appeared able to support a working population. Silos of a grain elevator poked above roof tops a few blocks away, and I drove over, parking on the

gravelled yard of the Ohio Farmer's Grain Corporation. No one in sight. I entered a small office shed standing by itself at the front of the lot. A trim all-American in office attire introduced himself — Dennis Chandler — and offered to explain the operation. We stepped into the yard, and while I marveled at the skyscraper cement silos with their silvery corrugated metal coverings for the elevators, he spoke into the tape recorder:

Chandler
We basically are an original co-op owned by 116 member elevators in the state of Ohio. We're a gathering point for commodities, basically corn, beans and wheat, within the Hardin County area. Grain is brought here by farmers in gravity bed wagons which are pulled behind a truck or tractor, sometimes three or four of them in tandem. They haul anywhere from 250 to 400 bushels per wagon. Eventually we load it in jumbo hopper cars on trains and ship it to the east coast. Each car holds 3,500 bushels. . . . I am not sure why this is called an elevator, but I presume, technically because everything is elevated by what they call elevator buckets. The grain is elevated from the ground floor to the top of the silos, and then when it's to be shipped out, it's gravity fed from the bottom into the train containers. When the grain comes in we first must test it for moisture. It should be dry; if it isn't, we have to discount it accordingly. Everything is bought on a weight basis, then that is multiplied by a factor which gives us the number of bushels. There's 56 pounds of corn in a bushel; soybeans are sixty pounds and so is wheat.

We pay our local producers immediately on request, and of course the price fluctuates daily, all based upon the Chicago Board of Trade, Futures Trading. . . . This soil, which is called muck, used to be some of the most fertile in the land. Not today. It used to be strictly a vegetable crop, and now it's strictly corn and bean ground. With the larger sized equipment farmers use today, they went in and tore out all the wind rows which were there to preserve the muck, made a lot of wide open field areas and then, of course anytime we have dust storms, the muck blows. Every year more disappears, and some areas are down to the clay. Unless they change their farming practices, I visualize that in the future there's going to be quite a problem for them, on account of the idea that they haven't, through conservation — self-conservation — tried to preserve it. . . . Each area of Ohio varies a little. If you travel, maybe thirty miles from here, you'll be in an area where it's dairy, chickens, hogs, livestock. But we're strictly grain in our area. They

usually call them the six months farmers — farm six months, then rest six months.

Two gas stations were conspicuously boarded-up on Main Street, and nearby a corner vacant lot had been converted into a community park, suggesting a venture more hippie than artist colony. A cement walk criss-crosses part of it, with poles on each side supporting a peaked roof. At one end of the walk a sign read, 'This is your park. Please help keep it clean.' An artist(s) had brightened the wall of the adjoining building with a mural labeled 'Happy Birthday America,' which didn't suggest hippy or artist colony.

As I was photographing the mural, a slightly-built boy around twelve passed, again from the supermarket, a small package in hand. Tears in his shirt and his quick pace made him particularly visible.

Lee
Excuse me. Do you live here?

Boy
Born here.

Lee
Do you know what that building with the tiles was once — there, down the street?

Boy
Not for sure, but I think I heard it was some sort of storage place. I don't know much because I don't get out of the house much.

Lee
What do you mean?

Boy
Well, they don't let me out very often. . . . Anything else?

Lee
No — and thanks.

He hurried on.

Back on the highway again, and soft rain recommenced. The next turnoff was McGuffey, an even smaller village than Alger, really only one long treed street, again with backyard fields of corn and soybeans.

The largest structure was a yellow brick building with overtones of Frank Lloyd Wright: the Upper Sciota Valley High School. Students must be bused in from the entire county, as there could not be enough young people in McGuffey to fill one classroom. I saw only one store, the McGuffey Grocery, and only one person. I stopped and asked him what the population was. He didn't know. During four visits to Ohio, I never found one person in any town who knew the population. Certainly nothing in these two marsh towns indicates Onion Kingdoms, not even a roadside Historical Society plaque.

South on the highway again, and in a short time entering Kenton, the Hardin county seat and a good sized town dominated by a hodgepodge of older buildings surrounding the county courthouse. Nearby stood the museum. Closed, even though a weekday afternoon. Also nearby was the Historical Society, and also closed, with no hours posted. When I asked for information at the gas station, the attendant advised me to 'go ask in the hobby store — right across from the front of the Court House.'

The museum schedule was a mystery to the genial lady in the craft shop as well, but she did know the Director, Richard Aller, and offered her telephone if I wished to call him. He informed me that museum hours were Wednesdays, Fridays and Saturdays from one to four, and further that it was completely operated by volunteer help, including himself. Both Mr Aller and the lady in the shop suggested I visit a bookstore just outside town, run by a trustee of the museum. The bookshop owner too was hospitable, and had three books on the county in stock: the first a genealogy; the second a history up to 1883; and the last a history of the marsh.

Bookshop Owner
You're interested in the muck? I'm from a muck farming family and my sons have muck farms. It's just about finished. Like almost all the farmers, my sons got greedy for more land and took down the wind protectors. Now they don't dare plow the fields in the fall. The winter here is windy, and you can see muck on top of the snow drifts. Then it's a big blow in the spring. It blows so hard muck fills up all the roadside ditches, and the public rushes out and scoops up the dirt from the ditches because it's such great top soil for their own gardening plots. Kids have to sweep it out of the schools. The clay bottom shows through in many places — like bald spots.

I bought the book on the marsh. Walking to the car, my eye retained two mysterious apostrophes in her sign.

BOOK'S AND THING'S BOOK STORE

Jack's fanatic concern over the emphasis given intelligence in our current value system, especially on the educational level, led him to fear he hadn't expressed himself well enough earlier. This time he took up pencil and paper.

Jack (written account)

I've lost respect for intelligence. I believe intelligence is worshipped in this country, and has infected most everyone, and particularly the younger people. What is happening when you can't have for a friend someone who you feel is not as smart as yourself? This school system we have fosters disrespect for people who don't have book ability. When people get older and have found their stations and have functioned in them, the old prejudices against people less intelligent mellow, and they now judge others more by their honesty and willingness to work.

You can tell a person he is ugly and get away with it, but don't tell him he is stupid. That will be the end of that.

Early on I decided to forget about intelligence in my work. As soon as you put some of that in, you are of course saying, 'I'm this smart.' Well, of course, many people can say that's stupid. I think that kind of competition is stupid.

I've seen many intelligent people with good personalities ruin their careers because they couldn't control their tongues. It's not what your brain is filled with, but how you use that information, how you live — that's what counts. If I were a President of a University, I would make every student and faculty member and administrative staffer take Humility 101 and Wisdom 101. But I don't know where I'd find a teacher.

Despite the good number of years of knowing Jack, I had actually seen very little of him before the Ohio trips. New York visits — to deliver sculpture to the gallery — never involved more than a two or three day stay: time only for a dinner party, talk about his work, sightseeing. I was aware that Fairlie was a minister's daughter, but not until the visits to Ohio did their commitment to organized religion become apparent. In New York they would have an occasional drink, perhaps a glass of wine. I've never seen them touch liquor in Ohio.

During the second visit to Ohio I asked Jack, late one night, about his commitment to Christ, and how it related to his art commitment. His comments were taped, but the next morning we discovered the recorder had malfunctioned. Jack retired to the kitchen table, and sometime later returned with his thoughts on paper.

Jack (written account)
I've often thought about my religious beliefs, and what to do about that part of what I feel or think in relation to my work. I've never been able to be clear about that. Of course the simplest thing would be to make obviously religious subject matter. I can't figure out how to do that without being something I just — well, I just don't know how to handle it. I wouldn't know how to approach that — the religious subject matter. Lee asked me if I'd gone to church as a child. And I had. My brother and sister and I always went to church. And I married Fairlie, who was the daughter of a preacher. And then I became close to Roy. And I think that's where I got my real feeling about how to live — or what, really a Christian is. That came from Roy, not the church. And I understood the way he lived and thought, and thought it was a good way to live. And so I kind of patterned my general attitude toward what's reasonable and what's understandable from Roy. We now go to church where Roy goes to church. You know — where you photographed us. And it's more — it's part church and part family experience. I've been to a lot of different churches. I don't have anything against any of them. It's just what type of church you respond to. There are all different kinds of churches for all different kinds of people.

In relation to making things, I wouldn't want to make anything that would offend anyone — I think that's a basic criteria. I know everyone's not going to like my stuff — pretty certainly — but that isn't the kind of offending I mean.

Lee and I got into a long discussion about image. Well, we talked about no artist seems to make good religious art today, except the folk artists. He wondered if an answer to my problem might be to alert the viewer of the religious feeling in my work through the titles. That is, I might create a sculpture which represented a deep religious thought for me, but because the usual symbols of religion might not be depicted — like no angels — the viewer could miss its spiritual content. However, a title indicating the religious direction would provide the viewer with another dimension to consider.

Lee asked me why I didn't drink hard liquor. He also asked me

why I listen to a Christian radio station while I work. I think it's basically to keep my mind straight while I'm working. Otherwise my mind wanders, gets on things I really don't want to think about. And I like to listen to it. It's good to go in and turn it on. I've been listening to it for years — WJYM, owned by Jimmy Swaggert — and they're generally familiar voices, saying things that I'm interested in. As far as the music is concerned, when you're listening to Christian music, you don't get any surprises. You don't hear anything you don't want to hear. Oh, I have listened to Bob Dillon. I like his record 'Shot of Love.' His latest record, 'Infidel,' speaks of problems and there's nothing particular worth mentioning. His own feelings which don't mean anything to me.

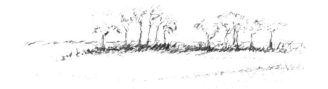

Jack created only nine sculptures for the 1983 show at Portnoy, and one represented the largest he had ever fired. "Father Son, Father Son, Father Son, Gail and Timmy, One Month. . . ." [Plate 55]

An informally dressed man — saddle shoes, wide-cut slacks, white shirt with open collar — stands on a rocky incline holding his month-old infant chest high. The man tilts his head and the child toward an invisible viewer, quite obviously a photographer who adds unexpected drama to the situation. Who is it? When the viewer moves into the man's glance, he becomes the photographer. Jack surely planted this entrapment. The viewer, whether he feels like the photographer or not, now looks at the figures conditioned with the knowledge that it is to be photographed. Details are more readily noted, and questions posed. For example, why not the mother with the child? Or better, why not both of them? Is this the first snapshot of the child with his parents? If so, why weren't arrangements made for a third person to handle the camera? The snapshot was surely planned before hand: the father is nicely dressed, his hair well brushed. The safest conclusion is that the wife is taking the shot, and next he will photograph her with their child. Everything is perfect for the picture, even that the father shows a little concern — note that vertical line between his brows, perhaps signaling his wife to press the shutter release. It's almost too unpretentious — even the smile — to be actual. But it is.

Jack
I used a photo bought at a yard sale in Harrod, Ohio. Dated in the forties. 'Gail and Timmy one month' was written on the back. Repeating father sons three times in the title was like mentioning their ancestors.

The sculpture harbors other vibrations. Even though a male holds the child, a madonna composition is suggested. Repeating 'father son' three times invokes the trinity. Jack's allusions grow richer.

Completing this sculpture necessitated several months of coiling to achieve the scale and subtle modeling wanted; and eventually grew too large for the hobby shop kiln, so Jack carted it to the Toledo Museum school, where again permission was granted to use their firing facilities.

"Beyond the Door There Is A Place to Walk, Explore, Rest, Discover and Dream" [Plate 60]
A desolate mountain side rises slowly, then tilts sharply to a great height. At the rear of the gradually rising foreground is a simple, perhaps abandoned, frame house — or more likely a mill: a peaked roof at the second floor, weathered wooden sidings, roof shingles missing. The side facing to the right is shored up with a high rock wall, as it borders a sandy river bed, which widens as it runs to the foreground and off the sculpture. Two or three trees stand across the ravine from the building, but the rocky promontory behind is arid. Repeatedly we survey the surface, searching for the significance of this subject.

Finally we walk around the sculpture, and at the rear find that the flat blackened sides have angled sharply toward each other so that the back panel is only about eight inches wide; and contains a single painted (oil) image: a closed screen door (real screening affixed) to a house, thrust at us as if by a zoom lens. Behind the screendoor is the regular door (wood, with the top half a curtained pane of glass), half open inward; and between these doors stands a beautiful young boy — no older than two or three, dressed in the smock children wore some fifty or sixty years ago. He presses against the (evidently locked) screendoor with hands and forehead, his eyes, fixed on the outside world, reflecting one compulsion: escape. The sculpture, open to any number of questions and interpretations, is gripping. Why is a boy this young suffocating? The drive to push through the screen is stronger than wanting to go out and play. Is the drive to escape from — or to?

Whatever the motivations of the drama, this dos-a-dos sculpture stands masterful, technically and psychologically. The mating of the diminutive building in the massive mountainscape with the enlarged screendoor throws our visual circuitry out for a moment. Then on encountering

the child, the circuitry shorts again. To think that there is no sign that this work is a dos-a-dos — or is there? Didn't the very incompleteness of the landscape arouse sufficient curiosity to force us to the back? Such audacity! The title, 'Behind the Door There Is A Place,' is as enigmatic as the dos-a-dos placement of the mountain and the boy. Perhaps the power lies in its very elusiveness, as the power of an earlier sculpture lay, just as inexplicably, in a hole a man had dug. Looking farther, we find a sub-title scratched on the side: 'Don't worry, mother has latched the door so baby won't push it open and fall.' The work is fraught with unresolved emotional conflict.

Lee
Is the screen door related to the mill?

Jack
No, at least not physically.

Jack confirmed a felt-relationship between the two images, but it could not bear verbalization. The mountain scene was borrowed in its entirety from a reproduction of a Ralph Blakelock painting, the boy reproduced from a 'found photograph.'

Also in this show was another sculpture in Jack's Interior/Exterior (Zen) posture.

"Over There, Look Inside, You Can See" [Plate 57]
A foot-long log lies on its side. Missing is a wedge, about a third of the log's diameter, that has been split away down its length, and in its place is an elaborate seascape, the bottom half choppy waves, the upper half a cloudcrowded sky. Along the horizon line —which runs along the core of the trunk — a schooner glides at full mast. On the upper right a hatchet bites into the log, its blade penetrating the bark enough to hold it upright. Once more a still surface conceals inner activity. Are the bark and the water mutually exclusive? Is the seascape the valid life of the tree, with the bark a masking facade? Does the seascape know it's inside a tree? Jack shrugs to all questions, only disclosing that the seascape was copied from a painting by Thomas Birch (American, 1779-1851).

The exhibition sold well, and important for Fairlie's budget, top prices reached $5,000.

Jack

Then when Roy's mother died, the house started falling apart. . . .
He just doesn't have the time for that kind of work. He's just too
busy. That's the truth. He doesn't have time to go fishing, to visit
people. He's always busy and he doesn't have money for someone
else to do it. Here's a Roy story. We were driving back from the
cabin — Steven, our son, Roy and Bobby. Bobby is Fairlie's sister's
son — they live in Sidney. He's about fifteen. Roy said to Bobby, 'I
want you to help me put a roof on the south side of the house this
weekend.' Bobby said, 'I've got to go to Sidney and sit for the baby.
Mom's on one of those welfare things where she has to report in
for certain days.' So they start arguing about it. Roy just went on
and on, complaining how these kids bossed him around and cost
him so much for gas to drive over to Sidney to see them all the
time, to pick them up and take them over here, and right away
they want to go back home and he had to drive them back, all his
time and money. Bobby just sat there, repeating how he had to
take care of his official G. R. (General Relief) business. Finally
Bobby decided all right, he'd stay with Roy. They went out to the
farm. A couple of days later they showed up. 'Well, Roy, did you
get your roof fixed?' 'No, it looked like rain.' Bobby said all Roy
did was sleep for two days, and he had just sat there and watched
him sleep. There you are. There's no explaining it.

Fairlie

You know in the winter he wears all he can, just about all his
clothes at once. You'd think he was a very big man. And in the
summer he wears less and less. He's pretty slight, you know. For
the past couple of years I've been doing his laundry. He leaves
pieces of clothing here and here. He has lots of things, all from
thrift shops.

Jack

When it's time to come back from the cabin, he says, well, I'll just
leave this here. And I say oh no you won't. He doesn't want to pick
it up and carry it.

Lee

Jack, you have always said he was the most Christ-like person you
ever knew. I like Roy, but —

Jack

Well, there is one trait that Roy has in relation to people is, well,
when you say he is a nice man, well, he has lived with folks who
are trash, with bums and he has put up with incredible things from

these people but still remained friends with them. He just simply doesn't get upset with people.

Lee
Trash and bums?

Jack
Do you know what a hobo is? They steal off you and they give you bad times. He's always been very helpful to people whenever anybody wants anything from him. If he's got it, he'll give it to you. If I wanted his farm, if I said Roy, I've got to have that farm, he would give it to me. If I wanted money, you know, he'll take it right out of his billfold and hand it to you and you say no no, but he keeps pushing it on you. He has always done things for poor people, not just put up with them, but he'll be their lawyers, get them out of jail, work on their divorce problems, like alimony, just anything you could imagine. . . . Have I answered about why he seems Christ-like to me?

Lee
Well, yes, his giving spiritually and materially to others. And yet, so strange, letting his physical world, the family house he inherited deteriorate around him. Isn't its collapse imminent?

Jack
But that only effects Roy. He lives alone and really that's nobody's business but his own.

Fairlie
My mother was very domineering. She ran the house. He never liked to do anything the long way or the best way. He always took the easy way out. He always has been that way. My grandfather — Roy worked with him, his father — and he was always after Roy. He'd never get it right. He would never really take orders at all.

Jack
Roy told me the other day when we were talking about coal, 'My dad taught me to always keep good coal and if I didn't have good coal around the house he would kill me. He taught me to always keep good coal — but I never did.' One time we were driving in his truck. The bumper fell off the truck. We got out his tools, laid a piece of cardboard on the ground and got under there and fixed the truck. I had to leave in the middle of it, and when I got back the truck was gone, but there laying right in the middle of the road was the cardboard and the tools, laying right there where he had left them. 197

Fairlie
He's good at making things, putting them together.

Jack
Yes, but he won't get involved in it. The battery went dead in his car, so instead of lifting the battery out and putting a new one in its place, he left the bad battery there and stretched the battery cable inside the car where he had the new battery on the floor. He hooked up that way.

Fairlie
I know that if a door gets jammed or anything, he'll be the first person to break it. Roy's twin is a lot like that too. If Ray can't make something work, he kicks it, throws it down.

Jack
One of the problems is that after he got the divorce, he has never worked. He decided there was no good reason for him to work, that is take a job somewhere. And so he has never had any money. If you don't have any money, you're always, you know, just scraping by. You know it costs money to keep things up.

Over and over a statement returns from the dusk conversation outside Lugenbuhl's house, the only comment Evelyn made, and that only moments before we went inside: 'I always thought that your work was a lot more serious than you ever wanted anybody to, well, that you ever wanted to admit to anybody. I think there's a very deeply serious part of Jack that he won't discuss or that he avoids discussing with people. I don't know. I just suspect it.'

Evelyn's intuitive observation plunged us under the surface, but only momentarily. Her husband changed the subject. Just as well: Jack would have floundered if forced to admit a 'deep serious part.' But Evelyn knows, and so does Jack.

Humor and immaculate craftsmanship had sustained Jack's reputation, but several years after his return to Ohio introspective elements entered the work, first with the transformation of stumps into hands, figures, flower pots; later followed by the exemplary 'Carrot Finger,' where sculpture and story jointly supported a weighty metaphor, if not parable. In the following year Jack, leaning on the photographic 'other world,' created the provocative 'Father Son Father Son Father Son' and compelling 'Behind the Door There Is A Place.' Ever deeper.

A serious cave, yes, and expressible only through work. Spirit has entered the flame firing the clay. The deepening of this intimacy between artist and object will require time. Jack has time. But not time to talk about it.

During my final trip to Ohio, the Earls announced they had found haven in a new congregation. Idalou and Jack Springer became followers of a black preacher, Pastor Thomas, who held services in a store front on the outskirts of Wapakoneta. Later an illness forced him to close the meeting place, and eventually the congregation dispersed. The Springers then switched to Hope Temple, where Pastor Jim Minke officiated. Serving as the Pastor's assistant was John Berns, a young preacher longing to have his own mission, and when he finally broke out on his own to preach in the bar area of an abandoned skating rink, the Springers followed.

Their first winter was miserable. The only income — $1,008 — was derived 'from selling things,' Mrs Berns told the Springers, 'not even enough for proper heating.' Eventually the congregation grew, and Berns moved to a store front in an unsuccessful mall, where he named his mission the Rock Assembly Church. At this point Fairlie and Jack joined.

Testimony of John Berns (written account)
Born in Chicago. At 5 his family moved to southern Florida. After high school served in the army for a year and a half, spending time in Korea. Back in Florida, attended Miami Dade Junior College for two years, followed by a year at computer school. In 1973 went to work for John Hancock Mutual Life Insurance Company, and was located in Elkhart, Virginia, for five years. In 1978 the company relocated him in Lima.

Worked (with Hancock) to 1981, then finally stepped away onto total faith, and began a total new work in Rock Assembly Church. We worked on total faith; no money. From 1981 until 1984 Rock Assembly has grown from 14 people to almost 200 to Sunday Mornings, and is a big influence in Lima today. We touch the lives of 10-20 million people through the medium of radio, T.V., newspapers with the message of Jesus Christ. We are now planning to build a city worth 2.5 million to help the needy. Our present Church is worth $300,000.

Not in the resume is biographical information Jack gleaned from Berns' sermons.

Jack
I know he performed before 500 people at one time playing the guitar and singing. He also was a musician for a while with a rock group in Miami — well, certainly Florida. After he got married, I believe, he went into insurance and went to the top quick because you know he's got a real personality. He won all kinds of awards because he was such a good salesman. They threw him out of the company, though, because he wouldn't stop talking about Jesus. I believe that he got saved when he was into rock and roll music. When he got saved he gave up rock and roll. I think it had something to do with meeting his wife, and his wife was witness to him. That is, his wife witnessed to him just the fact of Jesus, of needing Jesus or God, just explaining.

*

[From 'Cruden's Complete Concordance' for the St James version of the Bible: 'Since there was little writing among most of the people in olden times, the evidence of a transaction was most often given by some tangible memorial, or some significant ceremony. Witness in Greek is martus, or martur, and signifies one that gives testimony of the truth at the expense of his life. It is in that sense that the word is mainly used in the new Testament, and our word martyr has come from this also. . . . The disciples who had been with Jesus were to be witnesses for him, and when they chose another apostle in place of Judas, they thought fit to appoint one who had been a witness of the resurrection along with them.']

*

In July of 1983 Berns gained state-wide notoriety by carrying a wooden cross from Toledo to Lima, a distance of eighty-three miles.

'Associated Press Release' (excerpt):
LIMA, Ohio (AP) — The city law director says he has empathy for a group of clergy trying to raise consciousness against pornography dealers in Lima, but he says there will be no crusade in his office to stamp out book stores.

The Rev. John Berns, dissatisfied over what he calls inaction against pornography dealers by city and Allen County officials, said Wednesday that he will lug a 6-foot cross for 83 miles from Toledo to Lima to draw attention to the church's battle against smut.

'We're not out to hurt anyone,' Berns said. 'We just want people to know that there is as much a right not to choose this as there is to choose it. We want to put God back into community standards.'

Adult book stores in Lima have been open for about 18 months, and although an estimated dozen arrests have been made there on charges of pandering obscenity, there have been no convictions.

The religious leaders claim their 5,126 signatures on petitions prove that the stores violate community standards in the city of 50,000.

In one jury trial earlier this year, two men charged with pandering obscenity were found innocent.

'I don't think those seven or eight people on that jury wanted to be responsible for deciding what community standards would be,' Charles Harrad (Allen County Sheriff) said. 'A lot of people are just plain indifferent as long as it isn't next to their door or in plain view of their church.'

'Besides indifference, some residents must be shopping at the stores,' he said.

*

A larger denomination, the Church of God, had drawn unexpected numbers into its Lima assembly, whereupon the mother church provided $300,000 for a new church in East Lima. However, the growth of the assembly evidently did not expand as anticipated, and the local church found it could not pay its way. Berns heard of the problem, and through negotiations was able to obtain the building with minimal obligations until money could be raised to buy it. The 'our' in his earlier statement — 'Our present church is worth $300,000' — evidently did not mean the church as 'our possession,' only as 'our meeting place, which we do not yet own, is valued at $300,000.'

Jack
*There is, as I understand it, a certain monthly payment, part of
which goes toward the payment of the church. They need $30,000
by the end of the first year and then the church will be in the name
of Rock Assembly. Right now it's still in limbo financially, but the
Church of God is real reasonable. The road frontage is maybe only
150 feet wide, but it's a deep property, and at the back it spreads
out behind houses on the road. It's a ten acre plot.*

Acquiring the temporary location is but the first rung up the ladder to
Berns' ultimate dream: a City of Vision, of Faith and Hope.

Jack
*One of the things that John's interested in and is always promoting
ever since I went there is feeding people, giving people money
without asking questions and worrying about whether they will use
it in some strange way. Out of that grew the idea for a total health
center, which would include taking care of people with no place to
go, rehabilitating people like prostitutes. Like there was a prostitute
recently, just last week that accepted Christ on a street in Lima.
After it was over, the prostitute asked, 'Now what will I do?' Well,
Berns didn't have an answer because we have no place for that
person. We have no way to take care of her, and what he wants is
a place for those kind of people, plus old people, plus people who
need care that is not really serious medical care, and most of it
would be teaching and just giving people things they need, and out
of this grew the idea of this City of Vision, of Faith and Hope.*

*He asked me to do a drawing of his vision, and so I started. He
said he wanted the sanctuary to be a dome, and he wanted a
prayer tower and then he wanted five buildings and he told me
what their purposes would be, and that's why I put titles of their
functions right on the buildings. Plus there must be places for
people to live. I did a couple of sketches for him, and he made a
couple of comments and then we talked about it and I told him
that if it was a vision then it should have a visionary look and not
a real look, so that if in the future there are changes you aren't
held to this drawing. That's why the church now used isn't in the
vision because he isn't sure if the congregation would still be in this
church. So the second time I met with him I had a more complete
sketch, and at that time he said take it and do what you will with
it. My daughter, Kathy, and I got together and it just came real
easy, and worked out real good. I thought it came out well. It
didn't have all the quality that I wanted. The fountains in the center
are a little heavily drawn, because when I started drawing I did not*

have a clear idea and I didn't know how to draw water — I had to work with that. But the rest of it is pretty clear. He asked me to make some adjustments after I had it drawn, and I told him no. He wanted Rock Assembly, now written in lightly, put into color. I said no, John, if you change one area of the drawings, then the whole thing has to be redone. I don't know if he has ever had any art training, but he really responds to my work, really appreciates it. He got really excited about the drawing. He seems to really respond to my stuff.

Services are held on one or two week nights as well as on Sundays. The Earls invited Karen and me to attend one of the midweek meetings, held at six in the evening.

Walls of the Rock Assembly are cinderblocks, with a ceiling suggesting a tent: dark stained beams rise from the corners to a central apex. The square structure is oriented like a baseball diamond, the entry corner lying opposite the altar corner. Two hundred people would fill the pews. We arrived at the last minute, taking chairs toward the back, and with the seats about one-fourth occupied, it was not difficult to spot Stephen Earl a couple of rows ahead, and Idalou and Jack down front. Several blacks were in attendance.

The service was lively from the start: a young guitarist stepped to the altar microphone to strum and sing, accompanied by Peggy Tobin at a Hammond organ, also on the altar. The songs were rock, revival and western, and Berns' wife served as song leader. Eventually Pastor Berns, in a business suit, appeared at the microphone. His sermon was delivered with spirit, dramatic vocal modulations, extravagant arm gestures, occasional leg kicks, and hardly required a microphone. Congregational hand-raisings were frequent which Jack whispered signified 'Praise the Lord,' and also humility. When a member of the assembly interrupted the sermon to proclaim devotion for the Lord, Berns fell silent until the witnessing was completed. Jack had assured me there was no need to take notes, as all sermons were automatically taped, but later Jack wrote that the recorder had not functioned that evening. I remember only Berns' speaking ironically of those who preferred spending Sundays with cans of beer and televised football, rather than with God.

After the service we were introduced to Pastor Berns, who took us at once to the wall holding Jack's drawing — 32 x 22, larger than I had expected — of the City of Vision. Indeed the look was futuristic, a compound of buildings of almost Star Trek architecture. The rendering of the water in the central fountain was fine. Berns explained to what use each of the buildings would be put, and accented the importance of breaking ground for even one as soon as possible.

Jack
*Fairlie and I have been going to this church for only two or two
and a half months now. The style of worship here, I think, grew
out of the Pentacostal Church, but it isn't Pentacostal. What I know
about Pentacostal is only that it's a more free and open expressive
kind of worship. We have tried several churches — Church of
Christ, one of Roy's churches, a Nazareen church for about a year
— that's more quiet, with hymn books — and to Hope Temple, and
now here. I think basically what I like about this church is the
straight forwardness, plus the honesty in the obvious truth, and plus
the everyday use of Christianity that John teaches. I appreciate the
music, and sometimes he includes a regular hymn. I like both
kinds of music.*

*

Shortly after returning to New York, two tapes arrived from Jack
featuring Pastor Berns: live sermons from earlier that year.

'Pastor Berns Sermon "The Vision" ' (excerpts)
*Where there is no vision, the people perish. . . . What is a vision? It
is the act of seeing something divine or a revelation or a truth of
the knowledge of God. . . . When you receive a vision, you must
run with it. . . . The ACLU (American Civil Liberties Union) is a
Communist center. They have lost their vision. The nation has lost
its vision. . . . Our nation has gone away from righteousness. There
is no righteousness in the courts. . . . Satan wants to cry from this
pulpit. Well, he's not going to do it. . . . Are you ready to die for
Jesus Christ? . . . Give the Lord a hand (applause from the
congregation). . . . A lot of people do it their own way, not God's
way. . . . My landlord said to me recently, John, I'd like you to
leave. I'm fearful you're going to be killed. . . . Vision means
revelation; revelation means truth; truth means ability; ability
means to conquor; to conquor means to win! . . . I've seen angels.*

Recently Jack sent an update on Pastor Berns.

Jack (letter excerpt)
*Berns is up to something new. His church and another has come
together to form one church and they are in the process of starting
a Bible College and a Christian grade school. We have about 275
each Sunday morning now but the evenings are still small as it was
when you were there. they are feeding more people now. No new
buildings except the building where the other church was being
held in, a large store front in a Lima mall.*

204

One time I was watchin T.V. I said "One time I was watchin T.V." I was watching Public Television. They used to call it Educational Television. They don't call it that no more. It was a program on nature and animals and birds and plants and flowers and it was in color and everything was beautiful and there was music playin and there was a voice speaking also, telling you names and places and everything was so peaceful and pretty and telling me some of the wonders of nature.

And once in a while they would show me the narrator. He was sittin just so with one shoulder pointed at me and his hands were demurly folded in his lap. Sittin in a high backed green overstuffed antique lookin chair. Like maybe it had come out of some French palace over there. A conventional style lamp set on a table at his elbow and it had a big green shade on it and on the table lay two big thick books. The top one was green and a glass ashtray was there with a big black bent pipe sittin in it. In the backgrond was a crackelin fire in a fireplace that wasn't making any noice. A couple of vases was sittin on the mantel. Above he mantel hung a old oil painting of a head sittin on a black coat with a dark brown background surrounded by a very ornate gold colored frame. It was hangin on a green cloth covered wall. A man in the painting wasn't smilin.

The narrator was dressed like he'd always been dressed up only, just now, for our little chat, he'd taken off his tie and jacket and put on a different, a bit more colorful jacket and he'd taken off his shoes in a different room, I guess, and put on some shoe like slippers. His cloths didn't have no wrinkels in them. There was a big long haired special thorough-bred kind of dog sleepin at his feet on a persian looking rug.

The man's hair was a little bushy and a little gray and he was wearin gold rimed glasses and his mouth was moving and he was almost smilin and his voice was deep, clear and he had some kinda Europpean accent but you could understand every word perfectly clear. He had wonderful diction. He was explainin about whales, big whales, monster big whales, whales as big as two houses and his mouth closed and he looked at me and his mouth opened and he said, I said he said, "Whales came from squirrels."

*

The Perimeter Gallery opened in Chicago in 1982, and quickly gained a serious reputation under Karen Boyd's direction. Simultaneously, Alice Westphal, the director of Studio A, Jack's Chicago gallery, decided to limit her stable only to abstract artists. She had known Karen as a collector, and now Karen opened her gallery on the same floor in the same building. She also knew of Karen's interest in Jack, and so contacted Theo Portnoy in New York to obtain her reactions to Karen's representing Jack in Chicago. Theo also knew Karen as a collector, and particularly one intensely interested in Jack's work. Karen and Theo met and agreed to share the exclusivity on Jack's sculptures.

205

The two first works of Jack's to be shown at Perimeter Gallery illustrate Jack's deepening involvement with photography.

"Father Built A Safe Place" [Plate 62]
The source for the sculpture was a photograph of a father/mother/young daughter grouped on their livingroom sofa. The father sits to the left, his arm resting across his wife's shoulder so that his hand touches the right sofa arm; the child rests on her mother's lap. The parents are cut off just above the waist; and more, the father, on the left edge of the sculpture, is cut off at his right ear, so that his right shoulder and arm are missing as well. We see none of the sofa except the top of its right arm where the father's hand rests. The bottom of the figures may be missing, but not the full height of the papered wall behind, empty but for two small pictures hanging near the ceiling. At the right edge of the sofa a small table with lamp sits askew, and behind it is a closed door (supposedly leading to the front porch), with the top half a curtained window.

In translating the photograph to clay, Jack constructed three separate units: the rear wall, the truncated family, and the end table with lamp. The family and table were then affixed to the bottom of the wall. No laps or legs for the family. No sofa bottom. No floor — the family's upper halves rest directly on the sculpture stand. Initially we are confused by the placement of the partial family figures, yet it is also familiar. Of course, it is the recurring, characteristic and usually accidental cropping of snapshots. As stultifying as it may be to find a compositionally ridiculous photograph faithfully reproduced in three-dimensions, its amateur camera framing actually helps describe the family. The couple looks contentedly toward the photographer. After all, the work is called "Father Built a Safe Place."

The sculpture is a front/back, and on the reverse of the living room wall Jack has modeled their back porch, slightly illuminated, perhaps by moonlight. A small pile of stones to the right, and beside the closed door to the left a dog stares at a figure in the foreground (unseen by the viewer) whose shadow advances up the steps, menacing in that the shadow of a club — or even a rifle barrel — accompanies his shape. Two other approaching shadows are partially delineated, one at each outer edge.

Is this a safe place? Is there a safe place?

"There Was a Man Afloat in Days, Believing Wisdom Comes with Time. He Lived Through. People, Cars and Dogs in a House of Tar Paper Stone." [Plate 64]

Another work combines snapshot perspective with front/back construction. From the road at the front of the sculpture a lawn rises quite sharply to a house resting at the rear. A large leafy tree grows close by, and a nifty thirties sedan (Chevy? Ford?) is parked on the lawn to the upper right, near a shed. Through the branches overhanging the house front can be seen a small open porch, from which a woman in a housedress throws a wash basin of water into the yard. Vibrant whites, blacks and greens predominate. The viewer is drawn into the composition by the narrowing of the property at it rises: the lawn border on the left and the shed at upper right bend in to meet the sides of the house — once more a snapshot perspective, now wide angle. We move to the back of the scupture and look in disbelief: the house front is only a facade, propped up in the back by studs and planks, as are the shed wall and fence — all a reflection of a structure on a Hollywood film lot.

The full diaristic title, scratched on the back of the work, helps clarify the built-in impermanence.

In 1984 Portnoy held her first Earl show — six major works — in new quarters on East 56th street.

"It's Almost Time For The Kids To Get Home From Church."

This realistic front/back genre sculpture represents a typical struggling muck farmer's home, including the farmer's front yard — hole and shovel, of course — and the farmer himself standing on the porch, staring dead ahead. The usual iconography abounds, including a dog on the steps and the farmer's billed cap. Viewed from the rear we find Jack

has sliced the depth of the house in half, so that in the two rooms —
living room to left, bedroom to right — we see only what furnishes the
front halves. Not much — overstuffed furniture for the living room; a
dresser for the bedroom. Odd note: from the porch two doors lead into
the house, one open to the right, one closed to the left. From the back
we find the partially open door belongs to the livingroom. But where
is the door that should be opening into the bedroom? The dresser is
backed up against it.

From the rear we also see under the house, and scratched on the cement
foundation wall is the full title:

"It's about time for the kids to get home from church. Alice is
already fixing dinner. The corn looks good. It could use a rain. I
got to get that drain fixed before it rains. I wish John would have
come over this morning. Maybe we'll go visit Rod and Emmy this
evening after supper. Tomorrow is Monday." [Plates 65, 66]

The title, formed of musings of the man on the porch, expresses the
poignancy of contained, routine, safe relationships, anticipating
happenings that regularly happen.

"Sweet Flora" [Plate 82]
Here sits a young girl with an old face, a chain with a heart pendant
of stone around her neck. The head, framed in carefully set waves, is
slightly turned, her acquired expression almost patronizing, all in
contrast to the sweet doll quality provided by the gown of lace and
Swiss dotting which falls to the ground around her. Modeling on the
dress is virtuoso: the skirt's billowing solidifies into flat, firm planes, and
as it reaches the ground the surface suggests granite. Jack has created
an ambivalence between doll fabric and stone, which resonates with
the ambivalence between her expression and the heart pendant. The
frozen mood of the sculpture is heightened by the almost
monochromatic gray-beige palette, with the exceptions of hair,
eyebrows, eyes, all in browns — and the black heart pendant. Jack had
for some time been experimenting with oil paints on ceramics, a medium
allowing subtleties far beyond the potentials of china paints, and never
has he put them to more effective use, shading a close range of colors
into matte optical effects. Because oils cannot be fired, they endow —
or perhaps endanger — the sculpture with surface fragility.

Picasso stood before a young Gertrude Stein and painted her as she
would and did physically appear decades later. Jack stood before a
photograph of a young Flora he didn't know, and sculptured her
physically as that child — but psychologically as the grown Flora he

did know. Scratched into the rear of the low stool on which she sits is the full title:

"Sweet Flora, born the day of weeds and linoleum, through your life, now, early old, sitting on the lawn chair in the sun of another day, waving a can of beer. Speaking loud about money, sex and honesty. Who could save you. And now I see your child picture and know why you are loved."

Shortly after Jack delivered the Sears girls to the Portnoy Gallery, Theo telephoned to ask if I would photograph them with my wide view camera. Fine. But a setback soon appeared. Despite positional changes of the lightstands, a small highlight on one of the girls' foreheads refused to move, let alone disappear. No wonder the fleck of light was static: Jack had painted it in. Theo brought out the Sears catalog page, and indeed the highlight rested in the identical spot on the model, most likely a reflection from a studio photographer's strobe light.

Later I photographed "Sweet Flora," and again a problem, only this time with a shadow under the girl's puffed sleeve caused by a midday sun; Jack had painted in the shadow to match the snapshot from which Flora was borrowed. These were among the first major works with which Jack worked from photographs; I had no inkling of his fidelity to the source.

When a painter translates a realistic photograph to canvas, shadows and highlights are included: both are essential in establishing roundness on a one dimensional surface. These shadows, though, cause no problem when lighting the finished painting, since illumination falls on a flat plane and cannot create new conflicting shadows.

Lighting can, and alas, usually will create shadows on a three-dimensional work. Therefore lighting an Earl sculpture requires a decision: utilize illumination which will attempt to duplicate Jack's immovable shadows; or utilize illumination which will create a fresh second set of shadows.

Jack has transformed, down to every detail, a figure from a photograph into three-dimensions; and because he is not merely modeling a figure, but modeling a photograph of a figure, the photograph's shadows must be a part of the sculpture — must, that is, if the artist wishes the viewer to be fully aware that the sculpture is a dimensionalized photograph. And Jack does beg this awareness. Therefore Jack would see nothing distracting in adding shadows beyond those painted in.

*

"There Is A Place, Yes There Is A Place...." [Plate 76]

A tall wall traverses a rectangular base at midpoint, serving as a backdrop for scenes on either side of this dos-a-dos. On one side is a deep relief modeling of the bust of a woman in a deep orange/rust blouse, starkly contrasting with the high charcoal wall.

The reverse side:

On a sloping field a boy in his early teens sits on a gray kitchen chair. He holds a dog on his lap. Here the traversing wall is painted with gray, rolling, rain-bearing clouds, and at the far left corner an edge of a gray lake is visible.

As in the sculpture of the boy at the screendoor, the platform base on which the meadow is mounted narrows toward the front, optically pushing the boy and his dog at the viewer.

A fuller title is graven on an outer side of the dividing wall:

'There is a place, yes there is a place. Where it's June in Ohio. A place where first flowers bloom, white, pink, blue and yellow.
'Where you can rest on green moss there.
'Where your mind is still.
'Where your mind is still.
'Thank you God that there is a place.'

Do the blonde boy and his dog embody the described 'place'? What is to be made of this place and this boy with dog? What is a kitchen chair doing in a field of underbrush? He sits uncomfortably at the edge of the seat, holding tightly to the dog, and both face straight ahead. Is this another snapshot? Is this the place where flowers first bloom, where you can lie on green moss, where your mind can be still? What is to be made of the woman? Around thirty, wearing once fashionable harlequin-shaped frames for her glasses, her head turned slightly to the side. Although the bone structure appears fine, her face remains plain — perhaps intentionally, perhaps like the plain-faced actress who in the middle of the movie is transformed into a glamorous leading lady. This plain face is made spellbinding by an expression that is alert, reflective — and mostly inscrutable. Actually it is difficult to turn away from her concentration, and Jack may have modeled the most transcendental expression since the Mona Lisa's. Is she thinking of the place? The place where the boy is? Is he her son? The title of the earlier work with the child at the screendoor — "Behind The Door There Is A Place" — also refers to a place. Are these sculptures related? Both boys are blonde. Is this the same boy a few years older?

Jack (letter excerpt)
*Yes, I am working in the direction of "There is a place etc) I am
still working from photographs. I'm interested in relationships. I
think the relationships are getting more meaningful. Some times I
understand the piece, sometimes I don't. But certainly they are
more and more spiritual. Which is simple since every aspect of life
can have a spiritual meaning.*

*

The last visit to Ohio was during the week following Thanksgiving
(1983). Karen Boyd and I arrived at the Columbus airport in the early
evening within half an hour of each other, and as usual, Jack, Fairlie
and Roy were waiting to transport us north. No one had yet eaten
dinner, and since the drive would be almost two hours, we tried the
airport restaurant, where the cuisine was memorable only for Roy's
selections. The starter: French onion soup. The main course: 'Banana
Foster.' The latter comprised numerous scoops of various ice cream
flavors packed inside an enormous snifter shaped bowl, easily able to
accommodate a medium-sized bouquet. At tableside the waitress then
lighted the fuel under a chafing dish and commenced to flambee long
thick slices of banana. Five minutes later, after sprinkling flavors from
various bottles (certainly some alcoholic), after squeezing juices from
citrus fruits, after shaking spices from cellars into the pan, the sauce
itself was set to dancing in blue flames. Surely awed by Roy's attention,
the waitress augmented the drama by raising the chafing pan several
feet above the tabletop before tilting it: a flaming waterfall cascaded
into the mouth of the snifter. Roy's spoon immediately followed.

Jack
*It's his dream meal. The small first course can change, but never
the banana split. He'd plow a field for eight hours to get a banana
split. And this one has probably spoiled him forever. Oh, did you
notice how Roy orders? He always whispers so that the girls have
to bend over to hear. Then he has them closer.*

*

In recent correspondence with the John Michael Kohler Arts Center,
Ruth Kohler wrote that the Arts/Industry program at Kohler has
continued (Jack's last visit was in 1978 for the two-week mold-making
workshop) with a variety of programs from two-week workshops for
up to forty-six artists to four-month residencies for six to eight ceramists.

Lee
Are these two sculptures related?

Jack
No, not at all.

Lee
What does the word 'place' connote for you?

Jack
Well, the same as it does for anyone, I guess.

Lee
Certainly here it connotes something special for you, such as a 'peaceful spot.'

Jack
Well, yes, in this case I suppose. . . .

Lee
How are the woman and the boy related?

Jack
Oh, not at all.

Lee
But you have them in the same sculpture. There must be some connective. Do you know this woman?

Jack
No. She was in an old snapshot I found in one of those places where I look for photos.

Lee
What prompted the sculpture?

Jack
Well, I couldn't forget her face and I thought what would go with her, and I found an old snapshot of a boy reading a book in a meadow. That seemed appropriate. I was happy with them together.

Lee
And the child in the other sculpture. Is he from a photograph too?

Jack
Yup. And there 'the place' is a 'safe place inside.' Where his mother is. The screendoor is locked. I didn't think about it — I mean the boy's look, but it is intense. I just reacted emotionally to the photograph and everything fell into shape.

Ruth
*In 1984 we are changing the format and will have artists in
residence year-round, two to three at a time for periods of two to
six months. And here is some miscellaneous news. In 1979 the
American Club was completely renovated and is now a posh inn
which attracts guests from throughout the country. Needless to say,
the arts center no longer can afford to house the artists there. In
any case, we feel we have found a better solution for housing.
Since 1982, we have been providing apartments and homes which
the arts center rents and furnishes for their needs. . . . The only
other thing I can think of is the Kneevers Hotel where Jack, the
other artists and I used to dine [the homey restaurant Ladusa, Jack
and Steven patronized for dinner so often in Sheboygan] has
burned to the ground, Charles Elizabeth the Wonder Dog has died,
Clayton Hill has retired, I am gray, Jack no longer communicates
with us to our sorrow, but other than that life is superb.*

Recently Ruth contacted Karen Boyd in Chicago to affirm that if an Earl
retrospective exhibition were organized, she would very much like to
book it into the arts center.

*

Jack
*Now one thing I like to put into my work is long necks. I like long
necks on everything. Get back to something basic. Little heads. My
idea of a handsome man is a man with a short neck and I was
taught in art school that if you wanted a man to look strong, you
gave him a big head, big feet, big hands. Not like my things — I
don't want anyone to look strong. I want them to look weak.*

*

During four visits to Ohio, relative after relative was introduced onto
the scene, but never anyone who was not family — with one exception,
Darvin Luginbuhl, Jack's high school art teacher. However, I had
requested that meeting. Also, although some forty or fifty houses are
closely placed along both sides of the road from the highway right to
the Earl's house at the tip of Avondale point, never during any stay
was a neighbor seen inside or outside one of these residences. No
wonder a number of Jack's earlier genre works concerned what people
did in houses.

During the last trip we did meet Jack's mother at the tidy little house
in Wapakoneta built some years earlier by Jack and his brother. On

213

my first visit Jack had also taken me to the house — spankingly neat, unusually uncluttered, the lightly stained hardwood floors as unscuffed as the day they were nailed down — to see some of his early Bluffton College pieces. I had looked forward to meeting his mother then, but when we arrived Jack mentioned casually, 'Mom's away, but I have the key.' During my two other visits she was not mentioned. This trip I asked to photograph these earlier pieces she kept in Wapakoneta, and Jack readily drove us over.

Mrs. Earl is a lovely lady, medium height, graying hair, clear light skin. Although reserved, when brought into a conversation, her soft voice is lively. I remembered Jack's mentioning he visited her once a week, and occasionally mowed the lawn. Actually she normally prefers to trim the grass herself, a practical source of exercise. It appeared she did not mix often in Hanson-dominated Indian Lake activities.

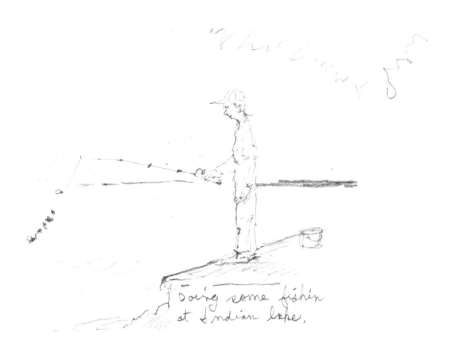

Doing some fishin
at Indian lake.

In 1983 the Western Carolina University invited Jack for an exhibition of ceramics created during the past ten years, which included over forty works. Again I was requested to make a statement for the catalog.

'Catalog Statement'

During a period when craftspersons cum artists submit themselves to formal and lingering educations with the dedication of lawyers and surgeons, Jack Earl, an Ohioan from Uniopolis, a town with no street addresses nor street names, was told that diplomas beyond high school were required to teach art. During four years he attracted as little attention as possible in passing through a small techer's college where he was the only art major; soon after at a state university he experienced a year and a summer of graduate work which included drinking tea from Japanese bowls — all in Ohio. Then for seven years — the only time he has ever lived outside Ohio — he taught at a large university and attended faculty bull sessions. A message finally arrived: go home. He did, bringing wife, children, dog and baggage back to a location near Uniopolis. Jack then became an artist with whom the art world would have to reckon.

Jack (letter excerpt)

I looked up that word 'sect.' I guess everybody belongs to a sect. I would describe my beliefs as 'Main Line Christian.' You turn on the Christian Radio and T.V. program and you'll pretty much hear what we believe. I believe what the Bible says but do not believe in being put under bondage to any man, form of worship, dress, food, etc. The Book says you are free. Good news. I don't have to hurt nobody or myself to be free. I'm glad I've got a choice. I go where I'm welcome, comfortable, am taught and told how to be a better Christian in relation to my daily living.

Work — I used to be interested in fame but then I found out what that was worth. I have accomplished what I thought was possible in that area. Pride is a dangerous area. I have to be very careful there. My statements have been changing over the years and I hope I will keep changing. Right now I would like to make some things that are interesting to make, will be good enough for someone to want to own, and that a person can look at it and be refreshed. I know the problems. Everyone knows the problems. I'm interested in the answers. I don't like the problems. I love answers.

I would just like to continue living and working like I am, touching both once in a while to make them better.

One day Fairlie brought me up to date on her solar still designed to produce gasahol.

Fairlie
Let's see, I built the still — a solar still — and I tried to make the mash, but I don't know how to make good mash —

Lee
What was it being made from?

Fairlie
Corn. It was supposed to make a very good high alcohol, but mine didn't work. I put it through once and didn't get any alcohol but I got some pretty terrible smelling water. But the process works. I still got my parts, but my problem is when I put it out on the water to get the sun, the wind's so strong it pushes it. So I decided I can't make it around here because the weather is against me, you know, as far as the wind is concerned — to make it the solar way, that is.

Lee
How big is this contraption?

Fairlie
It's about four feet by eight feet. It looks like a window where the sun comes through and evaporates the water out of the alcohol and separates it. The sun does this. It dries it up, you know.

Lee
The alcohol the mash is making?

Fairlie
Yeah, and when you get done you're supposed to have alcohol in one container and the residue in the other and it would work, but I just — you got to know how to make the mash to make the alcohol to make the right proof.

Lee
Weren't you given a recipe?

Fairlie
Well, there's a lot of people who tried to tell me all this, but the solar part was my own idea, and it would have worked, but I just had to be able to make the mash. Then too the wind pushed it around. So when I found out I couldn't get it to work around here I just took it apart and put it in my daughter's garage and it's still there and I probably won't go into it anymore because of the conditions around here. You know, the wind. Well, you could use the wind to make electricity, I guess, but I'm not going into that.

Jack (letter excerpt)
*The thing that makes me choose subject matter is somehow a
understanding, compassion, longing response and now, as I
mentioned one time John Berns taught me Bible application to
daily life, I have in the last pieces been using excerpts from the
Bible as titles or partial titles for the work. It certainly adds body,
reason and reality.*

*

Roy
*Did I ever tell you one of the very worst aspects of the muck
catching fire? You know the longer it burns down there
underground the more terrible it is because it leaves a sort of
cavern where the fire burns up the spongy muck and then when it
rains that hole fills up and turns the muck into gooey ground.
Roots just rot and sometimes you can't use that soil for years. That
is to say, until it dries up down underneath. When we had the last
big fire at my place we poured so much water underground to stop
the burning that it still hasn't dried up enough to use that soil for
planting. And of course when it rains hard it drains a lot of it all
over again into that cavern. There's a considerable lot to think
about when you live on a marsh.*

*

Jack
*Oh, did I tell you about Fairlie's mother? Well, she married again,
and then her new husband got cancer of the leg and they had to
remove it. I believe he used a wooden leg. Then recently he died.
So she lives in Sydney now where Fairlie's sister, Vicky, lives, and is
busy with the Church of Christ meetings, committees and so forth.
She comes to all the family functions now, even if Roy is there.
There is no animosity there. There is no animosity at all.*

*

Of all the reviews written of Jack's work, of all the comments on Jack
as Jack, and Jack as artist from teachers and associates, none has probed
more sensitively than Tom Ladusa's.

Tom
*Jack is a family man. His family is important. His family goes
everywhere with him. Now with his Ohio location, with the studio*

217

and family under the same roof, he doesn't have to take Steve or Fairlie with him going long distances; and so he can just settle down in the kitchen and make his work and drink his coffee and enjoy himself in an environment he feels really strong in. It seems to me that his ideas have always come from the immediacy around him. His ideas for his work are always right there inside himself — what he was living and had lived, with very little projection or abstraction of thoughts. He just dealt with situations, real life situations that he duplicated, that he remembered, that meant something to him. They were inbred. He was like creating a photoalbum.

If there is any kind of summation about how I feel about his work, I think that Jack essentially is trying to make a beautiful, gorgeous, elegant object, and unaware himself possibly that that object has all kinds of information in it, all kinds of feelings that probably just come out naturally because they are such a part of him. The real Jack comes out in conversation, in the way he walks, the way he deals with all kinds of situations, and that same thing goes into his material. It's got all that impact of personality and humor and freshness — a unique man stating things in his unique way, done beautifully, elegantly, gorgeously. Most of us accept it as a beautiful object, but I think there is so much more, and deeper than elegance. I am a person that thinks that you just go ahead and do things and get involved and set your sights, and I think Jack is the same way. He has the frame of mind that everything that does happen is okay. Everything is going to be all right. You know, like his house burned down, and he is able to quit his job, move and set up a new situation. He just goes on and it's done well — and now he's making work and selling it at Portnoy Gallery in New York and Perimeter Gallery in Chicago. I don't think there is anything pretentious about him — it's just something that was supposed to be. Every now and then he's going to need a change or something, and he will look to do something else. Changes might happen in that yearly kind of drive south to warm up the bodies, to go fishing and to relax. He's probably relaxing, but he's probably also looking and feeling and always trying to formulate the best way. I may be off base on that. Maybe he just goes fishing and gets away from it all, like a guy on an assembly line. I don't know exactly how Jack feels about his work.

I believe that sculpture for Jack — well, it's a living. It's something he does well. He knows he does it well, and he enjoys doing it. It's a job. He doesn't work non-stop and have pieces all around. He

makes work and puts it in a gallery and he sells it because that's what's going to pay the bills, the rent and so forth. I think that is his kind of kinship with our common interest, clay. I believe my way of thinking has been effected by knowing him, by being around him. It's like Jack saying to a student while at the University of Southern Louisiana doing his workshop, 'You only need one idea in life, and if you have one good idea, you can go on doing it forever.' Now, that is an interesting concept, and a concept Jack can live with, but I think by 'idea' he means a way of life. He doesn't alter his way of life by being a ceramist in a studio. As a matter of fact, he puts the studio right in his home.

As long as Jack has his children and his wife and his father-in-law and their planned trips and their fishing outings, as long as he can sell his work at the gallery, Jack Earl will continue, and continue to grow, and will see many things that will explain themselves through visual three-dimensional objects, and one thing you can always bet on is that they will always be beautiful and full of richness.

*

My likemindedness with Tom Ladusa's illuminations of Jack is tempered by a sole suggestion: perhaps Jack is credited with too casual a commitment to art. Jack lept, a crucial leap, forsaking one level of security at the risk of not attaining another more profound level, the leap common to those taunted by an unmined worth. Conceivably Tom was not aware that at the age of twenty-nine Jack asked his family to gamble its safety by placing his talent on the line. The rigor of belief in his gift was evident: twice he refused to accept as final disdainful evaluations by college professors of his qualifications for graduate school.

Even with eventual acceptance in the most respected ceramics department in Ohio, a fractious journey 'to understand art' awaited: years passed heavily before Jack, sequestered in a midwest aboveground underground, frustrated that no one could 'explain art,' would discover himself what initially could never have been conceivable: the meaning and reality of art (nonverbal states) lay in the meaning and reality of himself (nonverbal states). A flow, which circulates knowledge from the self, waits to be recognized, then respected (germane to spiritual energy); a self-knowledge capable of arousing the creation of responsive representations of the self, that is, unique communicable forms. Some examples of employable external mediums to express these forms? Word processor. Pen and drawing pad. Musical notes with/without flags. Gold, also iron. Porcelain, also hobby clay. Even mud has sufficed. 219

Jack
I am not a thinker. I feel things out and do them. I've never sat down and figured out intellectually what I am saying. When I do sit down to think about what to do, it's really an emotional experience.

*

Recently the 'Selected Letters' of Sherwood Anderson was reviewed in the Sunday 'New York Times Book Review.' A surprise awaited: 'I think his best stories are as good as any around. "Winesburg, Ohio" (which was written in a Chicago tenement, based on people he knew there, not in Ohio) is taught in colleges and universities throughout the land, as it should be.' The critic at least confirms that Anderson was born in Ohio, and grew up in a small Ohio town, Clyde. This information may not matter to Jack, as it's questionable that he rushed to the library for a copy of 'Winesburg, Ohio.' However, I (inadvertently) misinformed him about the models for the characters in the book, and also related that an Ohio lady claimed reading about these people made her feel unclean. Question for Jack: if she had known they were Chicago folk, would she have felt unclean?

*

Jack
I've been told the edge is dangerous so I am careful about it. How I'm careful is I know I'm about six feet tall so I kinda eye measure six feet from the edge and be sure to stay back that far, so even if I fall I won't be goin over the edge. That's where I walk, six feet from the edge.

*

Jack's first two porcelains were delivered from the kiln with the care lavished on princeling twins, even though the christening was limited to the leanest of titles, such as "Covered Jar." At hand lay the cradle-crate to speed them to the Everson Museum of Art. Jack recognized that this mesmeric clay allowed him to circumvent the frustrations of mediums incapable of duplicating his images; the Everson Museum jury's acceptance of the works, their award, and their acquisition substantiated his confidence in porcelain.

With the next porcelains, lengthy titles burst forth, as if only lyrics could contain his buoyancy. "Dogs Are Nice" became the germinal metaphor-story, emblazoned in gold handscript on a wall plaque. Seldom since

has a titleless work left his studio. Some meander, some are complete in one sentence, some suffice with a terse phrase, the latter usually scratched into the clay base. Wall plaques have reappeared for a number of the major works, such as "Carrot Finger."

Jack's knotting of word and three-dimensional form has made a major contribution to this direction. In 1977 the National Collection of American Art in Washington opened 'The Object as Poet,' a major exhibition documenting the breakdown between media, particularly fine art and writing. Included were works by, among others, Robert Rauschenberg, Claes Oldenburg, Saul Steinberg and, also from Ohio, James Melchert, all artists who have considered words integral to their imagery. Jack's porcelain sculpture, "Where I Used To Live In Genoa, Ohio," was seminal to the exhibition concept, and widely earmarked for reproduction and discussion by critics.

The pages of Jack's sketch pads contain more stories than drawings.

Jack
They all lie there, waiting for me to find some form for them. Probably they'll all have their day. When I use them for titles, I usually you know tighten them up, like you would poetry. No — I don't consider them as poetry. I'm not sure if I even know what poetry is. The words are just things rolling around in my head. Before I tighten them, they're just stories, a little too long, maybe, and rough, like some of the ones you said might go in the book. But you know I can't write, 'I like Roy,' but I can tell a story which will illustrate how I love him, and that can grow into a three-dimensional statement. But the clay piece still needs the words to go with it. The clay and words are part of one thing in my creative operation. . . . Maybe one day I'll only work with clay. No words. Maybe one day I'll only work with words. No sculpture. But not soon.

*

Once Jack mentioned what he liked best about my mid-seventies article for the 'Art In Virginia' magazine: the comparison of his borrowing sculptural forms with Shakespeare's lifting dramatic plots. I suspected that sentence had legitimized an action which Jack may have felt critics could consider thievery.

Jack has stolen from Iga masters, Voulkos, Autio, LaVerdiere, 'Playboy Magazine,' European and Oriental porcelain sculptors, Boucher, innumerable Italian painters, Blakelock, calendar artists, to name but a few sources — and now 'found photographs.'

Artists have interminably leaned on other artists' forms, consciously and unconsciously, to transform into personal visions. Jack responded to a porcelain vase in The Toledo Museum and stole it. He responded to nimble Boucher nudes, also seen at Toledo, and set them frolicking around and dangling from the vase. For his canvases, Picasso cloned scores of primitive figures from the Louvre basements. Jack now recognizes that thievings for personal reinterpretations are widespread and traditionally legitimate.

*

Karen telephoned with excitement: Jack had delivered more works for her show, among which was a definitive portrait at last, of Roy. No more hiding behind Bill, the marshland prototype; all Roy the man, the self-denied Minister, the self-proclaimed preacher, farmer, huckster, fisher and composer of words and music, slipping into late years, rows of onions, corn, soybeans pulsing through memories tender, bitter, lost.

In the life-sized bust Jack bends Roy's head slightly, leaving the face slack and eyes cast downward in reflection, a gesture embodying the contrition and splendor not merely of Roy, but of Roy's entire life, a portrait ensuring Roy earthly presence to bear witness as long as hobby clay endures. [Plate 72]

Jack
It took about a month, I guess; and I worked real hard on the oil surface. I'm proud of that.

Lee
Did he sit for the portrait?

Jack
No, I took some photographs and used them.

Lee
Did he like it?

Jack
Well. . . first he said it made him look old, and then after some thought he said it looked more like Ray. Then he gave me one of his secret smiles.

*

Once back in Ohio, Jack's work has consistently dealt with local values, and with each stylistic variation (easily identified with each new gallery exhibition), the perspective has deepened.

From dozens of faded, bent photographs in a junk shop box he may be inexplicably drawn to purchase two or three images. These are placed in a drawer at home. Later — weeks, months — another old photo trove is fingered through with the anticipation that a snapshot will fire the memory of an image in his private cache. If it happens, it is acquired. Later he places them side-by-side to confirm a symbiosis. If satisfied of an inter-(inner)-relationship, he builds the structure to support their arcana. Finally a title is assigned suggesting his reading of the energy, aware that what has been created is polysemic, contented that other viewers will deduce unlike but equally satisfying denouements.

Jack no longer questions if his sculptures are art, secure that none of the vertiginous evaluations can be finite. As he juxtaposes photographs, models their shapes and names the result he is not disquieted that none of his motivations during any stage of the creation can be fully understood, and certainly cannot be verbalized. We remember Degas: 'Only when he no longer knows what he is doing does the painter produce valuable work.'

Jack
I like to know that people like [my work]. It is then telling me I haven't made a mistake. My work is directed toward selling on the art market. If people don't like it, then it doesn't sell. As far as I

am concerned, there is no reason to make anything that doesn't sell, because I don't have any need to express myself. I've got other things to do.

Unless placed in the light of Jack's value system, this quotation from the John Klassen interview could chill the alleyways of the art community. Jack's concern for the maintenance of a state of grace precludes considering his talent more than a means of earning a livelihood. Allowing it added significance could be a signal of hubris.

Jack has never pressed any of his dealers for museum exhibitions, magazine coverage or any form of public advancement. He has attended no more than two or three of his exhibition openings. I once asked about his avoiding contact with the art public, and a reply was ready: he would be dragged into art talk; his work had nothing to do with art talk.

Unlike most artists, Jack hasn't maintained a collection of his own work. Or at least, not the usual collection: 'My collection of my work is all of broken pieces.'

Could Jack actually abandon his studio, let clay and oil tubes inspissate to rock, if sculpture guided by his spirit and hands did not interest collectors?

Lee
Hi, Jack.

Jack
Oh, Lee — hello!

Lee
The book is finished, I think.

Jack
Remember when you wrote you hated the thought of ever finishing it?

Lee
Yes.

Jack
We liked that.

Lee
Anything you can think of that's been left out?

Jack

....*I'm real sure you've got everything.*

Lee

....*How's Roy?*

Jack

Wait. I have news. I've just finished two paintings and they'll be in the show that goes with the book coming out. One for Chicago and the other for New York.

Lee

What medium?

Jack

Oil. And Dianne helps me. She blocks in the backgrounds first.

Lee

What's the subject matter?

Jack

Man with a dog.

Lee

Are the paintings the same?

Jack

No, different.

Lee

Are they humorous?

Jack

Not necessarily. They seem serious. You know, one day you feel that something you have to say would just be better in another medium. I'm not giving up clay...Oh, you asked about Roy. Well, I was with him this weekend. On Saturday he called because he couldn't use his truck, and would I take him to church at Flat Branch, you know where you photographed Fairlie and me. Then I would have to take him for lunch with the new Pastor as Roy had invited him and his wife. That's why he couldn't take the truck. But when Sunday morning came I didn't have a car. I forgot Fairlie would need it for her morning Sunday school class at Berns' place in Lima. Oh yes, Roy was already here. He came Saturday night and slept over so I wouldn't forget to take him to church in the morning. He has a special sleeping bed at our house. The softest bed we've got. He has a blanket for a sheet. Another blanket to cover up with. And there's a big thick sleeping bag on top of that

and two pillows that smell like Vick's Vapor Rub. Then Steven arrived so I borrowed his car. On the way to church Roy remembered he was invited to Linda's — she's one of Ray's daughters — church that night to see her kids in a play. Linda also invited Fairlie and me, but he forgot to tell us. In church Roy always sets in the same place, as far back as he can from the preacher — on the back pew. They are old straight board pews. When I went back there to sit with him he wasn't around. But I knew where he probably was so I waited. I discovered he had a big soft cushion there, with enormous yellow roses on it. A big bible was in the hymnal rack in front of him. I took his bible out and under that lay a big green unisex comb. Ever since Roy had his prostate trouble he has been big on drinking water. So in Sunday school in between the worship service he went to the outhouse. That's where I figured he was. I went down to the end of the pew so he wouldn't think I'd seen his nest of things. It was windy outside, and when he came back his hair was messed up. He set down, took the big gray comb and ran it through his hair a couple of times. Then he looked over at me and saw I was watching. His face went blank for a second, then he gave me a big smile. We had lunch in Kenton with the Pastor and his wife, and Roy wrote a check. By the way, on Monday he had to borrow money from the bank to cover it. I dropped him after lunch at Linda's house, about three or four miles from his farm. I went to Lima to do some Sunday Christmas shopping. Then to church and after the evening service with Berns along, Fairlie and Steven and me had dinner in Lima at 'Godfather's Pizza.' Then we picked up Roy and took him to our place so he could pick up his truck. Not home until 11:30 at night. Dianne and Lance — her husband — they now live in St Mary's — were there. He's got a job in a factory making dog food. He bags food. They came because he wanted to hunt rabbits Monday morning. Lance and Roy and me spent all Monday hunting. We hunt on Roy's farm. Lance and Roy got rabbits, not jack rabbits, just the ordinary kind. They used shotguns. I didn't have a license. Roy doesn't either, but he'd just tell the game warden he mislaid it. That's all I've been doing.

Lee
Well, I'm sure glad I asked about Roy.

Jack
Fairlie's here. She sends her love. Hey, you finished it! Good news!

Lee
Bye.

About a month after our phone call the following headline and opening paragraphs of an article appeared on the front page of 'The New York Times':

New Finding Backs Idea That Life
Started in Clay Rather Than Sea

Scientists in California yesterday reported a major discovery that supports the emerging theory that life on earth began in clay rather than the sea.

The discovery. . . showed that ordinary clay contains two basic properties essential to life: the capacities to store and transfer energy, coming from radioactive decay and other sources, the early clays could have acted as 'chemical factories' for processing inorganic raw materials into the more complex molecules from which the first life arose some four billion years ago. . . .

The theory is also evocative of the biblical account of the Creation. In Genesis it is written, 'And the Lord God formed man of dust of the ground,' and in common usage this primordial dust is called clay.

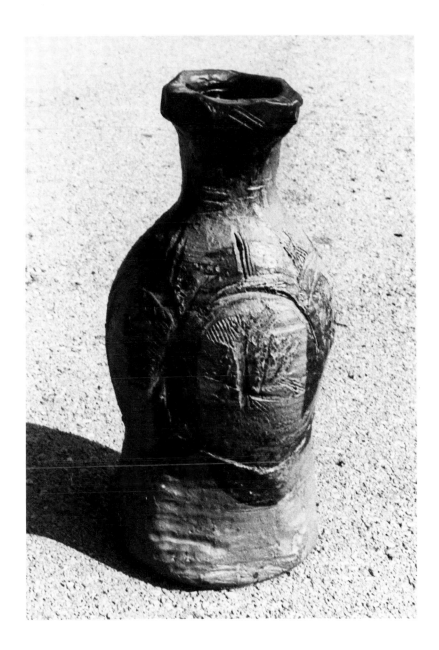

Plate 1: "Untitled Vase" (see page 40)
stoneware, glaze: 1964
Collection Evelyn and Darvin Luginbuhl, Bluffton, Ohio
Photo: Darvin Luginbuhl

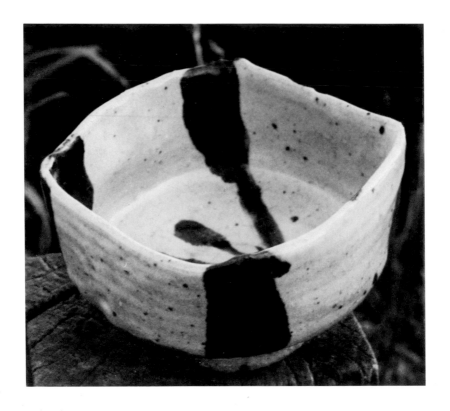

Plate 2: "Untitled Bowl" (see page 40)
stoneware, glaze: 1964
Collection Evelyn and Darvin Luginbuhl, Bluffton, Ohio
Photo: Darvin Luginbuhl

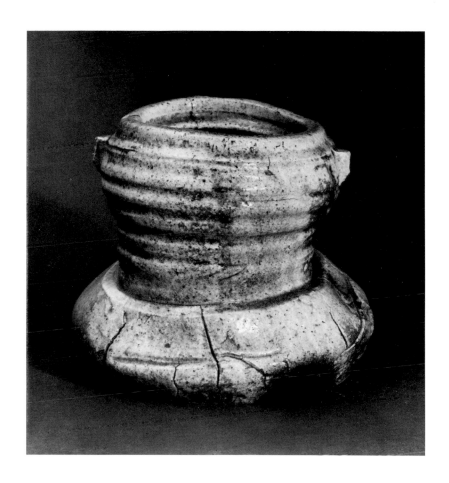

Plate 3: "Mizusaki" (water jar) (see page 38)
Iga ware: 20.6 cm. high: late 16th Century, Momoyama period
The Mary and Jackson Burke Collection, New York
Photo: Otto E. Nelson

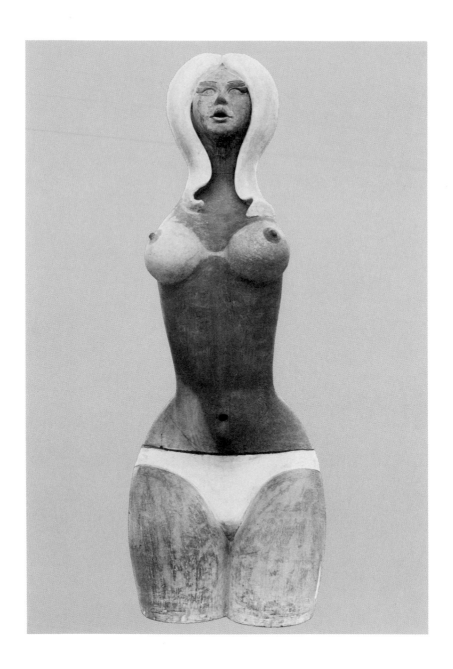

Plate 4: "Girl Torso" (see page 55)
stoneware, acrylic: life-size: 1965
Collection Lima Museum, Lima, Ohio
Photo: Courtesy Lima Museum

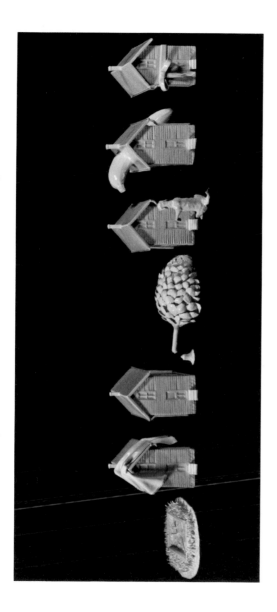

Plate 5: "Did you know that all those houses with curtains in the windows,
people live in them?" (see page 69, 71)
porcelain, glaze: 9 pieces: 1968
Collection Columbus Gallery of Fine Arts, Ohio
J.C. Penney Co. (Eastland) and
Columbus Gallery of Fine Arts Purchase Award
Photo: Courtesy Columbus Gallery of Fine Arts

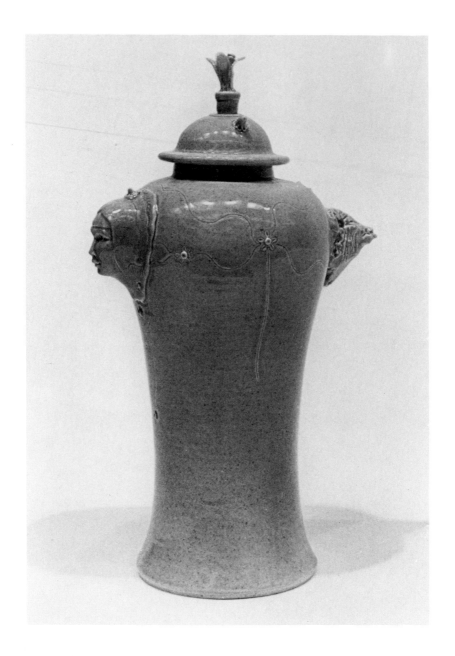

Plate 6: "Untitled Covered Jar" (see page 66)
porcelain, celadon glaze: coil built on wheel, modeled handles:
17″ high: 1968
Collection Everson Museum of Art, Syracuse, New York
Photo: Courtesy Everson Museum of Art

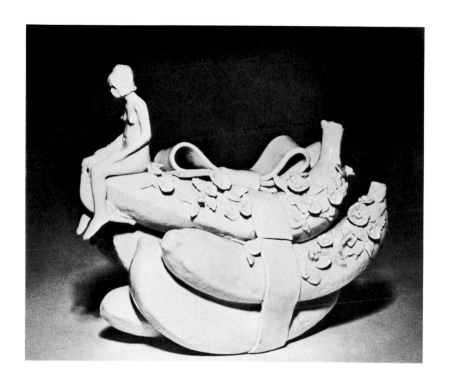

Plate 7: "Figure With Bananas" (see page 71)
porcelain, glaze: covered container: 7 x 8": 1968
Collection OBJECTS:USA, with international tour (1969-1972)
sponsored by Johnson Wax Company, Racine, Wisconsin
Photo: Hugh Laing

Plate 8: (left panel of frame): "I met Marsha in a bowling alley over in Belle Center about two years ago. I don't remember how we really first met but anyhow she showed me a few pointers about bowling and we had a couple beers. She ask if I wanted to take her home and I ask her where she lived because I didn't have much gas and I didn't have a dollar left to buy any. She said she lived over on 51 and I thought I ought to have enough for that so I said okay. She set real close to me all the way and she put her hand inside my shirt...that felt real good and I kept thinking about whether I'd have enough gas to make the trip and then I had to pick up the guy that gone bowling with me in the first place and take him home.

(right panel): I got her home and she ask if I wanted to sit in the car for awhile and I said I'd like to but I had to get back before the bowling alley closed and pick up Tom and take him home. She took her hand out, gave me a pretty long kiss, thanked me alot and went in the house. After I saw her at the alleys a couple more times we started dating and after a couple of months I figured we ought to get married and we live in a house trailer now and I still got my same job. She is going to have a baby in three months and after we get the trailer paid off we are going to use it for a down payment on a nice house...until then we store the stuff we don't have room for in her dad's barn." (see page 80)

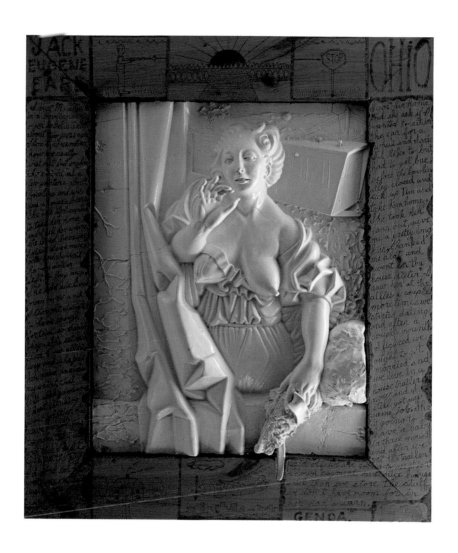

Plate 8:
porcelain bas-relief, glaze, 40½ x 34 x 5½″
burned wood frame: 1969-70
Collection Thomas L. and Geraldine M. Kerrigan, Bisbee, Arizona
Photo: Richard Byrd

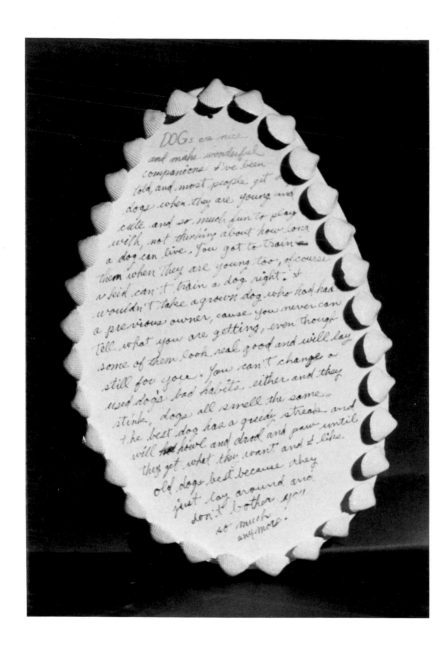

Plate 9: "Dogs Are Nice Plaque" (see page 75)
porcelain, glaze: 13 x 8⅜ x 1″: 1971
Collection Lee Nordness, New York
Photo: Lee Nordness

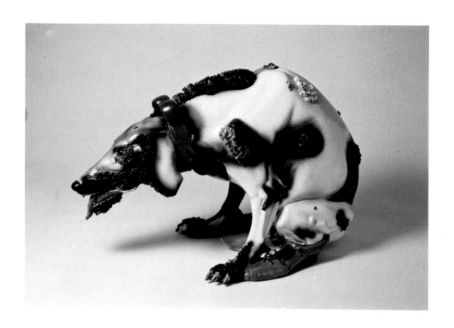

Plate 10: "Dogs are nice and make wonderful companions I"ve been told, and most people get dogs when they are young and cute and so much fun to play with, not thinking about how long a dog can live. You got to train a dog right. I wouldn't take a grown dog who had had a previous owner, cause you never can tell what you are getting, even though some of them look real good and will lay still for you. You can't change a used dog's bad habits either and they stink, dogs all smell the same. The best dog has a greedy streak and will howl and drool and paw until they get what they want and I like old dogs best because they just lay around and don't bother you so much anymore." (see page 75)
porcelain, glaze: 17 x 14 x 27″: 1971
Collection American Craft Museum, New York, gift of Karen Johnson Boyd
Photo: Ferdinand Boesch

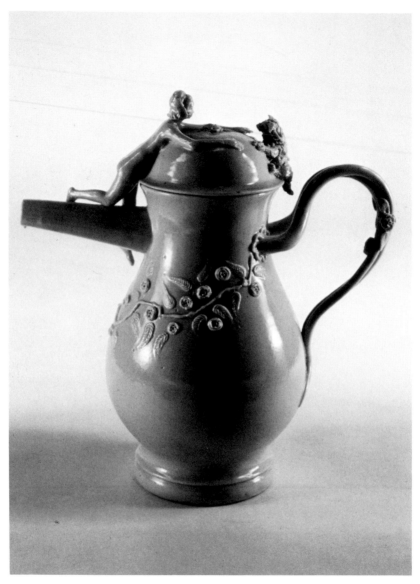

Plate 11: "My girl is a nice girl she's not too pretty, but she is real nice. We went swimming off by ourselves one time and she fell down and hurt her leg. I should have known then but it was too late and I guess she could have done better." (see page 76)

porcelain coffeepot, glaze: 10½" high: 1971
Jack Earl exhibition, American Craft Museum (1971), New York
Collection Bunty and Tom Armstrong, New York
Photo: Ferdinand Boesch

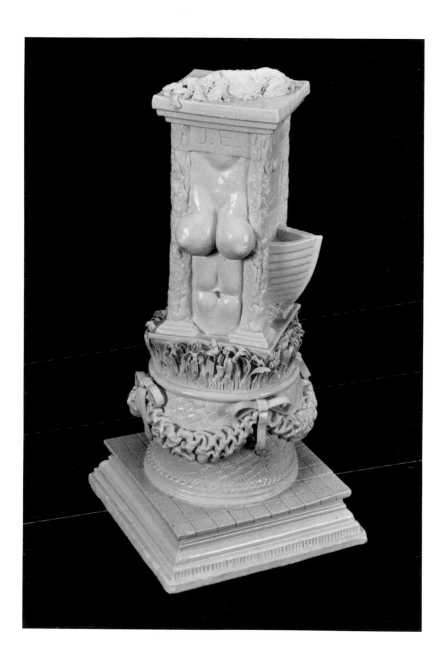

Plate 12: "Untitled"
porcelain, glaze: 12 x 5½": 1971
Collection Alice Westphal, Evanston, Illinois
Photo: Jon Bolton

Plate 13 (left to right):
"I used to live down south of Kenton in a little town but one day when I
was out riding my bike, I met this penguin and I haven't been able to set
still since."
"I was setting on the back step, cleaning the mud off my boots, when this
penguin flew down and set right beside me. I knew it wasn't real because
penguins can't fly, but I still dream about it off and on sometimes."
"One time I was picking flowers and I looked up and there was a penguin
picking flowers too and it had its basket full, so then we stopped picking
flowers and I never picked any again, but the penguin does all the time."
(see page 78)
cast porcelain, china paint: 30 x 12″, 30 x 17″, 30 x 18″: 1971
Exhibited in 'Clayworks: 20 Americans' (1971),
American Craft Museum, New York
Private Collection, courtesy of Allan Stone Gallery, New York
Photo: Bob Hanson

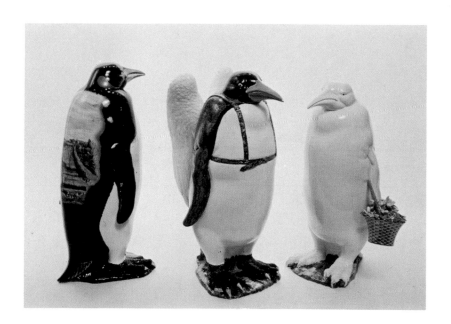

Plate 13

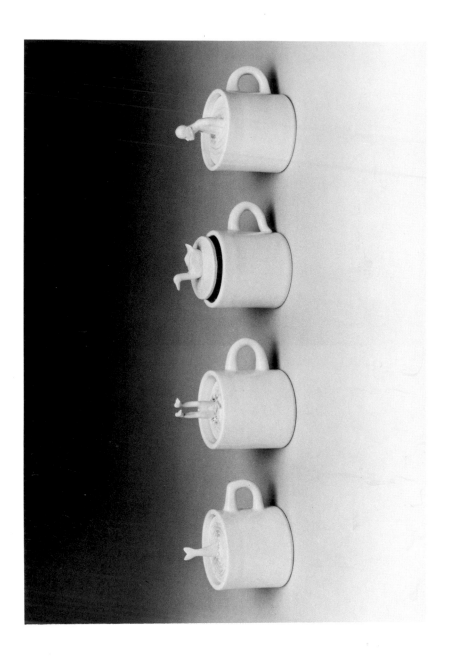

Plate 14: "Untitled four coffee cups with lids"
porcelain, glaze: 5″ high: 1973
Courtesy Perimeter Gallery, Chicago
Photo: Jon Bolton

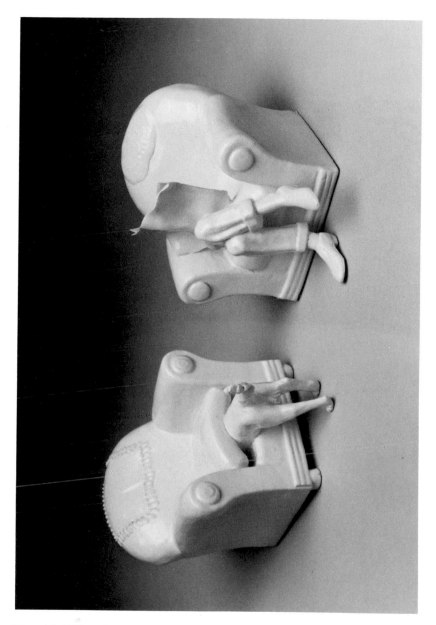

Plate 15: "Where's that bone?" (see page 90)
porcelain, glaze: 4⅝ x 6¾ ": 1973
"Evening News"
porcelain, glaze: 4⅓ x 6¾ ": 1973
Courtesy Perimeter Gallery, Chicago
Photo: Jon Bolton

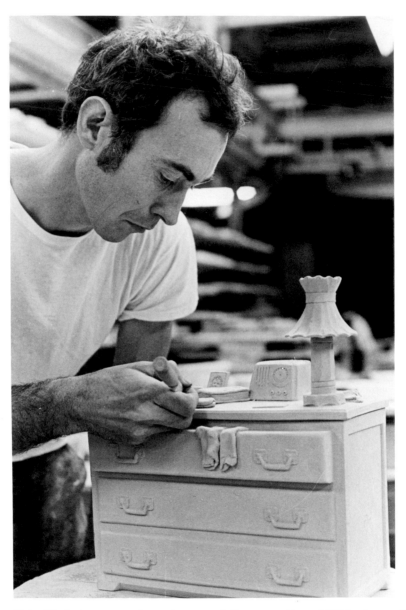

Plate 16: Jack executes last minute modeling on casting of "Ohio Dresser" before the firing. Molds for six multiples were created in Virginia in 1976, and later in the year cast at the Kohler Company in editions of nine each. Although none was produced in Ohio, the series was labeled 'Ohio Multiples' because the sudden preoccupation with Ohio themes presaged Jack's imminent return, with family, to his home state. (see page 107, 119) Photo: Courtesy John Michael Kohler Arts Center

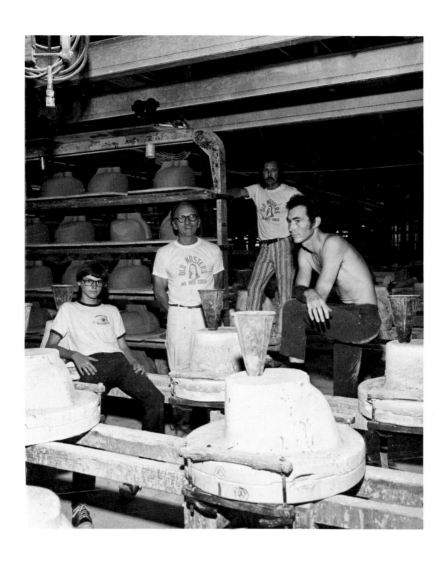

Plate 17: Jack, right, and Tom Ladusa, rear, the artists invited to the Kohler Company during the summer of 1974 for hands-on experience with industrial porcelain (vitreous china) techniques. Clayton Hill (to Tom's right) was designated Kohler liaison between the artists and artisans, and more important, mentor to Jack and Tom on Kohler processes. At left is Steven, Jack's son, the official gofer for the artists who simultaneously received a crash course in factory life. (see page 107)
Photo: Courtesy John Michael Kohler Arts Center

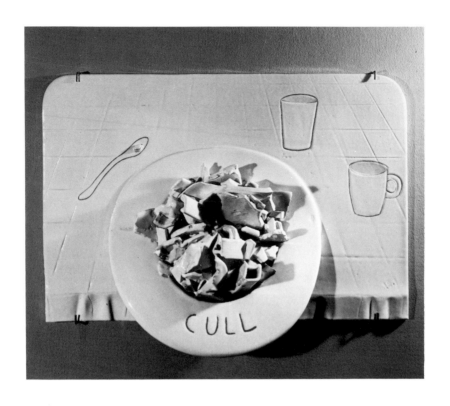

Plate 18: "Untitled" (see page 107)
vitreous china, Kohler glazes: 21″ high: 1974
Collection John Michael Kohler Arts Center, Sheboygan, Wisconsin
Photo: Courtesy John Michael Kohler Arts Center
Inevitably Jack's probing humor had to deal with cull, the Kohler
appellation for imperfect porcelain ware. Jack had noted the company's
sensitivity to spoilage, and here it appears he has served up a plate of
cull—which someone is going to have to eat!

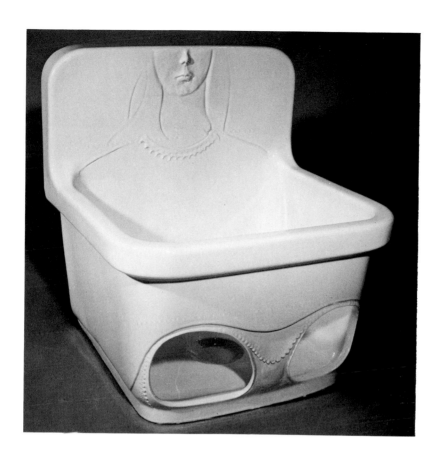

Plate 19: "Untitled" (see page 90, 107)
vitreous china, Kohler glazes: 21¾″ high: 1974
Collection John Michael Kohler Arts Center, Sheboygan, Wisconsin
Photo: Courtesy John Michael Kohler Arts Center
Another of Jack's transformations, this time from Kohler sink
to seated girl.

Plate 20: "Lunchroom Mural" (see page 118)
vitreous china, Kohler glazes: 120 x 160": 1976
Collection Kohler Company, Kohler, Wisconsin
Photo: Courtesy Kohler Company
The mural Kohler Company commissioned Jack to execute for the
employees' lunchroom reportedly was received in good spirit by everyone
except the President, who felt awkward being placed on a horse, and
downright disheartened when he and the horse became an equestrian
statue on the roof.

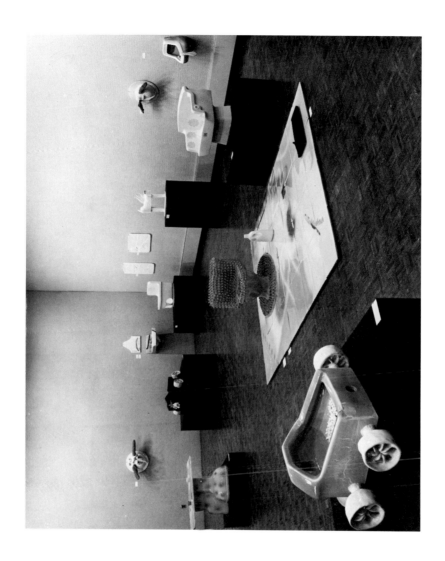

Plate 21: "Four Weeks at Kohler" exhibition, 1974 (see page 107)
Installation view: John Michael Kohler Arts Center, Sheboygan, Wisconsin
Photo: Courtesy John Michael Kohler Arts Center

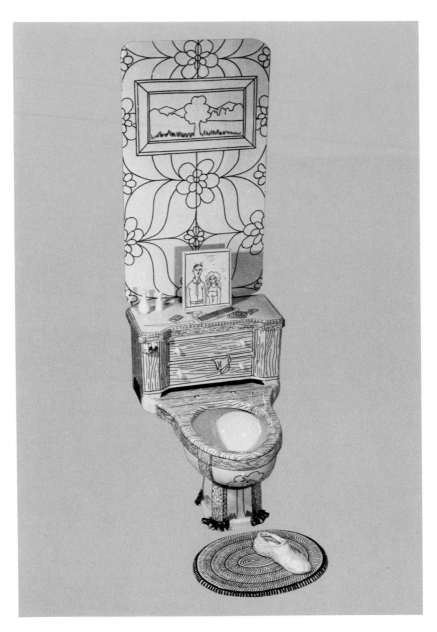

Plate 22: "Untitled" (see page 107)
vitreous china, Kohler glazes: 74″ high: 4 pieces: 1974
Collection John Michael Kohler Arts Center, Sheboygan, Wisconsin
Photo: Courtesy John Michael Kohler Arts Center
One of Jack's most delightful translations of anonymous Kohler ware to a
downhome bathroom set, woodgrain and all.

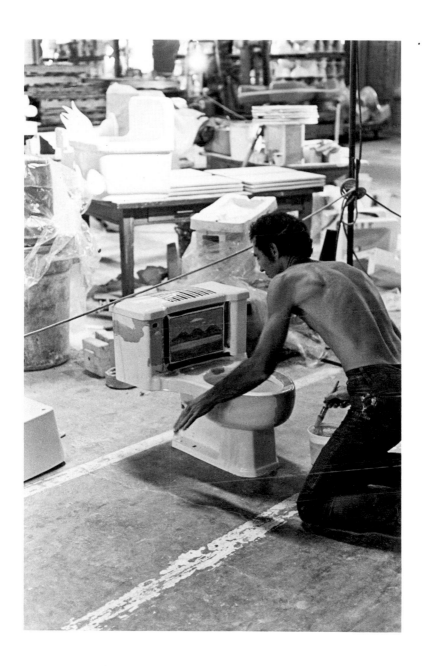

Plate 23: Jack brush paints colorful Kohler glazes
onto a mundane but basic Kohler fixture. (see page 107)

Plate 24 (Side 1): "Where I used to live in Genoa, Ohio, people lived in houses. They lived in them mostly at night. During the day they would come out and do things. When it got dark they would go in and turn on the lights and after a while they would turn them off. Nobody knows what people living in their houses is." (see page 89)
porcelain, china paint, glaze: 5⅝ x 7 x 4¾": 1973
Exhibited in 'The Object as Poet' (1976-77), organized by the Renwick Gallery of the National Museum of American Art, Smithsonian Institution
Collection Roxana and William Keland, Monterey, California
Photo: Jon Bolton

Plate 25 (Side 2) (see page 89)

Plate 26: "Duck on Waves: a duck can stir you, all floating and pretty
setting there making you think but as soon as you get to know him you
find out he don't want nothing." (see page 90)
porcelain, glaze: 10¾ x 10½ x 48½″: 20 pieces: 1973
Collection Karen Johnson Boyd, Racine, Wisconsin
Photo: Jon Bolton

Plate 27: "Girl in Box" (see page 89)
porcelain, china paint: 3¾ x 3½ x 5¼ ": 2 pieces: 1973
Courtesy Perimeter Gallery, Chicago
Photo: Jon Bolton

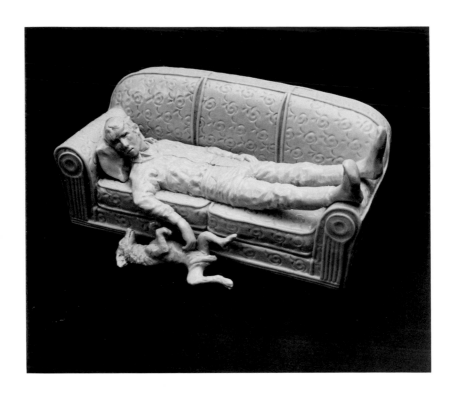

Plate 28: "Be Right There!"
porcelain, glaze: 4⅛ x 8¾ x 5″: 1975
Courtesy Perimeter Gallery, Chicago
Photo: Jon Bolton

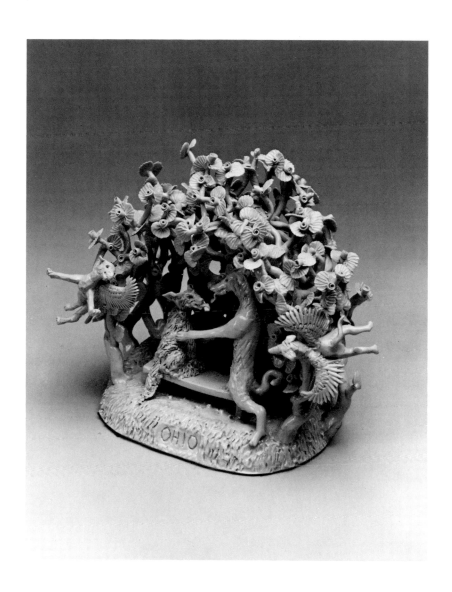

Plate 29: "Love in the Arbor" (see page 120)
porcelain, glaze: 7¼ x 6 x 9″: 1975
Collection Karen Henrietta Keland, Chicago
Photo: Jon Bolton

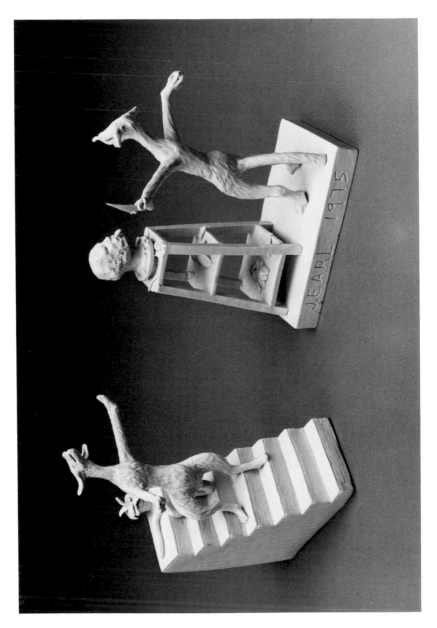

Plate 30 (left to right) (see page 120)
"Dog Descending the Staircase"
 porcelain, glaze: 9¼ x 5⅛ x 5″: 1975
"The Sculptur"
 porcelain, glaze: 8¾ x 6⅜″: 1975
Courtesy Perimeter Gallery, Chicago
Photo: Jon Bolton

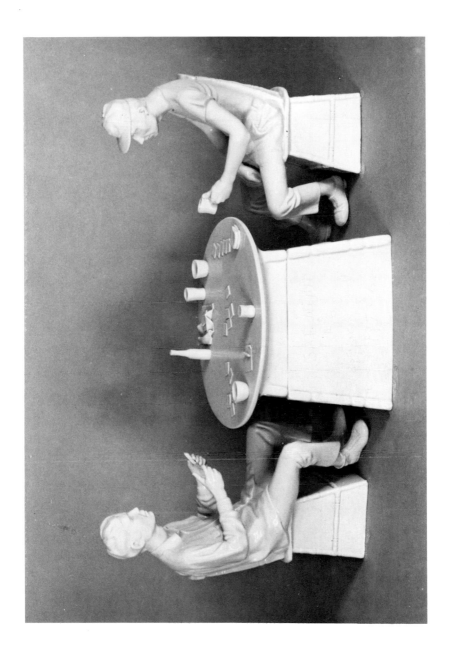

Plate 31: "Saturday Night" (see page 119)
vitreous china, glaze: 9″ high: 3 pieces: edition of 9: 1976
Collection Sy and Theo Portnoy, Scarsdale, New York
Photo: Jim Frank

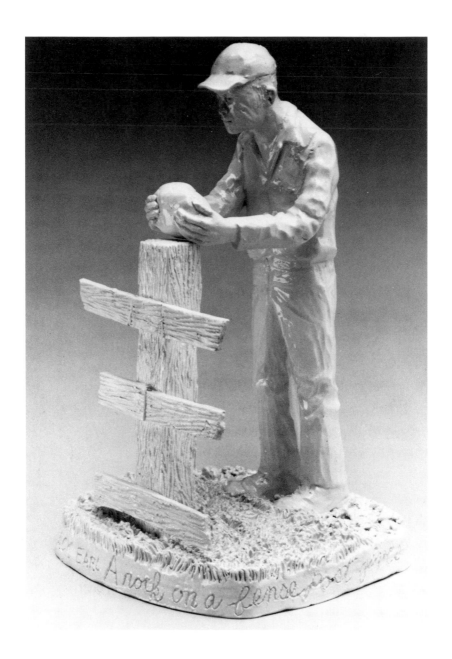

Plate 32: "A rock on a fence post gives you
somethin to look at as you pass by." (see page 128)
porcelain, glaze: 7¾ x 4⅝ x 4½ ": 1977
Collection Thomas B. Martin, Granby, Connecticut
Photo: Dan Kelley

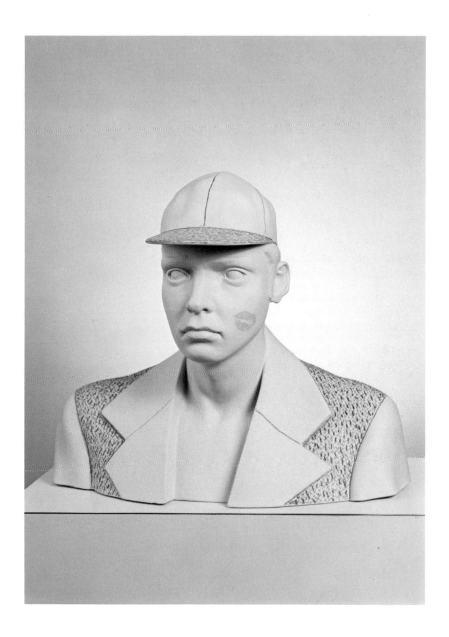

Plate 33: "Ohio Boy with Kiss" (see page 119)
vitreous china, glazes: 16 x 18 x 9": edition of 9: 1977
Collection Mr. and Mrs. James F. Keane, Palm Beach, Florida
Photo: Bruce Rosenblum

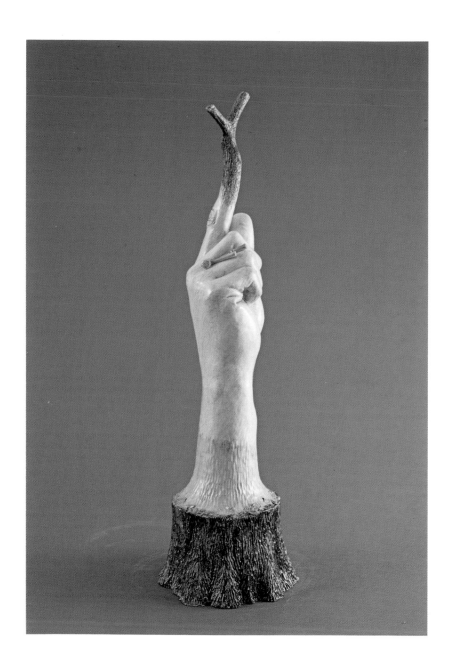

Plate 34: "The Hand" (see page 129)
ceramic, china paint: 20½″ high: 1978
Collection Karen Henrietta Keland, Chicago
Photo: Jon Bolton

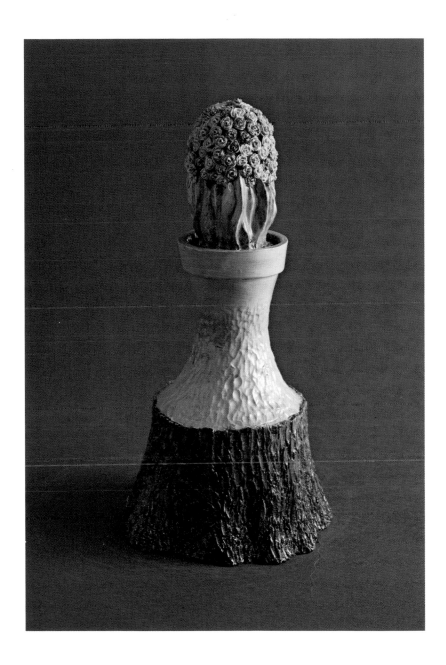

Plate 35: "Flowers"
ceramic, china paint: 10½ ″ high: 1978
Collection David Bourdon, New York
Photo: Martin Jackson

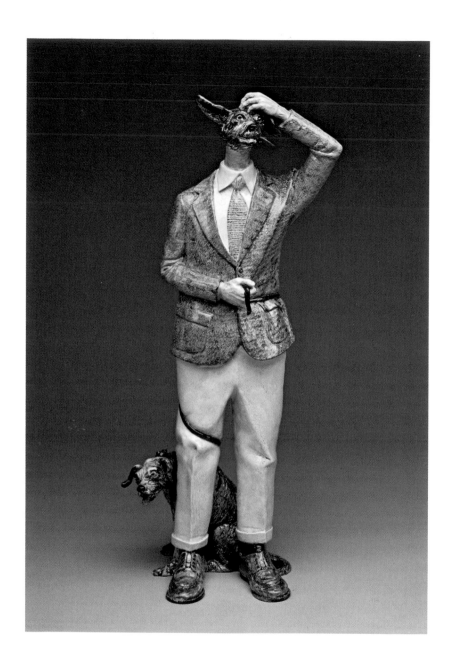

Plate 36: "Dog Gone" (see page 144)
ceramic, china paint: 18¾ʺ high: 1978
Collection Katherine Nikolina Keland, Racine, Wisconsin
Photo: Jon Bolton

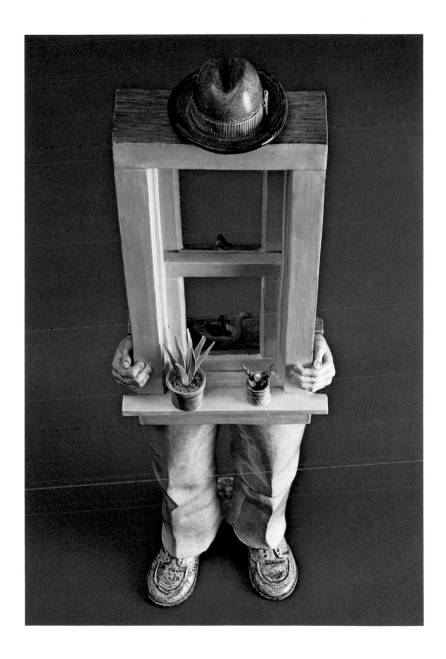

Plate 37: "Springtime in Ohio" (see page 145)
ceramic, china paint: 20 x 6 x 5": 1978
Collection Sue, Malcolm and Abigale Knapp, New York
Photo: Malcolm Knapp

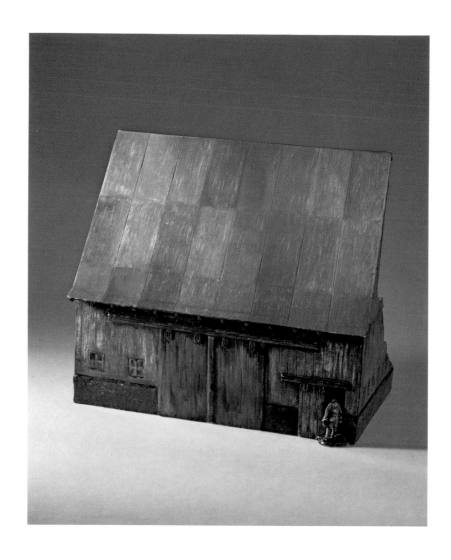

Plate 38 (Side 2): "Josiah Wedgwood built his city out of clay."
porcelain, oil, dos-a-dos: 10½ x 11½ x 8¼ ": 1979
Exhibited in "Contemporary Ceramics: A Response to Wedgwood,"
Buten Museum of Wedgwood
The Saxe Collection, Menlo Park, California
Photo: Joe Schopplein

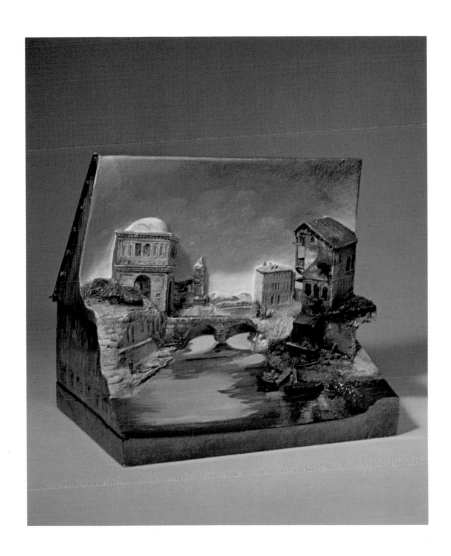

Plate 39 (Side 1)

Plate 40: Reproduction of landscape by unknown artist used by Earl for landscape within the tree in Plate 41. (see page 174)
Photo: Jon Bolton

Plate 41: "There was a man who worked at Copelands and he lived at 513 W. St. and then he got a job at the stove factory—and now he lives at 1680 Lincolnshire Dr.—and then he bought a new Oldsmobile and his kids are grown now—and one lives in Texas—one says I'll be down Sat. So the man's wife cooked a bunch of chicken for everybody—but they didn't come. Now the man has to eat chicken all week." (see page 174)
ceramic, china paint: 20 x 12″ diam.: 1979
Courtesy Perimeter Gallery, Chicago
Photo: Jon Bolton

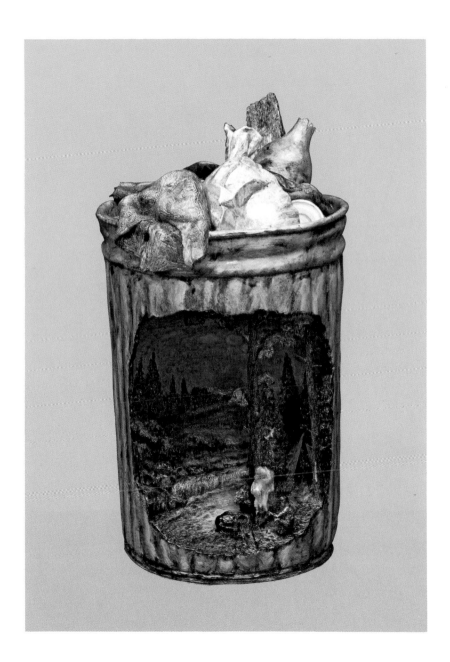

Plate 41

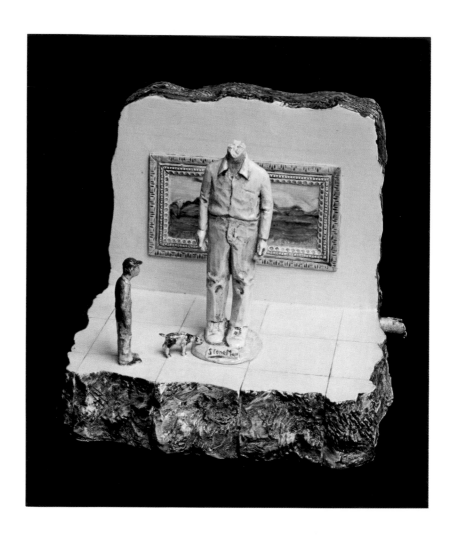

Plate 42: "Bill meets Art at the Museum." (see page 144)
ceramic, china paint: 7 x 7¾ x 7¼ ": 1979
Delaware Art Museum, Wilmington;
purchased from NEA funds and contributions
Photo: Courtesy Delaware Museum

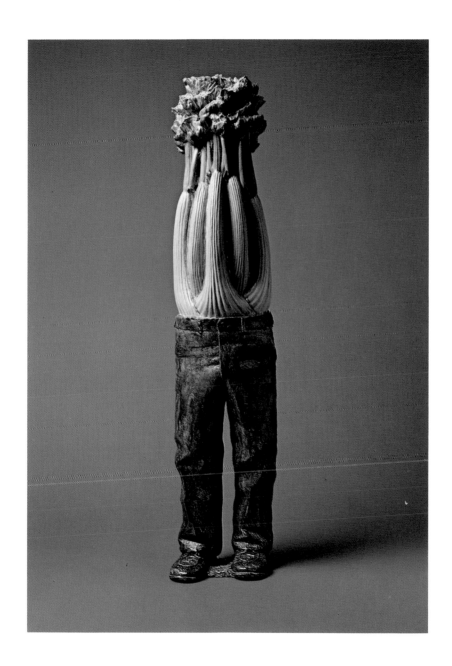

Plate 43: "The Celery Man" (see page 145)
ceramic, china paint: 28 x 6 x 6″: 1980
Collection Daniel Jacobs, New York
Photo: Bernard Handzel

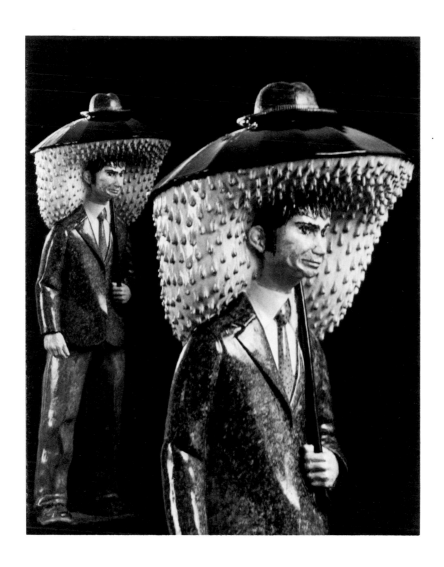

Plate 44: "Here comes the sun!"
ceramic, china paint: 27 x 9 x 8″: 1980
Collection Mr and Mrs Derek Lidow, Los Angeles
Photo: Martin Jackson

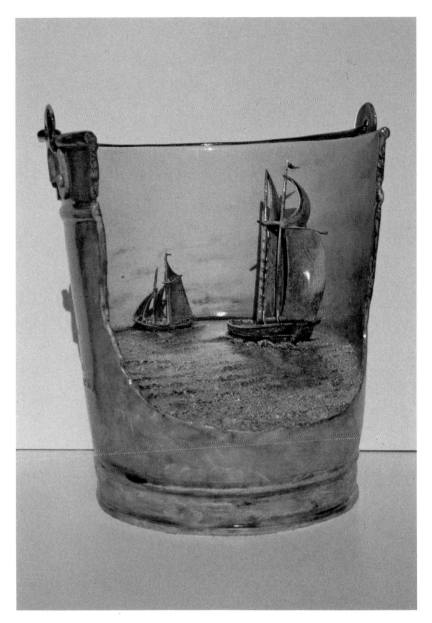

Plate 45: "The Bucket Man"
ceramic, china paint: 11 x 11″ diameter: 1980
Ohio Arts Council Individual Artist Fellowship,
Recipient/FY 1980
Courtesy Perimeter Gallery, Chicago
Photo: Rob Micus

Plate 46: "The man, from his youth now he is old, sitting in the evening, drinking coffee, and looking again through yellow light bulb light at the paper calendar picture hanging on the kitchen wall. He knows why he looks and what he sees but he can't say because the picture is a secret he keeps from his words." (see page 150)
porcelain, china paint: 11¾ x 10 x 10″: 1980
Collection Renwick Gallery of the National Museum of American Art, Smithsonian Institution; Museum Purchase
Photo: Edward Owen

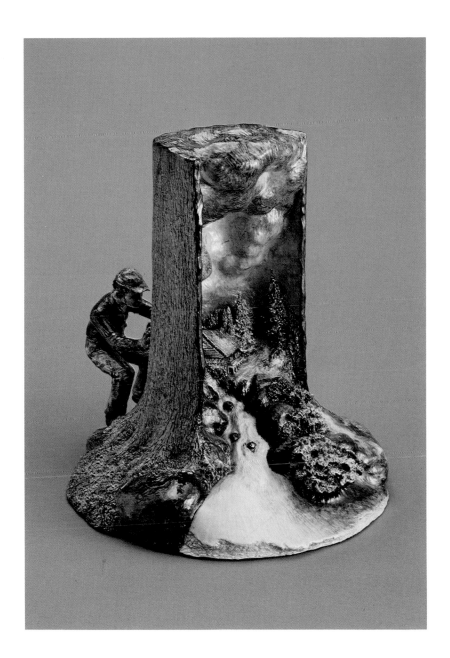

Plate 46

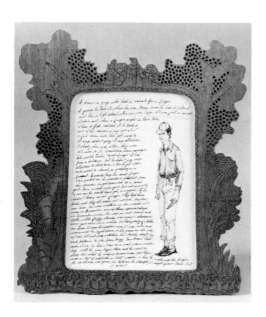

Plate 47: "The Story of Carrot Finger: I knew a guy who had a carrot for a finger. I guess he had it when he was born cause he had it when I met him in high school when we was boys. It was just a carrot stickin' out where a finger ought to have been. When I first noticed it I looked out of the corner of my eye at it a few times and then got used to it and didn't pay it any attention. Nobody else did either, they were all used to it. Sometimes some younger kid would holler 'Carrot finger' at him from a distance but he didn't pay any attention to them kids. When he got older and went to church, a wedding or a funeral, he would keep his carrot finger in a pocket so he wouldn't distract from the service. He got married to a local girl here, a real nice girl, but not as pretty a one as he could have got, I suppose, if he hadn't had a carrot finger. They had three kids and they all come out normal. Anyhow, one time he was walkin in the woods. It was in December, one of those special days in December when the sun is real warm and little white fluffy clouds was passin shadows over you once in a while. He had plenty of clothes on since it was December and it was nice and warm and he layed down in the grass on the side of that hill and was watchin' the clouds drift by and listenin to the bees buzz. You know how nice it is to hear bees on a real warm winter day. Well he was layin there and he went to sleep but what he didn't know was that there was a lot of rabbits in that woods. When he woke up his finger, the carrot one, was gone. He told me he thought it might grow back but it didn't." (see page 157)
drawing on paper: ink, colored pencil: 21¾ x 18½"
 burned design on wood frame: 1981
Collection Karen Johnson Boyd, Racine, Wisconsin
Photo: Jon Bolton

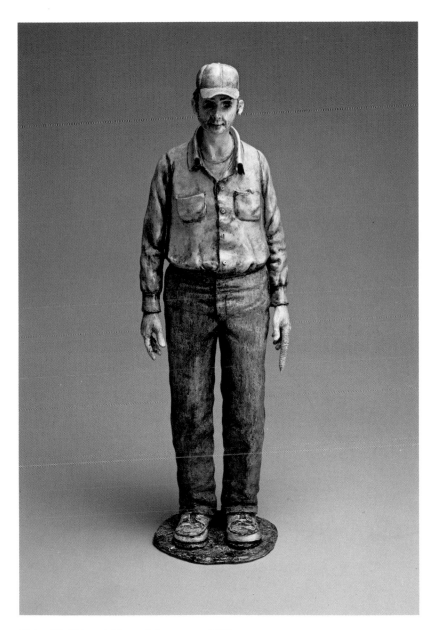

Plate 48: "Carrot Finger" (see page 157)
ceramic, china paint: 27 x 8 x 6″: 1981
Ohio Arts Council Individual Artist
Fellowship Recipient/FY 1980
Collection Karen Johnson Boyd, Racine, Wisconsin
Photo: Jon Bolton

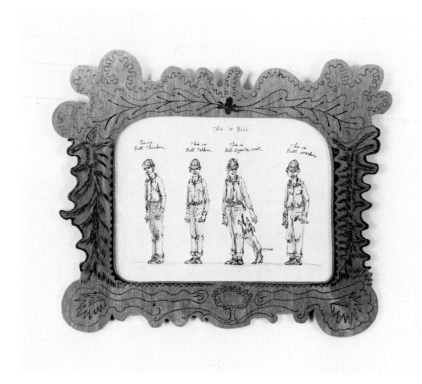

Plate 49: "This is Bill thinkin! This is Bill talkin!
This is Bill tryin' to rest. This is Bill workin!" (see page 159)
drawing on paper: ink, colored pencil: 18½ x 22″:
burned design on wood frame: 1981
Collection William and Marsha Goodman, New York
Photo: Michael Goodman

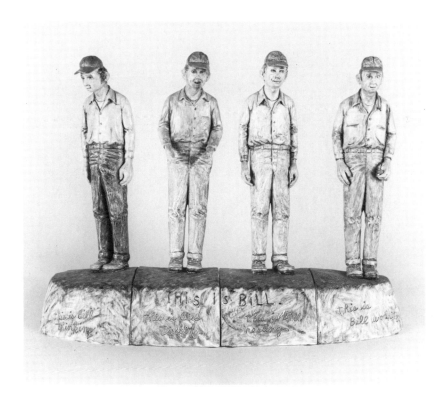

Plate 50: "This is Bill. This is Bill thinkin! This is Bill talkin!
This is Bill tryin' to rest. This is Bill workin!" (see page 159)
ceramic, china paint: 14 x 21¼ x 6¾": 1981
Collection William and Marsha Goodman, New York
Photo: Michael Goodman

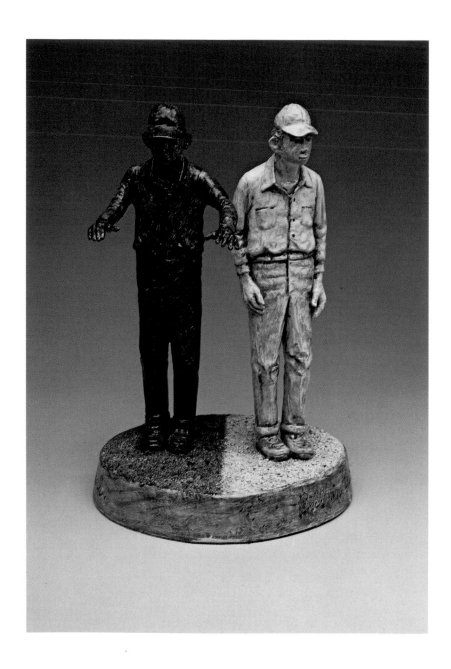

Plate 51: "Bill in the Light and Bill in the Dark"
ceramic, china paint: 14½ x 8½ ": 1981
Collection Andrea Kristine Keland, Woodside, California
Photo: Jon Bolton

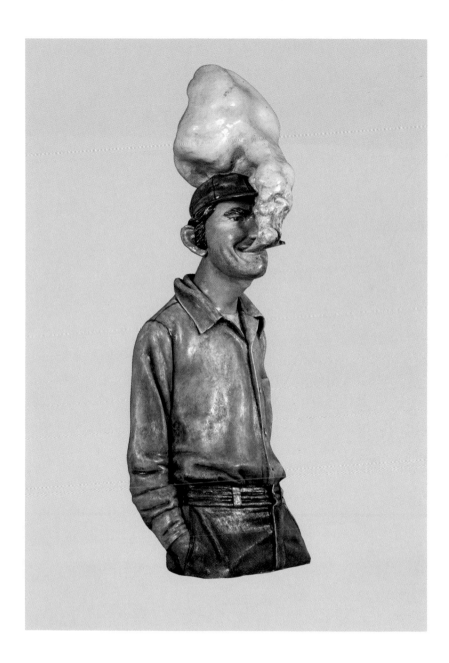

Plate 52: "That's Bill—That's Bill smokin!" (see page 160)
ceramic, oil: 46 x 17 x 13": 1981
Courtesy Theo Portnoy Gallery, New York
Photo: Jim Frank

Plate 53: "It was Sunday afternoon and Bill's friend came over and they went to Indian Lake fishing and there's Bill getting his picture taken with his catch."
ceramic, china paint: 28 x 8 x 6": 1981
Collection Beth and George Meredith, Upper Montclair, New Jersey
Photo: Bill Wagner

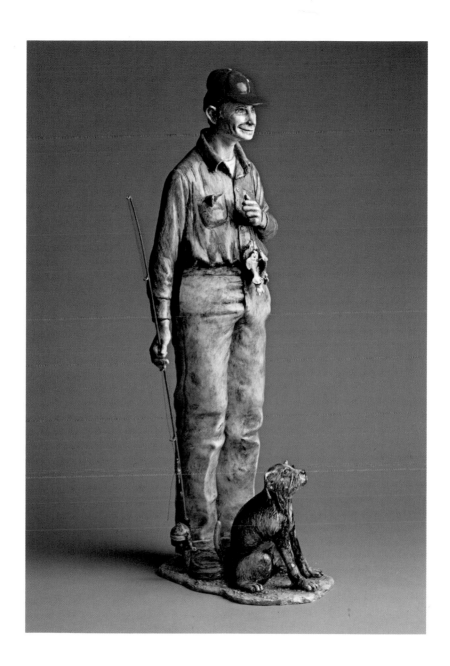

Plate 53

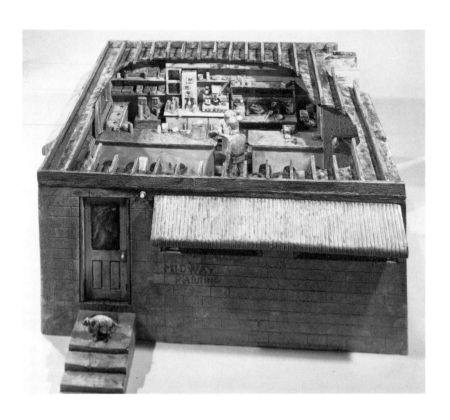

Plate 54: "The Midway Diner" (see page 179)
ceramic, china paint: 11½ x 23 x 24″: 1981
Collection Lynn Plotkin, Brentwood Gallery, St. Louis
Photo: Lee Nordness

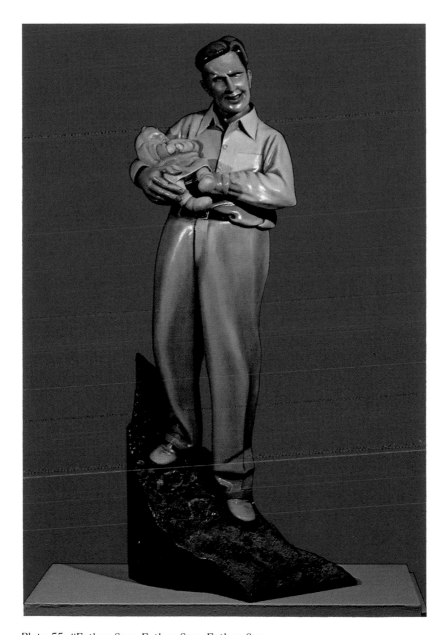

Plate 55: "Father Son, Father Son, Father Son,
Gail and Timmy, One Month" (see page 193)
ceramic, oil: 44 x 18 x 14¾": 1984
Ohio Arts Council Individual Artist Fellowship Recipient/FY 1983
Collection Anne and Ronald Abramson, Rockville, Maryland
Photo: Lee Nordness

Plate 56a: Reproduction from Sears Roebuck catalog used for "His Girl" and "Miss Sears" Plate 56.

Plate 56 (left to right) (see page 179)
"His Girl (Miss Sears 1968)"
 ceramic, china paint: 19½ x 20 x 14″: 1982
 Collection Alfred and Mary Shands, Louisville, Kentucky
"Mr Sam Doke"
 ceramic, china paint: 27 x 19 x 13″: 1982
 Collection George and Beth Meredith, Upper Montclair, New Jersey
"Miss Sears 1979"
 ceramic, china paint: 22½ x 22 x 18″: 1982
 Collection Theo Portnoy Gallery, New York
 Photo: Lee Nordness

Plate 56

Plate 57: "Over there! Look inside! You can see!" (see page 195)
ceramic, china paint: 17¼ x 21½ x 10″: 1983
Courtesy Theo Portnoy Gallery, New York
Photo: Lee Nordness

Plate 58: "Man and His Hole Bowl" (see page 180)
ceramic, china paint: 16¾ x 16¾ ": 1983
Collection Judy and Pat Coady, Brooklyn, New York
Photo: Lee Nordness

Plate 59 (Side 2)

Plate 60 (Side 1): "Beyond the door there is a place." (see page 194)
ceramic, china paint: dos-a-dos:
21¾ x 18 x 17": 1983
Collection Warren Rubin and Bernice Wollman, New York
Photo: Lee Nordness

Plate 61 (Side 2)

Plate 62 (Side 1): "Father built a safe place, shadows,
dogs and stones on the back porch." (see page 206)
ceramic, oil: front/back: 9½ x 10½ x 12″: 1983
Collection Alfred and Mary Shands, Louisville, Kentucky
Photo: Rob Micus

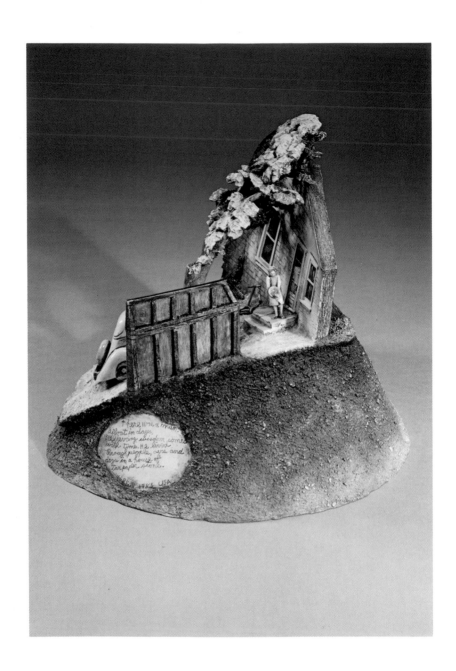

Plate 63 (Side 2)

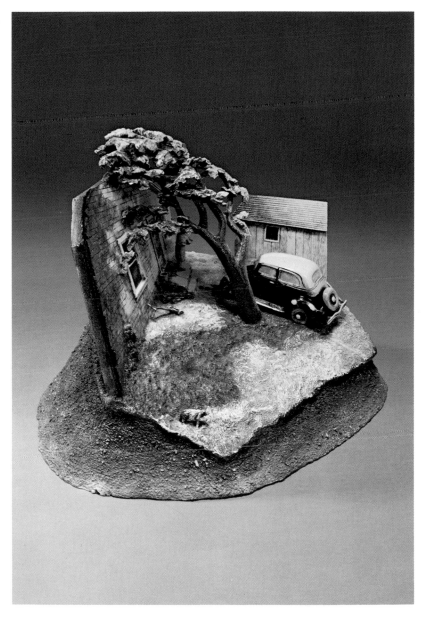

Plate 64 (Side 1): "There was a man afloat in days, believing wisdom comes with time. He lived through people, cars and dogs in a house of tarpaper stone." (see page 206)
ceramic, oil: dos-a-dos: 15½ x 20 x 20″: 1983
Courtesy Perimeter Gallery, Chicago
Photo: Jon Bolton

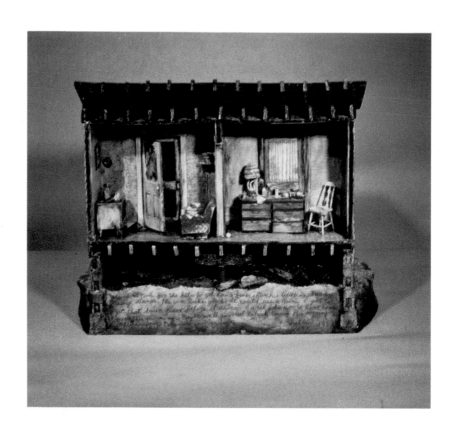

Plate 65 (Side 2) (see page 208)

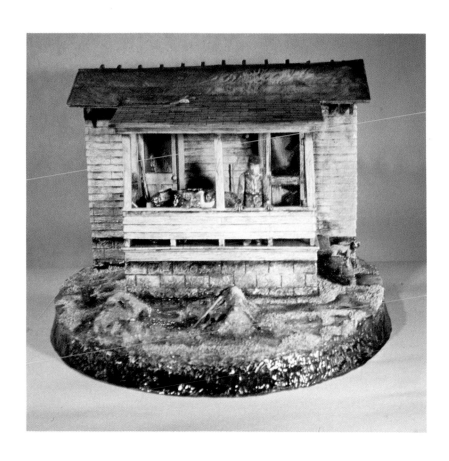

Plate 66 (Side 1): "It's almost time for the kids to get home from church."
(see page 208)
ceramic, oil: dos-a-dos: 17 x 21 x 17½ ": 1984
Collection Harold and Gayle Kurtz, New York
Photo: Lee Nordness

Plate 67 (Side 2)

Plate 68 (Side 1): "And the trees said to the fig tree, come thou and reign over us. But the fig tree said unto them, should I forsake my sweetness, and my good fruit and go to be promoted over the trees?"
ceramic, oil: dos-a-dos: 28¼ x 16¼ x 21⅛": 1984
Courtesy Perimeter Gallery, Chicago
Photo: Jon Bolton

Plate 69 (Side 2)

Plate 70 (Side 1): "Not to worry, by the father held safe. The calendar says it's spring. We've had a couple rains. There is still snow against the woods and where it's drifted deep along the fence rows—and in the creek where the water hasn't washed it away. The ground is wet—too wet for the farmers to work in the fields."
ceramic, oil: dos-a-dos: 28⅜ x 21⅛ x 21″: 1984
Courtesy Perimeter Gallery, Chicago
Photo: Jon Bolton

Plate 71 (Side 2) (see page 222)

Plate 72 (Side 1): "Roy, the man who saved his family.
Acts, Chapter 16, Verse 31." (see page 222)
ceramic, oil: 38⅞ x 20½ x 10½ ": 1984
Courtesy Perimeter Gallery, Chicago
Photo: Jon Bolton

Plate 73 (Side 2)

Plate 74 (Side 1): "Sy, Book of Psalms I, Zachariah Chapter 10,
Verses 1 and 2"
ceramic, oil: dos-a-dos: 30 x 20″: 1984
Collection Sy and Theo Portnoy, Scarsdale, New York
Photo: Lee Nordness

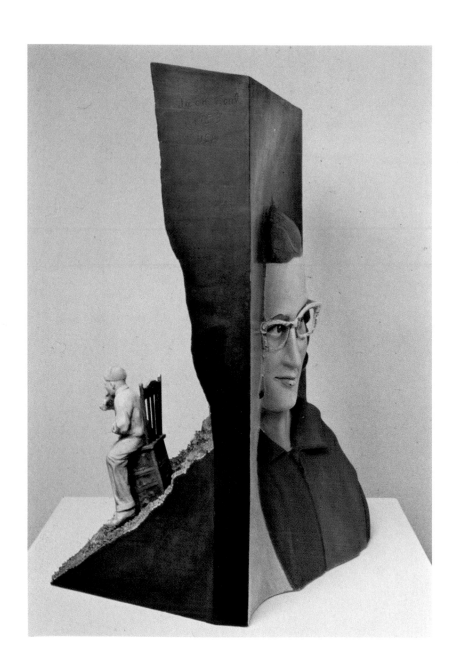

Plate 75 (Side 2) (see page 210)

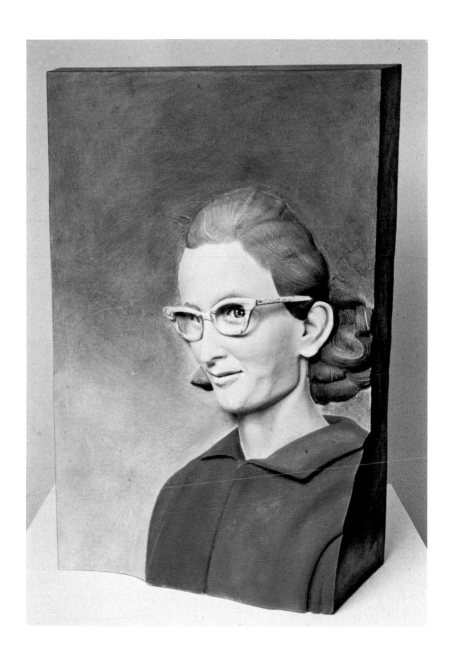

Plate 76 (Side 1): "There is a place, yes, there is a place." (see page 210)
ceramic, oil: dos-a-dos: 27½ x 18 x 17″: 1984
Collection S. Alpert Family Trust, Wayland, Massachusetts
Photo: Joshua Schreier

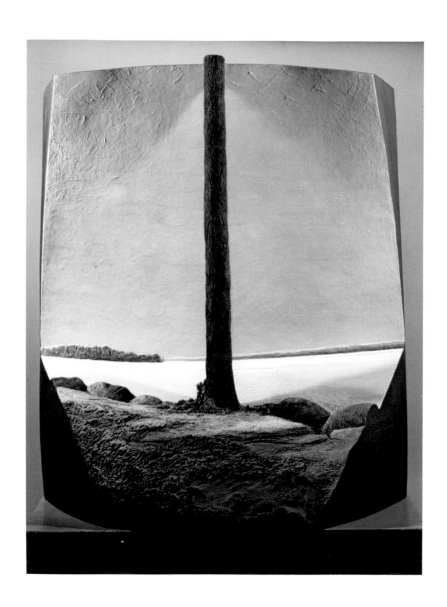

Plate 77 (Side 2)

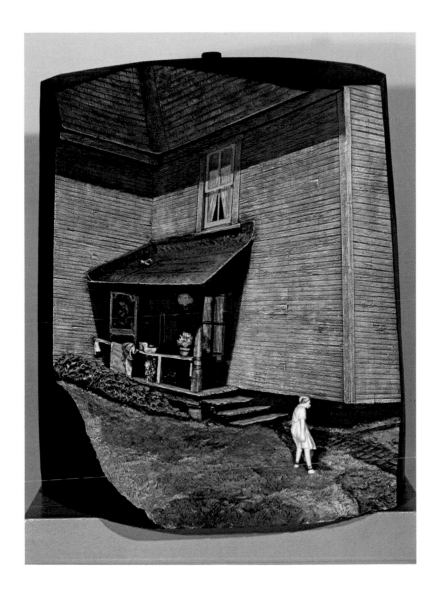

Plate 78 (Side 1): "There was a little city, and few men lived within it, and there came a great king against it, and built great bulwarks against it. Now there was found in it a poor wise man and he by his wisdom delivered the city, yet no man remembered that same poor man."
ceramic, oil: dos-a-dos: 27 x 22½ x 20″: 1984
Exhibited in 'On the House,' John Michael Kohler Arts Center, Sheboygan, Wisconsin 1984
Collection Daniel Jacobs, New York
Photo: Lee Nordness

"This Walter—and this is about Walter. One time I stepped from a Chicago, Ill. street onto the sidewalk and there, written in red, was a story about a guy's friend who drank alcohol until he blacked himself out and the rats ate him alive. That is hard. But Walter ain't going to black himself out with alcohol, drugs, books, or pictures or evil imaginations. So the rats won't eat him because he gets his hair cut where his dad gets his cut. Walter's friends laugh, but they'll be moving to California.

 or

"Raise your kids up in the way they should go (whether they like it or not) and they will not depart from it. Praise God."
ceramic, oil: 29¾ x 27¼ x 28": 1984
courtesy Perimeter Gallery, Chicago
Photo: Jon Bolton

Plate 79

Plate 80 (Side 2): "And they left the house of the Lord God of their fathers and served groves and idols: and the 'Spirit of God came upon Zecariah the son of Jehoiada the priest, which stood above the people and said unto them, thus saith God, why transgress ye the commandments of the Lord, that ye can not prosper? Because ye have forsaken the Lord, He hath also forsaken you."

Plate 81 (Side 1)
"You are ten thousand, the center of the flower, words of peace,
a tree planted."
ceramic, oil: dos-a-dos: 27¼ x 15 x 22¼ ": 1984
Courtesy Perimeter Gallery, Chicago
Photo: Jon Bolton

Plate 82: "Sweet Flora" (see page 208)
ceramic, oil: 26 x 19½ x 16½ ": 1984
Courtesy Theo Portnoy Gallery, New York
Photo: Lee Nordness

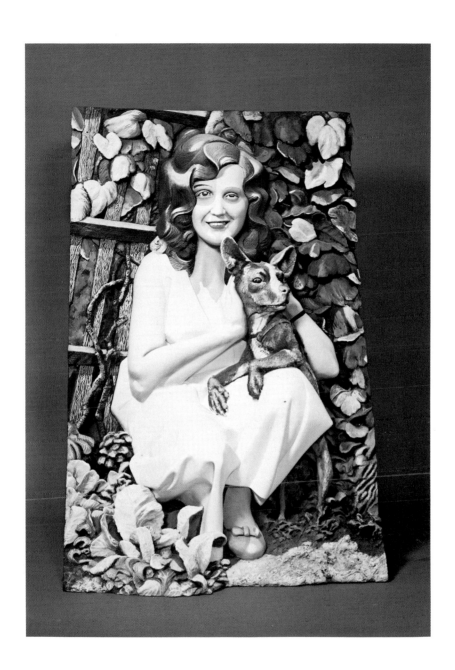

Plate 83 (Side 1)

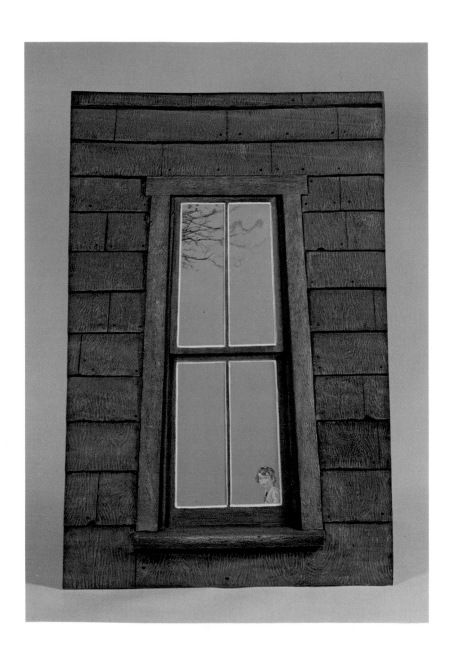

Plate 84 (Side 2)

Plate 83 (Side 1): "Now I will sing to my well-beloved, a song of my beloved touching his vineyard. My well-beloved hath a vineyard on a very fruitful hill."
ceramic, oil: dos-a-dos: 33 x 22 x 20″: 1985
courtesy Theo Portnoy Gallery, New York
Photo: Wm. A. Miller

Plate 85: Jack with his father, Kermit Earl. No wonder Jack
was able to build houses when grownup.

Plate 86: In front of their Indian Lake home: Jack, as patriarch, with Steven, Fairlie, and Dianne. The lake stretches some five miles south, just behind the photographer. (1979)

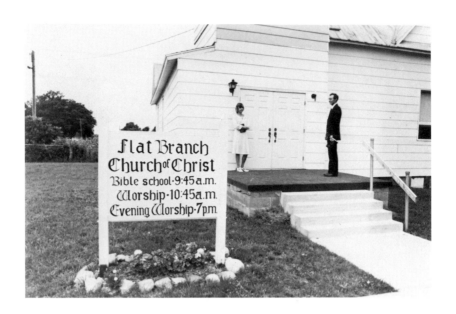

Plate 87: The church Roy attends at Flat Branch. When the photograph
was taken (1979) Jack and Fairlie were among the congregation, but a few
years later switched to the Rock Assembly church in Lima.

Plate 88: Fairlie and Jack at Flat Branch, with corn reaching for the
horizon. The mood is quintessential Ohio. (1979)

Plate 89: Steven, Roy and Jack leaning against a pickup in the Earls' back yard at Indian Lake. When not moving, the Hanson and Earl men seldom stand in any position which could be labeled formal. (1981)

Plate 91 (top): Daisy Mae, immortalized in Jack's sculptures,
in a familiar stance. (1983)

Plate 92 (bottom): Jack, Fairlie and Roy, mid-winter at Roy's farm. Note
the December shades Roy and daughter wear. (1983)

Plate 90: The Hanson twins, Ray and Roy, who went different ways but were never far apart. Roy seems to bear a ribbon, perhaps for good conduct. Or shooting rabbits. (1981)

Plate 93: Roy Hanson, on his farm on the marsh, has spaded up a clump of the 'richest soil in the world—muck,' to show the photographer. (1983)

Plate 94 (left): The younger daughter, Dianne, with her husband, Lance Kellermeyer, and their two children. (1984)

Plate 95 (right): The elder daughter, Kathy, with husband, Robert Shaw, and their three children. (1984)

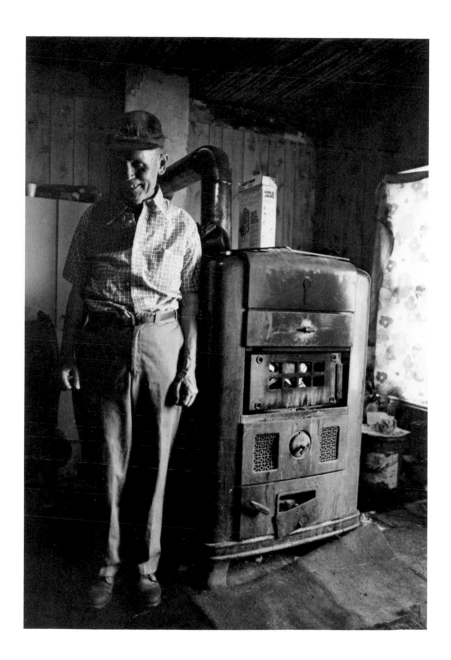

Plate 96: Roy Hanson in the kitchen of his farmhouse.
Note the outsized coal stove. (1981)

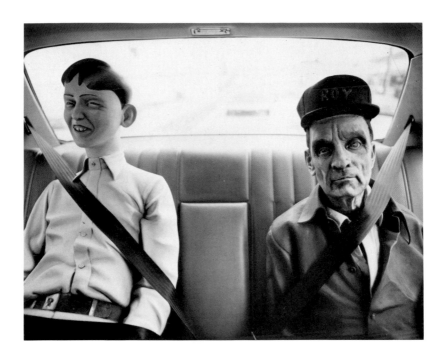

Plate 97: Roy and Walter strapped into the back seat of Karen Boyd's car, which seemed the safest way to transport these recent portrait sculptures by Jack. Roy is of course Roy Hanson; Walter, Jack claims, is a composite. The photograph is eloquently bizarre.
Photo: Jon Bolton

Plate 98: Jack's garage studio in Ohio, tidier than usual. The photograph at left was taken by the author: Jack stands in the middle of the county road into Uniopolis, backed by a field of July corn. The sculpture with farmer's cap nearby is a mystery. (1979)

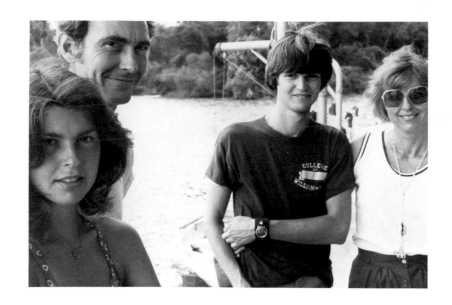

Plate 99: At the lakefront of their Indian Lake home:
Dianne, Jack, Steven and Fairlie. (1979)

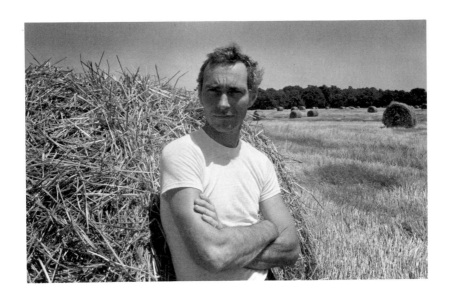

Plate 100: On a drive around Indian Lake we passed fields of 'farm
sculpture'—bales of hay. Jack agreed to a photograph,
after a little coaxing.

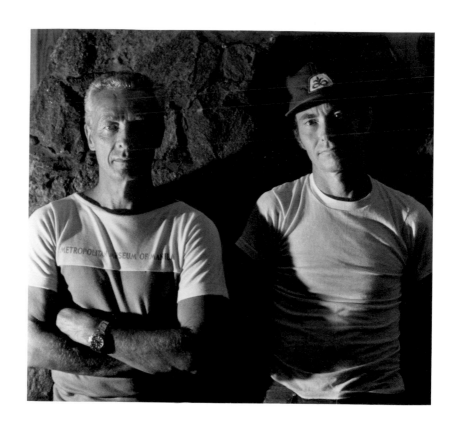

Plate 101: Lee Nordness and Jack Earl. (1983)

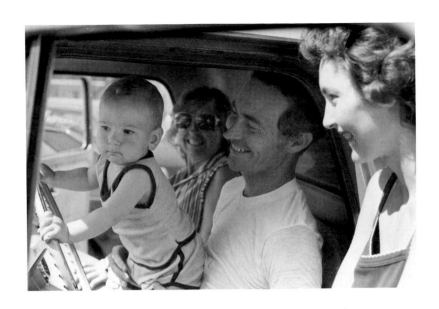

Plate 102: Gramps Earl and Grandma Fairlie visit their first grandchild,
Bob and Kathy's son, Robbie. Mother watches at right. (1979)
Photos: Plates 86-102 (except 97) by Lee Nordness

Colophon

Jack Earl: The Genesis and Triumphant
Survival of an Underground Ohio Artist

Designer: Walter Hamady
Line drawings and page numbers: Jack Earl
Typeface: ITC Cheltenham
Typesetting and camera mechanicals: Jane Rundell
Paper for text, plates and dust jacket: Warren Papermill
Cover stock: 12 point Feedkote
Color separations and half-tones: Litho Productions, Madison, Wisconsin
Printing: on Heidelberg Speedmasters at Litho Productions
Binding: smythe-sewn at Zonne, Chicago

This First Edition comprises 5,000 copies.